GREAT DESTINATIONS

OF A LIFETIME

GREAT DESTINATIONS
OF A LIFETIME

CLAUDIA MARTIN

amber
BOOKS

First published in 2020

Published by Amber Books Ltd
United House
North Road
London N7 9DP
United Kingdom
www.amberbooks.co.uk
Instagram: amberbooksltd
Facebook: amberbooks
Twitter: @amberbooks
Pinterest: amberbooksltd

ISBN: 978-1-78274-987-5

Project Editor: Michael Spilling
Designer: Keren Harragan
Picture Research: Terry Forshaw

Printed in China

Contents

Introduction

Many of us spend our lives planning and dreaming of future travels. While some hope for sun-warmed beaches, others yearn for wind-whipped wilderness or to touch the monuments of civilizations that marked the Earth millennia before we were born. Yet all of us who long to travel are hungering to escape the everyday, for a few minutes, days or months, and to discover for ourselves that the world is even more wonderful than we had dreamed.

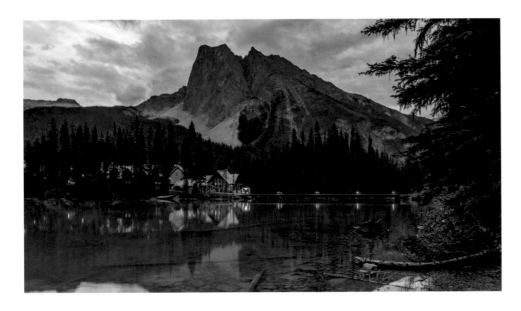

While some often overlooked destinations are almost in our own backyard, just a short stroll from the nearest cafe, others will take a large dose of determination to reach: the petroglyphs of remote Siberian valleys, the glacier-carved peaks of the snaking Karakoram Highway, or the shifting sand dunes of Namibia. Some destinations, from the Pyramids of Giza to the Great Wall of China, are rightly on most people's list of dream adventures; others, no less remarkable, may be little known and little visited, from the dragon's blood trees of Socotra to the mud volcanoes of Azerbaijan.

ABOVE
EMERALD LAKE, YOHO NATIONAL PARK, CANADA
This lake, high in the Rocky Mountains, glows a vivid turquoise due to refraction of light by the clouds of glacier-ground limestone in its water.

OPPOSITE
WAT SA SI, SUKHOTHAI, THAILAND
Built in the 14th century, this graceful Buddhist temple lies on its own island at the centre of the ruined capital city of the Kingdom of Sukhothai.

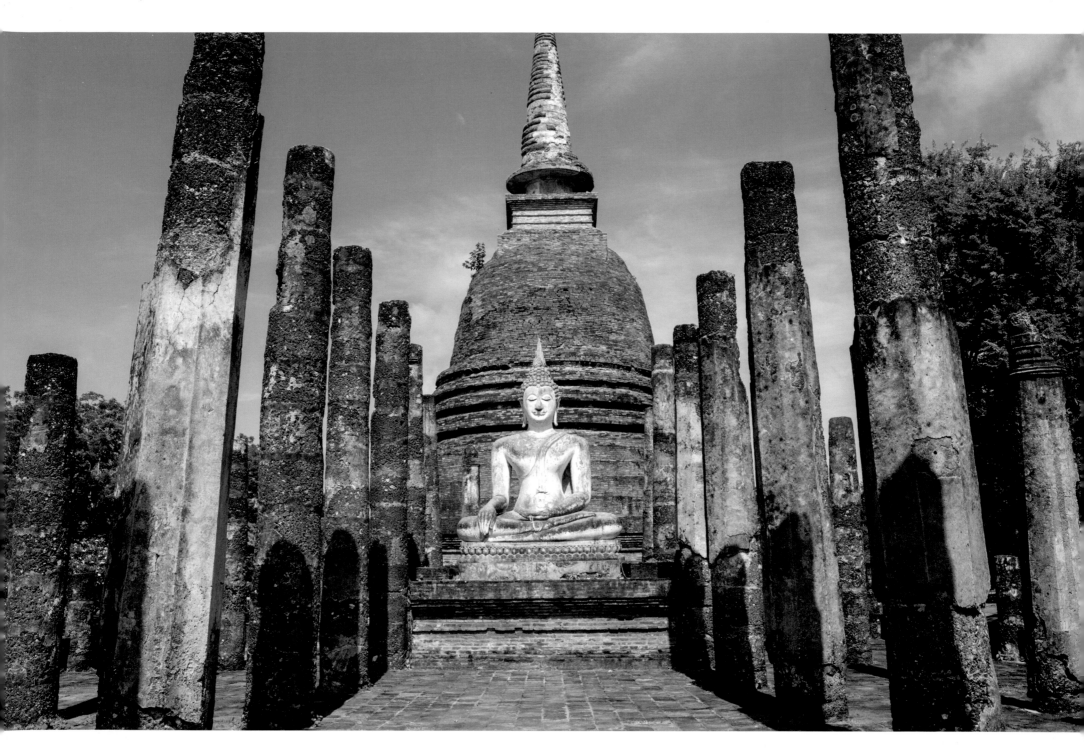

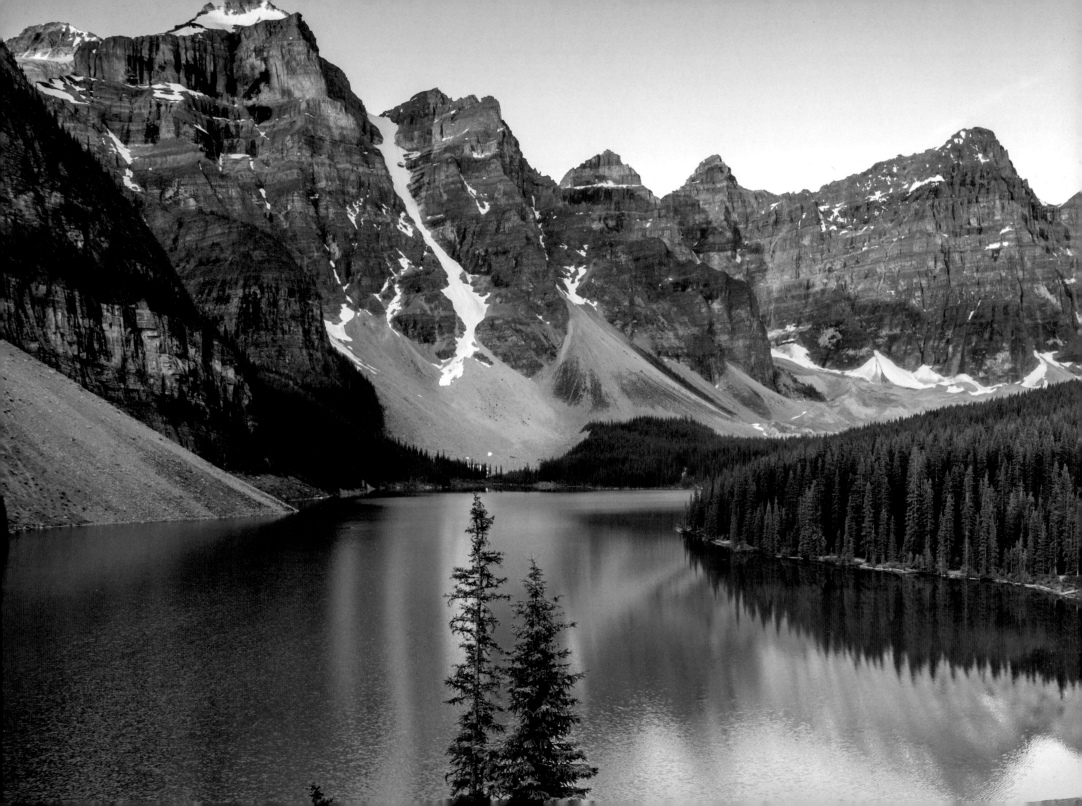

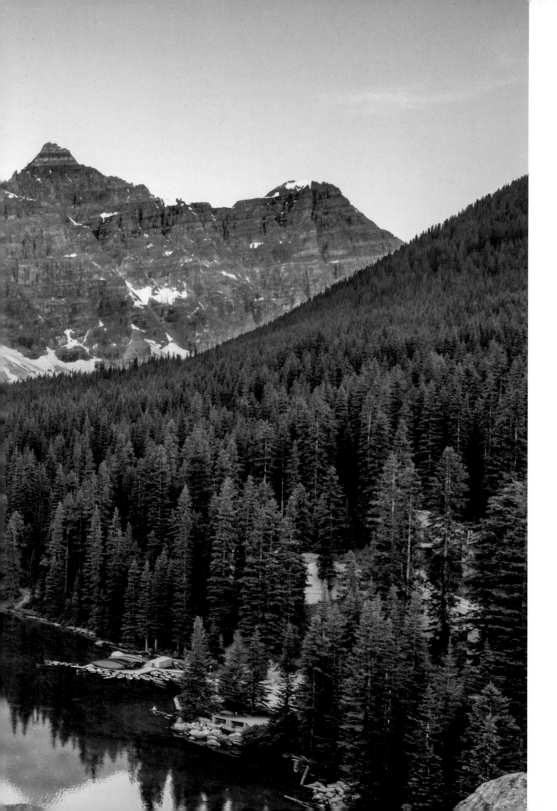

North America

This vast, varied continent stretches from the crevassed glaciers and untouched coniferous forests of the far north to the tropical beaches and forests of Central America. Along the way are temperate rainforests, home to rarely glimpsed birds, and deserts where Joshua trees manage to eke out their existence for many hundreds of years. Ice, rivers, wind and rain have worn the region's landscapes into extraordinary canyons, cliffs and hoodoos. Volcanism has done its work here, too, leaving volcanoes towering above the plains and bright, bubbling springs of super-heated water.

This continent was possibly first inhabited around 19,000 years ago, when brave adventurers walked across the land bridge between eastern Siberia and modern-day Alaska. After the descendants of these hunter-gatherers had settled to farming, they built some of the world's most extraordinary ancient cities, from monumental Teotihuacan in central Mexico, to the richly complex nerve centres of the Maya civilization, which stretched from southeastern Mexico to El Salvador. Modern dreamers and engineers have also left their breathtaking marks on the continent, from the Golden Gate Bridge to gravity-defying roads.

MORAINE LAKE, ALBERTA, CANADA
In Banff National Park, this azure glacial lake reflects the rocky summits of the Ten Peaks. The water's brilliant colour is due to refraction of sunlight by the tiny particles of rock deposited by surrounding glaciers.

LEFT

ST JOHN'S, NEWFOUNDLAND AND LABRADOR, CANADA

St John's has its origins as a fishing village in the early 16th century, its single-storey homes and storage sheds simply constructed from wood. Although the majority of these early buildings were destroyed by fire in the 19th century, many were rebuilt in traditional hip-roofed style. It was probably not until the 20th century that the residents' habit of painting their homes in bright colours earned downtown St John's the nickname of 'Jellybean Row'.

RIGHT

THE BATTERY, ST JOHN'S

Aside from the settlements of Greenland, St John's is the most easterly city in North America. For a provincial capital, it has a low population density of just 244 inhabitants per sq km (632 per sq mile). The Battery neighbourhood, on the slopes of Signal Hill at the entrance to the harbour, was an important battery for the defence of St John's during both World Wars. During World War II, the harbour was home to ships engaged in anti-submarine warfare.

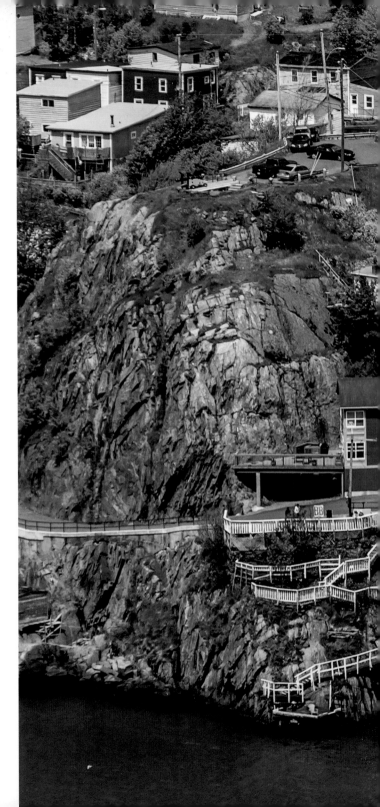

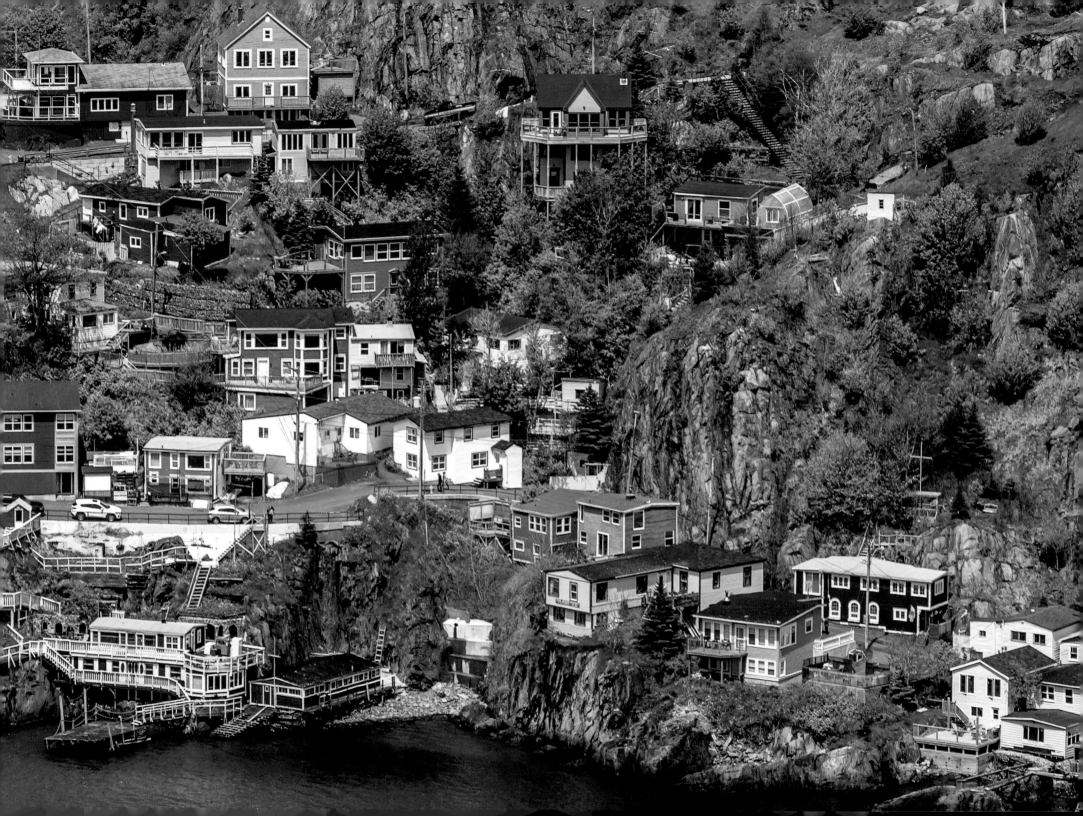

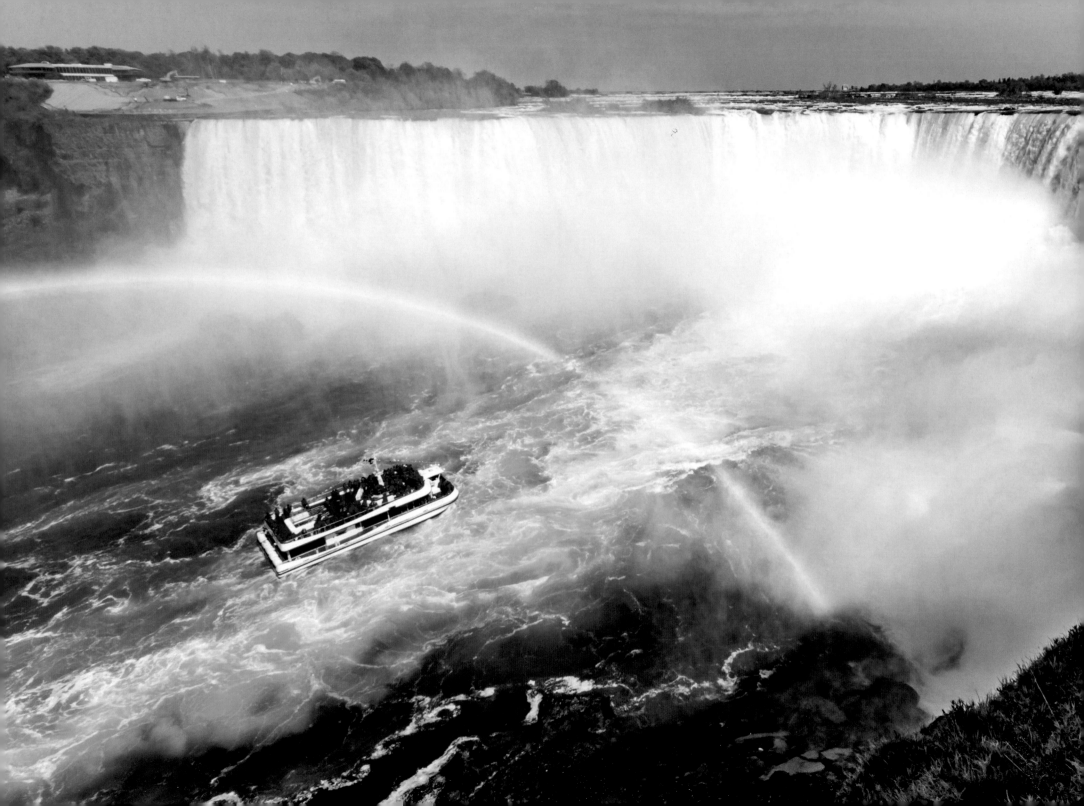

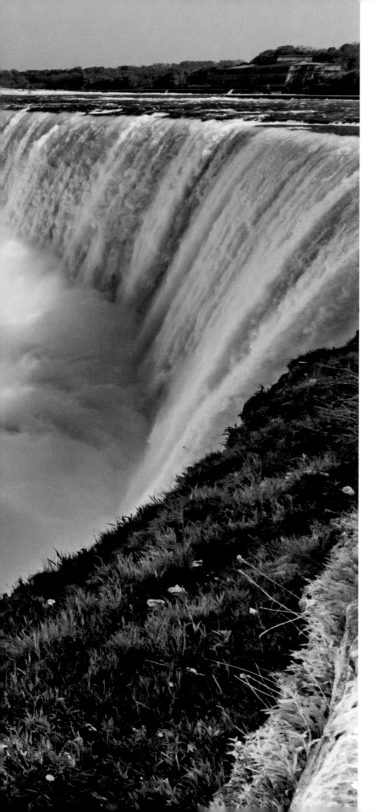

NIAGARA FALLS, CANADA–UNITED STATES

Horseshoe Falls is the largest of the three falls on the Niagara River along the Canada–United States border. This waterfall has a width of 820 m (2,700 ft). American Falls is 290 m (950 ft) wide, while the smallest, Bridal Veil Falls, is just 17 m (56 ft) wide. In 1901, a Michigan teacher named Annie Edson Taylor was the first person to go over the falls in a barrel. After narrowly surviving the experience, she said, 'No one ought ever do that again.'

CASTLE MOUNTAIN, ALBERTA, CANADA

Halfway between the town of Banff and Lake Louise, in Banff National Park, is this seemingly castellated outcrop. Its crenellations were caused by the differing rates of erosion of its soft shale and hard dolomite and quartzite. Lying on a thrust fault, a crack in Earth's crust where older rocks are pushed above younger ones, Castle Mountain is the easternmost peak of the Park Ranges of the Canadian Rockies.

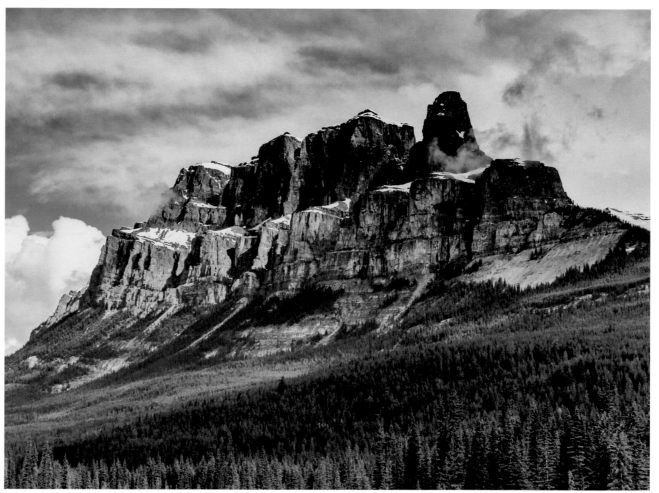

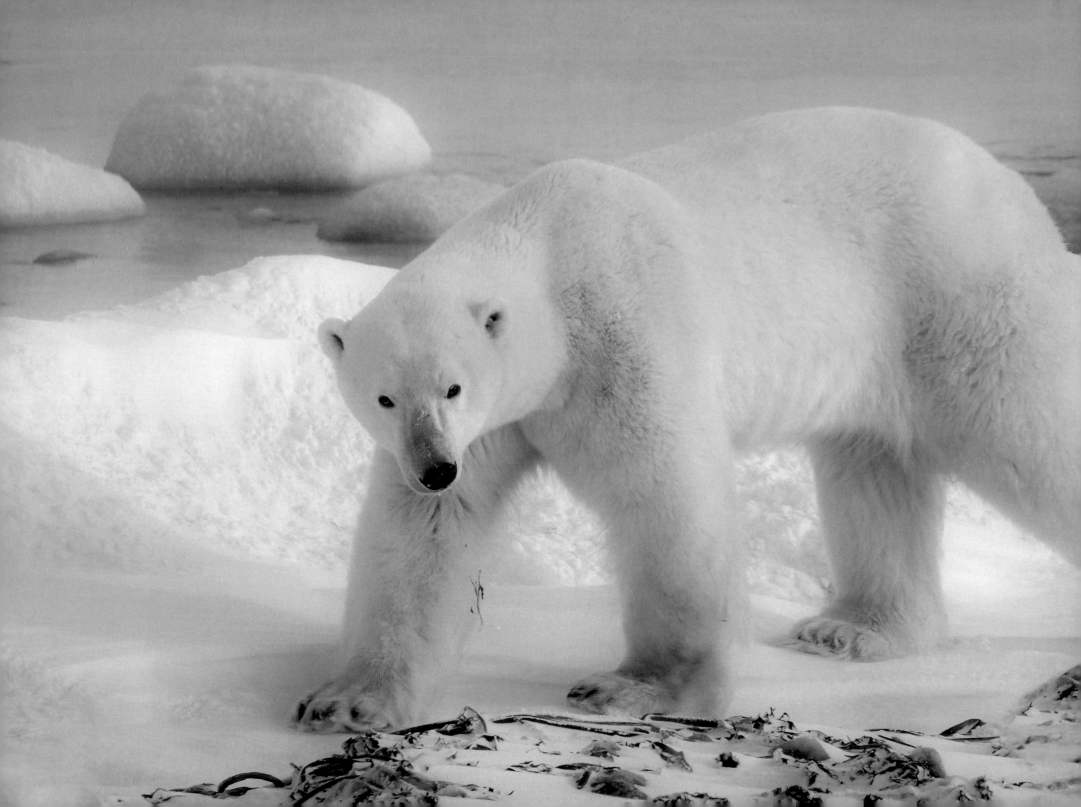

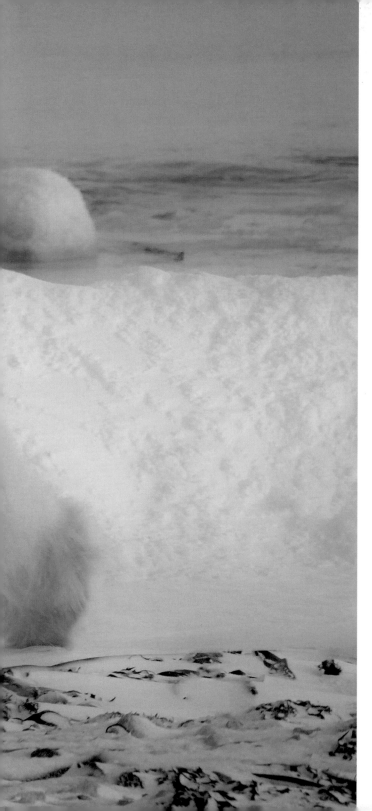

HUDSON BAY, CANADA

The northern reaches of Hudson Bay, lying just above 60°North, experience a polar climate. Polar bears roam the shores of the bay in summer and autumn, sometimes bothering the residents of nearby towns. In the town of Churchill, house and car doors are always left unlocked, in case a pedestrian has to take shelter. In winter, the bears move onto the re-frozen sea ice to hunt for ringed seals. Bears can often be seen at holes in the ice, waiting for their prey to come up for air.

RIGHT

VERMILION RIVER, BRITISH COLUMBIA, CANADA

The Vermilion River flows through Kootenay National Park, where it foams over the famous Numa Falls, before joining forces with the Kootenay River. The Vermilion takes its name from mineral springs near its headwaters, where the local Ktunaxa people obtained iron oxide for body paint. Just south of Numa Falls, the river has carved its way through a narrow canyon cloaked by firs, larches, spruces and junipers.

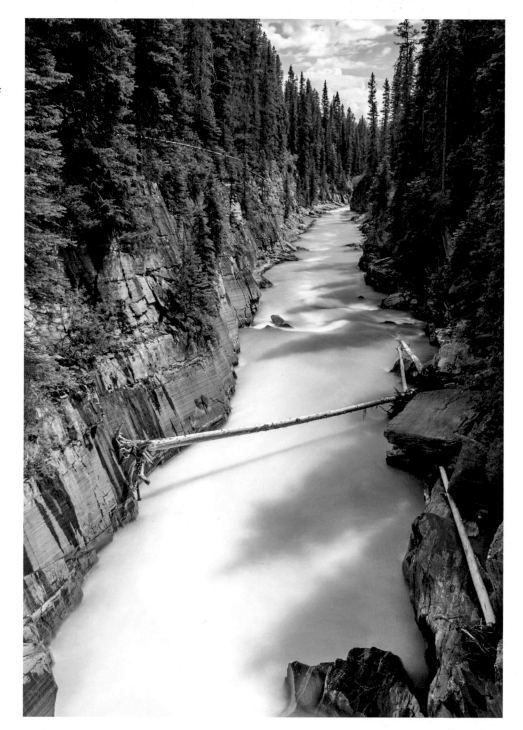

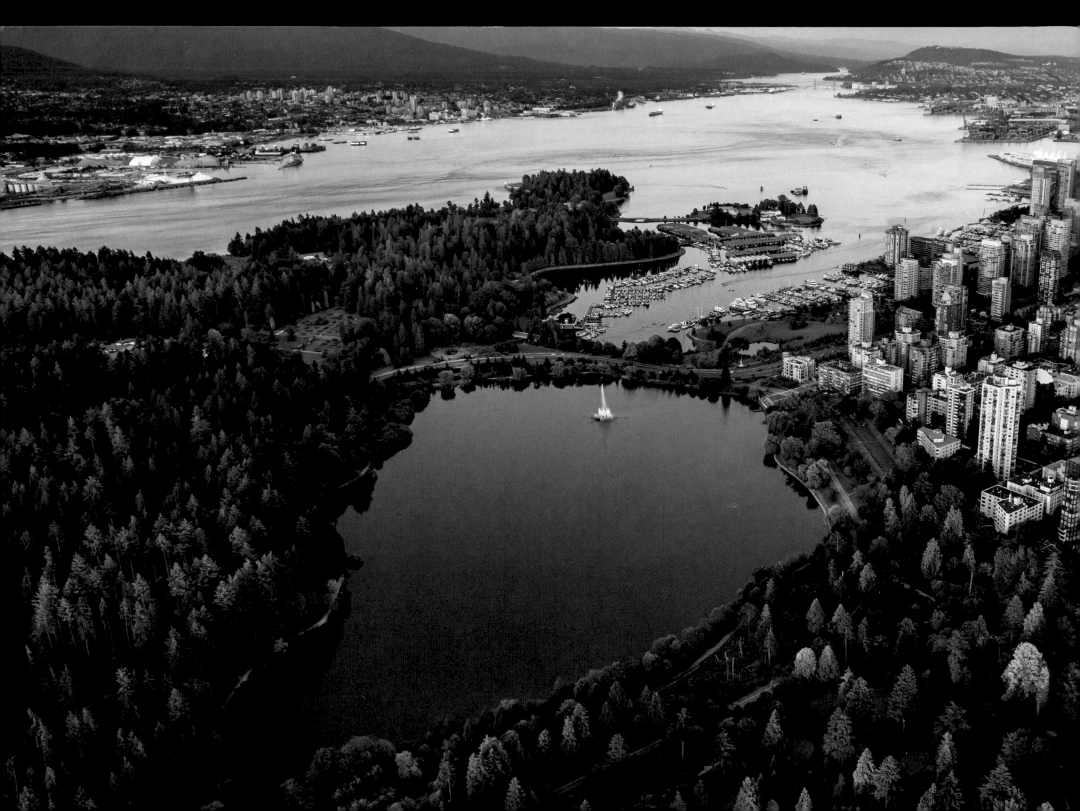

LEFT
VANCOUVER, BRITISH COLUMBIA, CANADA

The city of Vancouver was originally named Gastown, after John 'Gassy Jack' Deighton, who opened a bar next to a sawmill here in 1867. The growing settlement was renamed Vancouver in 1886, after British Royal Navy captain George Vancouver, who explored the region in 1792. Modern Vancouver lies on both sides of the Burrard Inlet, a fjord carved during the last ice age. Downtown Vancouver, with its many office towers, lies on the south shore.

BELOW
ORCAS, VANCOUVER ISLAND, BRITISH COLUMBIA

Across the Strait of Georgia from the city of Vancouver is Vancouver Island, 460 km (290 miles) long and the largest island off the west coast of the Americas. Orcas (also known as killer whales), humpback whales, grey whales and minke whales can all be spotted along the coast, particularly between April and October. Orcas are the largest species of dolphin, reaching up to 8 m (26 ft) long. These apex predators hunt fish, seals and smaller dolphins.

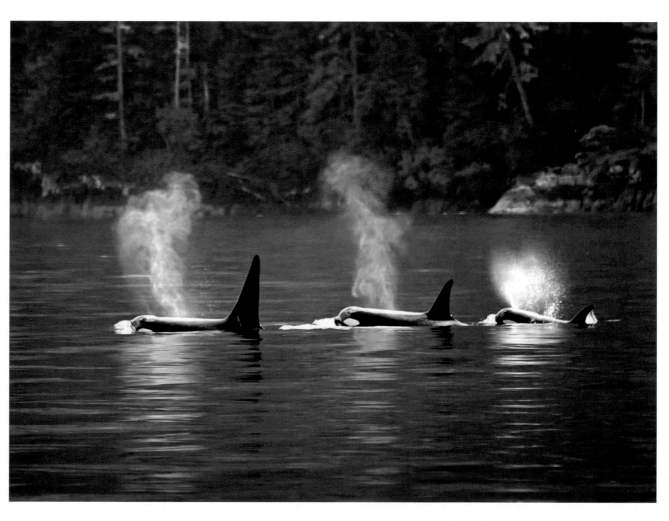

DEMPSTER HIGHWAY,
YUKON–NORTHWEST TERRITORIES, CANADA

For most of the year, this 737-km (458-mile) road links the Klondike Highway in Yukon to Inuvik in Northwest Territories. The highway crosses the Peel and Mackenzie Rivers by ferry in summer and ice bridge in winter and spring. During freeze-up (late-October to mid-December) and thaw (mid-May to mid-June), Inuvik is reached only by air.

NAIKOON PARK, HAIDA GWAII ARCHIPELAGO,
BRITISH COLUMBIA, CANADA

On Graham Island, the largest island in the Haida Gwaii archipelago, Naikoon Provincial Park is the ancestral home to the Gwak'rala'chala people, part of the Haida Nation. Black bears can be spotted in the park's coastal temperate rainforest. Birds such as the hairy woodpecker, Steller's jay and northern saw-whet owl have evolved into island subspecies here.

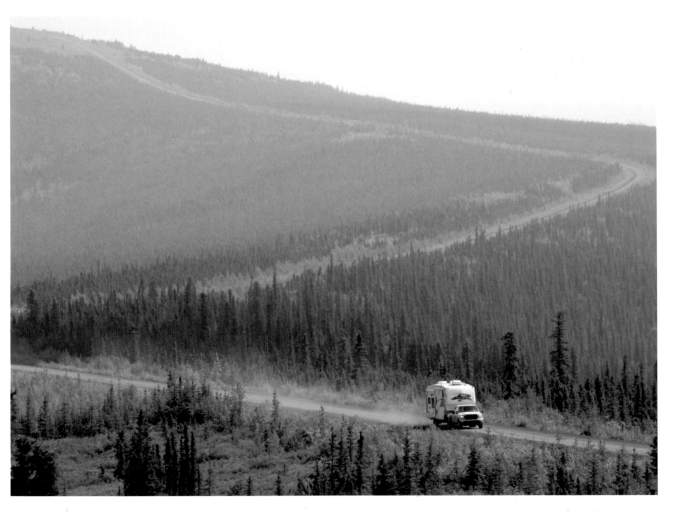

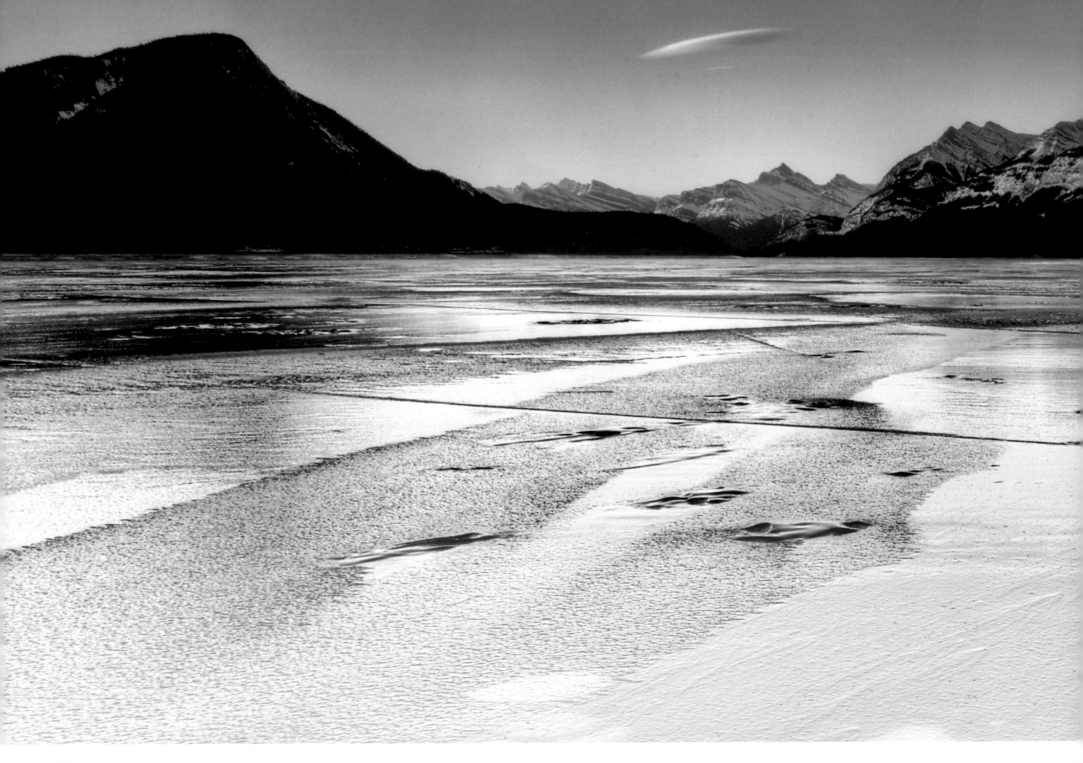

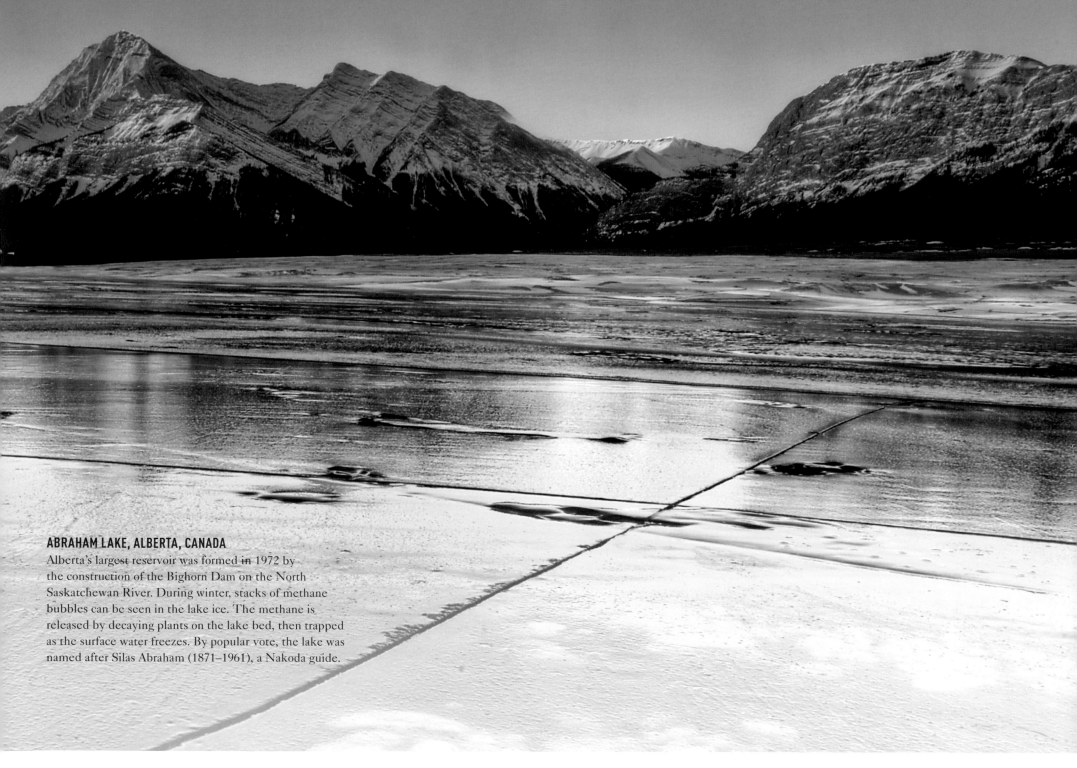

ABRAHAM LAKE, ALBERTA, CANADA

Alberta's largest reservoir was formed in 1972 by
the construction of the Bighorn Dam on the North
Saskatchewan River. During winter, stacks of methane
bubbles can be seen in the lake ice. The methane is
released by decaying plants on the lake bed, then trapped
as the surface water freezes. By popular vote, the lake was
named after Silas Abraham (1871–1961), a Nakoda guide.

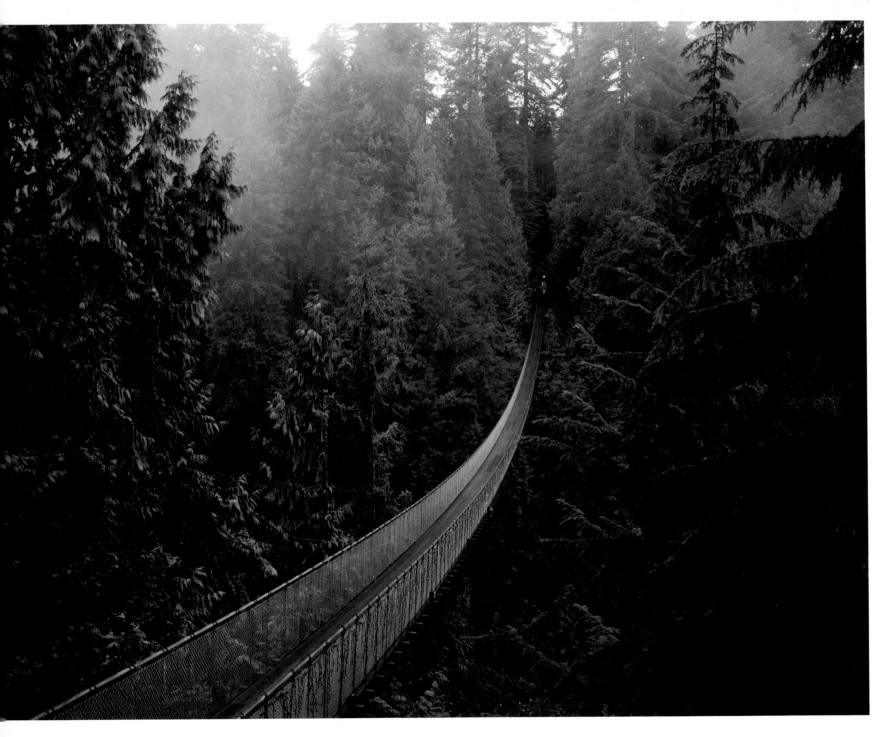

LEFT

CAPILANO SUSPENSION BRIDGE, BRITISH COLUMBIA, CANADA

This 137-m (450-ft) long suspension bridge across the Capilano River was first built from hemp ropes and cedar planks in 1889. Today, it relies on wire cables. In the privately owned park surrounding the bridge is one of the world's largest collections of First Nations totem poles, including some sculpted by Coast Salish, Haida, Tsimshian and Tlingit artists. Totem poles tell the stories of great events, family lineages and legends.

OPPOSITE

AUYUITTUQ NATIONAL PARK, BAFFIN ISLAND, NUNAVUT, CANADA

On Canada's largest island, Baffin, is the 21,470 sq km (8,290 sq mile) Auyuittuq National Park. Lying inside the Arctic Circle, the park encompasses numerous fjords and glaciers. Flora is sparse here, but plants such as mountain avens and heather can be found, often growing in clumps for warmth. Fauna includes North American brown lemmings, snowy owls, polar bears, Arctic foxes and barren-ground caribou.

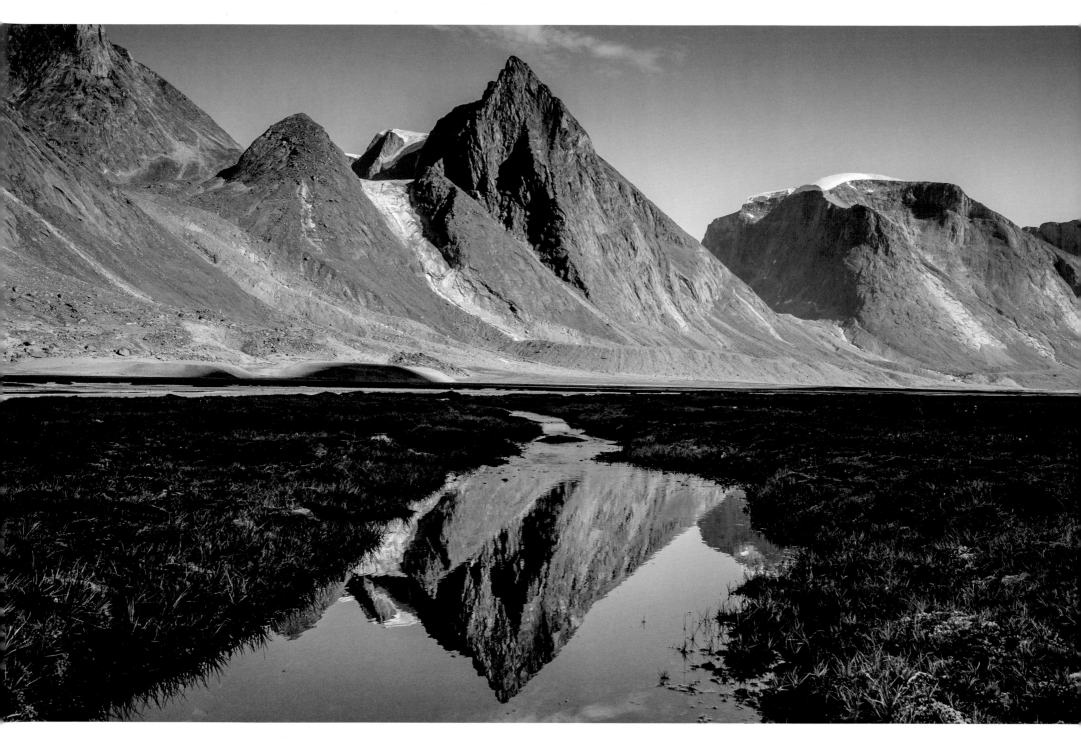

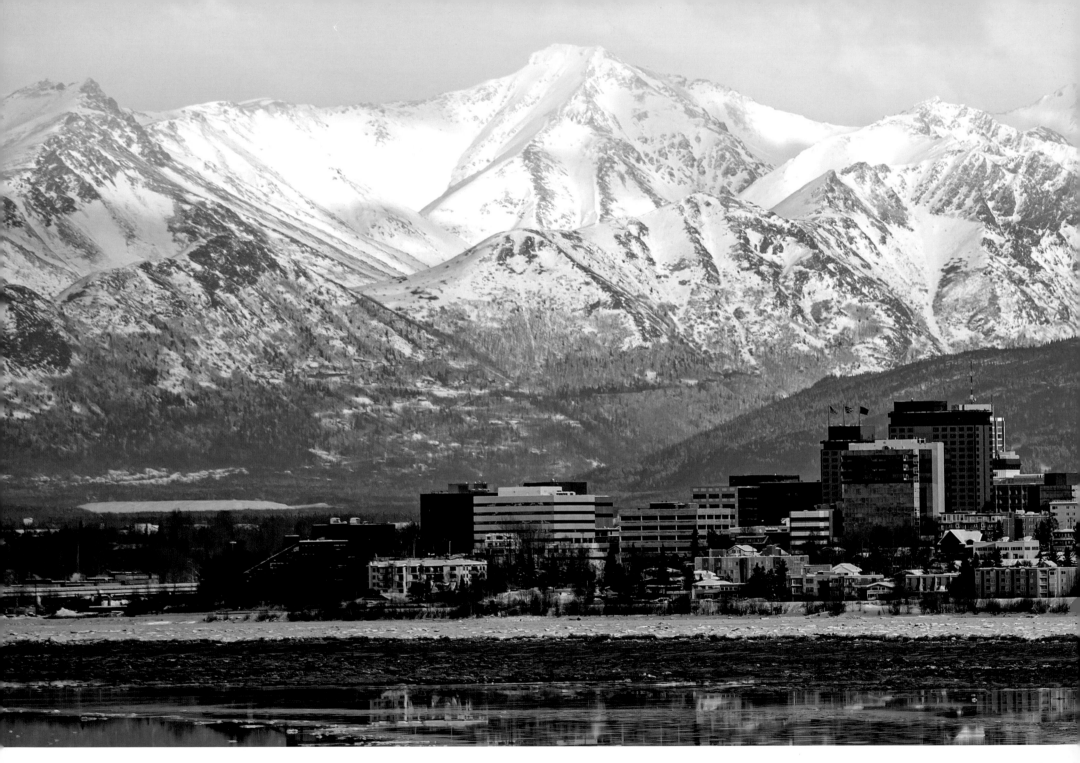

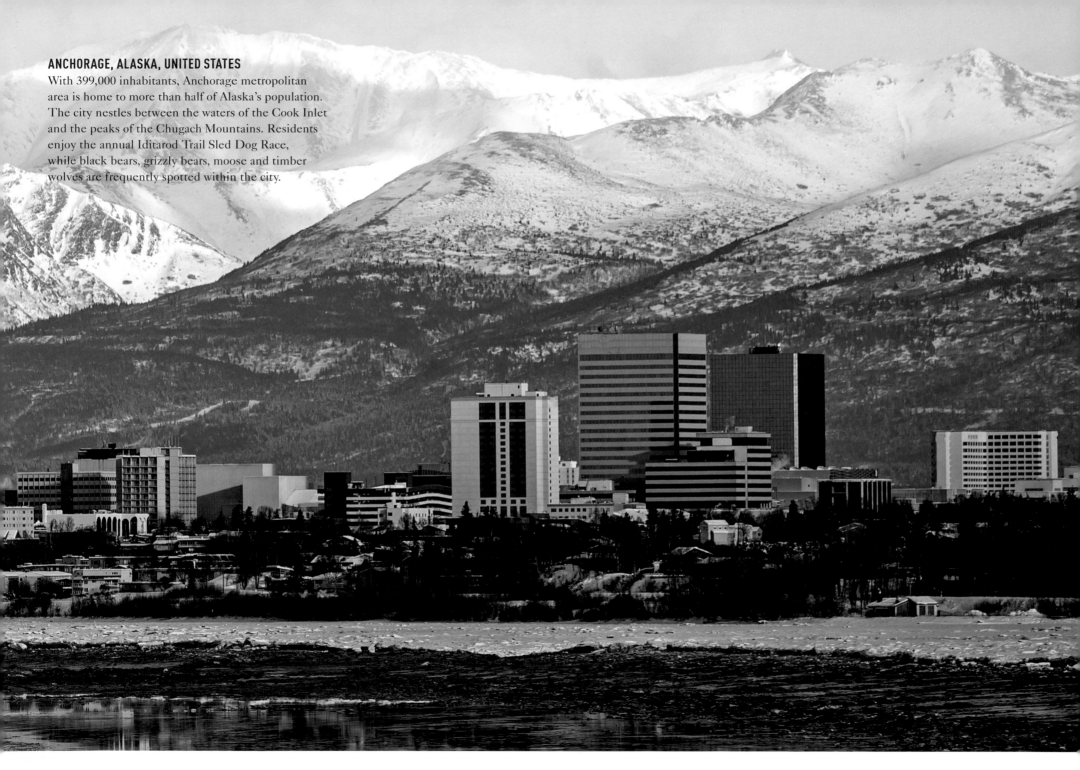

ANCHORAGE, ALASKA, UNITED STATES

With 399,000 inhabitants, Anchorage metropolitan area is home to more than half of Alaska's population. The city nestles between the waters of the Cook Inlet and the peaks of the Chugach Mountains. Residents enjoy the annual Iditarod Trail Sled Dog Race, while black bears, grizzly bears, moose and timber wolves are frequently spotted within the city.

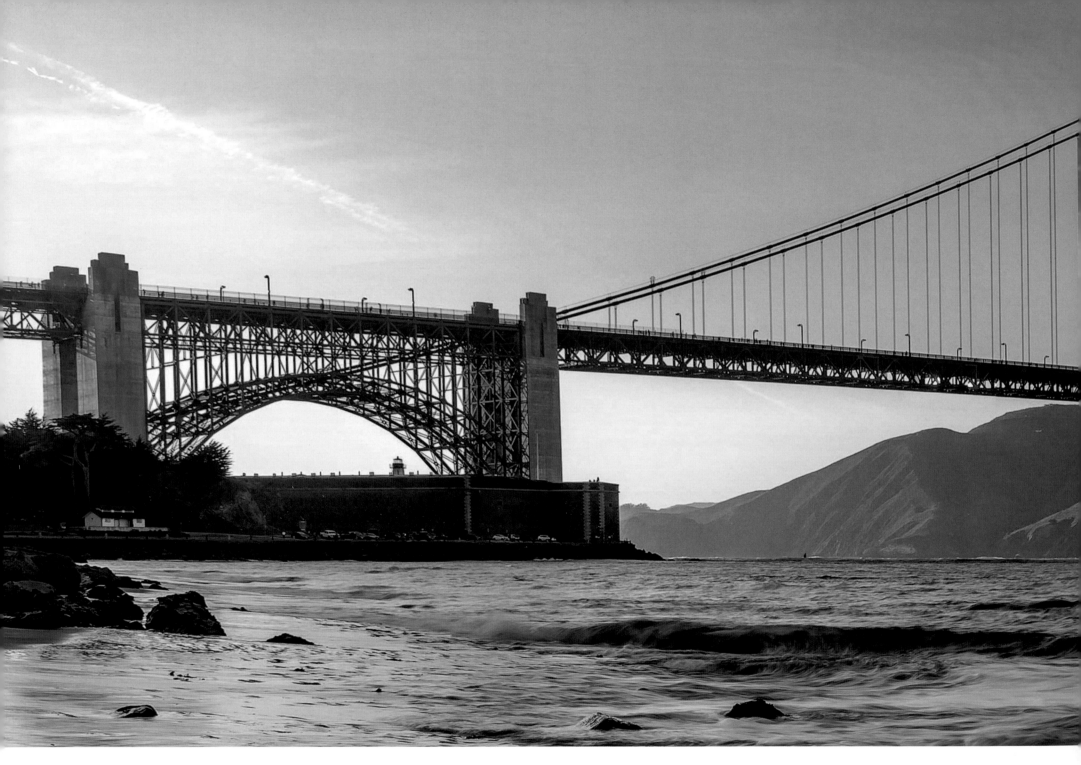

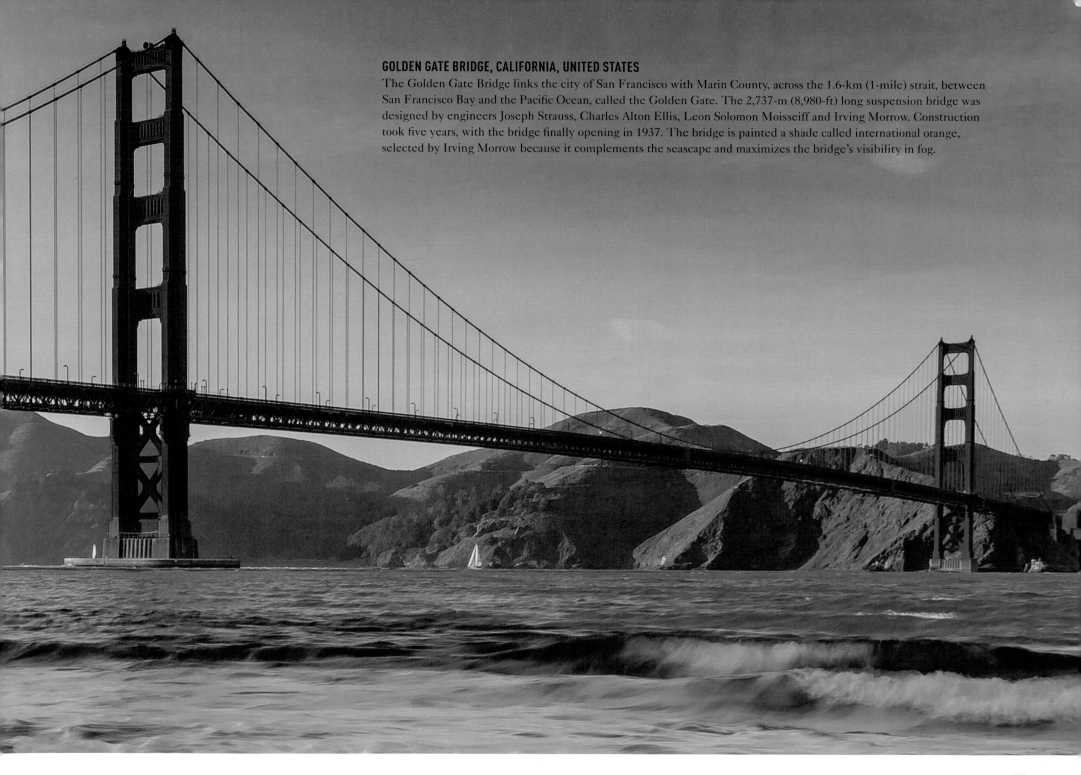

GOLDEN GATE BRIDGE, CALIFORNIA, UNITED STATES

The Golden Gate Bridge links the city of San Francisco with Marin County, across the 1.6-km (1-mile) strait, between San Francisco Bay and the Pacific Ocean, called the Golden Gate. The 2,737-m (8,980-ft) long suspension bridge was designed by engineers Joseph Strauss, Charles Alton Ellis, Leon Solomon Moisseiff and Irving Morrow. Construction took five years, with the bridge finally opening in 1937. The bridge is painted a shade called international orange, selected by Irving Morrow because it complements the seascape and maximizes the bridge's visibility in fog.

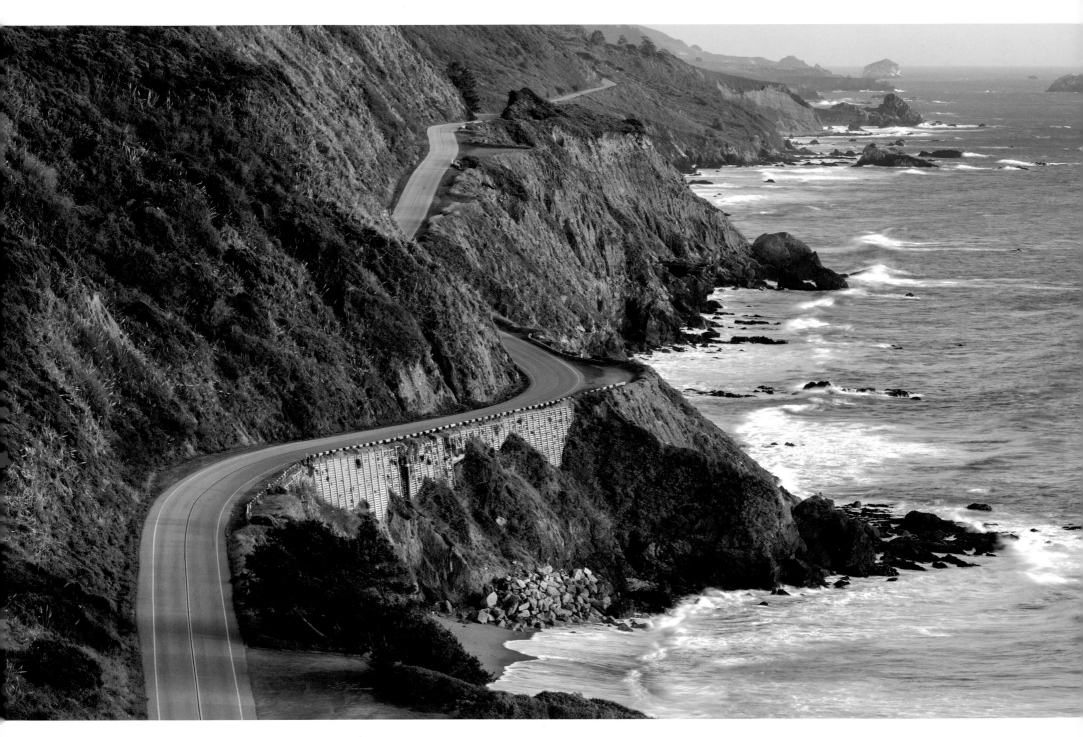

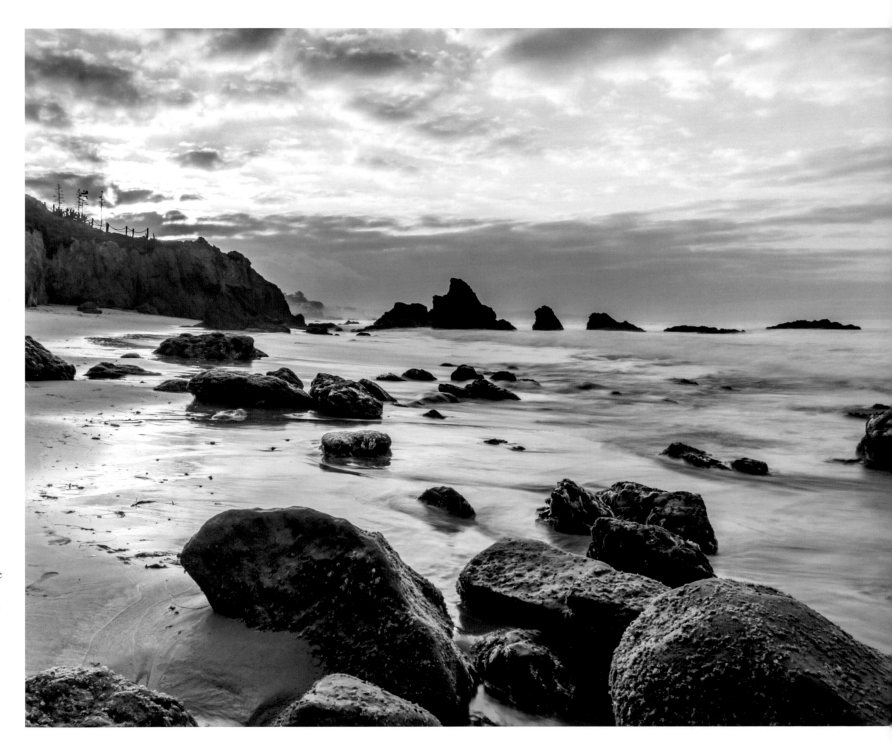

OPPOSITE

PACIFIC COAST HIGHWAY, BIG SUR, CALIFORNIA

The 114-km (71-mile) portion of California State Route 1 that clings to the coast of Big Sur, is considered one of the world's most dramatic drives. Big Sur, named by the Spanish as '*el país grande del sur*' (the big country of the south), is where the Santa Lucia Mountains rise abruptly from the Pacific Ocean. Construction of the road, often carved into the cliffs, took 18 years, with the road finally opening in 1937. The road is closed by landslides and storms.

RIGHT

EL MATADOR BEACH, MALIBU, CALIFORNIA

West of Los Angeles, Malibu is known for its rocky coastline and for being the home of numerous movie stars. The coast is backed by a region of chaparral and woodland, much of it protected as state parks. Malibu was named for the Ventureño Chumash settlement of Humaliwo ('The Surf Sounds Loud'). In 2010, Malibu's Surfrider Beach was designated as the first World Surfing Reserve to protect it from development.

JOSHUA TREE NATIONAL PARK, CALIFORNIA, UNITED STATES

Yucca brevifolia, more commonly known as the Joshua tree, grows in the Mojave Desert's Joshua Tree National Park as well as other arid regions of the southwestern United States. The tree has a top-heavy branch system, with roots reaching down to 11 m (36 ft). With sufficient rain, clusters of flowers appear in spring to be pollinated by the yucca moth, which also lays eggs inside the flowers. The largest, oldest trees reach around 15 m (49 ft) tall.

ZABRISKIE POINT, CALIFORNIA, UNITED STATES

The landscape of Zabriskie Point is composed of claystone and other sedimentary rocks that formed at the bottom of Furnace Creek Lake, which dried up 5 million years ago. Today, the climate is arid. When rain does fall, it cannot soak into the sun-baked ground but courses down the hillsides, eroding a network of gullies and rills. The spot is named after Christian Brevoort Zabriskie, who made his fortune mining borax here.

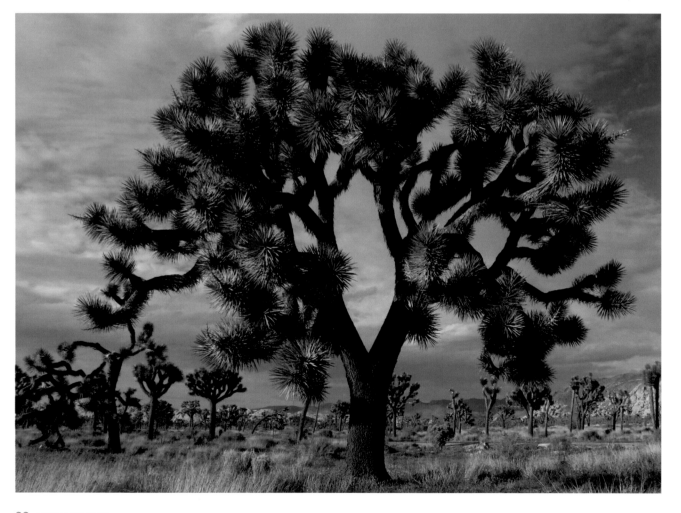

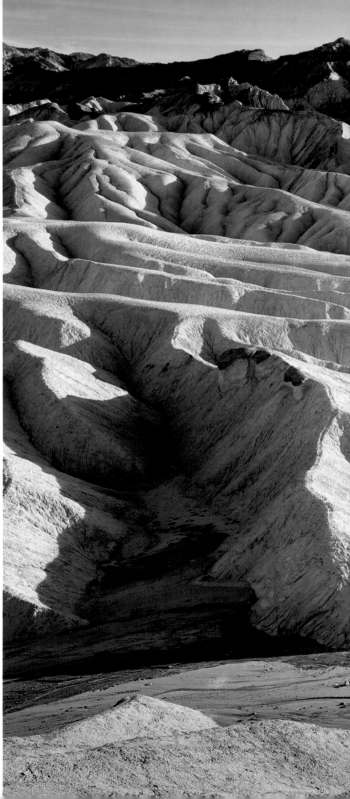

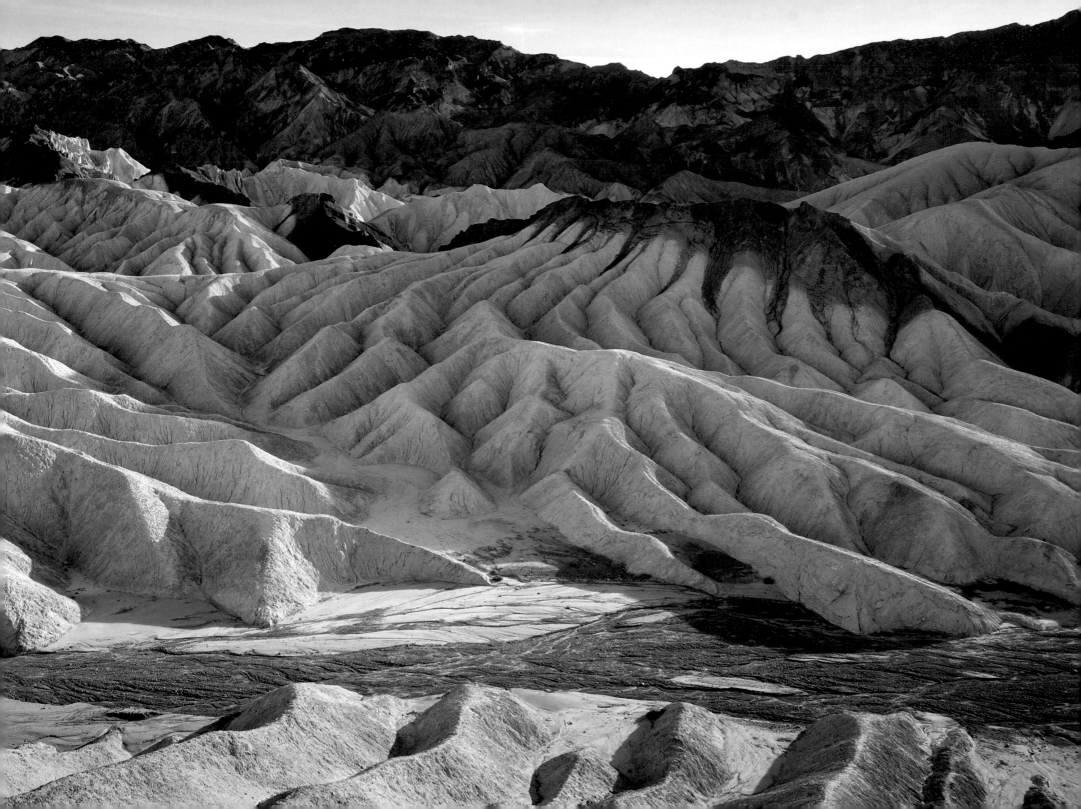

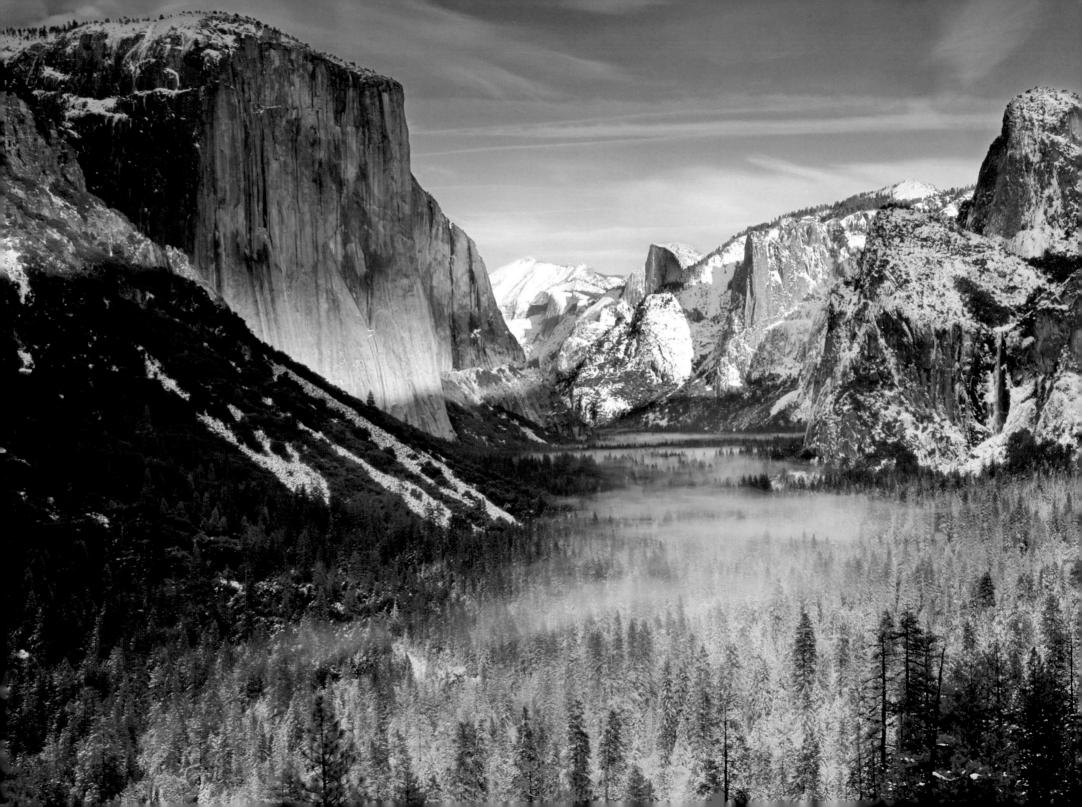

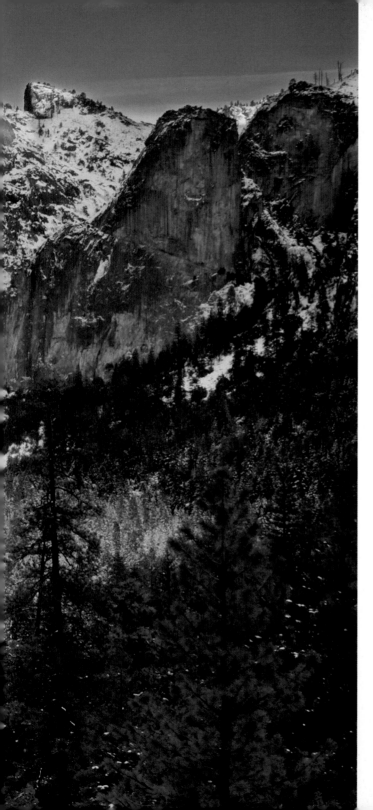

YOSEMITE VALLEY, CALIFORNIA, UNITED STATES

From Tunnel View, on Yosemite National Park's State Route 41, the granite monolith of El Capitan can be seen on the left, with Bridalveil Falls across the valley and Half Dome in the distance. Yosemite Valley was carved by glaciers over the last 30 million years. Smaller glaciers left many hanging valleys, which are shallower valleys elevated above the main one. Waterfalls such as Bridalveil pour from these into the deep valley below.

YOSEMITE FALLS, CALIFORNIA

The highest waterfall in Yosemite National Park is Yosemite Falls, reaching a total height of 739 m (2,425 ft). This drop is made up of the Upper and Lower Falls, plus the Middle Cascades. At the base of the falls there was once a village of the Ahwahnechee people, who told stories of the witches who inhabited the plunge pool. The Ahwahnechee ground black oak acorns to make flour, while hunting mule deer and elk.

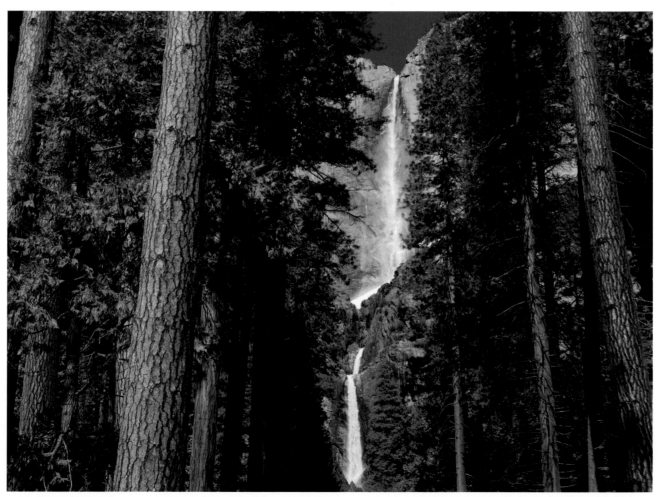

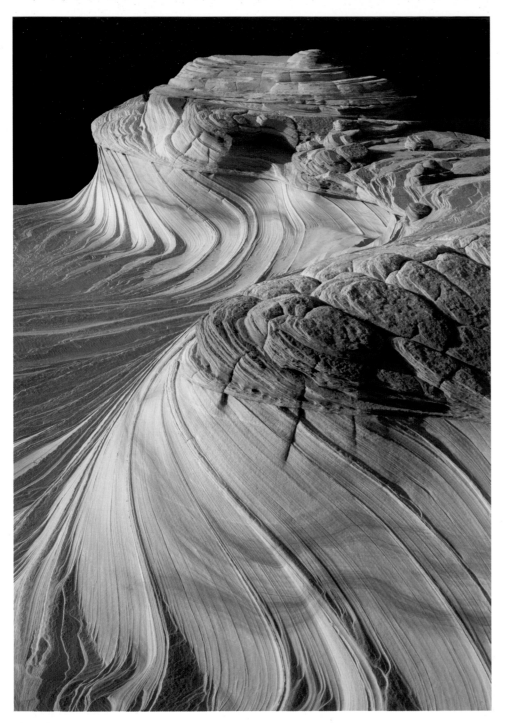

THE SECOND WAVE, ARIZONA, UNITED STATES

The Paria Canyon-Vermilion Cliffs Wilderness, spanning the border between Arizona and Utah, is home to many swirling erosional rock formations. They were formed as the wind whipped Navajo sandstone, loosening particles of sand, which it blasted against the rock. Ripples are caused by the different erosional rates and grain sizes of layers within the sandstone. To safeguard the fragile formations, access to the Wilderness is limited to just 20 permits per day.

LOWER ANTELOPE CANYON, ARIZONA

In the LeChee Chapter of the Navajo Nation, and accessible only by guided tour, are Lower Antelope Canyon (Hazdistazí, or 'Spiral Rock Arches', in Navajo) and Upper Antelope Canyon (Tsé Bighánílíní, or 'The Place Where Water Runs Through the Rocks'). They are slot canyons, formed by flash flooding as rivulets gushed through cracks in the sandstone. The risk of flash flooding is monitored daily.

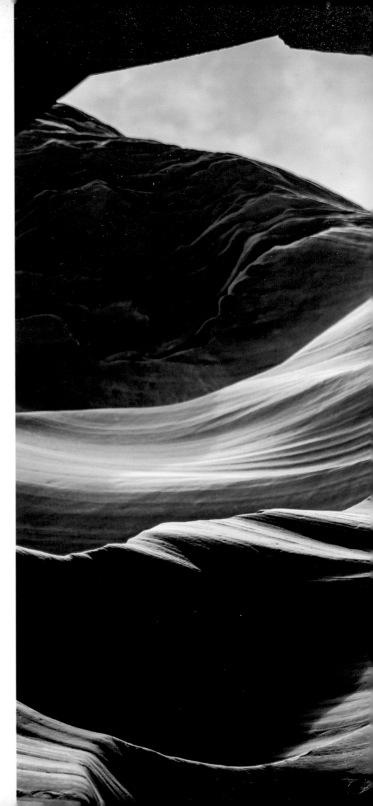

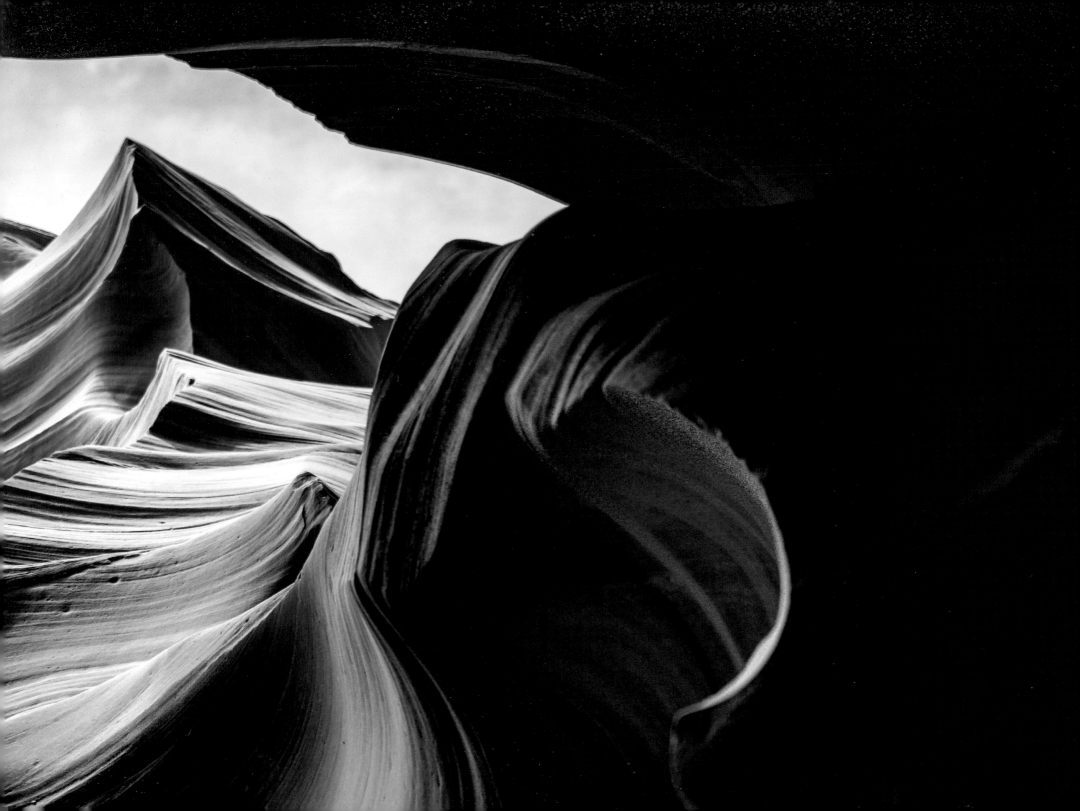

GRAND CANYON, ARIZONA, UNITED STATES

Around 446 km (277 miles) long, up to 29 km (18 miles) wide and reaching 1,857 m (6,093 ft) deep, the Grand Canyon was carved by the Colorado River over the last 6 million years. The canyon's striped appearance is the result of different layers of rock, from 2-billion-year-old Vishnu schist, at the canyon's deepest points, to 230-million-year-old Kaibab limestone at the rim.

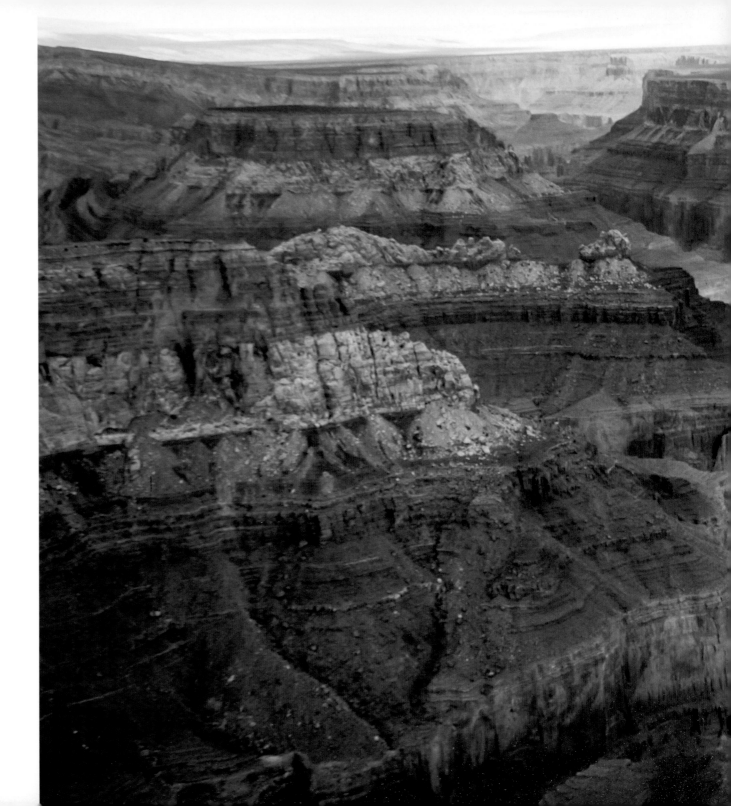

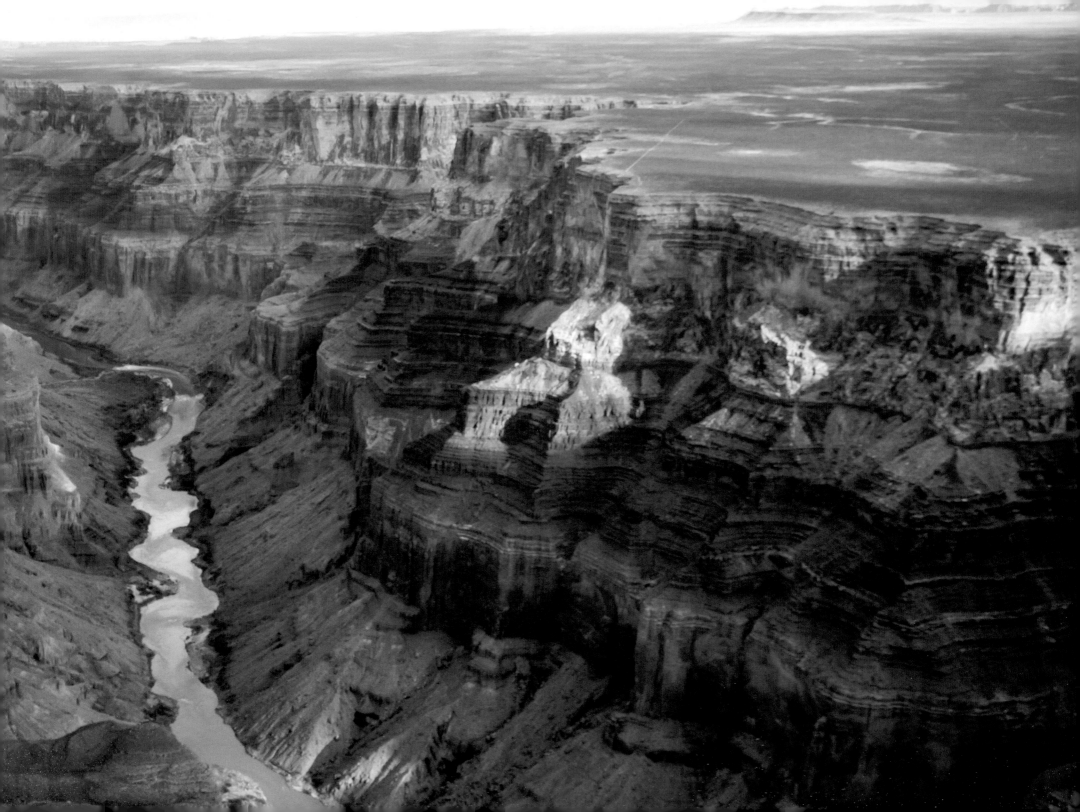

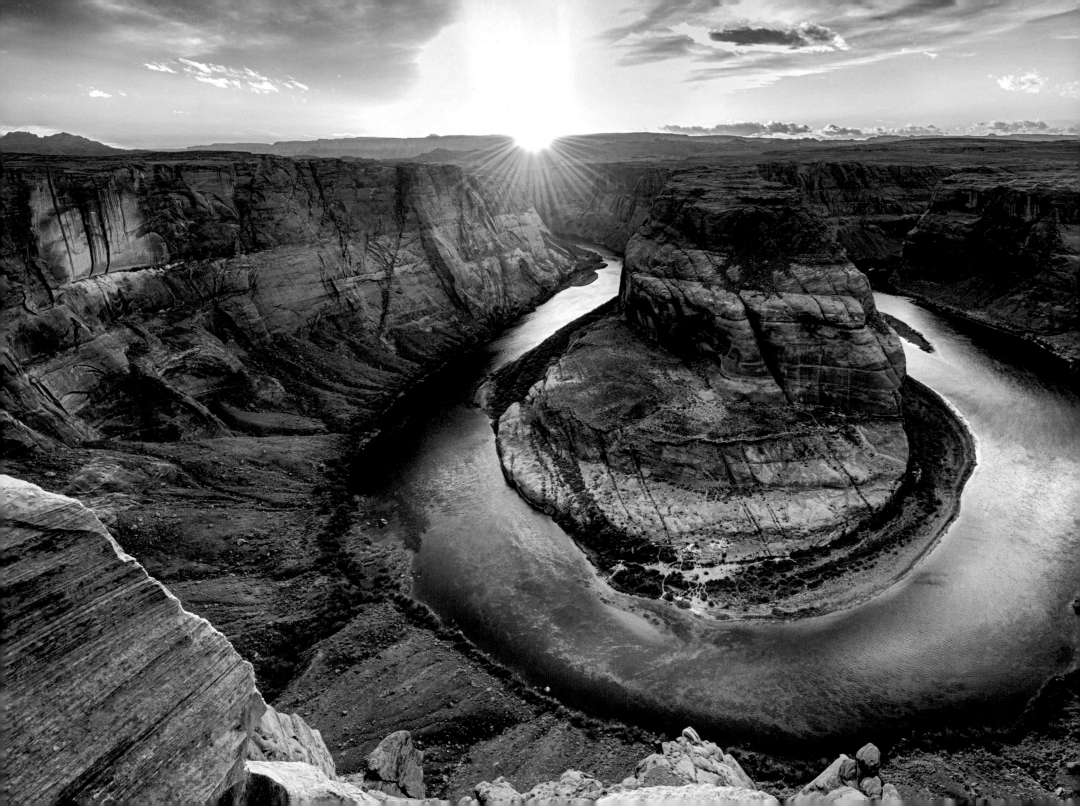

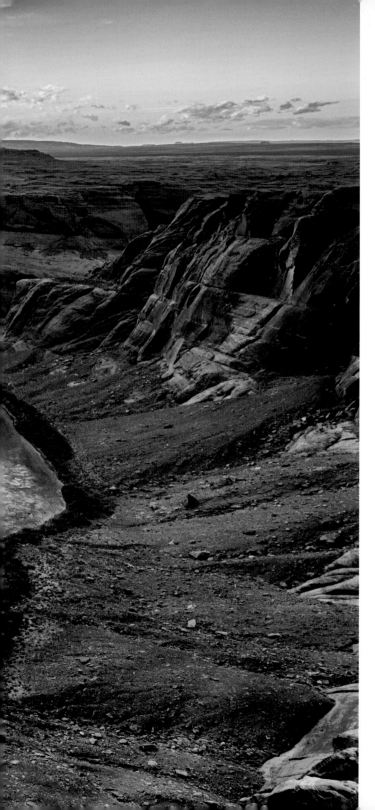

HORSESHOE BEND, ARIZONA, UNITED STATES

Upstream from the Grand Canyon, the Colorado River has cut a horseshoe-shaped meander into the sandstone of the Colorado Plateau. This is an incised meander, formed where a meander cuts unusually deeply because uplift of the rock leads to further downward erosion by the river. The best overlook, 300 m (1,000 ft) above the water, is reached by a sandy hiking trail starting from Route 89 near the town of Page.

VIEW FROM YAVAPAI POINT, GRAND CANYON, ARIZONA

Situated on the South Rim, Yavapai Point offers views of the canyon's many-hued rock strata and sculpted buttes. The viewpoint is also a good spot to pick up the circular Yavapai Point Trail or the understandably popular South Rim Trail. The South Rim Trail allows quieter views into the inner canyon than can be enjoyed from fenced viewpoints. It follows a 21-km (13-mile) route that is mostly paved and offers some shade.

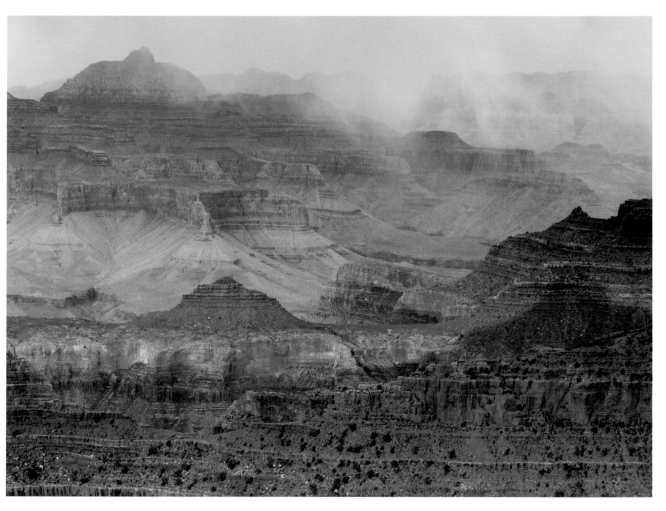

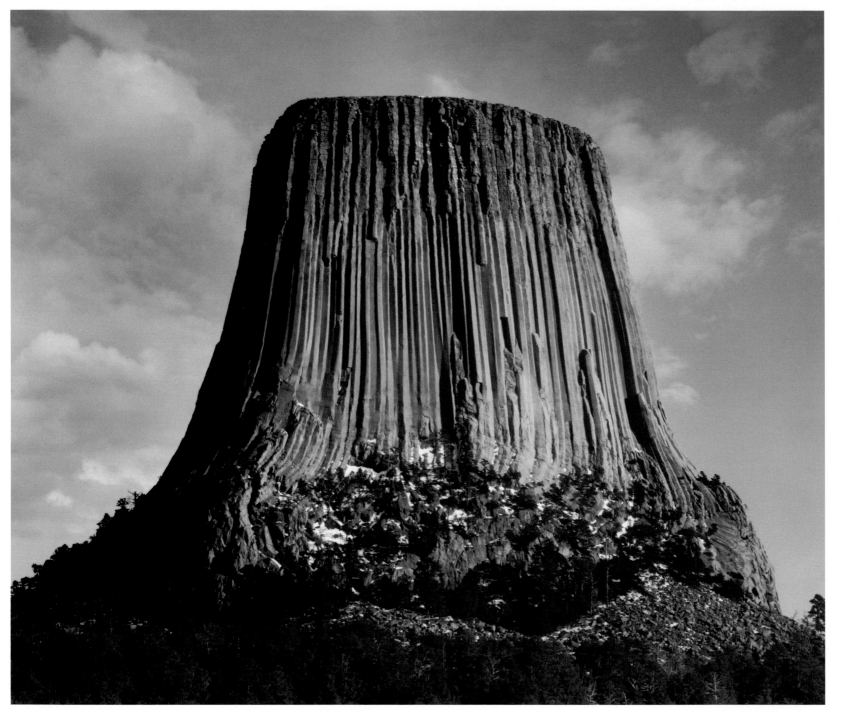

DEVILS TOWER, WYOMING

This 265-m (867-ft) tall plug of phonolite is believed to have formed around 40 million years ago when magma cooled and hardened inside the vent of a volcano. As the rock cooled, regular cracks appeared, usually forming six-sided columns. The softer, sedimentary rocks surrounding the phonolite slowly eroded away. Due to ongoing erosion, columns of phonolite regularly break off. The piles of scree at the tower's base indicate that it was once considerably wider.

OPPOSITE
GRAND PRISMATIC SPRING, YELLOWSTONE NATIONAL PARK, WYOMING

The United States' largest hot spring is heated by a supervolcano under Yellowstone National Park. The spring's rainbow colours are made by mats of algae and bacteria around the edges of the mineral-rich water. The pool's centre is too hot for microbes to survive. The microbes make varying amounts of the pigments chlorophyll (green) and carotenoids (yellow, orange and red) depending on temperature.

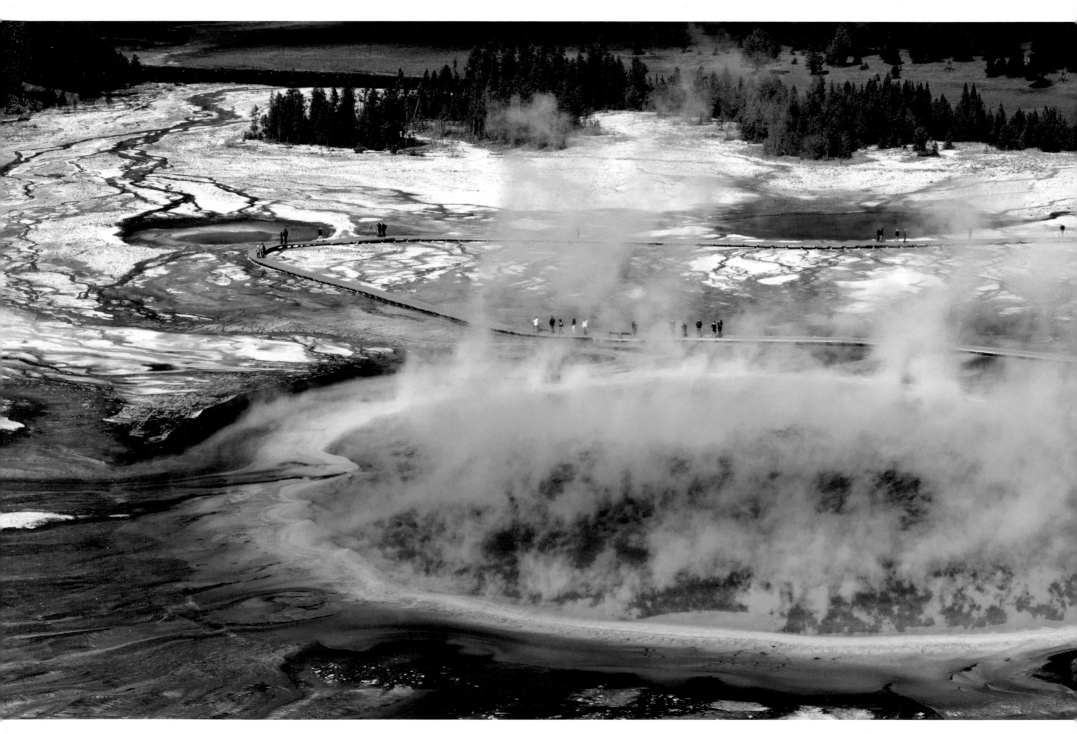

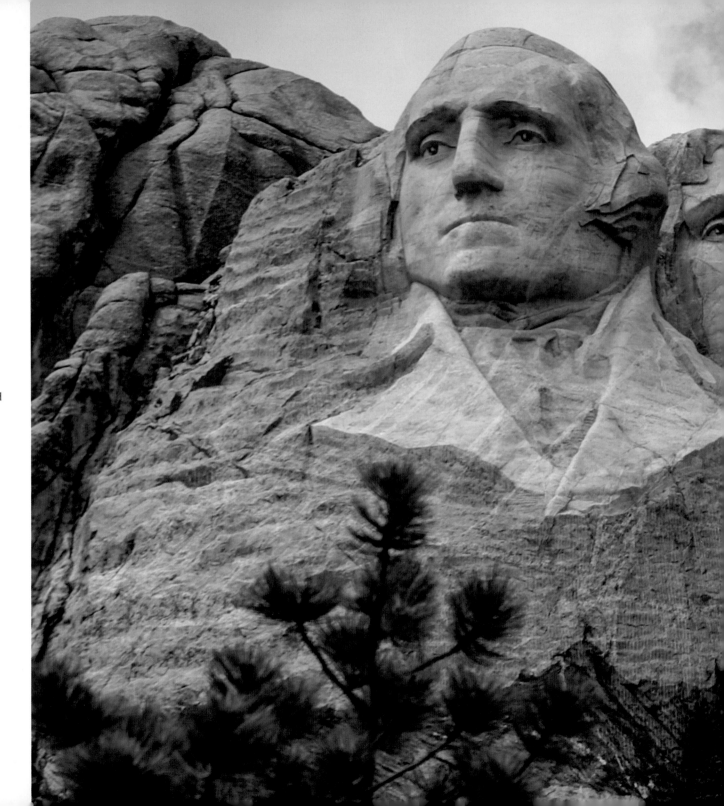

MOUNT RUSHMORE, SOUTH DAKOTA, UNITED STATES

Carved into the granite of Mount Rushmore, in the Black Hills, are the 18-m (60-ft) high heads of four presidents (left to right): George Washington (1732–1799), Thomas Jefferson (1743–1826), Theodore Roosevelt (1858–1919) and Abraham Lincoln (1809–1865). The work was designed and overseen by sculptor Gutzon Borglum and his son Lincoln between 1927 and 1941, when the funds ran out, resulting in the presidents' torsos being left unfinished.

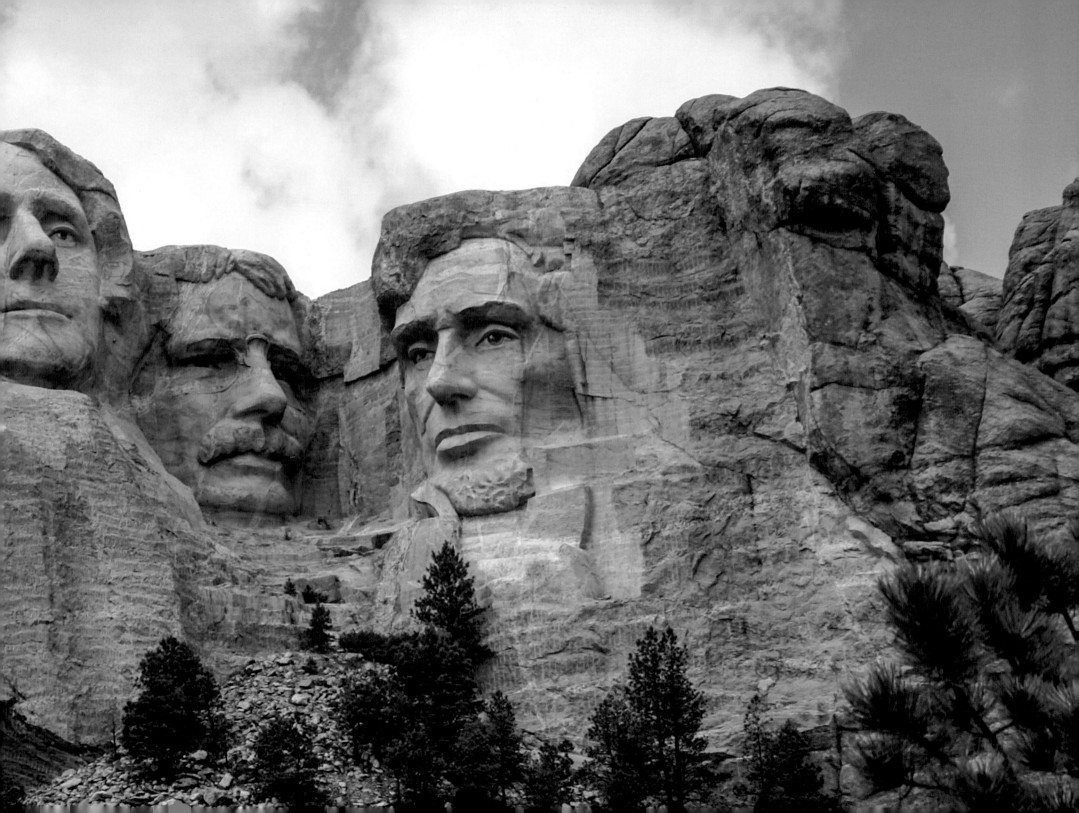

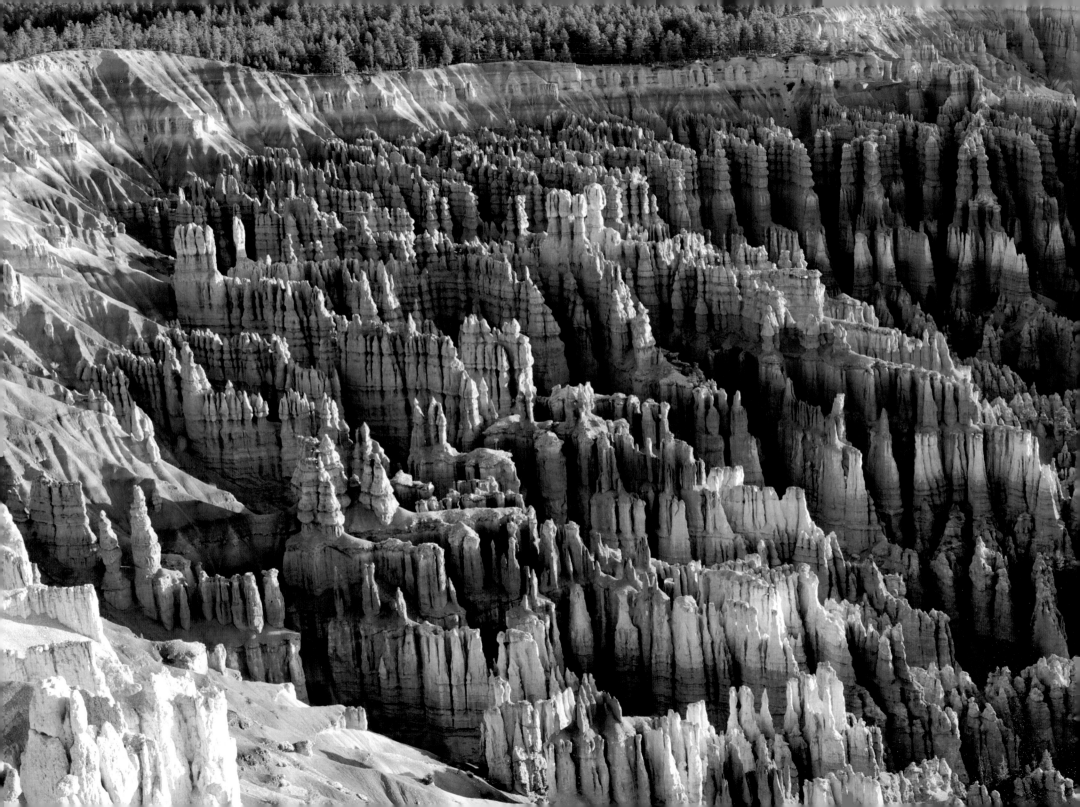

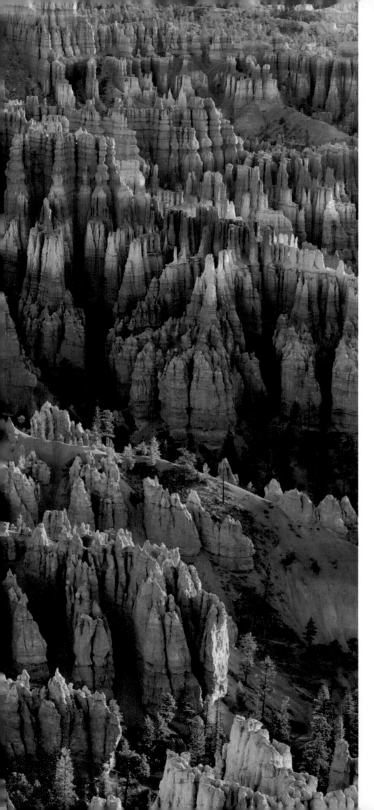

LEFT
BRYCE CANYON, UTAH, UNITED STATES

The natural amphitheatres of Bryce Canyon National Park are home to hundreds of hoodoos. These rock spires were formed by frost and stream erosion, which widened vertical cracks in the rock. The soft sedimentary rock of the hoodoos has been protected from wearing away entirely by the tougher dolostone rock that lies at their top. The rock's sunset shades are created by haematite in the limestone and siltstone.

BELOW
OUTER BANKS, NORTH CAROLINA, UNITED STATES

A 320-km (200-mile) string of barrier islands and spits, formed by sand deposition, lies off the coast of North Carolina and southern Virginia. Until the 1930s, the islands were reached only by boat, resulting in the Bankers' unique dialect, called High Tider (pronounced 'Hoi Toider'). In the past, some Bankers made a living from scavenging the many wrecked ships that earned these tempestuous waters the nickname 'Graveyard of the Atlantic'.

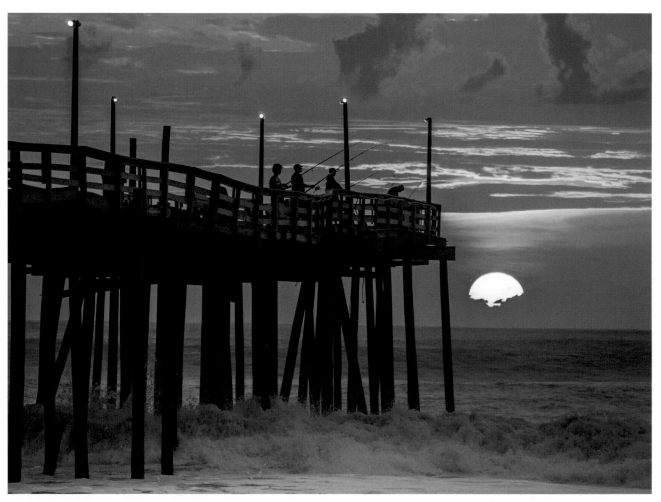

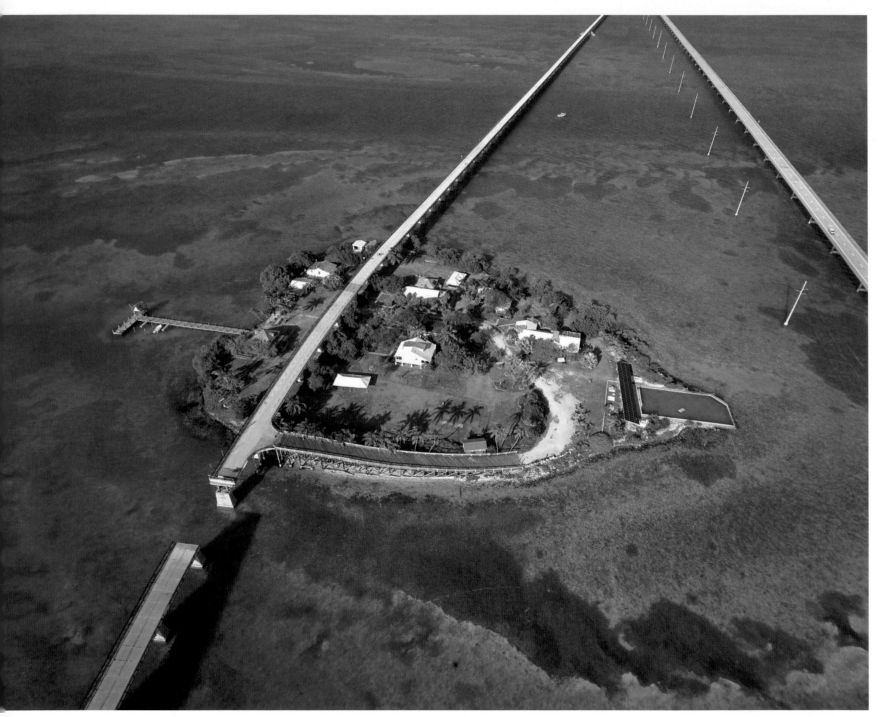

PIGEON KEY, FLORIDA, UNITED STATES

The Seven Mile Bridge connects Knight's Key, in the Middle Florida Keys, to Little Duck Key, in the Lower Keys. Today, there are two bridges, running side by side. The older one, now closed due to sagging, was completed in 1912; the newer was completed in 1982. Pigeon Key has access to the old bridge via a ramp, near to where the bridge's (now removed) swing span allowed boat passage. Pigeon Key is a US historic district, where 11 wood-framed buildings date from the early 20th century.

OPPOSITE

UPPER MATECUMBE KEY, ISLAMORADA, FLORIDA

The village of Islamorada encompasses five of the Upper Florida Keys, reached by boat and US Highway 1. Positioned between the Atlantic Ocean and the Gulf of Mexico, Islamorada is on the migration routes of many fish species, making it popular with licenced sports fishermen hunting for tarpon, sailfish, blackfin tuna, mahi mahi and marlin. During loggerhead turtle nesting season, care must be taken on the beaches.

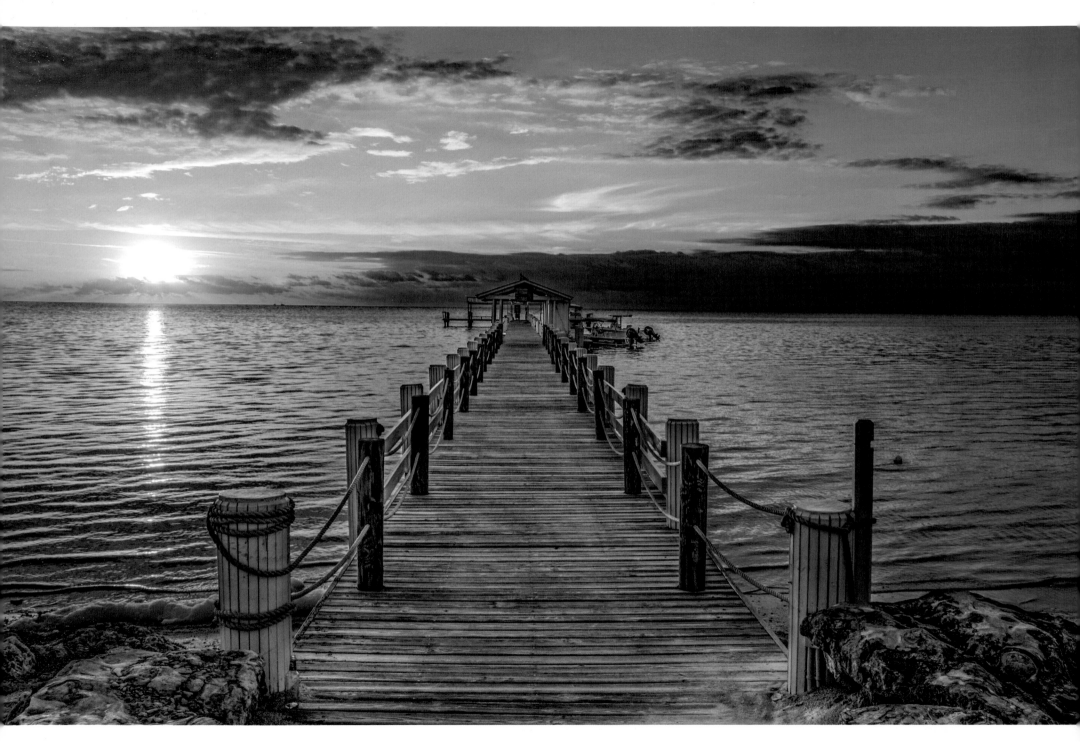

KAUAI, HAWAII

Kauai is the oldest of the main Hawaiian Islands, which formed over a hotspot in Earth's mantle between 5 million and 400,000 years ago. As the Pacific Plate moved slowly northwestward, a chain of volcanoes began to rise above the water's surface. At 1,598 m (5,243 ft) tall, the island's highest peak is Kawaikini, the summit of the island's dormant central shield volcano. Shield volcanoes form from runny lava that spreads widely before hardening.

NA PALI COAST STATE PARK, KAUAI

This state park protects the *na pali* ('many cliffs') of the island's northwestern coast and the Kalalau Valley, home to many endangered plant species, such as the endemic Kalalau schiedea and *Dubautia kalalauensis*. The region is accessed only by hike, boat, kayak or paddleboard. The ocean gives the best vantage point for viewing the many waterfalls that plunge into the sea from hanging valleys, constantly eroding the rock into rugged pinnacles.

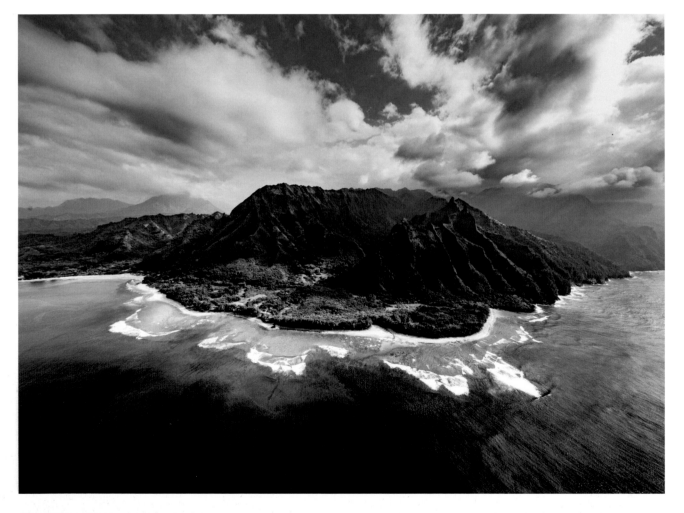

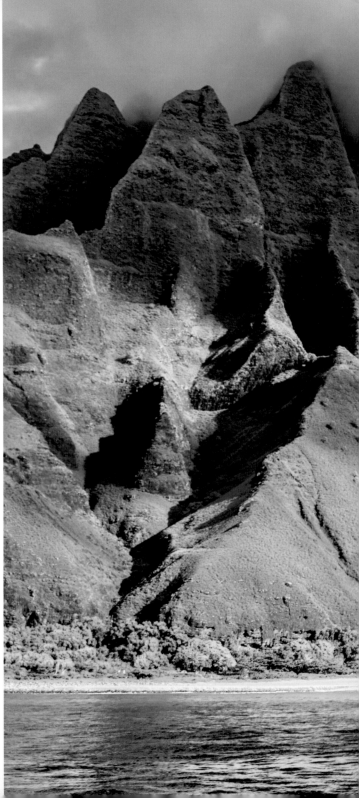

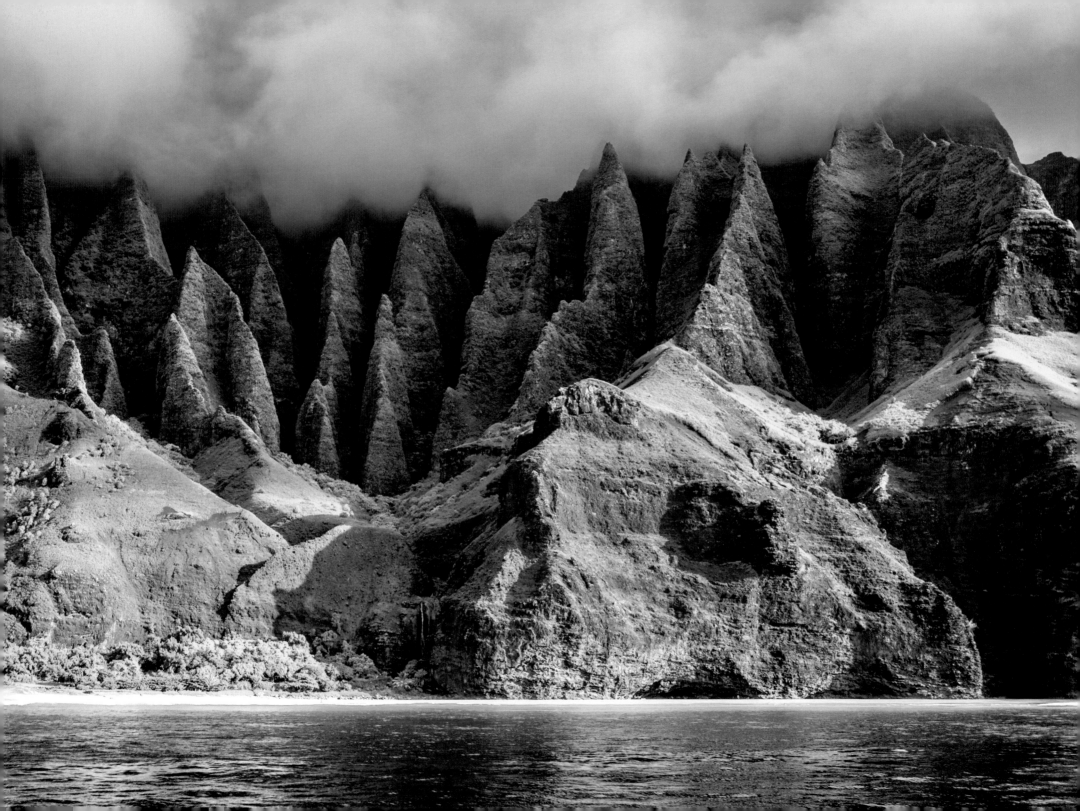

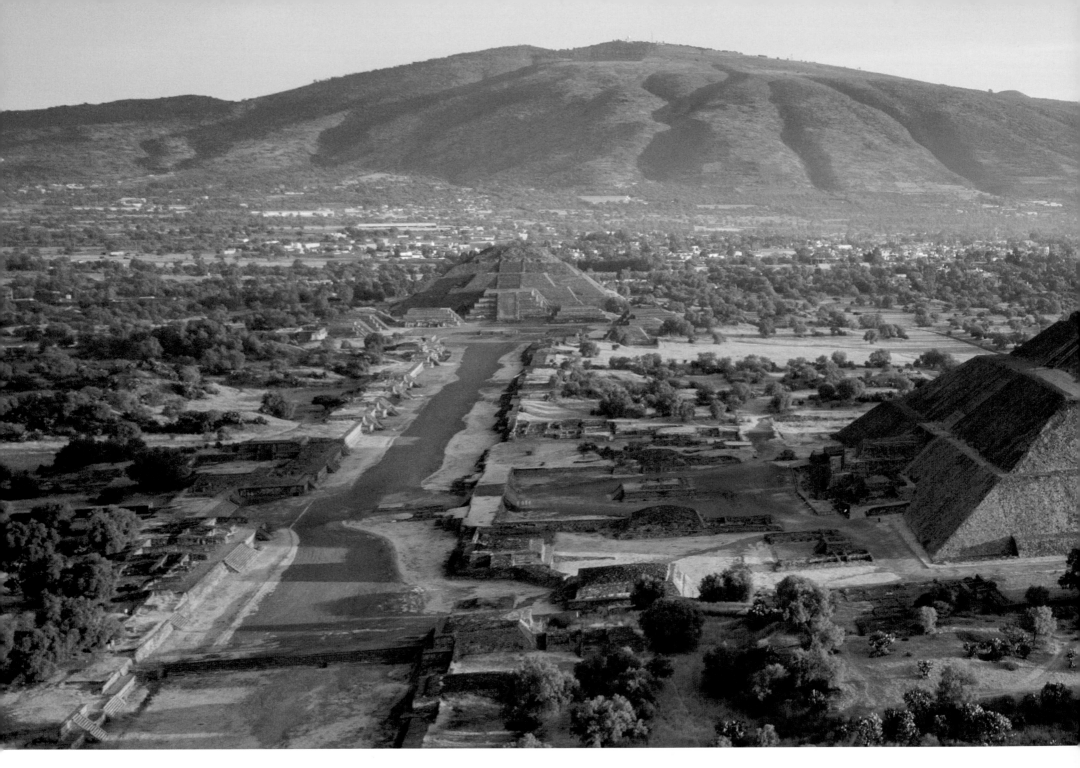

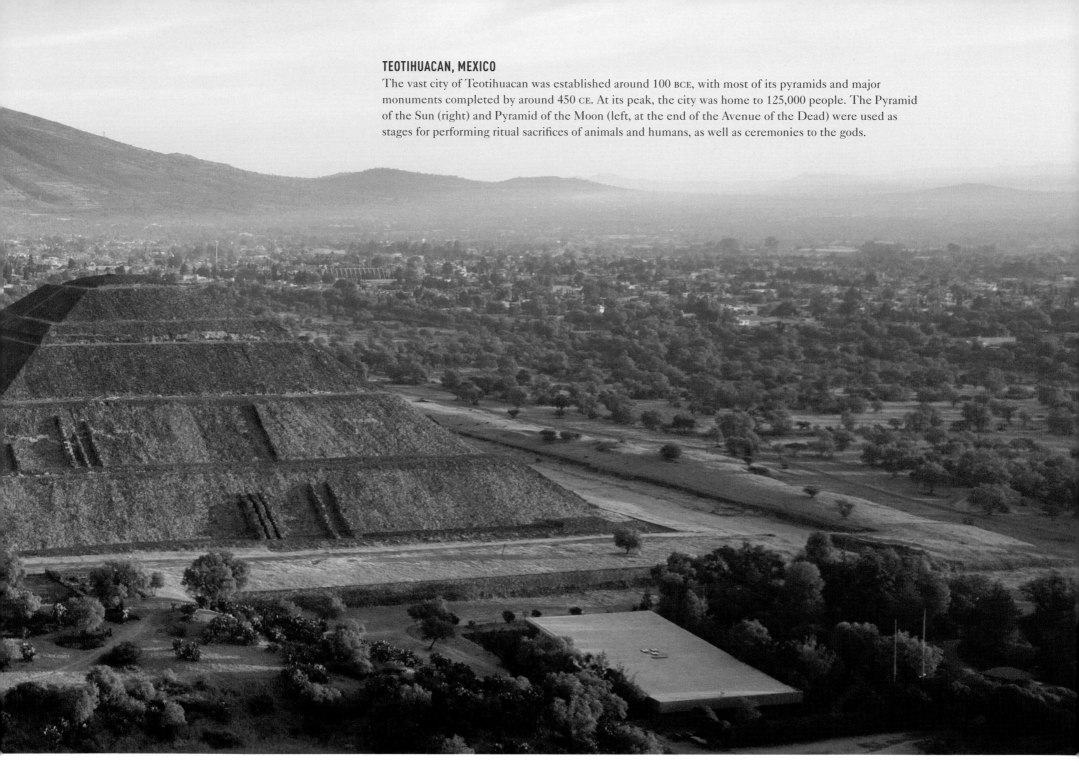

TEOTIHUACAN, MEXICO

The vast city of Teotihuacan was established around 100 BCE, with most of its pyramids and major monuments completed by around 450 CE. At its peak, the city was home to 125,000 people. The Pyramid of the Sun (right) and Pyramid of the Moon (left, at the end of the Avenue of the Dead) were used as stages for performing ritual sacrifices of animals and humans, as well as ceremonies to the gods.

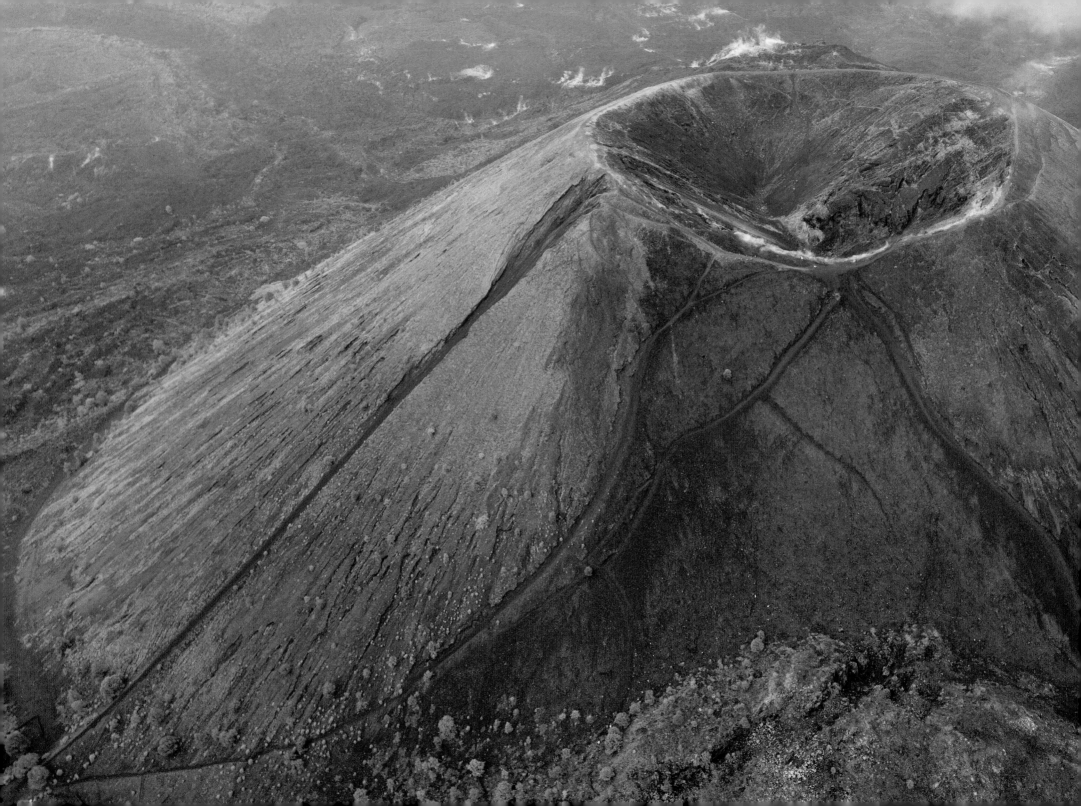

PARÍCUTIN, MEXICO

Parícutin is a cinder cone volcano, made of loose pyroclastic fragments. It formed as gas-charged lava exploded from a new vent, solidifying and falling as cinders to make a near-symmetrical cone. The volcano emerged suddenly from a cornfield in 1943, growing to 50 m (164 ft) high within 24 hours. The last growth spurt, resulting in a cone 424 m (1,391 ft) high, ended in 1952. The volcano forced permanent evacuation of the surrounding area.

PALENQUE, MEXICO

The Maya city-state of Palenque dates from around 220 BCE to 800 CE. It is known for its high-quality bas-relief carvings of rulers, gods and mythology. Structures excavated so far include temples set atop step-pyramids; a palace with saunas, baths and an observation tower; wealthy homes with courtyards and ornamental pools; and a ball game court. The surrounding forest is noisy with the calls of howler monkeys and parrots.

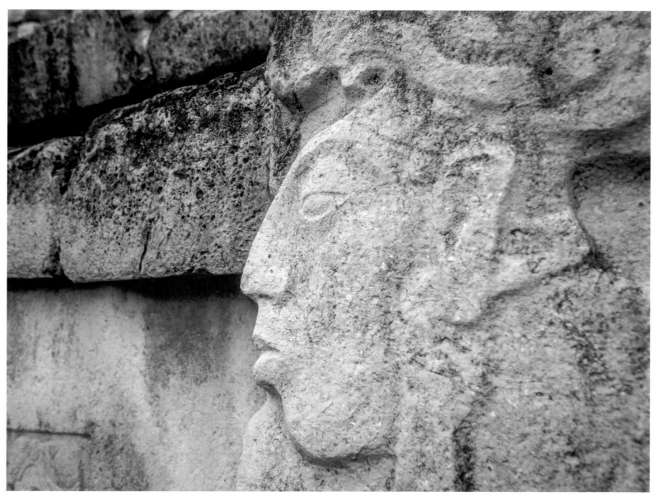

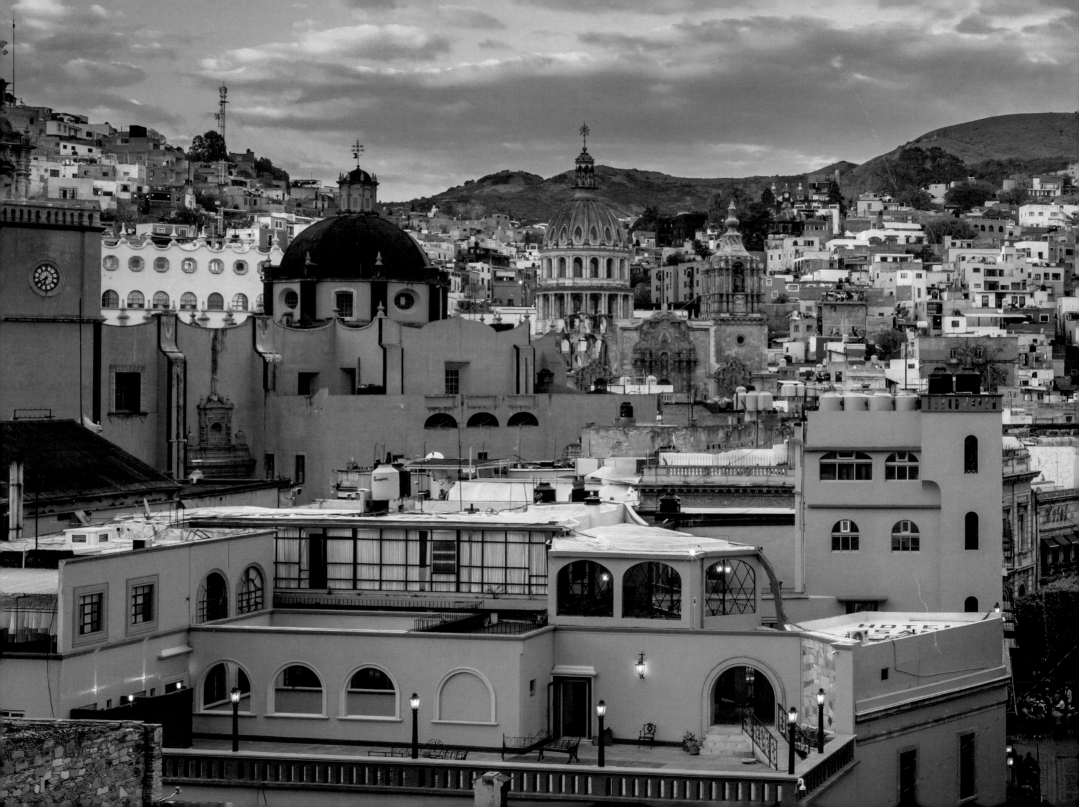

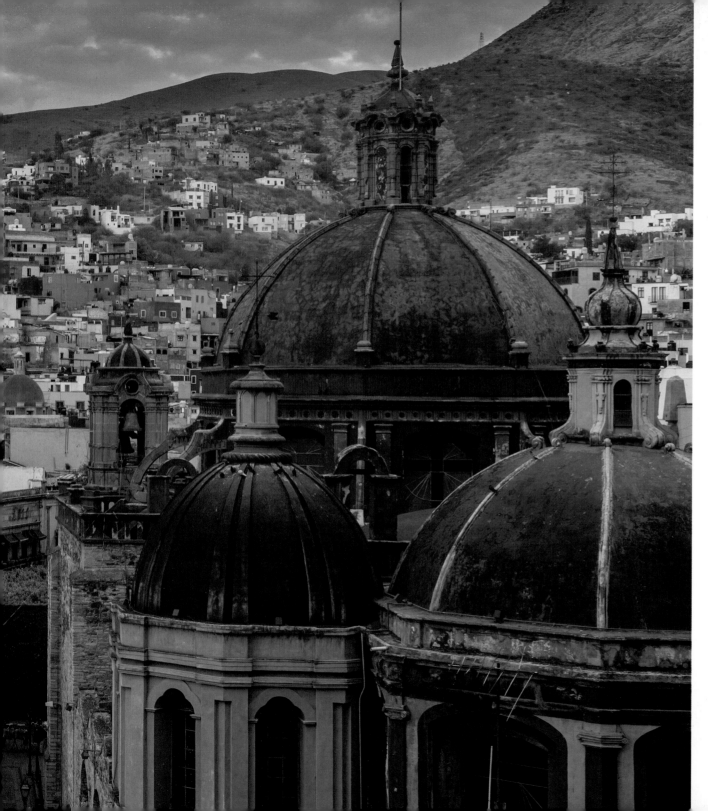

GUANAJUATO, MEXICO

This city of 170,000 people is squashed into a narrow valley, most of its winding streets too slim or step-ridden to be passable by cars. The few through roads are in tunnels mostly dug during the colonial period, originally to help with flood control, then strengthened in the 1960s for use by cars. Above ground, notable 17th-century buildings include the yellow Basílica Colegiata de Nuestra Señora de Guanajuato and the red-domed Templo de San Diego.

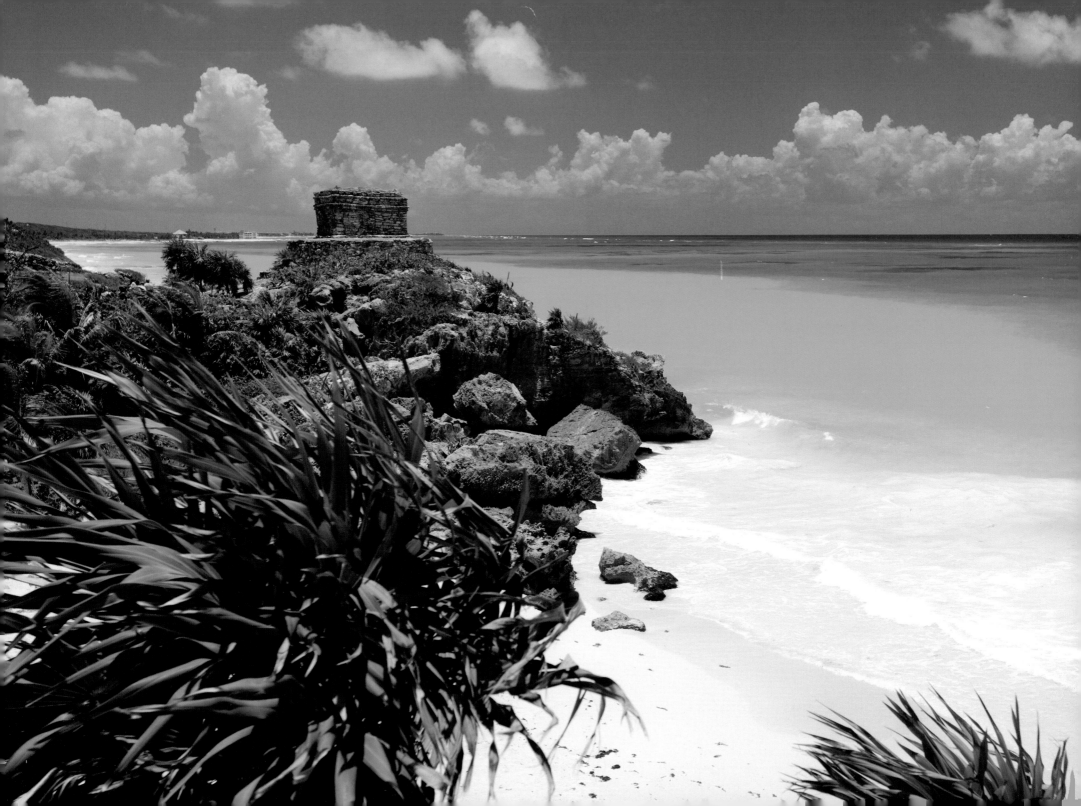

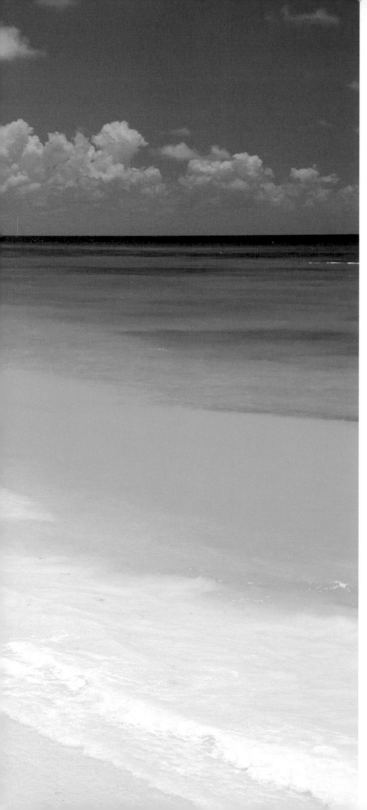

LEFT
TULUM, YUCATÁN PENINSULA, MEXICO

The walled Maya port at Tulum was at its peak during the 13th and 15th centuries, managing to survive for a few decades after the Spanish invasion. The Temple of the Wind God (pictured) stands a little apart from the rest of the ruins, on a cliff beside the sea. The base of the building is round, offering less resistance to the wind from all directions. The wind god was known as Huracan, probably sharing a root with the word 'hurricane'.

BELOW
TIKAL, GUATEMALA

Maya civilization stretched from southeastern Mexico, through Guatemala and Belize, to western Honduras and El Salvador. Tikal, in modern Guatemala, was one of the largest Maya cities, dominating the region from 200 to 900 CE. The so-called Temple I is a limestone step-pyramid built as a funerary temple for Jasaw Chan K'awiil I (682–734 CE). The temple is topped by a characteristic roof comb, decorated with a much damaged sculpture of the seated king.

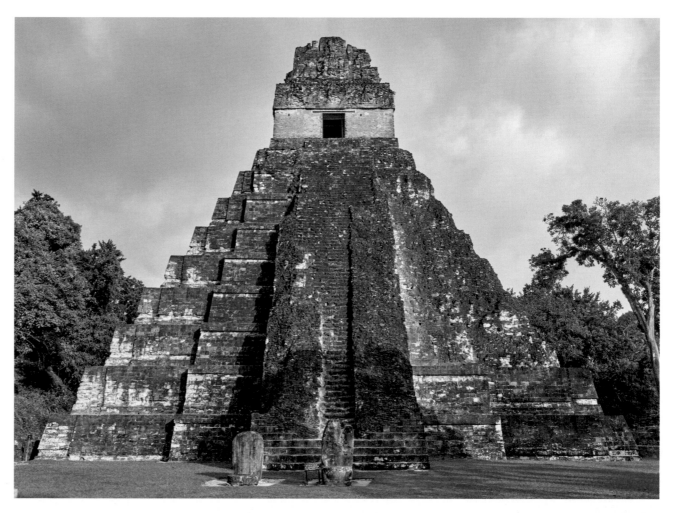

FORTUNA WATERFALL, ARENAL VOLCANO NATIONAL PARK, COSTA RICA

This 70-m (230-ft) waterfall is at the base of the dormant Chato volcano and close to the far more dangerous Arenal volcano, which was highly eruptive between 1968 and 2010. The national park draws birdwatchers from across the globe, hoping to catch a glimpse of a resplendent quetzal, with its iridescent streamer-like tail up to 65 cm (26 in) long.

MONTEVERDE CLOUD FOREST, COSTA RICA

Constantly cloaked with cloud due to the high humidity and mountainous terrain, Monteverde is home to 878 species of epiphytes and at least 500 species of orchids, growing on and around its gnarled, twisted trees. Animal life includes 58 species of bats and 161 frogs and toads. The forest's golden toad famously became extinct in 1989.

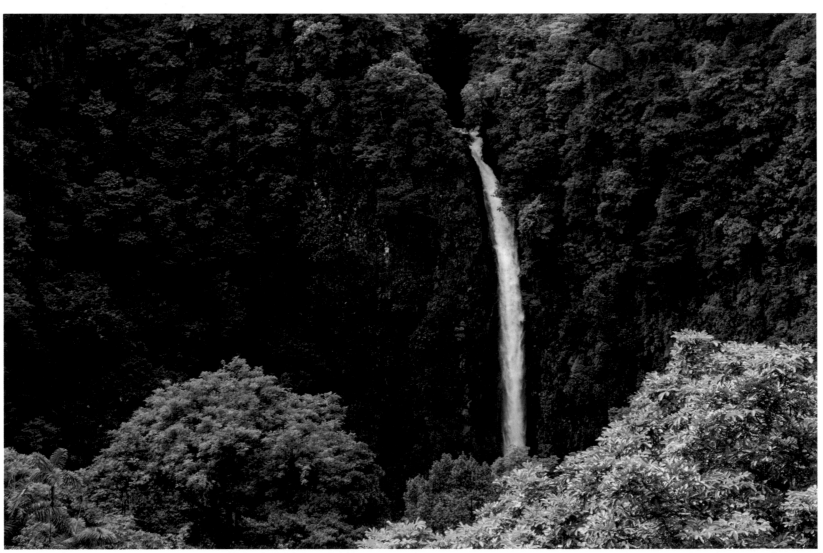

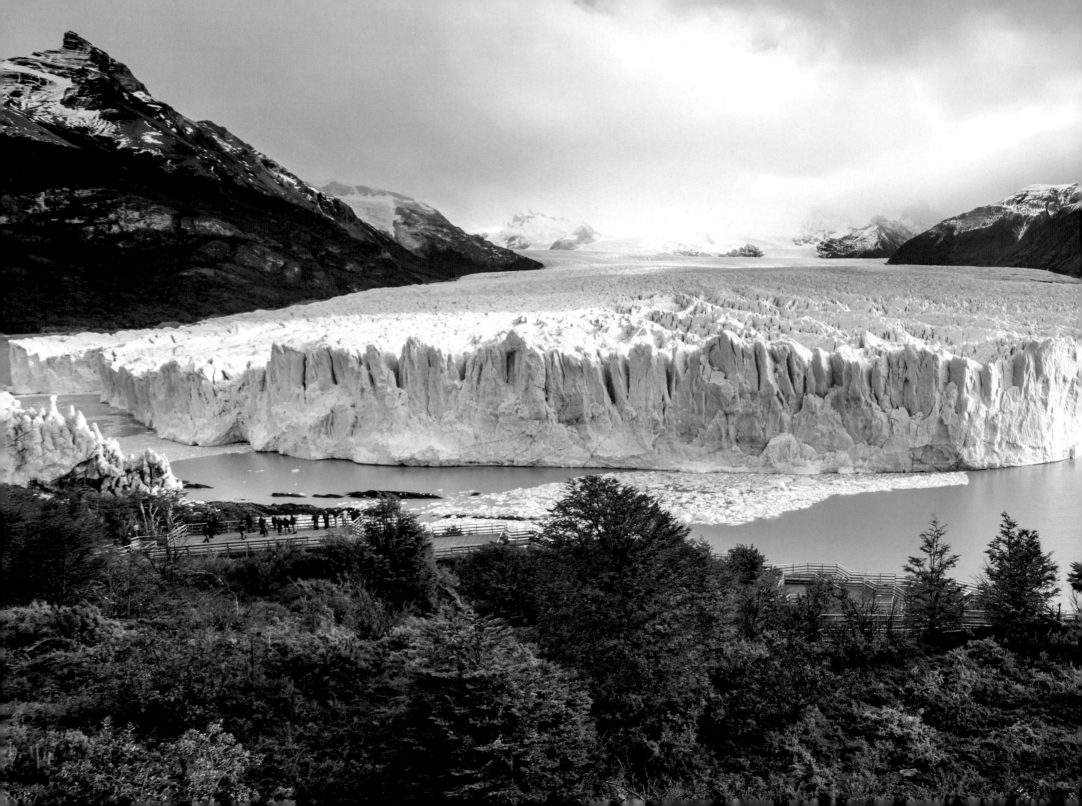

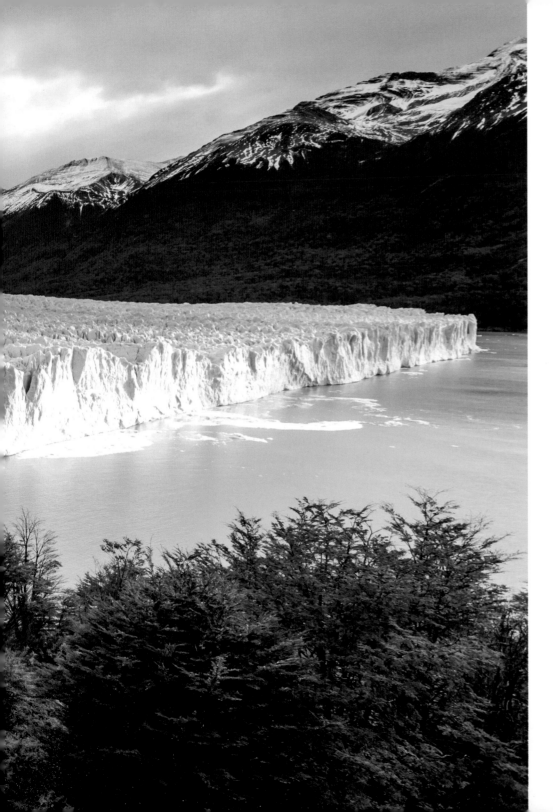

South America

Stretching from tropical Venezuela to cold and windswept Argentina, the Andes are the world's longest mountain range on land. Among the range's jagged peaks are cantankerous volcanoes, glaciers and gleaming, mineral-rich salt flats. It was among these mountains that the Incas built their dry-walled cities, connected by a network of cliff-hugging pathways. High in the Andes is also the continent's largest lake, Titicaca, where the Uru people live nearly as they have for centuries, on islands skilfully constructed from lake reeds.

To the east of the snow-capped mountains is the world's largest rainforest, the Amazon, its ecosystem both extraordinarily productive and extraordinarily at risk from human damage. Noisy with the calls of macaws and monkeys, the rainforest is still home to 390 billion trees, with creepers and bromeliads clinging and climbing between them. Further north are the tepuis of Venezuela and the Guianas, flat-topped mountains where animals and plants have evolved in isolation for many thousands of years. It is from one of these tepuis that the world's tallest waterfall, Angel Falls, plunges for nearly a kilometre.

PERITO MORINO GLACIER, ARGENTINA
This 250 sq km (97 sq mile) glacier is one of 47 glaciers fed by the Andes Mountains' vast Southern Patagonian Icefield. The glacier's terminus is 5 km (3 miles) wide, towering more than 70 m (240 ft) above the surface of Argentino Lake.

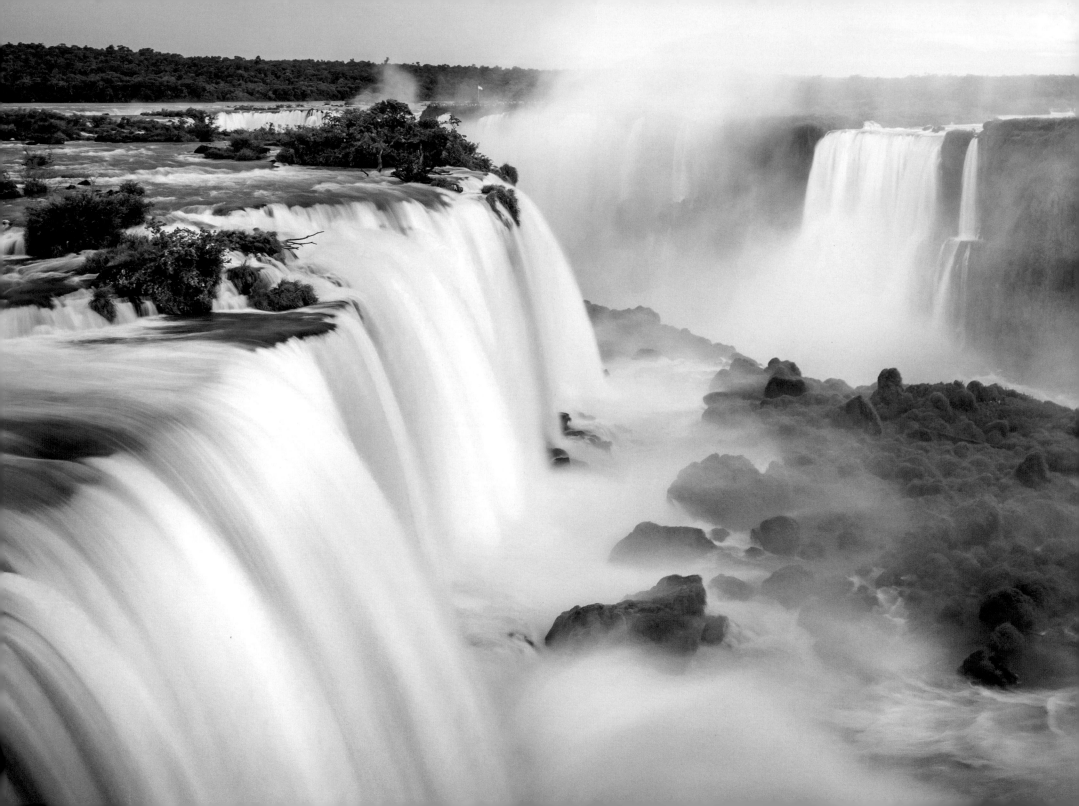

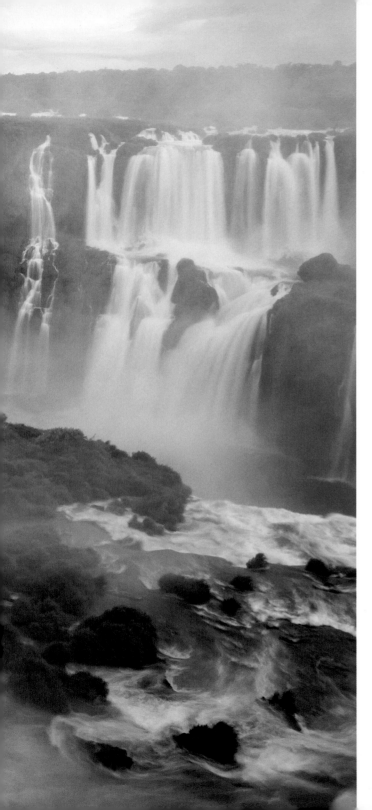

IGUAZU FALLS, ARGENTINA–BRAZIL

These 275 foaming waterfalls are formed where the Iguazu River flows over the edge of the Paraná Plateau, a vast, largely flat sheet of hardened lava. Around half of the river's flow falls into a long chasm called Garganta del Diablo ('Devil's Throat'), which is 80–90 m (260–300 ft) wide. Although neither the widest nor tallest waterfall in the world, Iguazu has a total width of 2,700 m (8,858 ft) and a maximum height of 82 m (269 ft). The falls' name, from Guarani or Tupi, translates as 'big water'.

IBERÁ WETLANDS, ARGENTINA

At 20,000 sq km (7,700 sq miles), the Iberá Wetlands are one of the largest wetlands in the world, encompassing forested swamps, peaty bogs, lakes, lagoons and rivers. The region is home to the two Argentine members of the Alligatoridae family, the yacare caiman (pictured) and the broad-snouted caiman. The yacare caiman, which grows up to 3 m (9.8 ft) long, feeds on snails, fish and other aquatic animals, sometimes also preying on land animals such as capybaras and snakes. It may live for around 50 years.

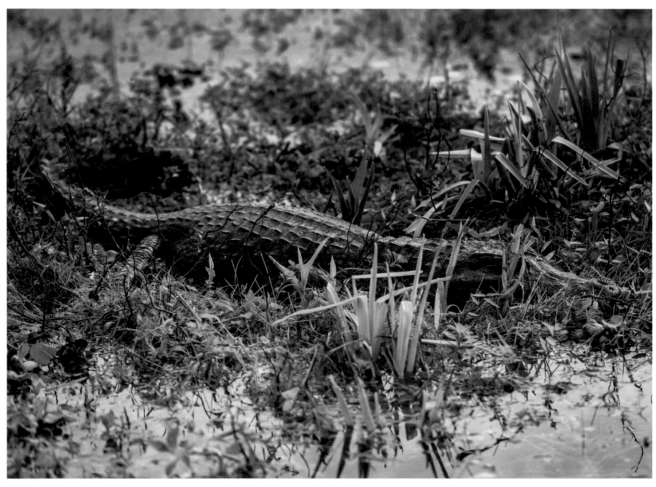

FERNANDO DE NORONHA, BRAZIL

This archipelago of 21 tiny islands lies 350 km (220 miles) off the Brazilian coast. The islands are the tips of volcanic mountains, formed mainly of the igneous rocks basanite, phonolite and nephelinite. The archipelago is home to several species of endemic flora and fauna, including flowering plants such as *Capparis noronhae* and the Noronha elaenia, a tyrant-flycatcher. The exceptionally clear offshore waters make the islands a compelling dive destination.

CHRIST THE REDEEMER, RIO DE JANEIRO, BRAZIL

A 30-m (98-ft) tall statue of Christ the Redeemer overlooks the city of Rio de Janeiro. Designed by French-Polish sculptor Paul Landowski, the work was completed in 1931. Carved from easy-to-work soapstone, the statue has a core of concrete and steel, engineered by Brazilian Heitor da Silva Costa. The statue stands on Mount Corcovado, a granite bonhardt, which is a huge dome of exposed rock often nicknamed a 'sugar loaf' for its shape.

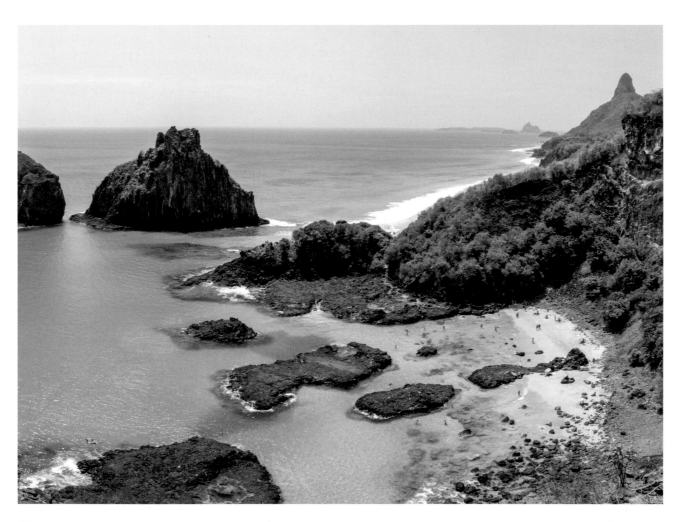

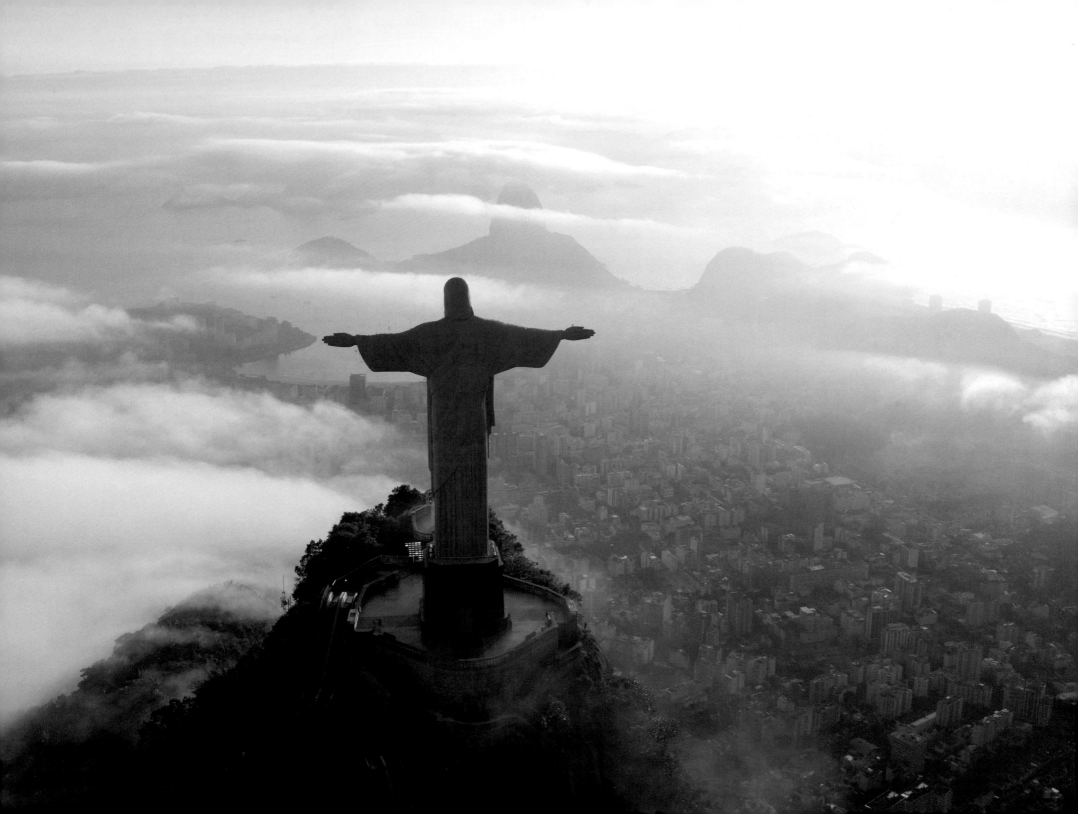

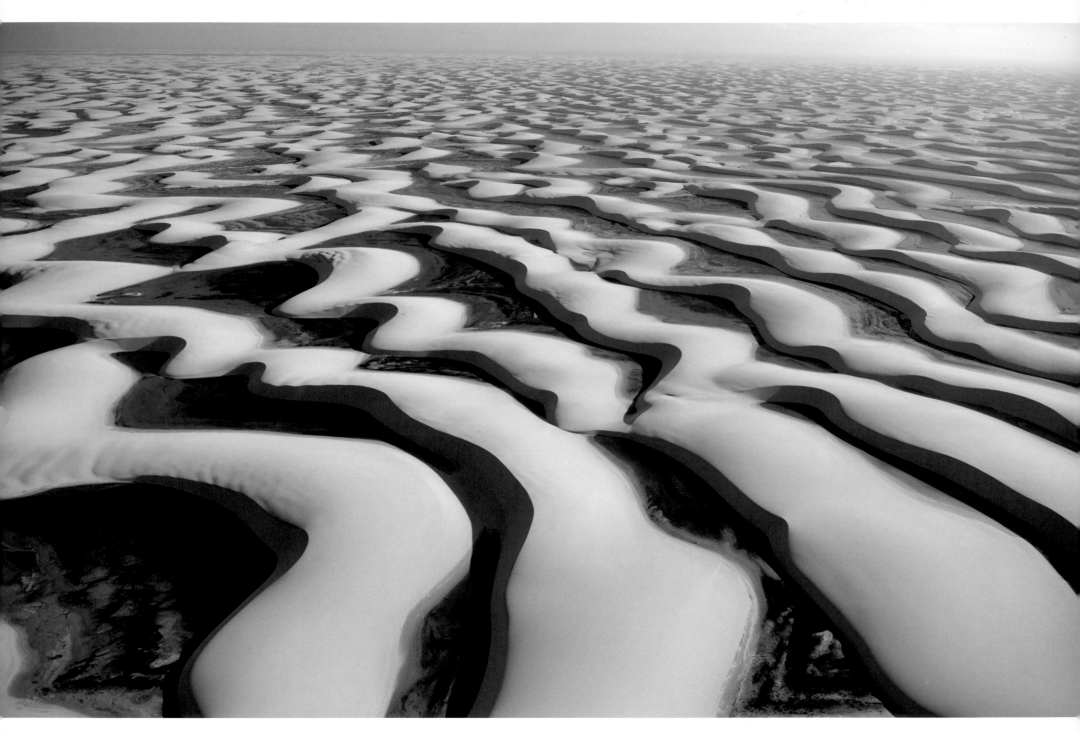

OPPOSITE
LENÇÓIS MARANHENSES NATIONAL PARK, BRAZIL

The rolling sand dunes of this coastal national park are formed from the sand carried toward the sea by the Parnaíba and Preguiças Rivers. The sand is then blown back inland by the prevailing winds, creating dunes up to 40 m (130 ft) tall. Although the region looks like a desert, it has relatively high rainfall during the rainy season, creating freshwater lagoons in the dips between the dunes, which lie over impermeable rock. These lagoons are home to species such as the wolf fish, which burrows into the sand during the dry season.

RIGHT
MARBLE CAVES, CHILE

Reached only by boat, these caves, columns and arches were eroded from a promontory of marble, on the vast glacial lake of General Carrera. The formations were made by wave action over the last 10,000 years. In early morning light, particularly from September to February when the ice melt feeds the lake, the pale rock eerily reflects the turquoise blue of the water.

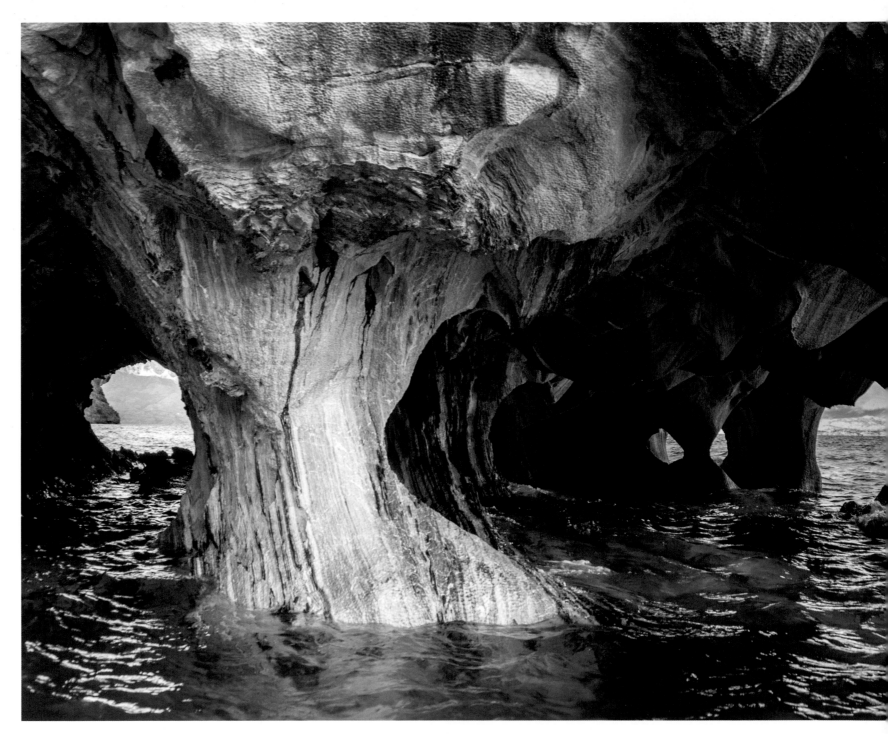

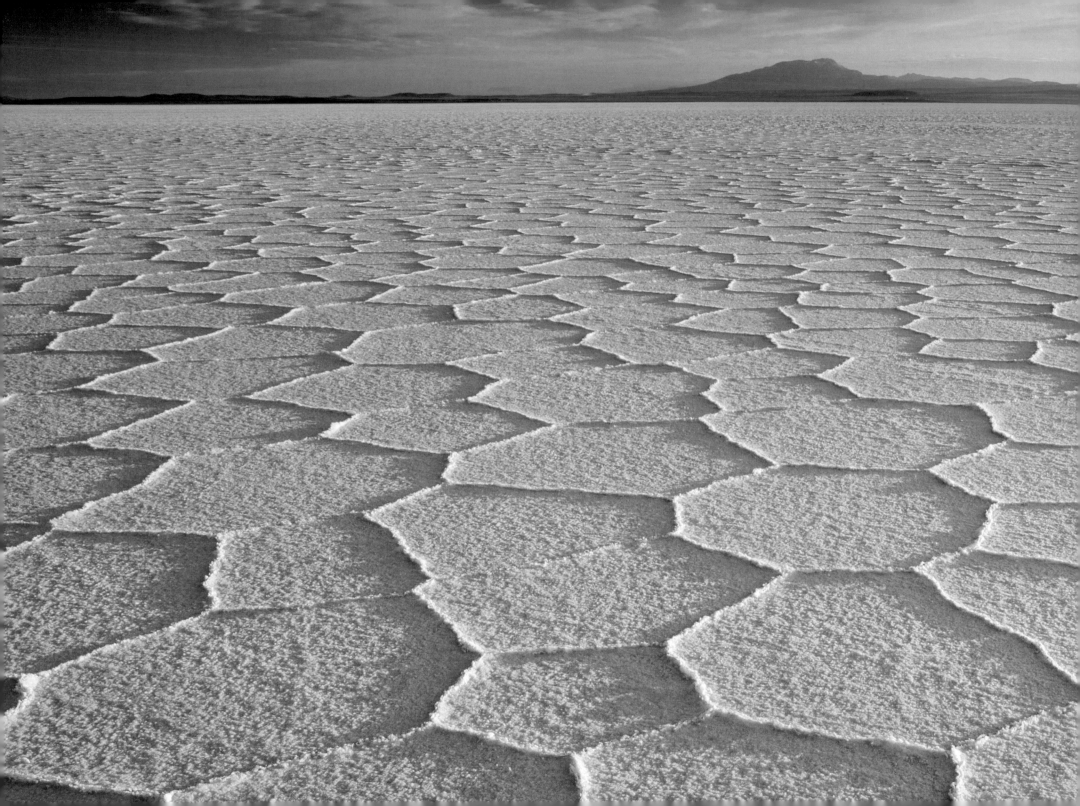

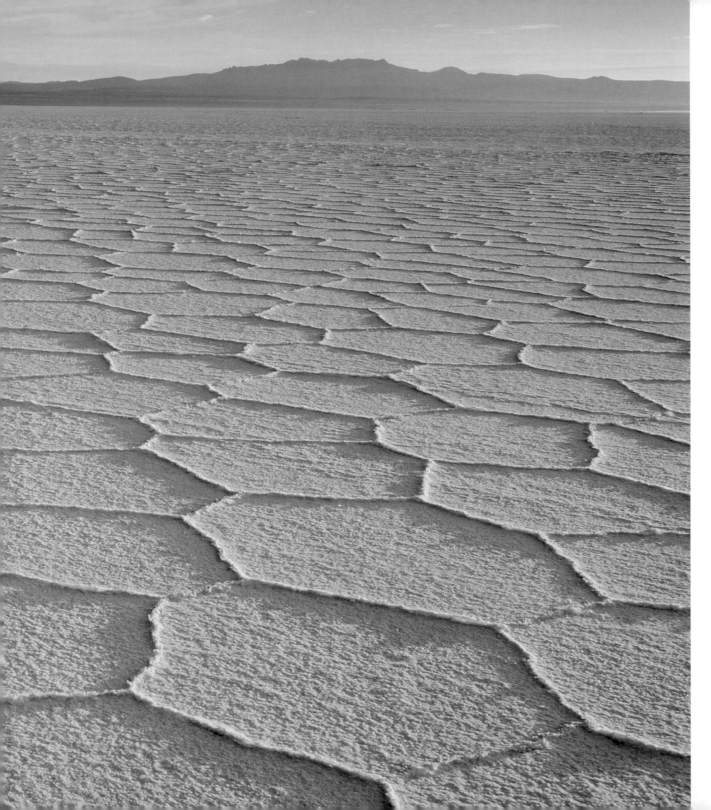

SALAR DE UYUNI, BOLIVIA

Covered in a crust of salt up to several metres thick, the Salar de Uyuni is the world's largest salt flat, with an area of 10,500 sq km (4,000 sq miles). The salt flat formed around 11,000 to 13,000 years ago as ancient salt lakes dried up in this increasingly arid region of the Altiplano plateau. Beneath the salt crust is mud saturated with brine that contains high levels of lithium chloride. The Bolivian government intends to mine this lithium, which makes up a huge proportion of the world's reserves.

BELOW
LAKE TITICACA, BOLIVIA–PERU

With an area of 8,372 sq km (3,232 sq miles), Lake Titicaca is the largest lake in South America. Many centuries ago, the Uru people moved onto the lake to escape attack from encroaching peoples, constructing floating islands using totora reeds. Today, around 1,200 Urus live on an archipelago of 60 artificial islands, which are equipped with watchtowers, homes and grazing space for animals. The Uru live by fishing, catching birds and selling craftwork.

RIGHT
CORDILLERA REAL, BOLIVIA

Despite its proximity to the equator, this mountain range in western Bolivia is heavily glaciated. Part of the Andes Mountains, the 125-km (78-mile) long range has its highest point at the 6,438-m (21,122-ft) summit of Illimani. The Andes are fold mountains, formed by around 45 million years ago as the Nazca and Antarctic plates slid under the South American plate. Stretching for 7,000 km (4,300 miles), the Andes are the longest mountain range on land.

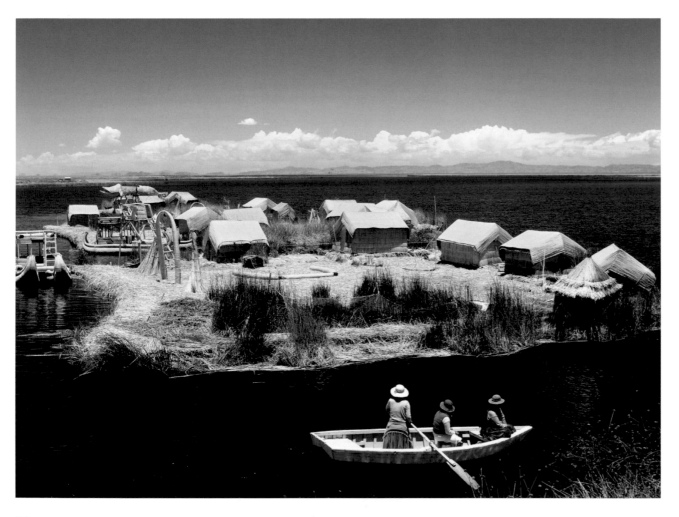

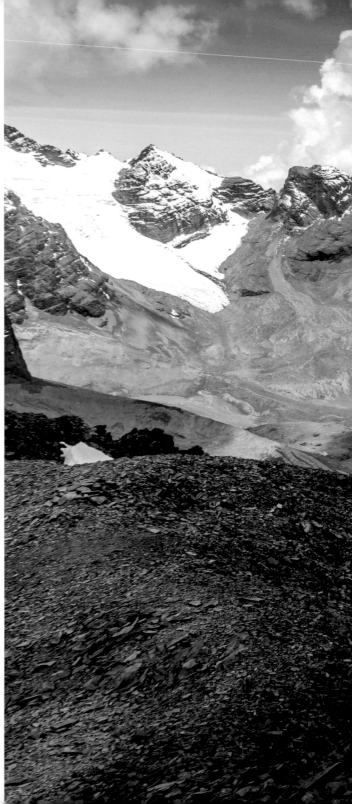

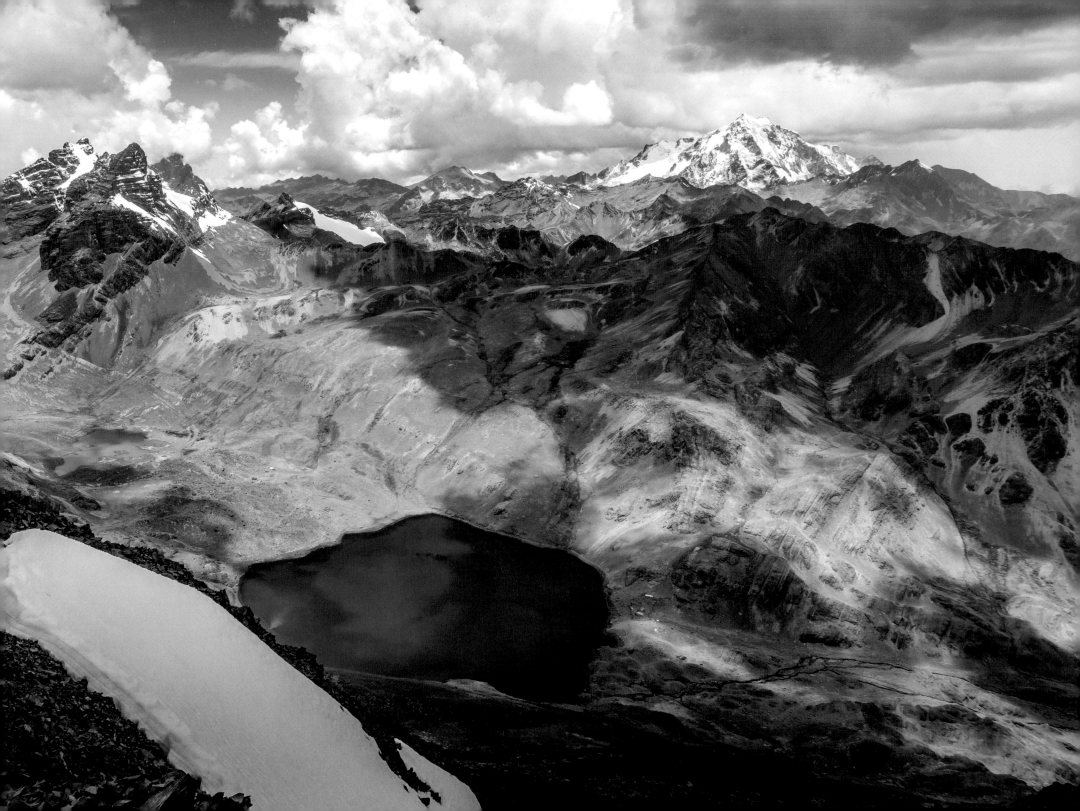

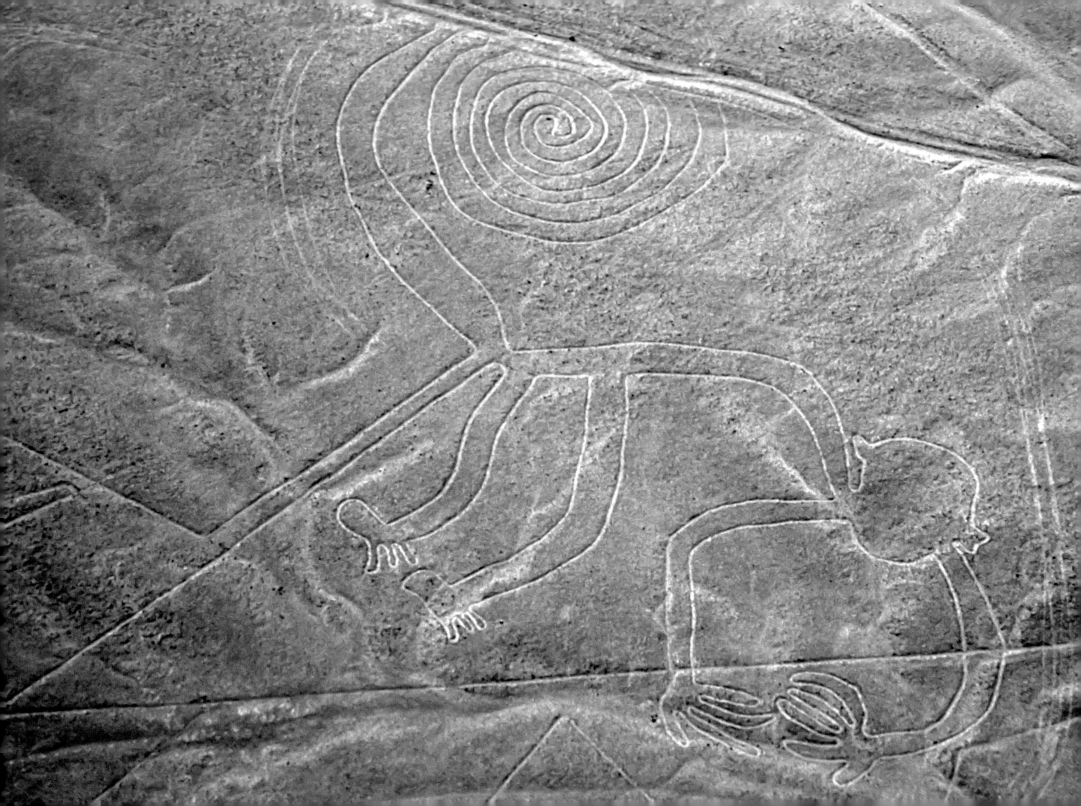

LEFT
NAZCA LINES, PERU

Carved into the Nazca Desert between 500 BCE and 500 CE, the Nazca Lines are a collection of designs that range from lines and geometric shapes to trees, flowers and animals. Covering around 50 sq km (19 sq miles), the designs are best seen from the air but can also be viewed from surrounding hills. They were made by scratching away the top layer of reddish-brown pebbles to reveal the paler subsoil, almost certainly for religious purposes – perhaps so they could be seen by gods in the sky.

BELOW
JAVARI RIVER, AMAZON RAINFOREST, PERU

The Javari River rises on the border between Brazil and Peru, flowing northeast through the Amazon Rainforest until it joins the Amazon River at the Brazilian town of Benjamin Constant. With an area of 5.5 million sq km (2.1 million sq miles), the world's largest rainforest is home to one in ten of the world's known species, including at least 2.5 million insect species, 40,000 plants and 2,200 fish. Nearly one fifth of the forest has already been cut down by loggers, farmers and miners.

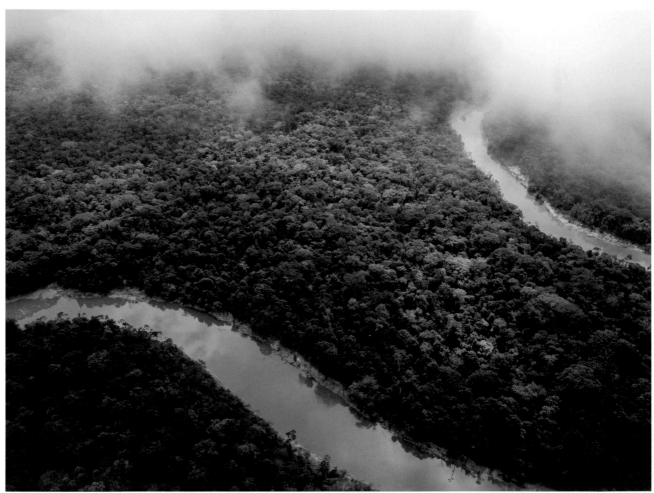

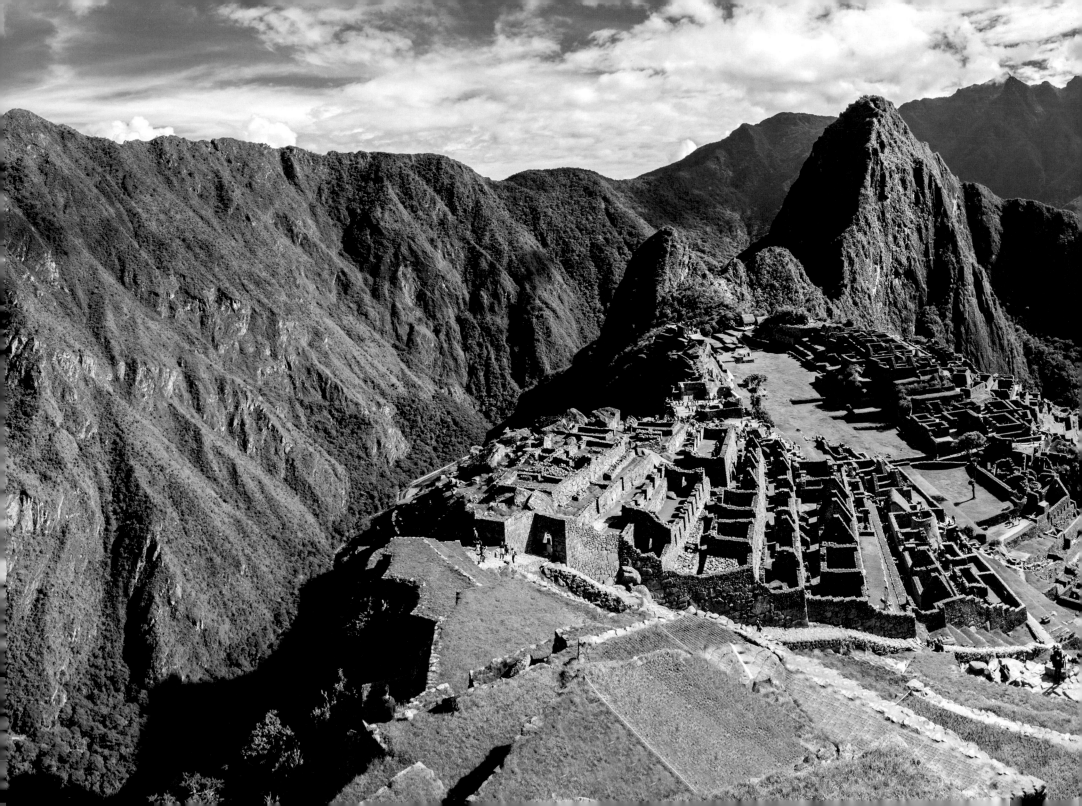

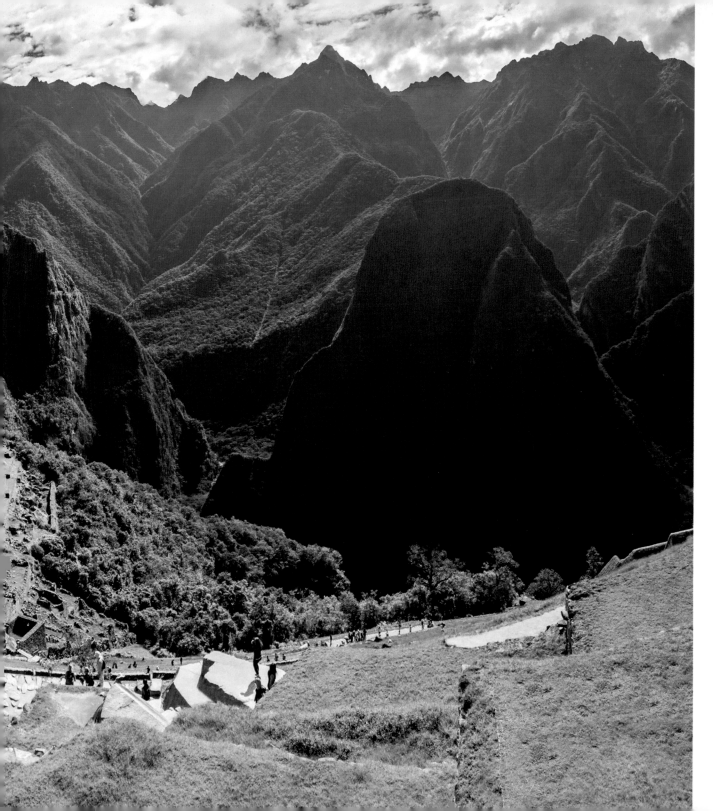

MACHU PICCHU, PERU

From the 13th century, the Incas controlled an empire that stretched from southern Ecuador to northern Chile. Their rule was cut short by the arrival of the Spanish in the 16th century. At Machu Picchu, perched between granite peaks, an estate was constructed for Inca emperor Pachacuti (1438–72). The homes, temples, guardhouses and storehouses had polished drystone walls.

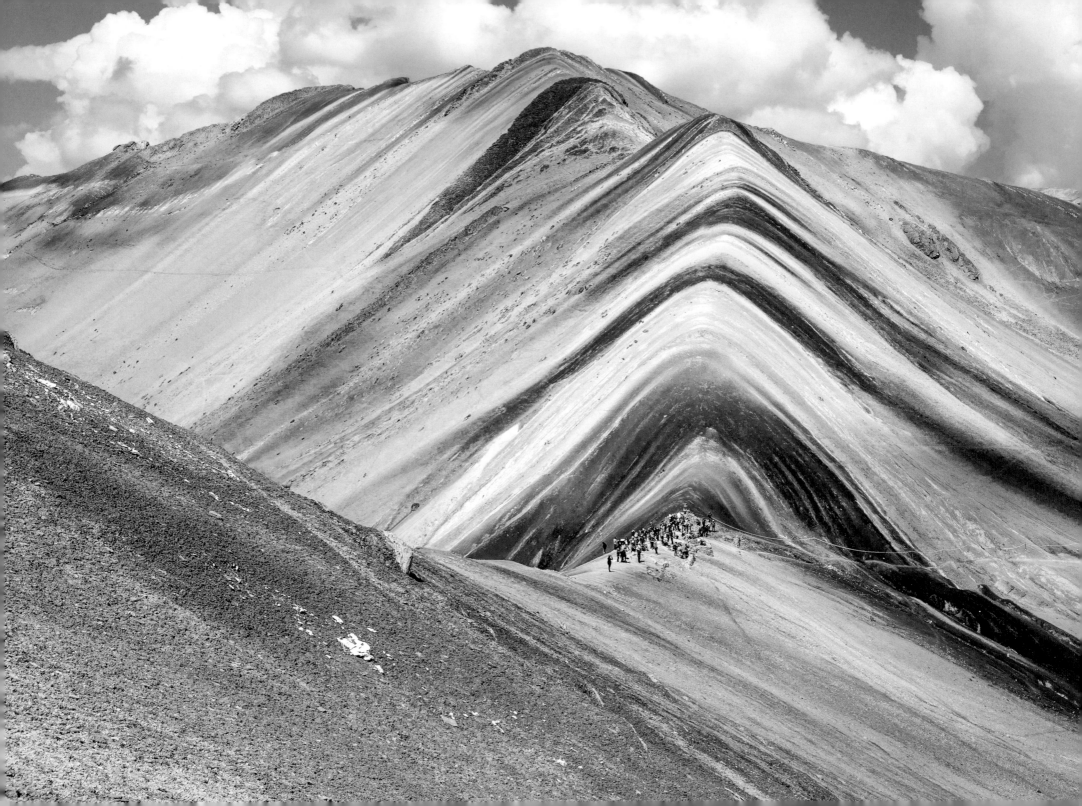

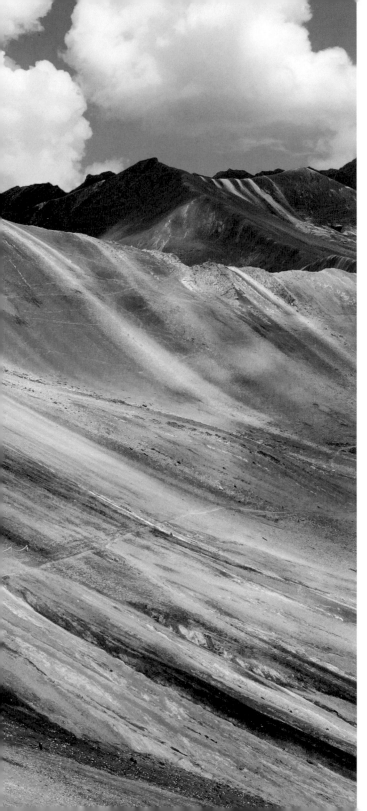

LEFT

VINICUNCA, PERU

Also known as the Montaña de Siete Colores ('Mountain of Seven Colours'), this 5,200-m (17,100-ft) peak is reached by a steep trek and an unpaved road. The colours are created by the different mineral compositions of the rock strata: red is made by claystone rich in iron, white by marls high in calcium carbonate, green by phyllites containing ferromagnesian minerals, and yellow by sandstones packed with sulphurous minerals.

RIGHT

SOUTH AMERICAN SEA LIONS, PARACAS NATIONAL RESERVE, PERU

Protecting both marine and desert ecosystems, this reserve is also home to *lomas*, areas of fog-watered vegetation found in the coastal desert of Peru and northern Chile. South American sea lions are common along the coast, where they drag themselves onto rocks and beaches to rest, mate and give birth to pups. The reserve is also dotted with remains of the Paracas culture, which flourished from 800 to 100 BCE.

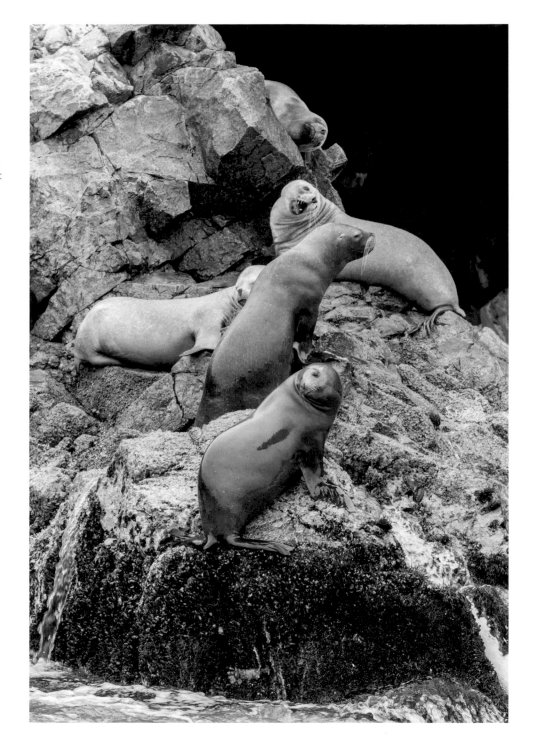

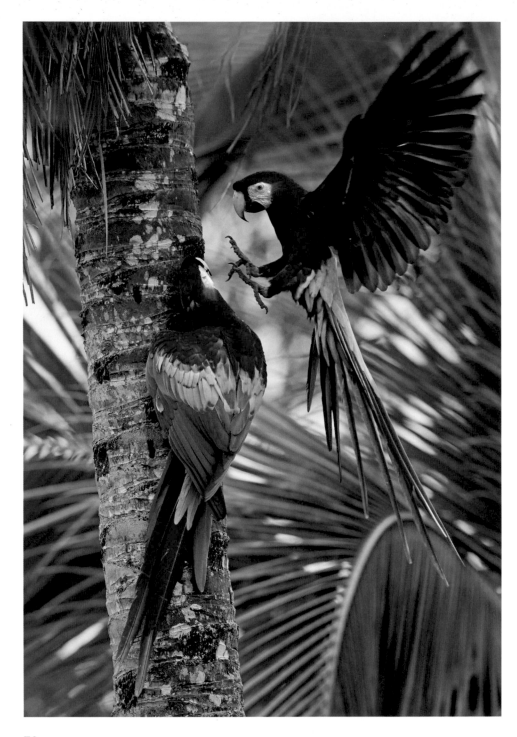

SCARLET MACAWS, MANÚ NATIONAL PARK, PERU

This park encompasses Andean grassland, tropical rainforest and cloud forest, which is found at higher elevations and always cloaked in low cloud because of the cooling of moisture-laden air currents pushed upward by the mountains. Birds found in the park's lowland regions include scarlet macaws, harpy eagles and blue-crowned trogons. In the mountains, Andean condors, giant hummingbirds and Andean cock-of-the-rocks can be spotted.

INCA TRAIL, PERU

The Inca Trail hiking routes lead through the Andes Mountains to Machu Picchu. The interconnected routes are of different lengths, the shortest taking just one day. Longer routes include an ascent to 4,200 m (13,800 ft), which can cause altitude sickness if time is not taken to acclimatize before departure. The routes follow part of the 40,000-km (25,000-mile) paved Incan road network, once used by traders, diplomats and messengers.

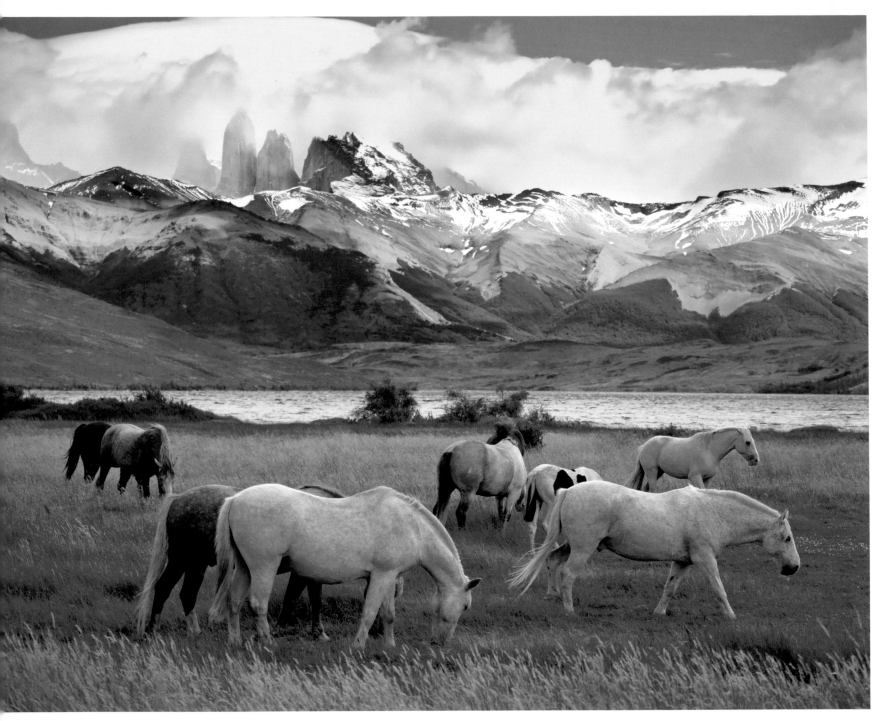

TORRES DEL PAINE
NATIONAL PARK, CHILE

In the Patagonian Andes, the centrepiece of this well-glaciated national park is the three granite peaks of the Torres del Paine (pictured in the background). The spires took their current form after the softer overlying sedimentary rock was worn away. The park is home to herds of wild horses, called *baguales*. It is believed *baguales* are descendants of Andalusian horses released by Spanish *conquistadores*. The horses are preyed on by pumas, which also frequently attack the park's guanacos.

OPPOSITE

CAÑO CRISTALES, COLOMBIA

From July to November, the bed of the Caño Cristales River is coloured a brilliant red, as well as yellow, green and blue, thanks to the pigments of the aquatic plants that cling to it. The red is the result of the endemic *Macarenia clavígera*, which is able to survive even where the current is strongest. The river is also known for its many circular, pebble-eroded pits, called giant kettles.

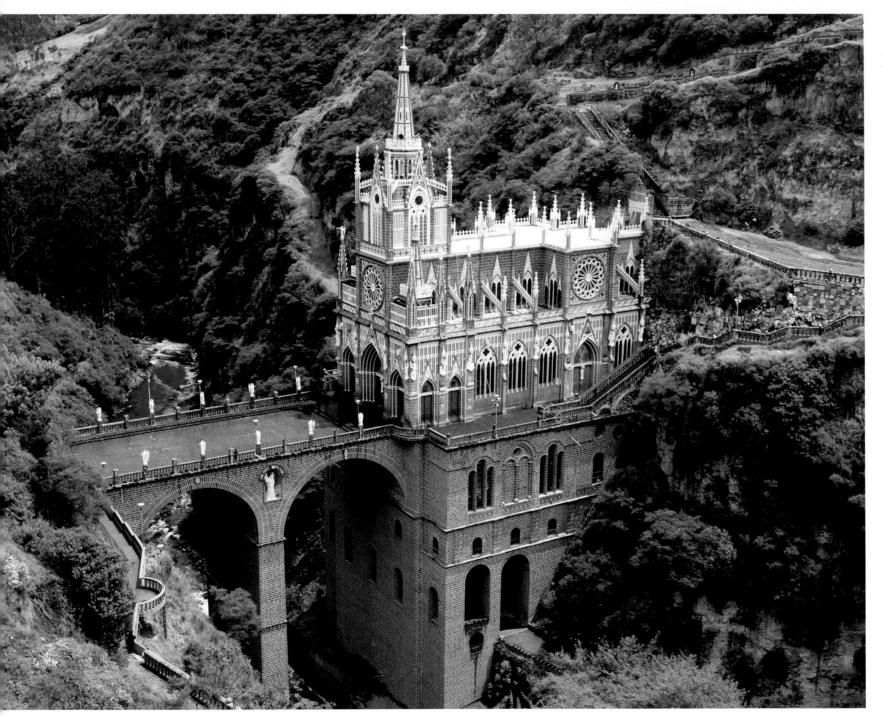

LAS LAJAS SANCTUARY, COLOMBIA

Completed in 1949, this church took 33 years to build, funded by donations from local churchgoers. It is sited inside a canyon of the Guáitara River and accessed by bridge. The location is the result of a legend dating from 1754, when the Virgin Mary appeared here during a storm to Maria Meneses de Quiñones and her young daughter Rosa. A straw and wood shrine was soon built on the spot, replaced with grander structures over the years. Thousands of pilgrims visit the shrine every year.

COTOPAXI, ECUADOR

Ecuador's second highest peak is the active stratovolcano Cotopaxi, which reaches 5,897 m (19,347 ft). Cotopaxi is part of the Avenue of Volcanoes, which runs for 320 km (200 miles) between two parallel cordilleras and boasts nine peaks over 5,000 m (16,400 ft) high. The volcanoes were formed by the same tectonic plate subduction that formed the Andes Mountains. Cotopaxi has erupted more than 80 times since the first recorded eruption, in 1534.

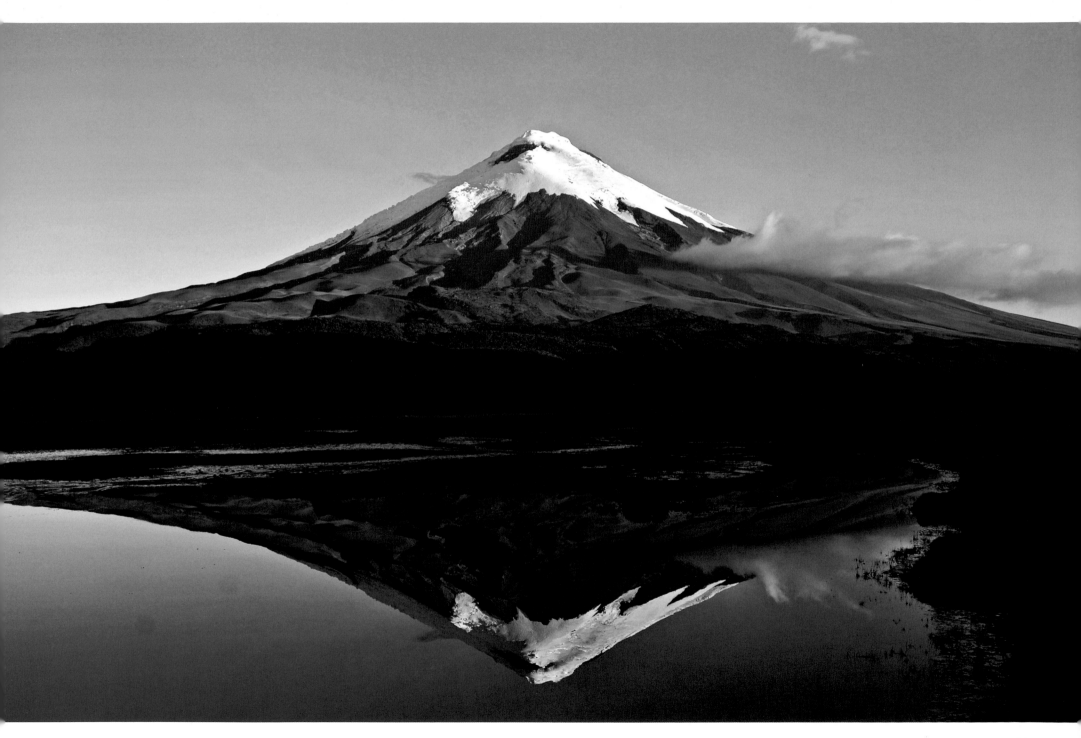

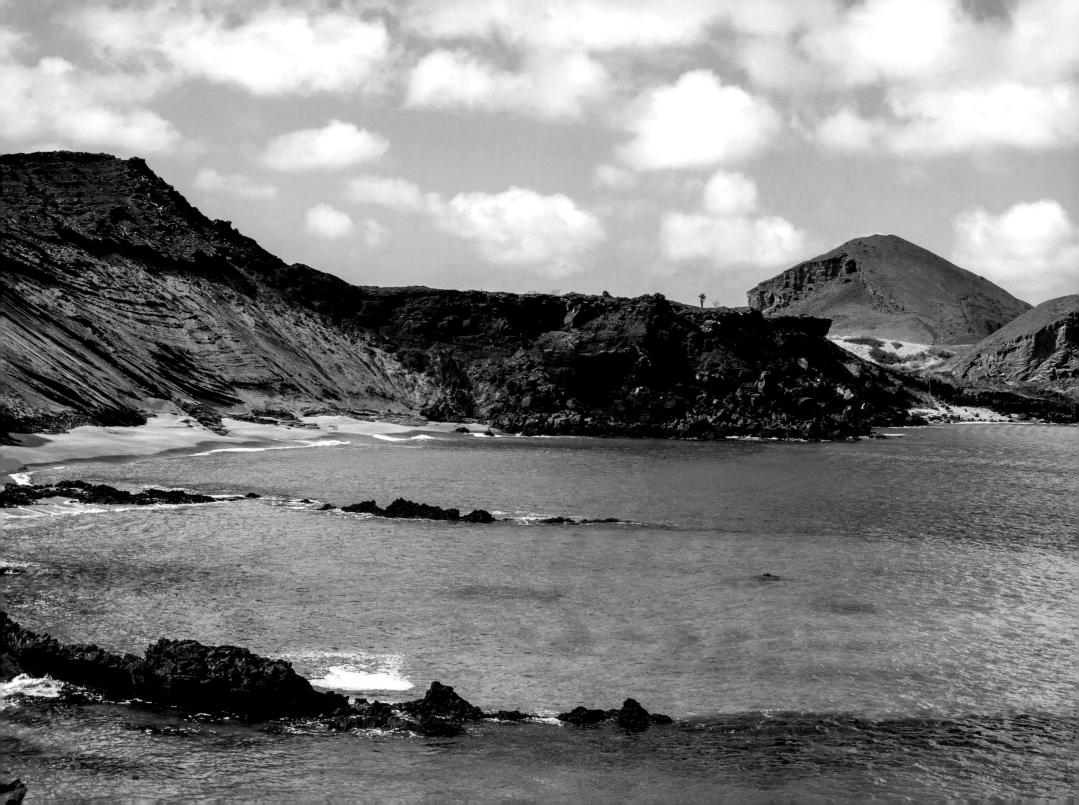

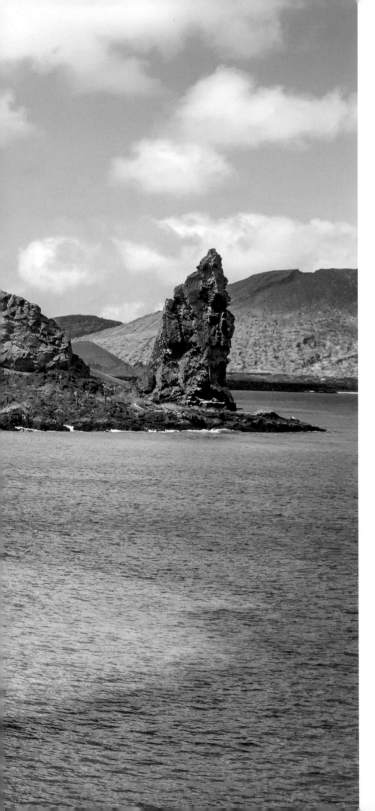

BARTOLOMÉ, GALÁPAGOS ISLANDS, ECUADOR

Bartolomé, one of the younger Galápagos Islands at around 2 million years old, is home to the basalt Pinnacle Rock, a volcanic cone formed when lava erupted from an underwater volcano and was so swiftly cooled that it exploded. Close by is an underwater volcanic crater. Little Galápagos penguins have established a breeding colony in a cave behind the rock. The island was named after Sir Bartholomew James Sulivan, a companion of Charles Darwin when he visited aboard the HMS *Beagle*.

PRICKLY PEARS, GALÁPAGOS ISLANDS, ECUADOR

The Galápagos Islands have six endemic species of prickly pear cacti, forming an easily examined and fascinating study in adaptive radiation. The tallest species, up to 12 m (39 ft) tall, is found on Santa Cruz, while the smallest, just 2.6 m (8.5 ft) tall, is on Santa Fé. The fruits, seeds and pads of prickly pears are the main food sources for animals living in dry lowland areas of the archipelago. These animals include finches, mockingbirds, land iguanas and the famous giant tortoises.

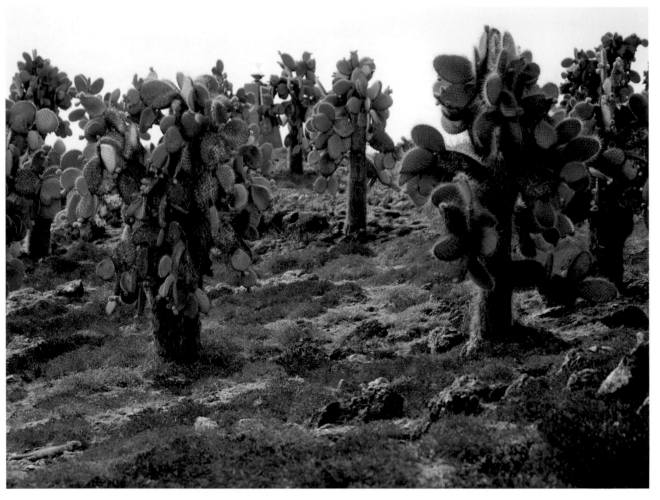

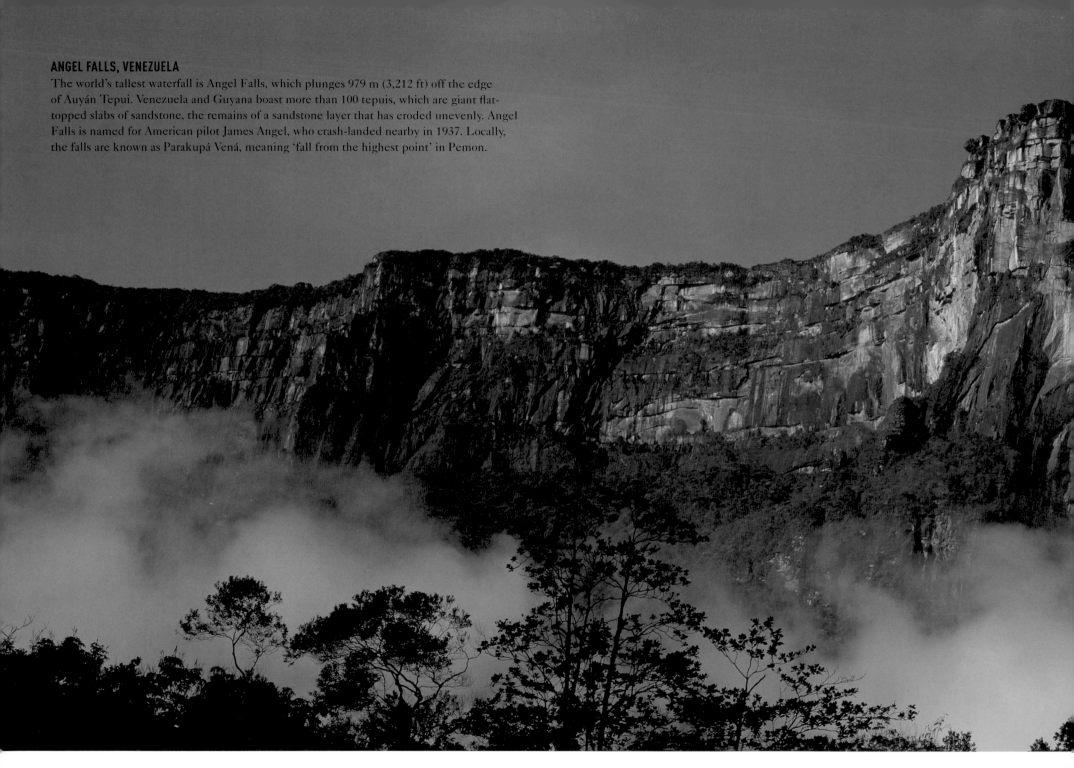

ANGEL FALLS, VENEZUELA

The world's tallest waterfall is Angel Falls, which plunges 979 m (3,212 ft) off the edge of Auyán Tepui. Venezuela and Guyana boast more than 100 tepuis, which are giant flat-topped slabs of sandstone, the remains of a sandstone layer that has eroded unevenly. Angel Falls is named for American pilot James Angel, who crash-landed nearby in 1937. Locally, the falls are known as Parakupá Vená, meaning 'fall from the highest point' in Pemon.

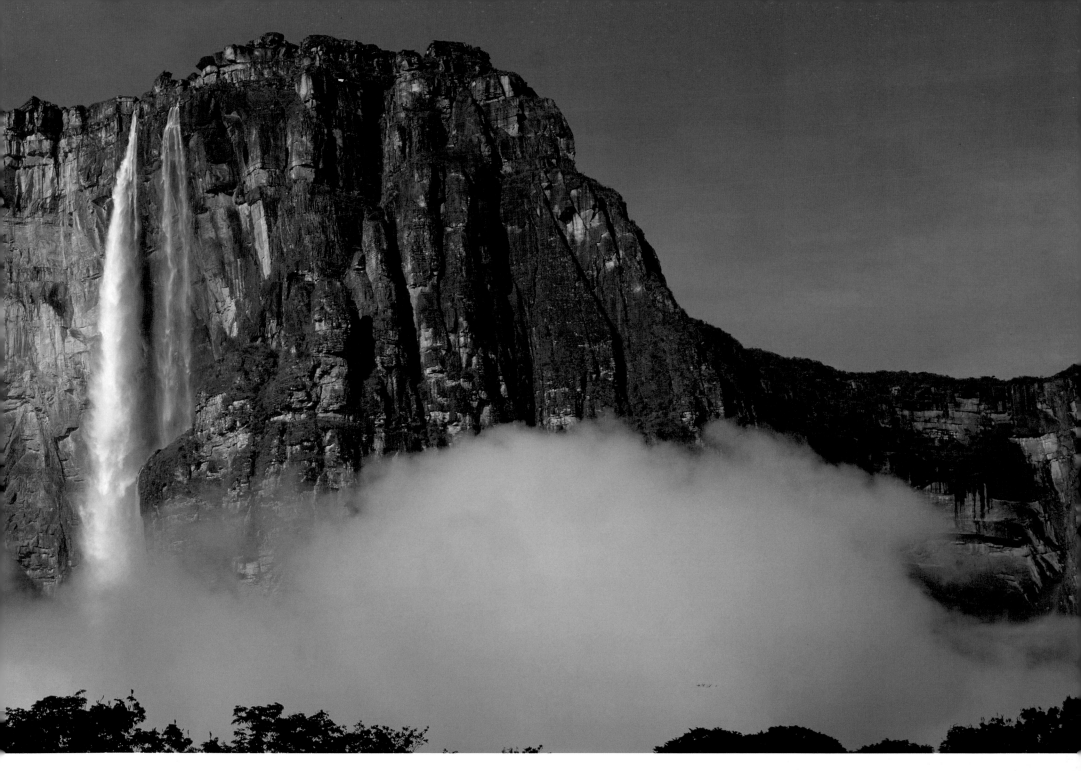

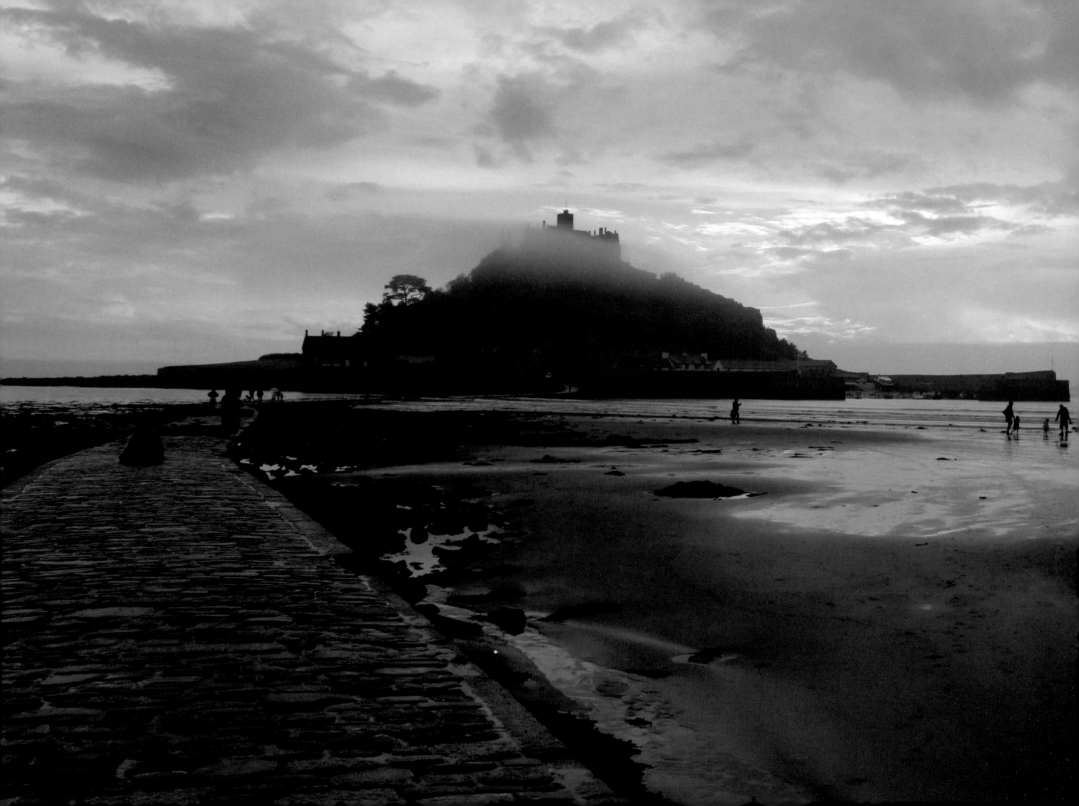

Europe

More than 40,000 years ago, artists in Europe's Franco-Cantabrian region began to leave a mark on their world by decorating the walls of caves. At first, they made hand prints and simple shapes, but later they created dazzlingly lifelike figures of animals and humans. By the Bronze Age, Europe's peoples, now relatively organized, skilled and well-travelled, could conceive and construct great stone structures, such as Britain's Stonehenge. It was in Greece that Europe's earliest true civilizations flowered, first on the island of Crete and later on the mainland, where the city states constructed some of the world's most elegant and iconic buildings, including the 5th-century BCE masterpieces of Athens' Acropolis.

More recent monuments to the creativity and ambition of humankind include the monasteries, churches and castles of the Middle Ages, as well as Europe's endless attempts to change and master the landscape, from the sea-conquering polders of the Netherlands to great power stations, reservoirs and bridges. Yet, above all, the beauty of Europe's landscape shines through, from the fells of England's Lake District to the wild forests of Russia.

ST MICHAEL'S MOUNT, ENGLAND
The tidal island of St Michael's Mount, in Cornwall, is accessible by causeway between mid-tide and low water. It was given to the Benedictines by Edward the Confessor in the 11th century. The church and priory built by the monks still form the heart of the island's castle.

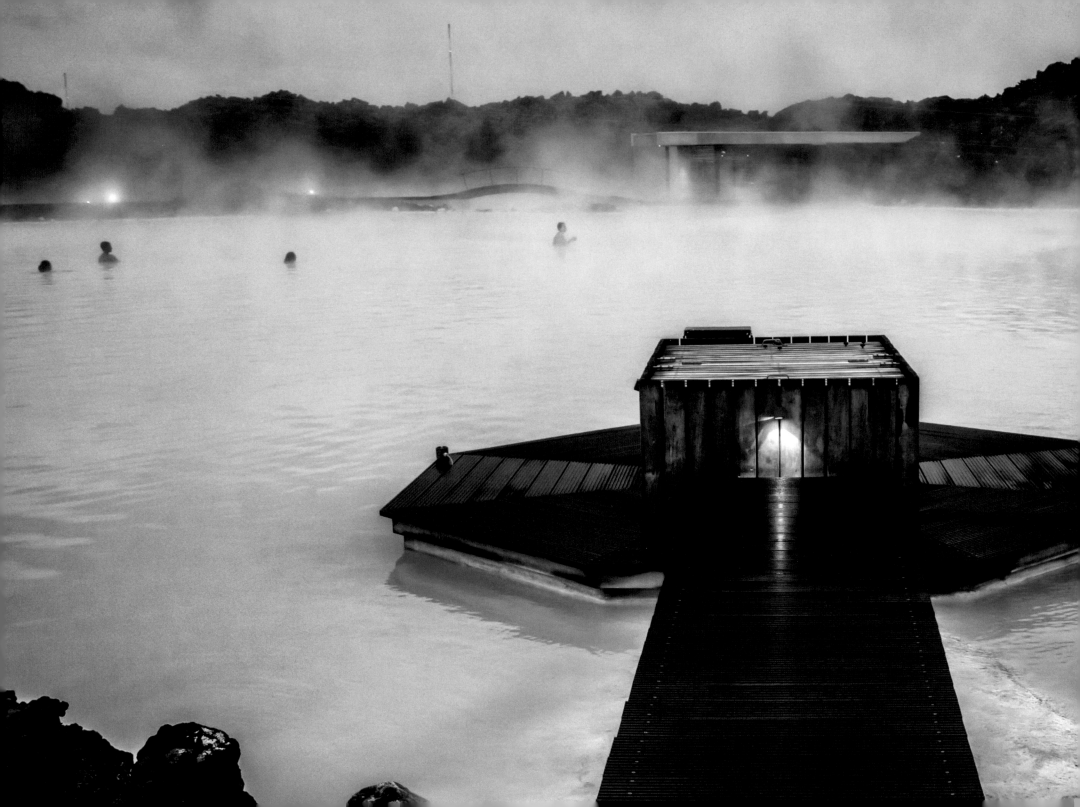

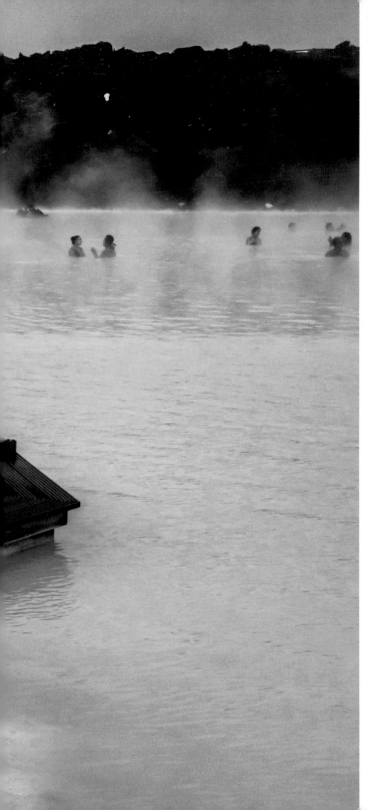

BLUE LAGOON, ICELAND

In the lava field of Grindavík, on the Reykjanes Peninsula, the Blue Lagoon geothermal spa is supplied with water of 37–39°C (99–102°F) by the Svartsengi geothermal power station. The station uses water heated underground to turn electricity-generating turbines, then releases the water into the human-made lagoon. The water is rich with salts, algae and silica, the last of which accounts for its milky-blue shade. The cocktail is believed to benefit the skin.

VATNAJÖKULL ICE CAVE, ICELAND

The Vatnajökull ice cap, up to 950 m (3,120 ft) thick and 7,900 sq km (3,100 sq miles), covers 8 per cent of Iceland. Numerous caves can be found in the ice cap's many outlet glaciers, formed after the ice refreezes in winter after canals of flowing meltwater have run through the glaciers during summer. Every winter, local guides hunt for new caves that are stable enough to explore, venturing inside only during cold periods without heavy rain.

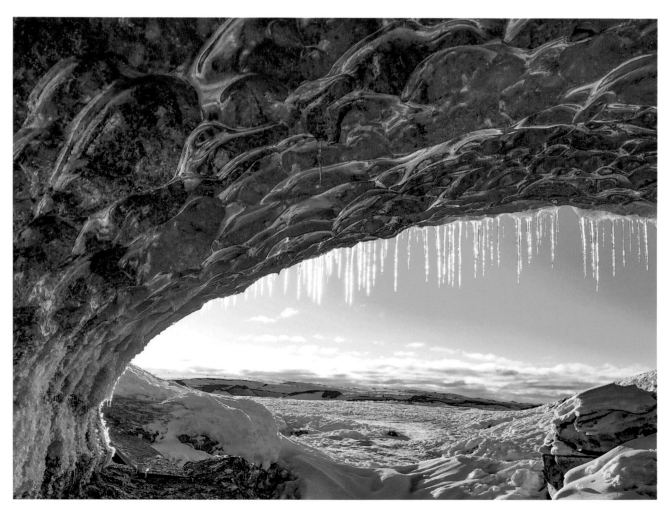

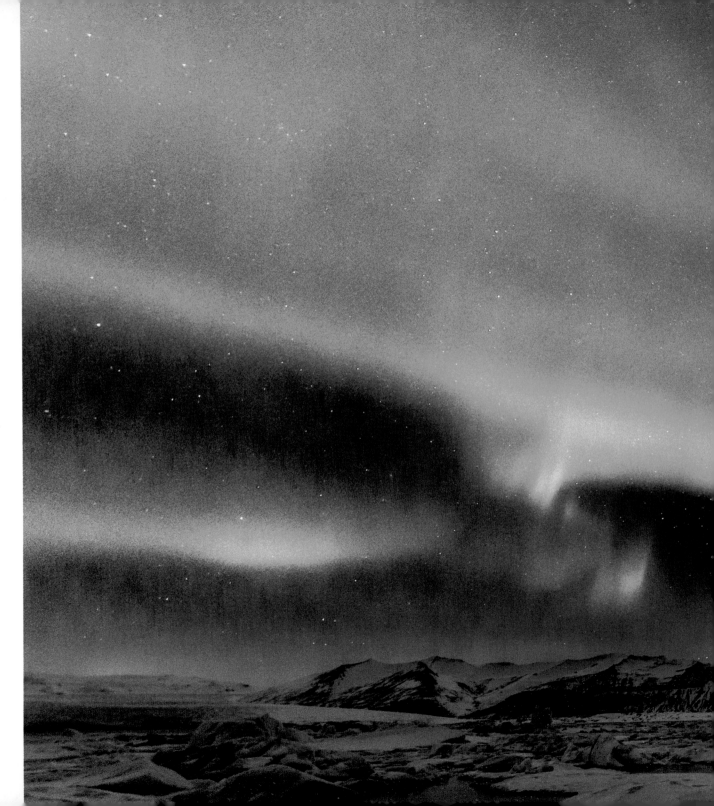

AURORA BOREALIS, ICELAND

The best time to view the northern lights in Iceland is September to March, when the nights are long. The aurora are caused by the solar wind, a stream of charged particles from the sun. These collide with gas particles in Earth's atmosphere, passing on energy, which is released as light. Different gases give off different colours of light. The lights are seen around the North and South Poles because the solar wind is deflected to these regions by Earth's magnetic field.

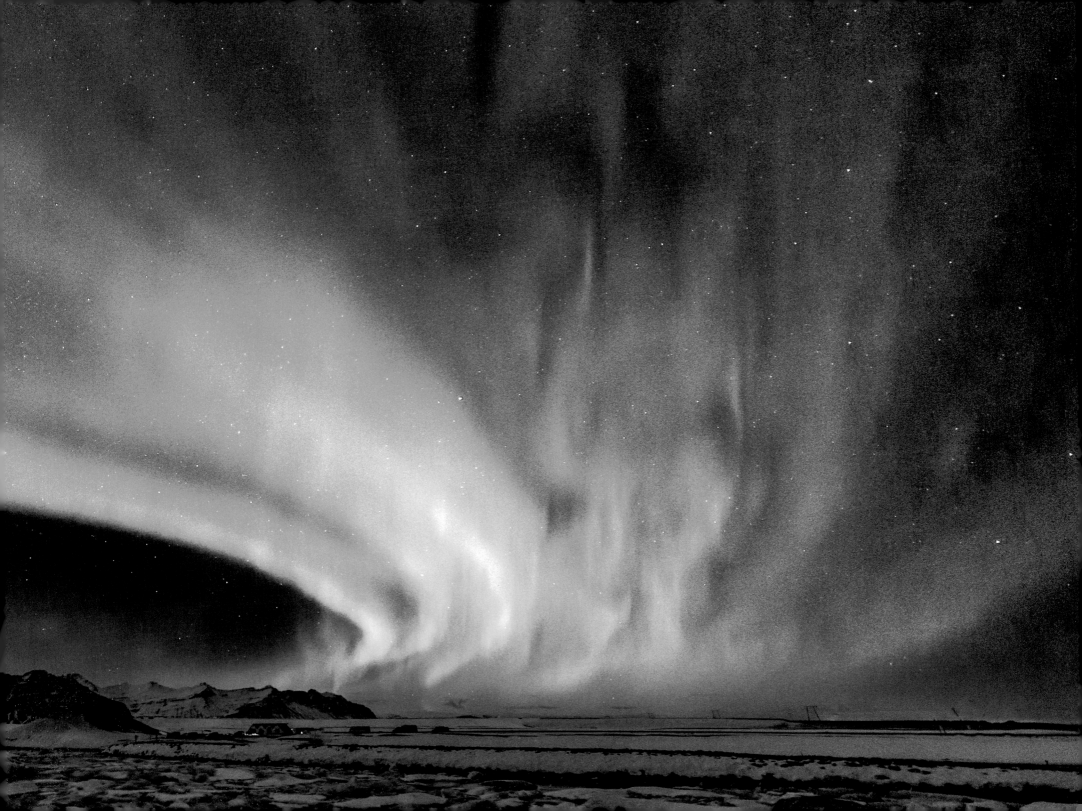

VERDENS ENDE, NORWAY

At 'World's End', on the southernmost promontory
of the island of Tjøme, is a replica of a *vippefyr*, or
tipping lantern. Functioning as a lighthouse, these
lanterns were erected along Norway's coasts in the 17th
and 18th centuries. Wood or coal was burned in the
basket. Tjøme and the surrounding ocean, islands and
islets of the outer Oslofjord lie in the Faerder National
Park. Diverse marine environments are protected
here, including kelp forest and eelgrass meadow.

BERGSFJORD, NORWAY

The island of Senja, in Norway's most northerly county,
Troms og Finnmark, is far inside the Arctic Circle.
According to Norwegians, the island's landscape offers
'Norway in miniature'. Along Senja's heavily fjorded
western coast, rugged mountains rise steeply from
the sea. The eastern side offers softer vistas, with
rounded, forested hills and farmland. The island's
inhabitants make much of their living from fishing,
particularly for halibut, potato-growing and tourism.

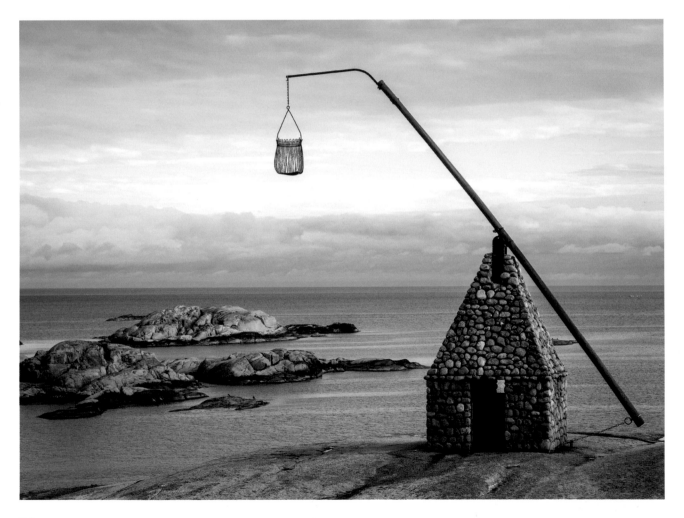

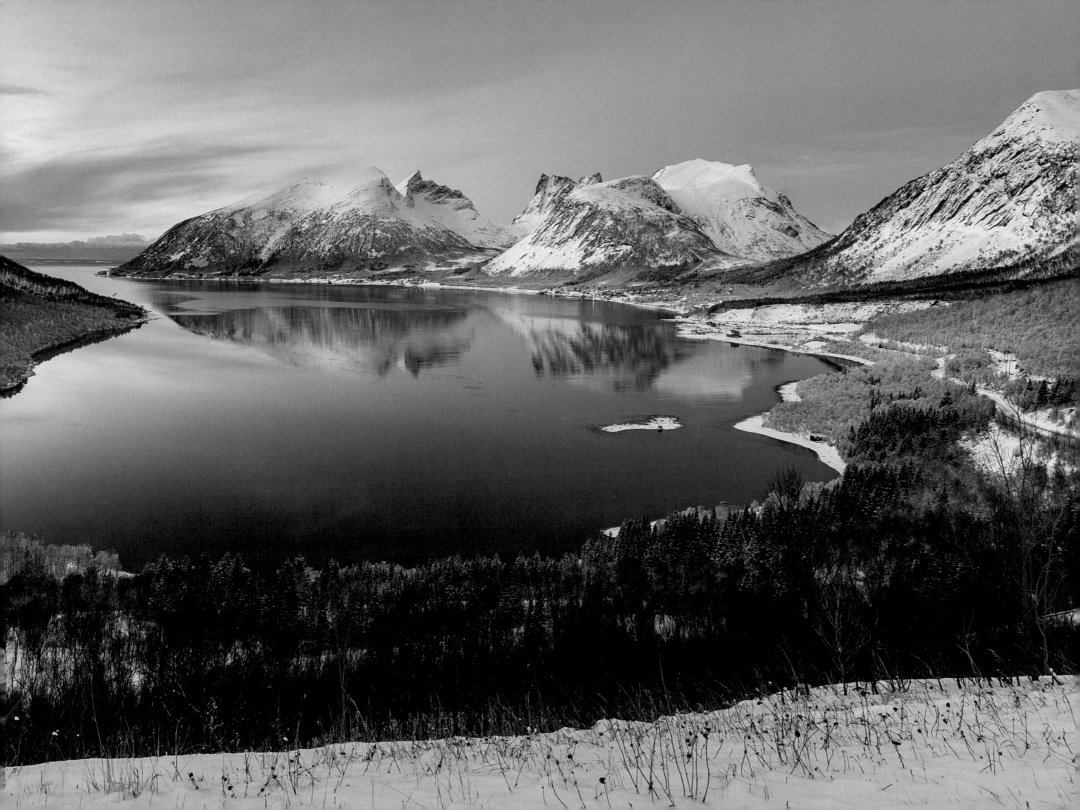

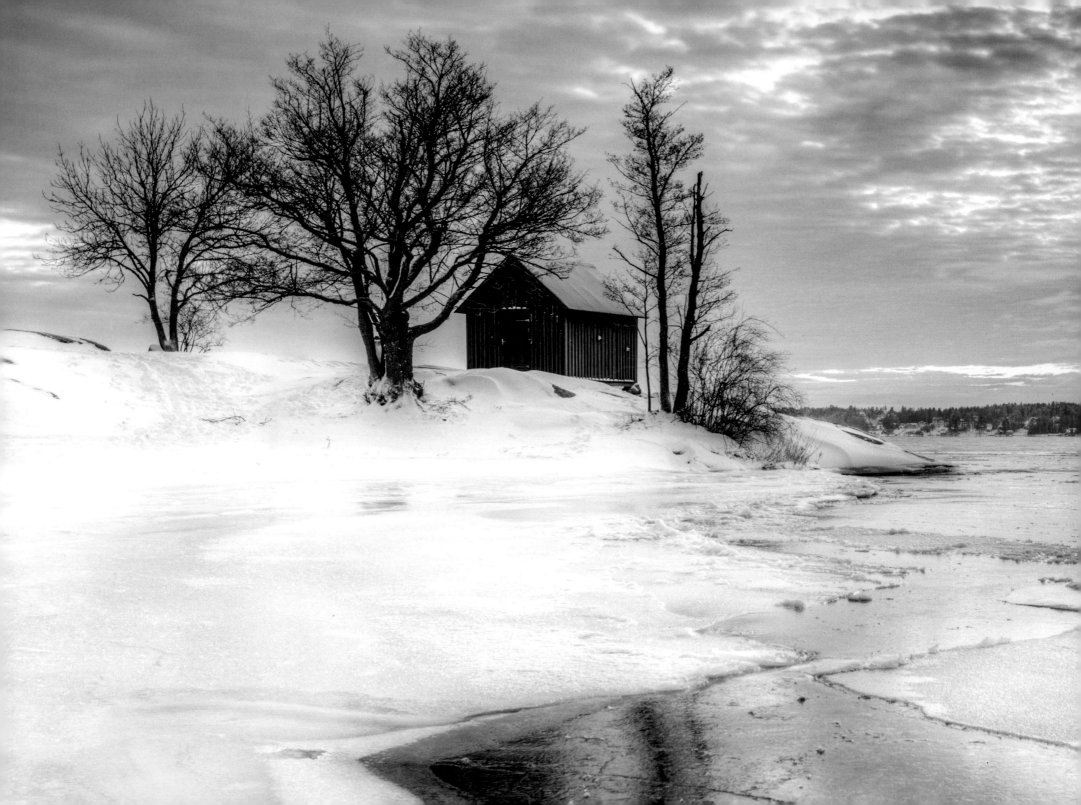

STOCKHOLM ARCHIPELAGO, SWEDEN

Off the coast around Stockholm, an archipelago of 30,000 islands and islets is scattered over the Baltic Sea, the largest of them reached by ferry from the capital. The islands are home to around 50,000 holiday cottages, mostly owned by Stockholmers, the simplest just single-room red cabins. ABBA's Björn Ulvaeus and Benny Andersson wrote many of their songs in a cabin here.

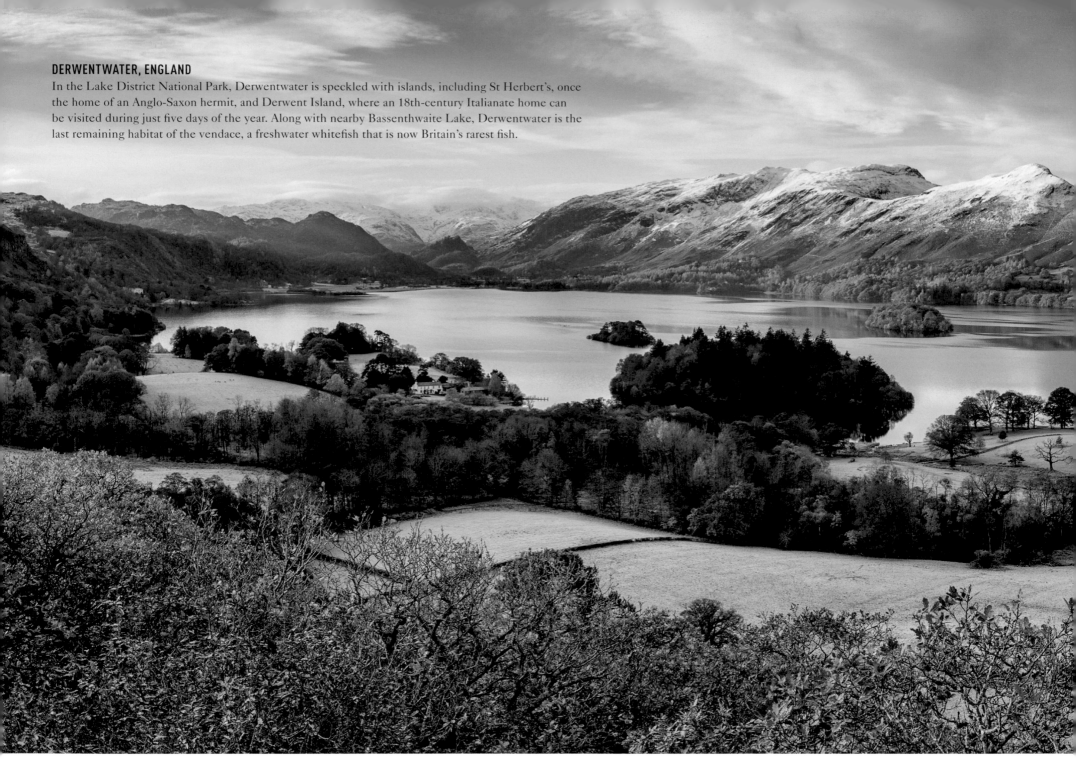

DERWENTWATER, ENGLAND

In the Lake District National Park, Derwentwater is speckled with islands, including St Herbert's, once the home of an Anglo-Saxon hermit, and Derwent Island, where an 18th-century Italianate home can be visited during just five days of the year. Along with nearby Bassenthwaite Lake, Derwentwater is the last remaining habitat of the vendace, a freshwater whitefish that is now Britain's rarest fish.

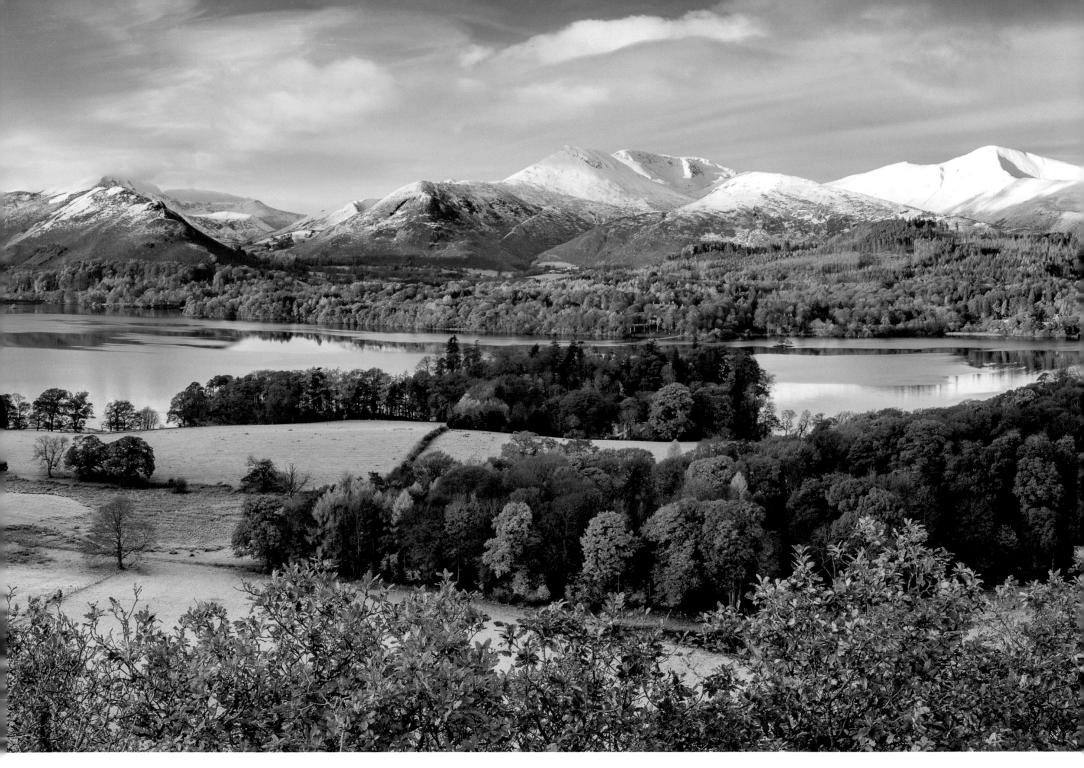

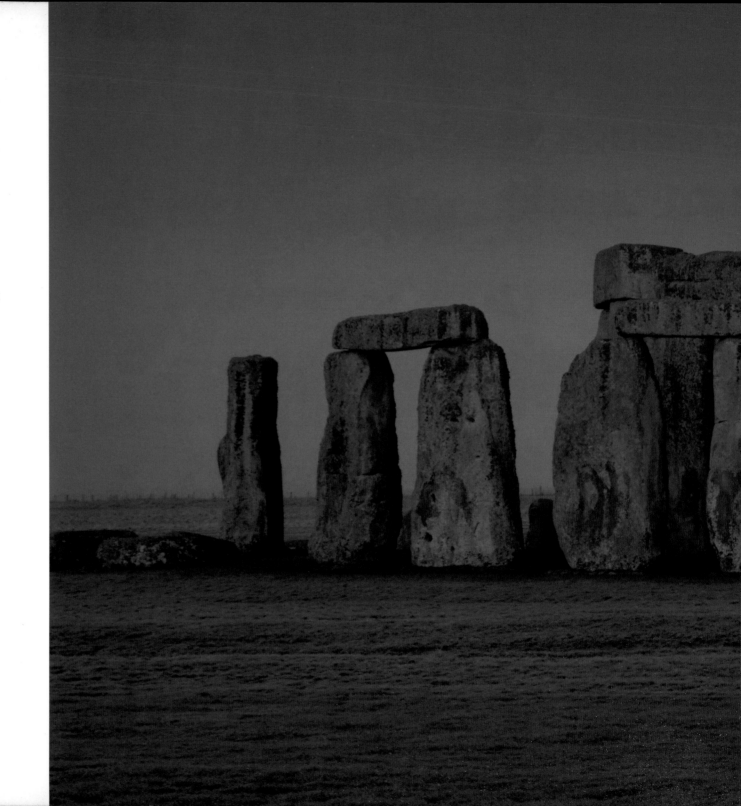

STONEHENGE, ENGLAND

On the chalk plateau of Salisbury Plain are the standing stones, earthworks and burial mounds of Stonehenge, constructed in stages between 3000 and 2000 BCE. Since the people who built the henge left no written records, the structure's purpose remains the subject of intense debate. Whether the site was a place of worship, sacrifice or healing, it is certain that immense effort was taken to transport stones weighing up to 25 tons, probably by rolling them on tracks of logs.

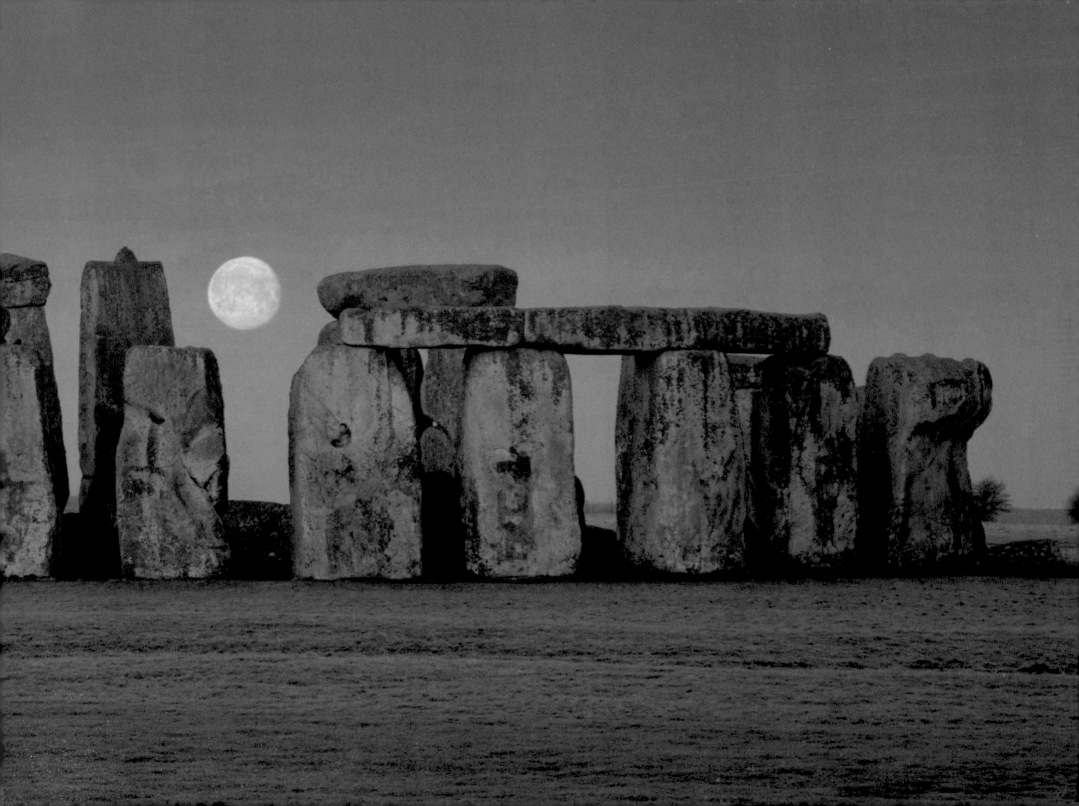

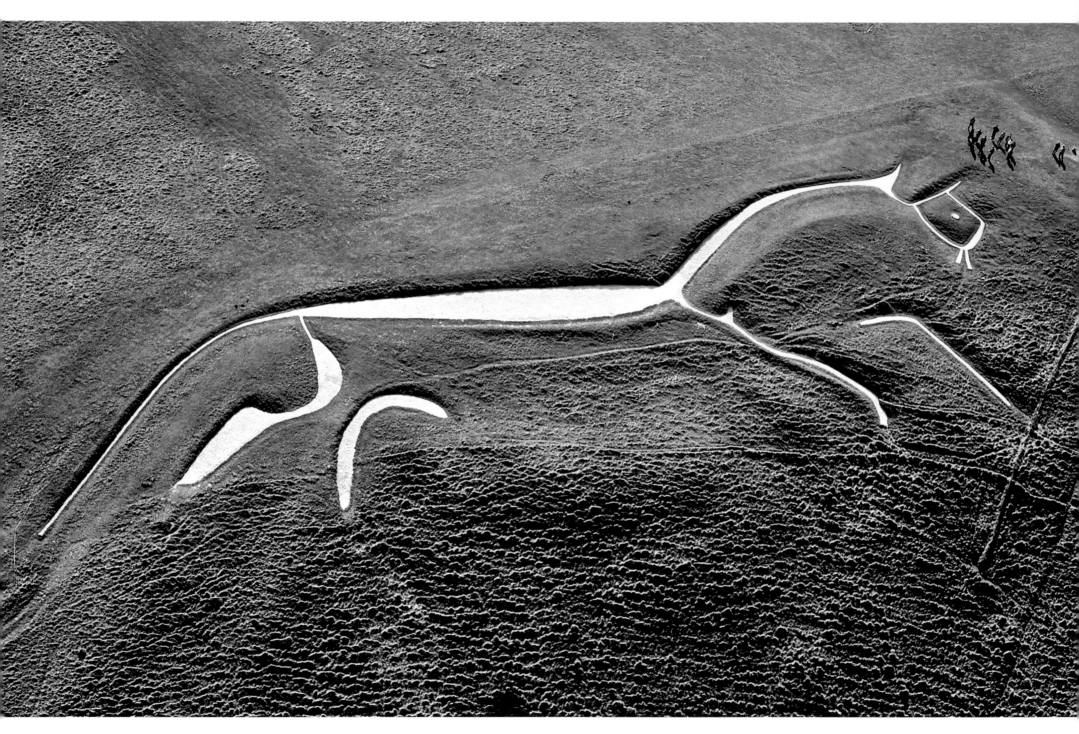

UFFINGTON WHITE HORSE, ENGLAND

Around 110 m (360 ft) long, this minimalist artwork was made by filling trenches with crushed white chalk. Excavations suggest the figure was made between 1380 and 550 BCE, perhaps by the same tribe that built the nearby Iron Age hill fort known as Uffington Castle. Although there is debate that the animal is truly a horse, it is similar in design to horses seen on Celtic coins. At midwinter, the sun seems to overtake the horse, perhaps relating it to beliefs that the sun was carried across the sky by a horse.

PEAK DISTRICT NATIONAL PARK, ENGLAND

The Peak District is dotted with tors of millstone grit, outcrops of coarse sandstone that have eroded more slowly than the surrounding rocks. Hathersage Moor (pictured) inspired the setting of Charlotte Bronte's *Jane Eyre*, after she stayed at Hathersage vicarage in 1845. The village's North Lees Hall was probably the model for Mr Rochester's Thornfield Hall.

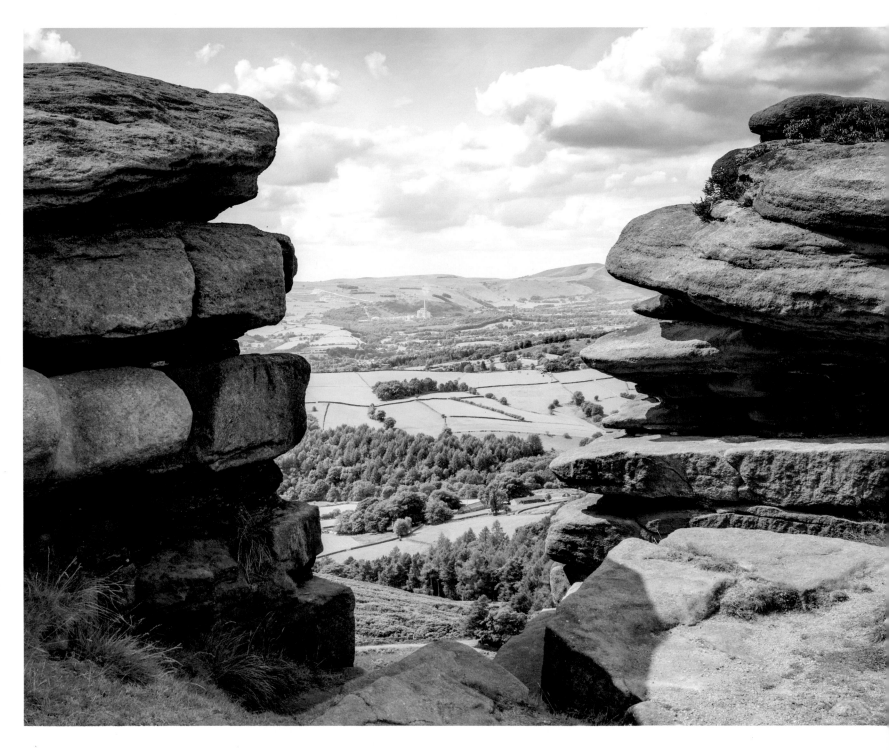

CASTELL Y GWYNT, SNOWDONIA NATIONAL PARK, WALES

The 'Castle of the Winds' is near the summit of
Glyder Fach in Snowdonia. The spiky rock outcrop
was an entrance to the dragon's lair in the 1981 film
Dragonslayer. Snowdonia is known as Eryri in Welsh,
surprisingly from the Latin '*oriri*' (to rise). The national
park contains the United Kingdom's highest peaks
outside Scotland, including Snowdon itself, which reaches
1,085 m (3,560 ft) above sea level. Its summit is reached
by hike or the easier Snowdon Mountain Railway.

EILEAN DONAN CASTLE, SCOTLAND

Eilean Donan is a small tidal island, now permanently
connected to the mainland by stone bridge, that lies at the
meeting point of Loch Duich, Loch Long and Loch Alsh,
in the western Highlands. The island's earliest fortifications
were built in the 13th century, but the castle was almost
entirely destroyed in 1719 during the Jacobite Risings.
The building was reconstructed in the early 20th century,
following the existing ground plan but more a romantic
re-imagining of a medieval castle than the original artefact.

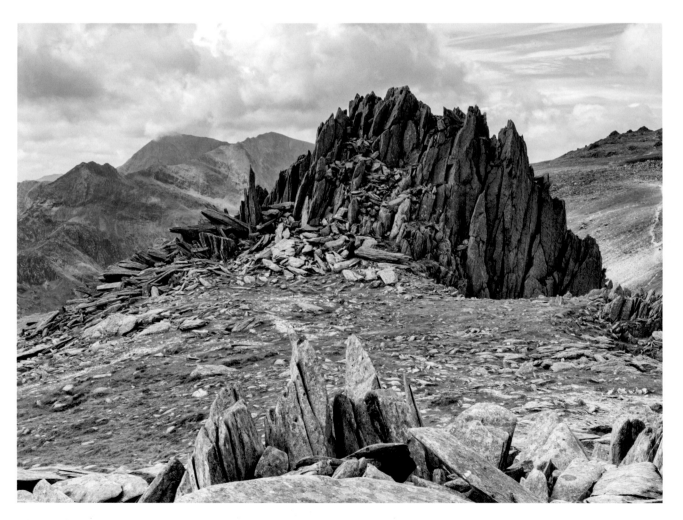

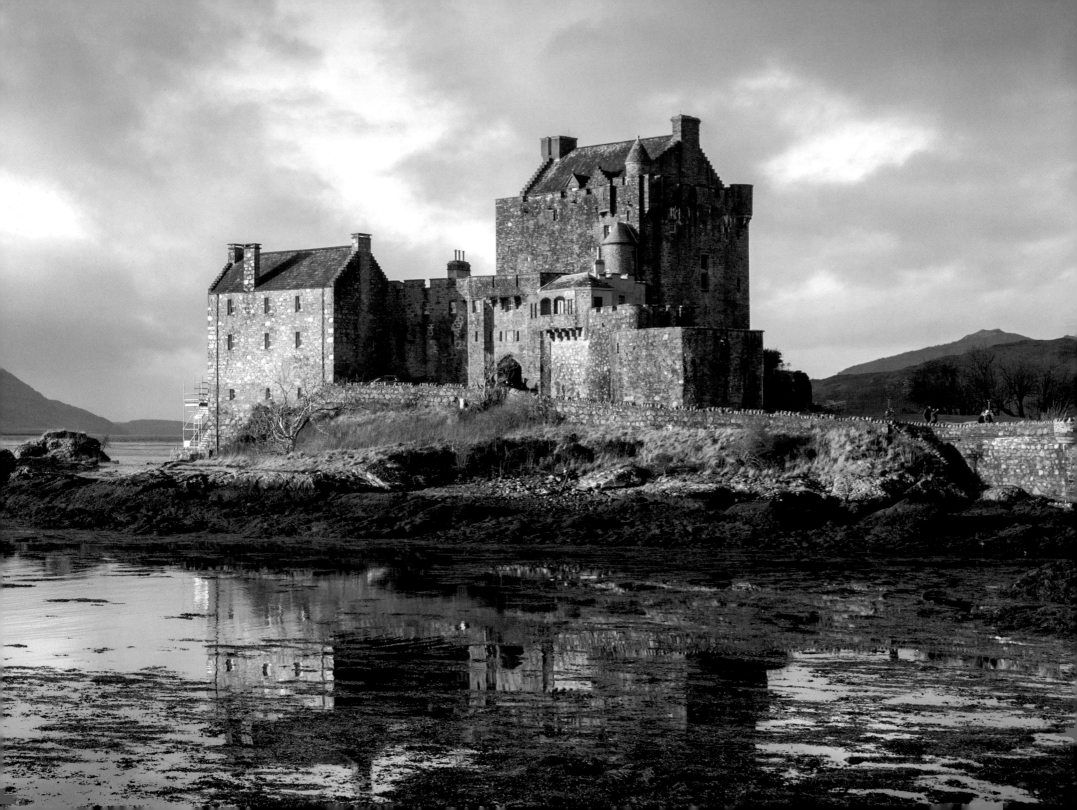

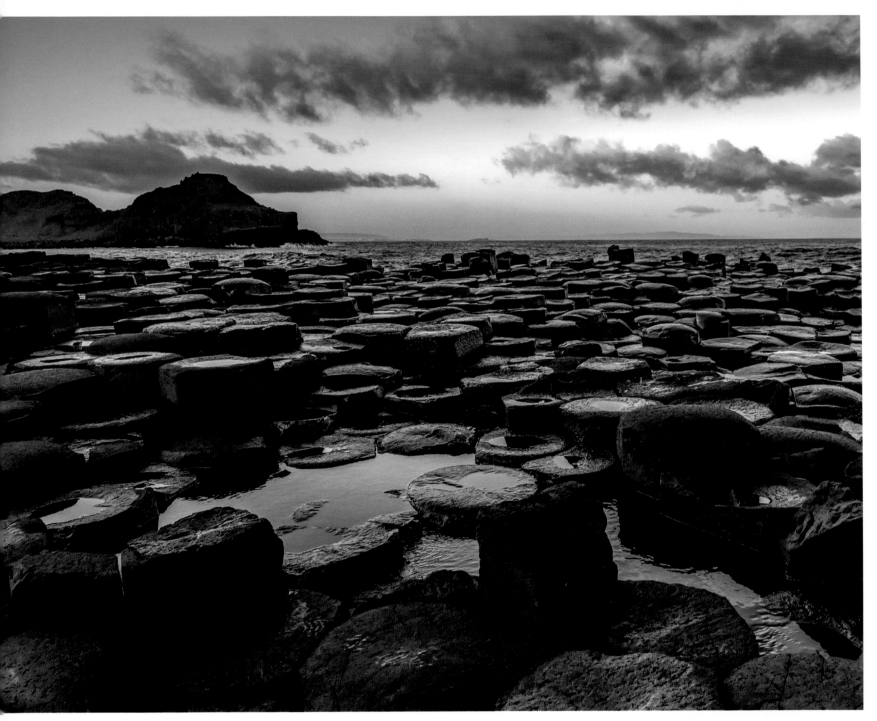

GIANT'S CAUSEWAY, NORTHERN IRELAND

The Giant's Causeway is made up of around 40,000 basalt columns. Most of the columns are hexagonal, but some have four, five, seven or eight sides. The columns formed 50 to 60 million years ago, after immense quantities of basaltic lava flowed out of a fissure vent. As the lava cooled, it hardened and shrank, a network of spreading cracks forming a regular pattern. However, legend tells us that the causeway was thrown down by the giant Finn McCool.

KINDERDIJK, NETHERLANDS

In 1738–40, 19 windmills were built to drain water from the Alblasserwaard polder. This low-lying region had been reclaimed from the water during the Middle Ages, through the building of canals and dikes, but was at continual risk of flooding. The windmills pumped water into a reservoir, from where it was released into the River Lek when its level was low enough. Today, the work is done by two diesel-powered pumping stations close to the windmills.

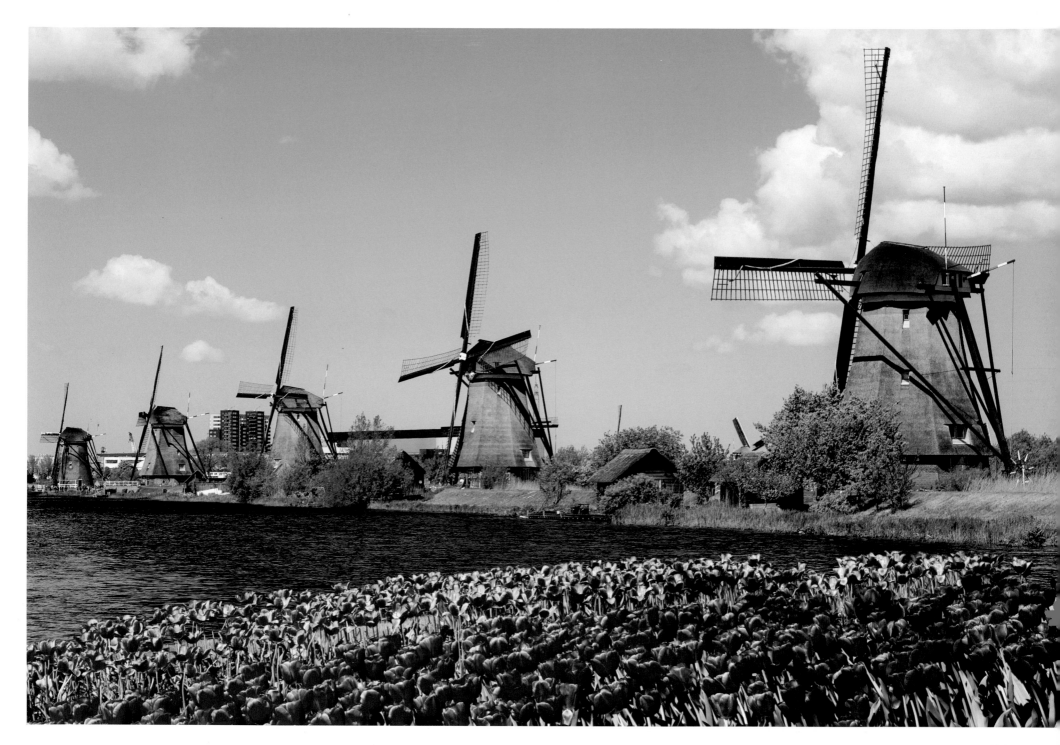

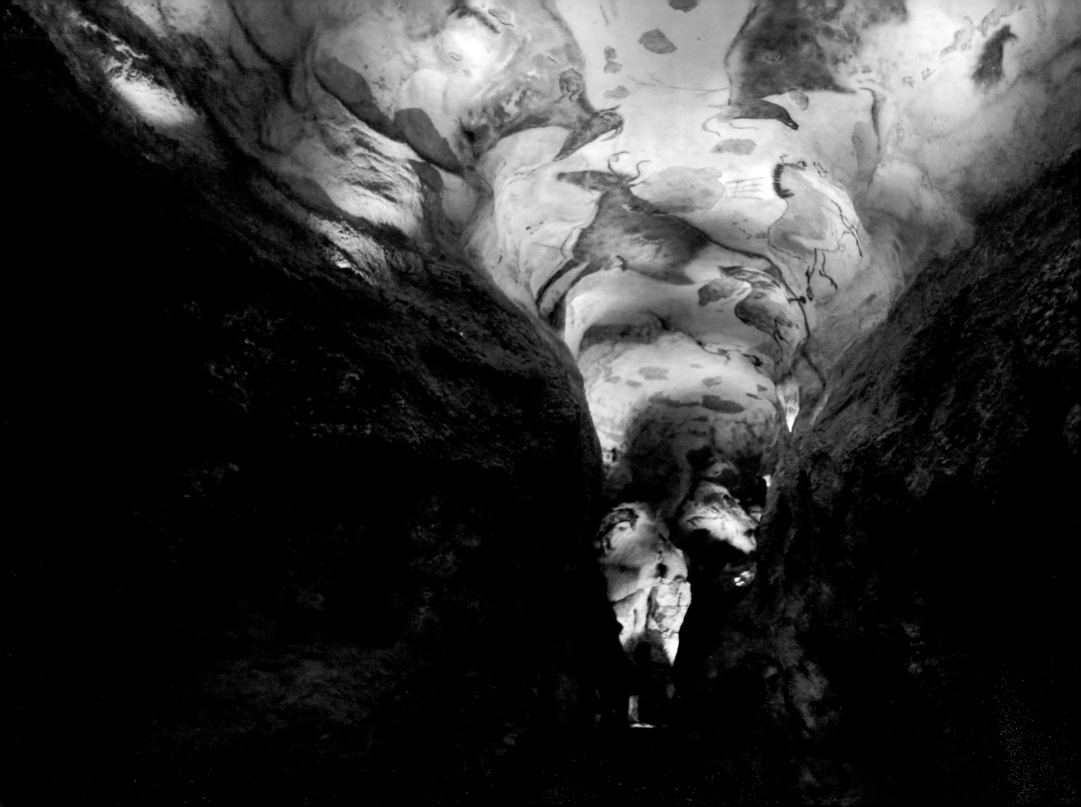

LEFT
LASCAUX CAVES, FRANCE

More than 600 paintings, including nearly 6,000 figures, cover the walls and ceilings of a cave complex near the village of Montignac, Dordogne. The pictures date from around 17,000 years ago, but were the work of many generations of artists. Most of the paints used were red, yellow and black, made from pigments such as iron oxide, haematite and goethite. The most frequently depicted animals are horses, bulls and deer.

BELOW
MONT-ST-MICHEL, FRANCE

Just off the coast of Normandy, this tidal island is crowned by its soaring abbey, begun in the 8th century but today a fairytale mix of Romanesque and Gothic features. The abbey ramparts offer views across the mudflats and along the coast. Walkers should beware the tides, said to rise as fast as a galloping horse. The fortress town at the abbey's feet is a maze of winding cobbled streets, where the famous Mont-St-Michel omelette can be tried.

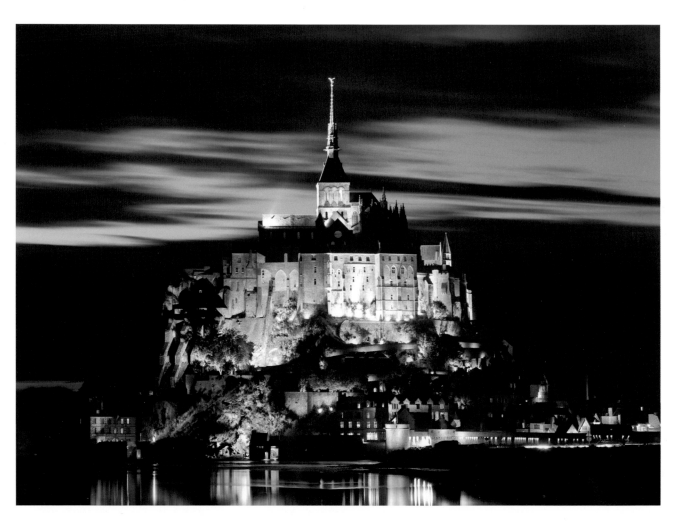

CAMARGUE HORSES, FRANCE

For centuries, probably longer, these hardy, short horses have lived wild in the Camargue wetlands of the Rhône delta. This ancient horse breed, always with a grey coat, is related to Iberian horses from the northern regions of the peninsula. Despite being no more than 150 cm (59 in) tall at the withers, Camargue horses are strong enough to be the mounts of the *gardians*, who herd the black Camargue bulls used in bullfighting.

BIARRITZ, FRANCE

In the French Basque Country, Biarritz rose to fame during the 19th century, when European royalty, aristocrats and actors flocked to its Belle Epoque hotels, baths and casinos. The city has six beaches, from the packed and pricey Grande Plage to the surfer's paradise of Plage Marbella. The quieter Plage de la Milady is popular with locals who know when to avoid the breakers that pound the shoreline at high tide.

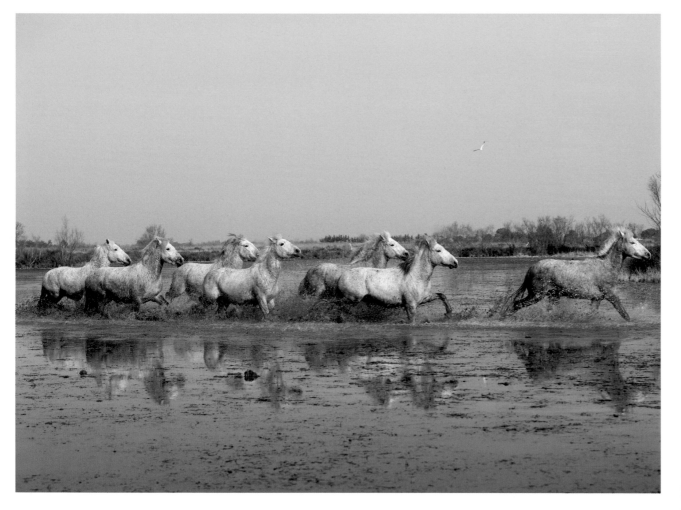

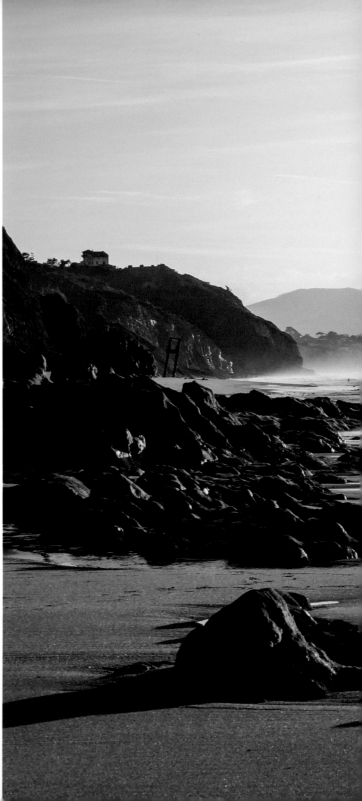

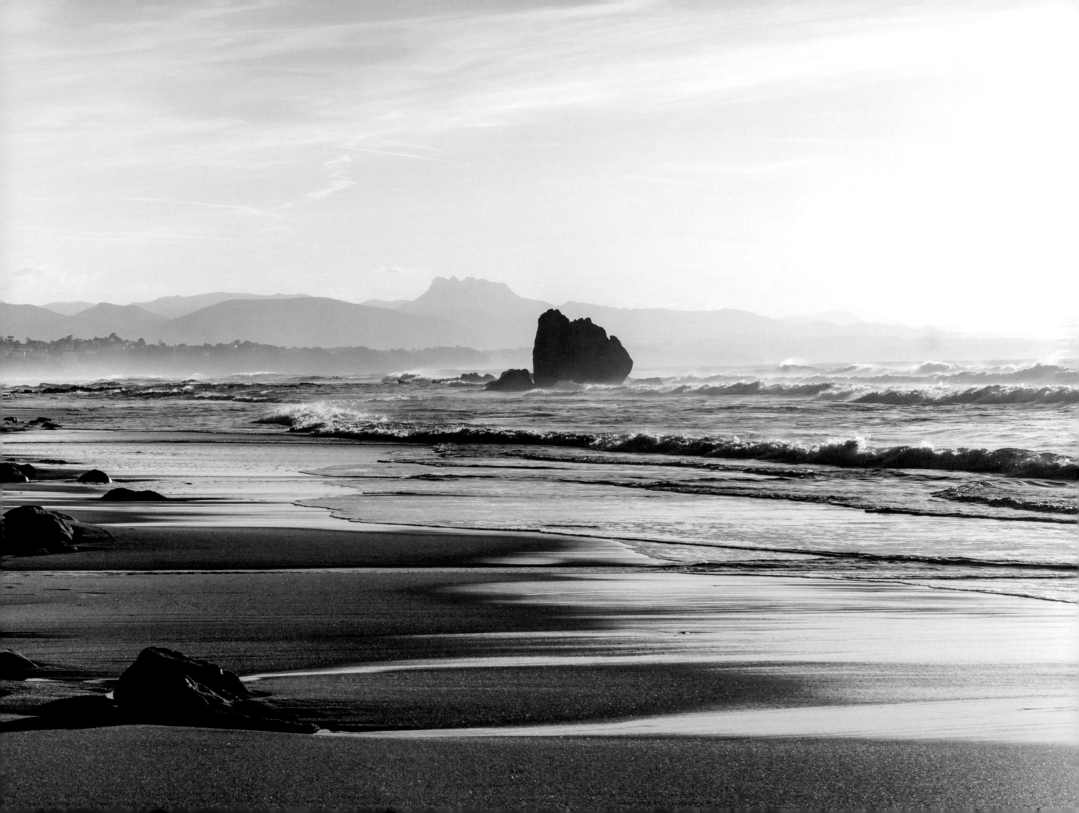

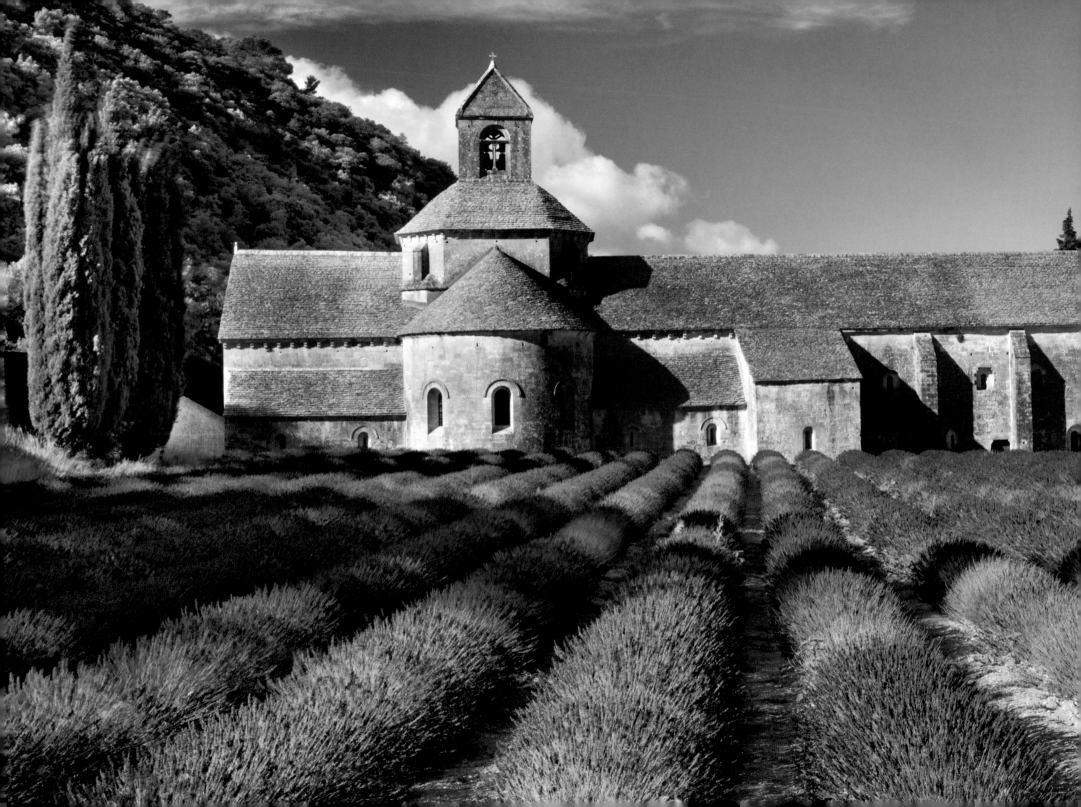

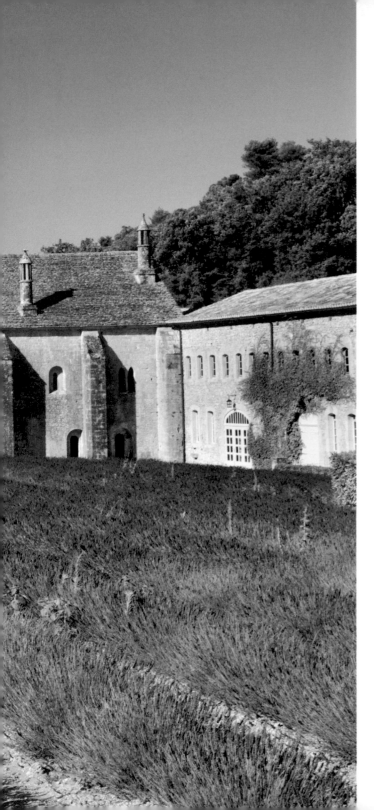

LEFT
SÉNANQUE ABBEY, FRANCE

The Cistercian abbey of Notre-Dame de Sénanque was founded in 1148, with many of its Romanesque buildings dating from the late 12th century. The abbey is home to a community of monks who make a living by growing lavender and keeping bees. Lavender may have been brought to France by traders around 600 BCE, but it was the Romans who named the plant, from the Latin '*lavare*' (to wash), and learned how to extract its oil. They used it to scent their baths and for its medicinal properties.

RIGHT
CLIFFS OF ÉTRETAT, FRANCE

Up to 90 m (300 ft) high, the cliffs at Étretat, in Normandy, are marked by layers of Cretaceous chalks. Chalk forms when countless calcite shells, belonging to micro-organisms called coccolithophores, pile up on the seafloor. After being compressed by additional sediment, the shells cement into rock. Chalk erodes easily as waves pound the coast, a process that has formed Étretat's natural arches and L'Aiguille ('The Needle').

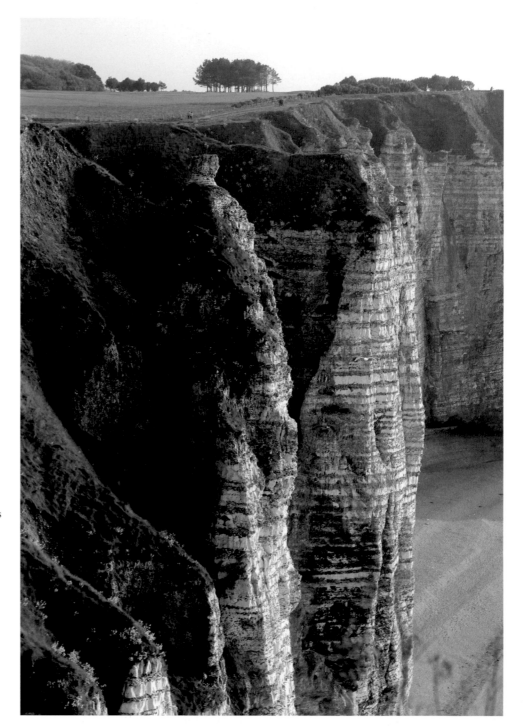

BELOW

CAP DE FORMENTOR, MALLORCA, SPAIN

This rocky headland, home to the highest lighthouse in the Balearic Islands, is the most northerly point of the island of Mallorca. Visitors travel from across the world to swim in the turquoise waters of Mallorca's pine-wrapped coves, while cyclists and hikers head for the limestone bluffs and spires of the ruggedly beautiful Serra de Tramuntana mountain range. In January and February, white and pink almond blossom covers the landscape like snow. The almonds will be baked in *gato d'ametlla*, the sweet, soft almond cake.

RIGHT

ALTAMIRA CAVE, SPAIN

The earliest art in this 1-km (0.6-mile) cave is believed to be 36,000 years old. The artists used charcoal, ochre and haematite to portray local animals, such as bison, horses and deer. To create the illusion of movement and depth, the artists not only worked with different dilutions of paint but used the curves and dips of the walls. To preserve the art from damage inflicted by visitors' breath, the cave is now closed to the public. A replica of the cave and art can be explored in the neighbouring museum.

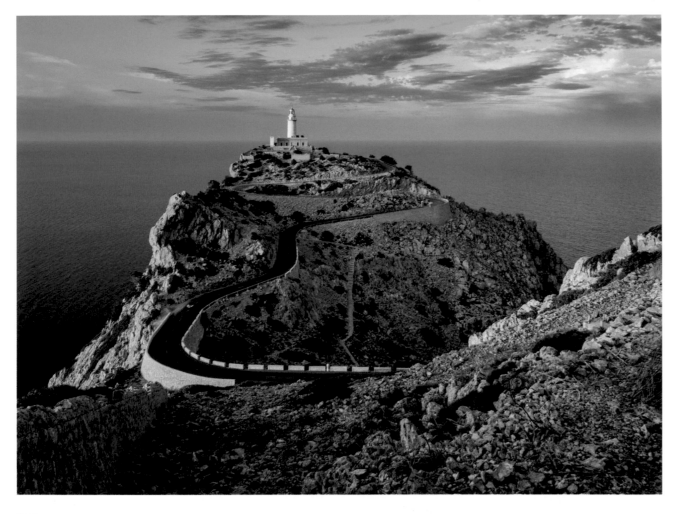

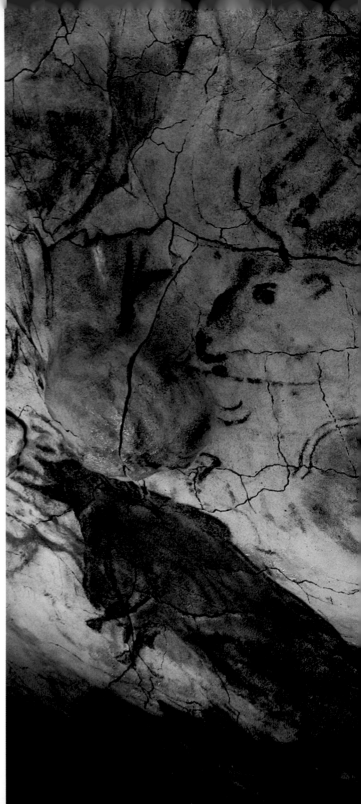

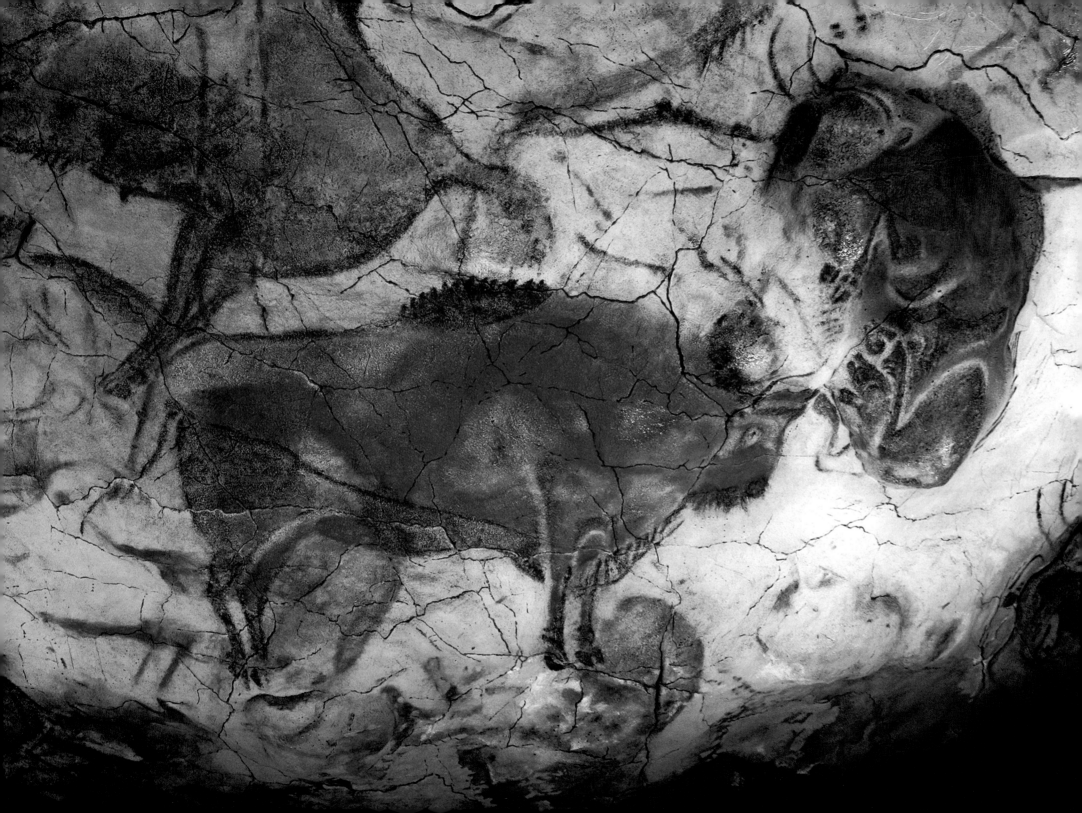

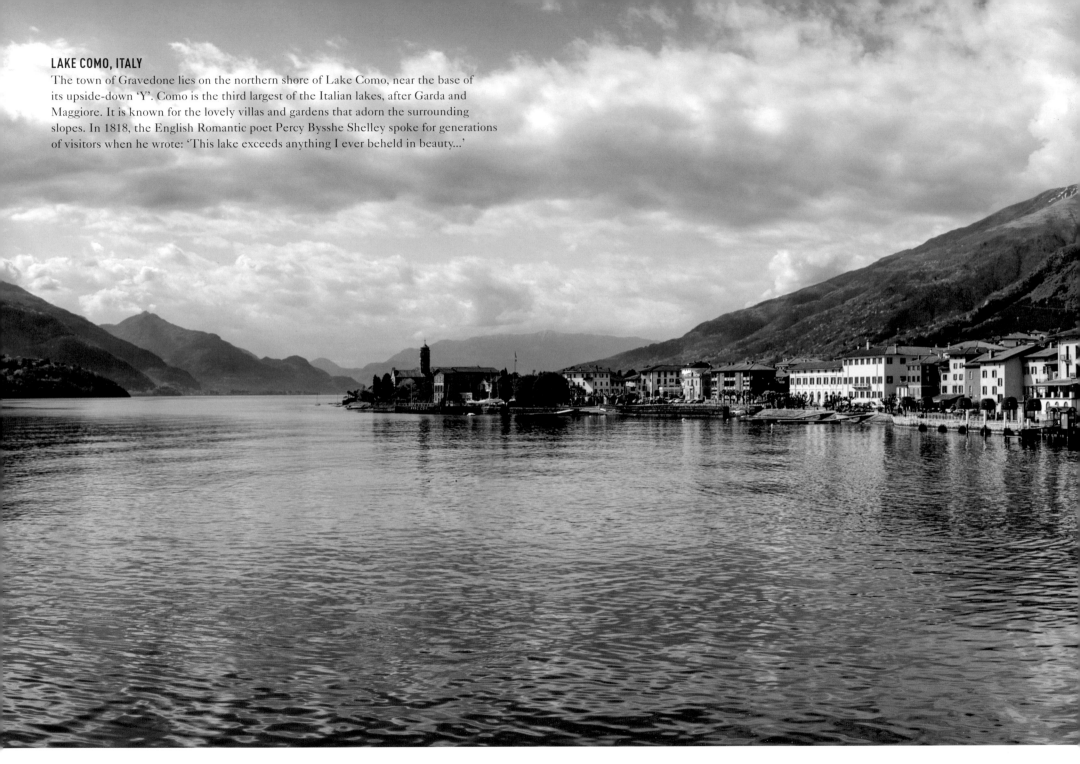

LAKE COMO, ITALY

The town of Gravedone lies on the northern shore of Lake Como, near the base of its upside-down 'Y'. Como is the third largest of the Italian lakes, after Garda and Maggiore. It is known for the lovely villas and gardens that adorn the surrounding slopes. In 1818, the English Romantic poet Percy Bysshe Shelley spoke for generations of visitors when he wrote: 'This lake exceeds anything I ever beheld in beauty...'

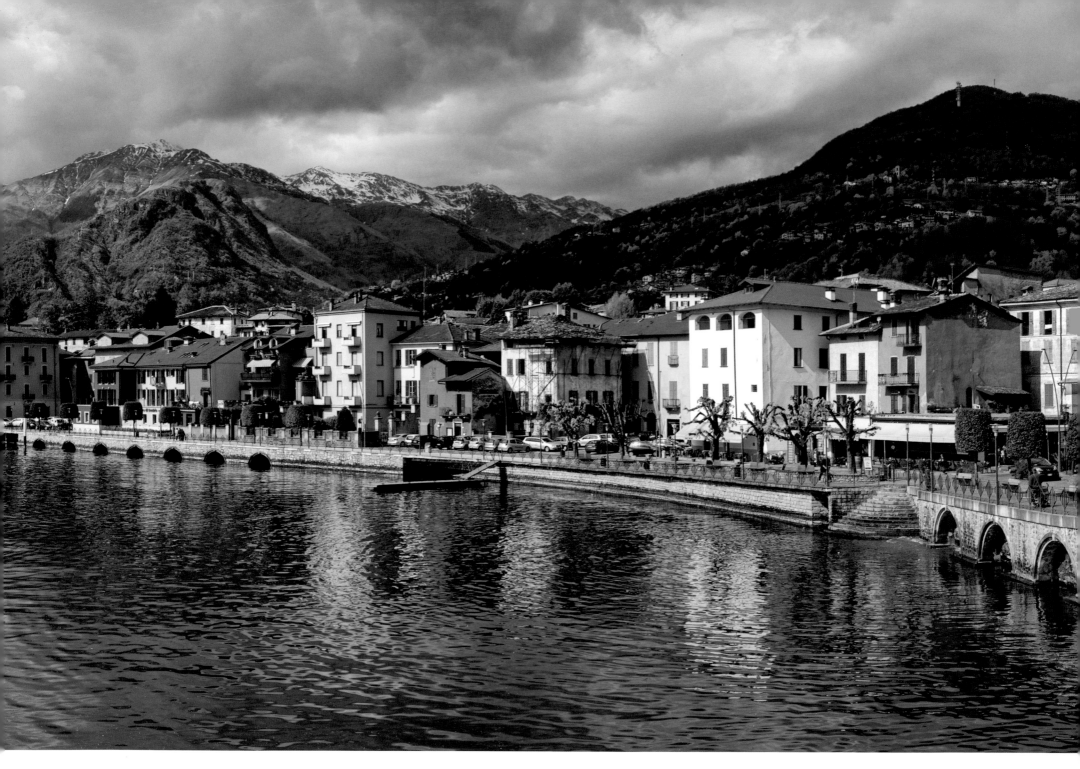

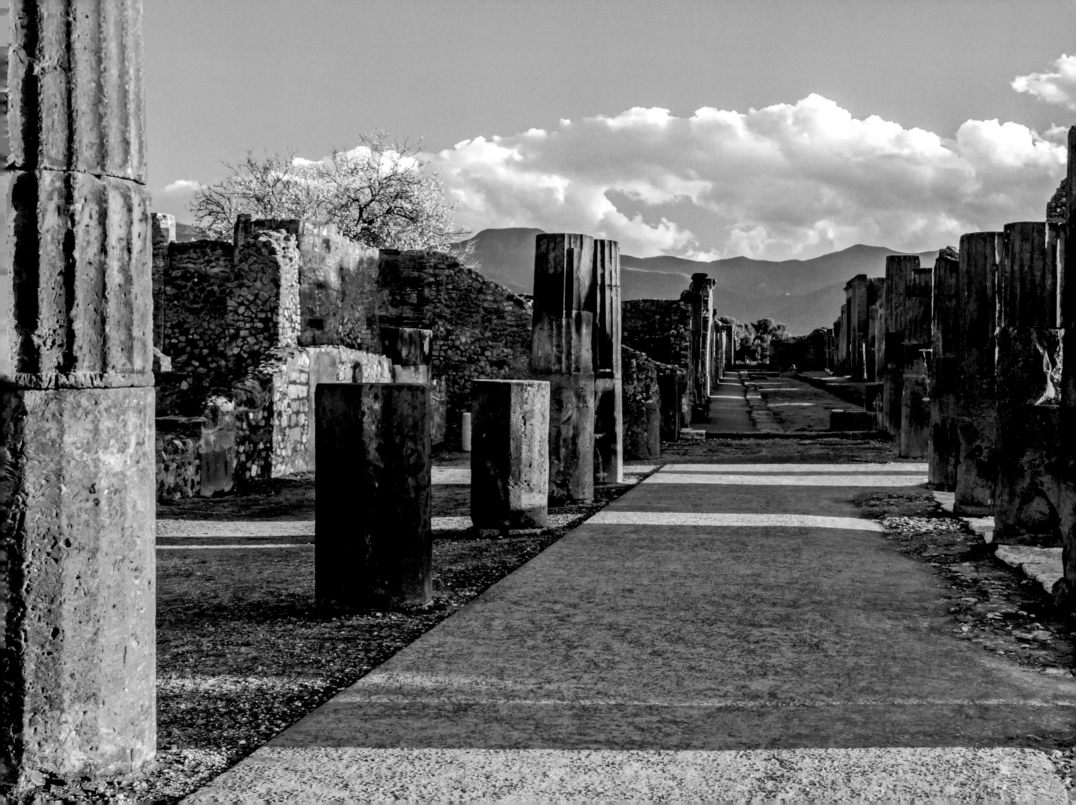

POMPEII, ITALY

At the foot of Mount Vesuvius, the wealthy Roman town and port of Pompeii was buried under volcanic ash and pumice during the volcano's devastating eruption of 79 CE. Protected from air and moisture for 1,500 years before their excavation, the town's temples, amphitheatre, baths, barracks, shops and homes, many still decorated with mosaics and wall paintings, bring Roman life hauntingly to life.

ORCIA VALLEY, TUSCANY, ITALY

Tuscany's rolling hills are carpeted by potato fields, olive groves and vineyards, many of them growing Sangiovese grapes. Cypress trees cluster around stone farmhouses. South of Siena, the Orcia Valley is a UNESCO World Heritage Site thanks to its iconic landscapes, depicted by Renaissance painters of the Sienese school. Paintings of the valley helped fortify Renaissance ideas about the harmony of man and nature.

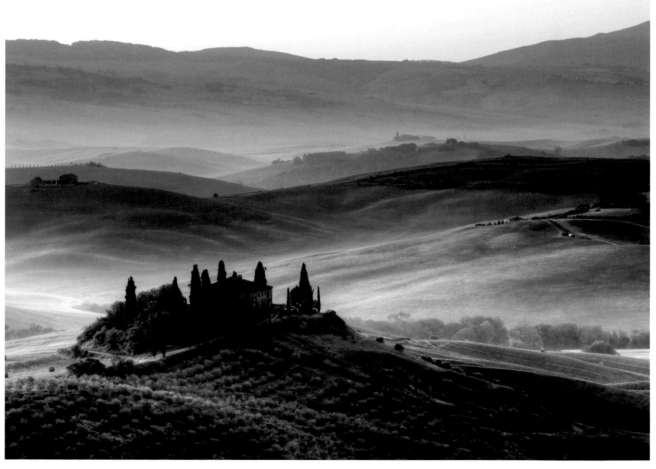

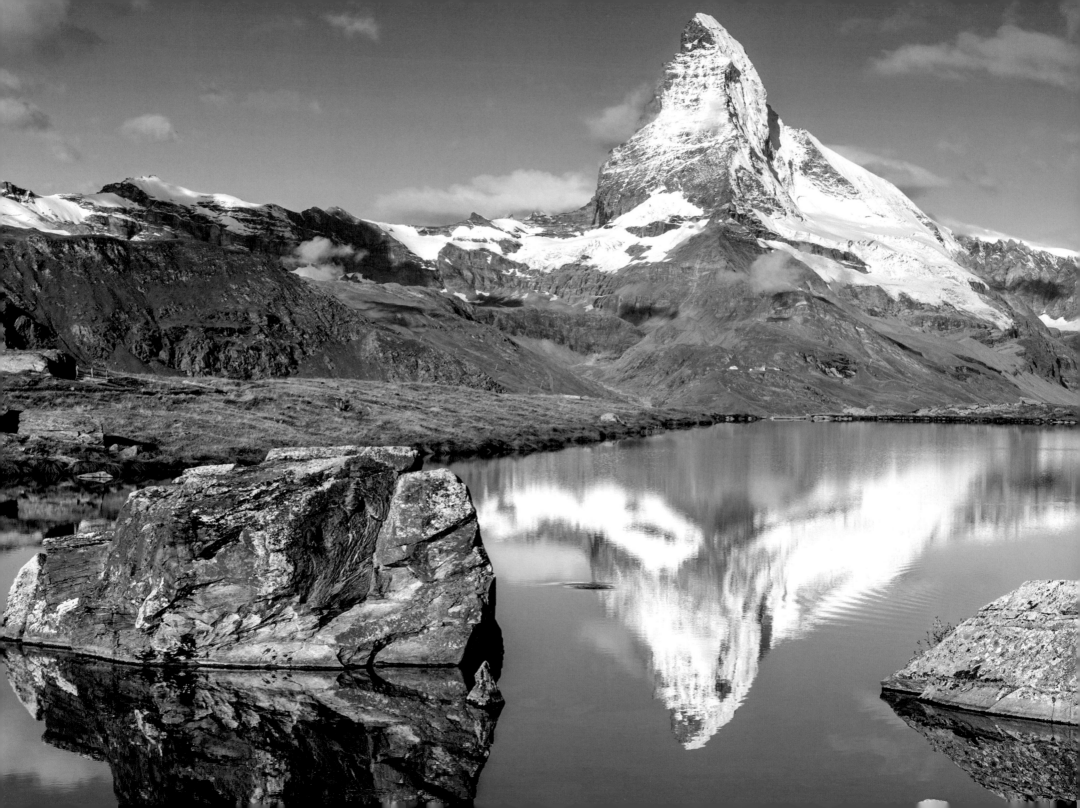

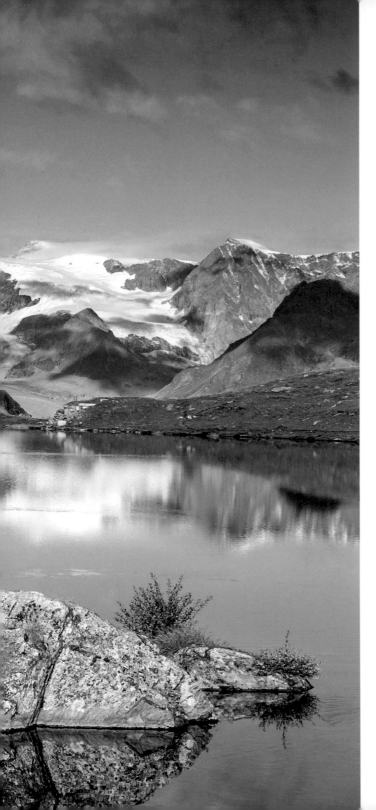

MATTERHORN, SWITZERLAND–ITALY

Reflected in the Riffelsee lake, the Matterhorn's gneiss peak is 4,478 m (14,692 ft) high. It owes its pyramidal shape to glaciers that diverged from the peak, gouging out four faces that are nearly aligned with the four points of the compass. These faces are too steep to accumulate much snow, which falls in regular avalanches to the glaciers below. The Matterhorn was not successfully climbed until 1865, although four of the seven summiteers died on their descent.

KUGELBAKE, WADDEN SEA FLATS, GERMANY

On a sandy promontory in the city of Cuxhaven is the Kugelbake ('Ball Beacon'), a wooden navigational aid that stands about 30 m (100 ft) high. It is positioned where the River Elbe flows into the North Sea, beside a busy shipping lane. The first Kugelbake was erected here in 1703 and has been replaced many times since, due to the constant battering by wind and water. The current structure was built at the end of World War II. Every night, a fire was lit in the structure's basket, guiding mariners through the estuary.

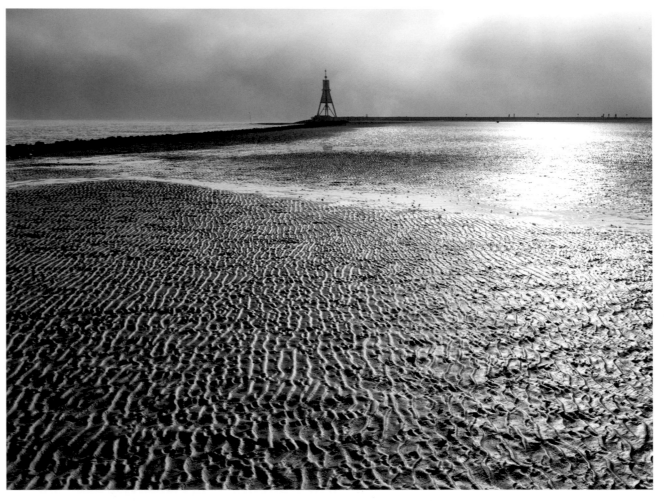

BLACK FOREST, GERMANY

This forested, mountainous region of southwestern Germany is bounded to the west and south by the Rhine. The rounded peak of Feldberg is the region's highest point, reaching 1,493 m (4,898 ft). Despite many historical episodes of clearance, the Black Forest's conservation areas are thick with Scots pine, oak, beech and elm, alongside *grinde*, which are treeless expanses of wet heathland that have been created by grazing cattle since the 14th century.

BASTEI, ELBE SANDSTONE MOUNTAINS, GERMANY

Straddling the border with the Czech Republic, the Elbe Sandstone Mountains are known for their many erosional features, including mesas, pillars, chimneys, caves and ravines. At Bastei, rock pillars rise 194 m (636 ft) above the Elbe River. The fingers were sculpted by water over the last few million years. In 1851, a sandstone bridge was built to link some of the pillars for the benefit of the growing tourist industry.

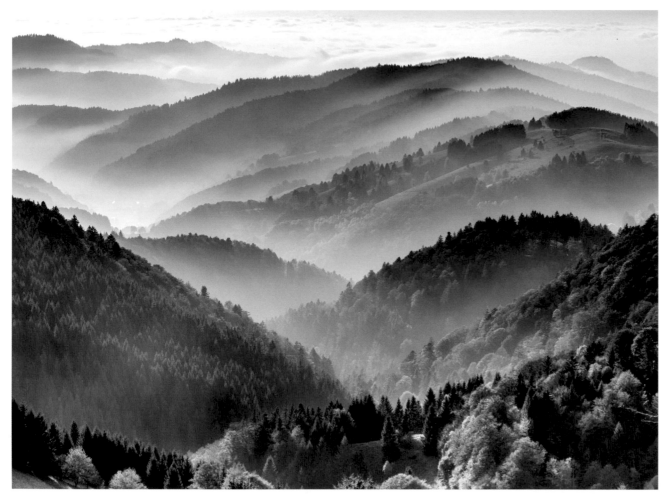

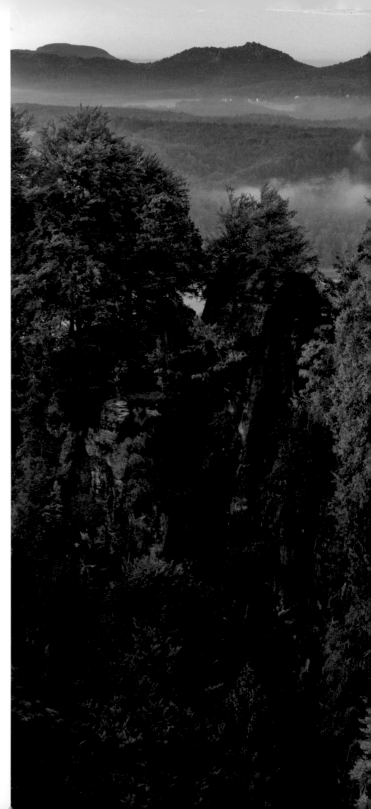

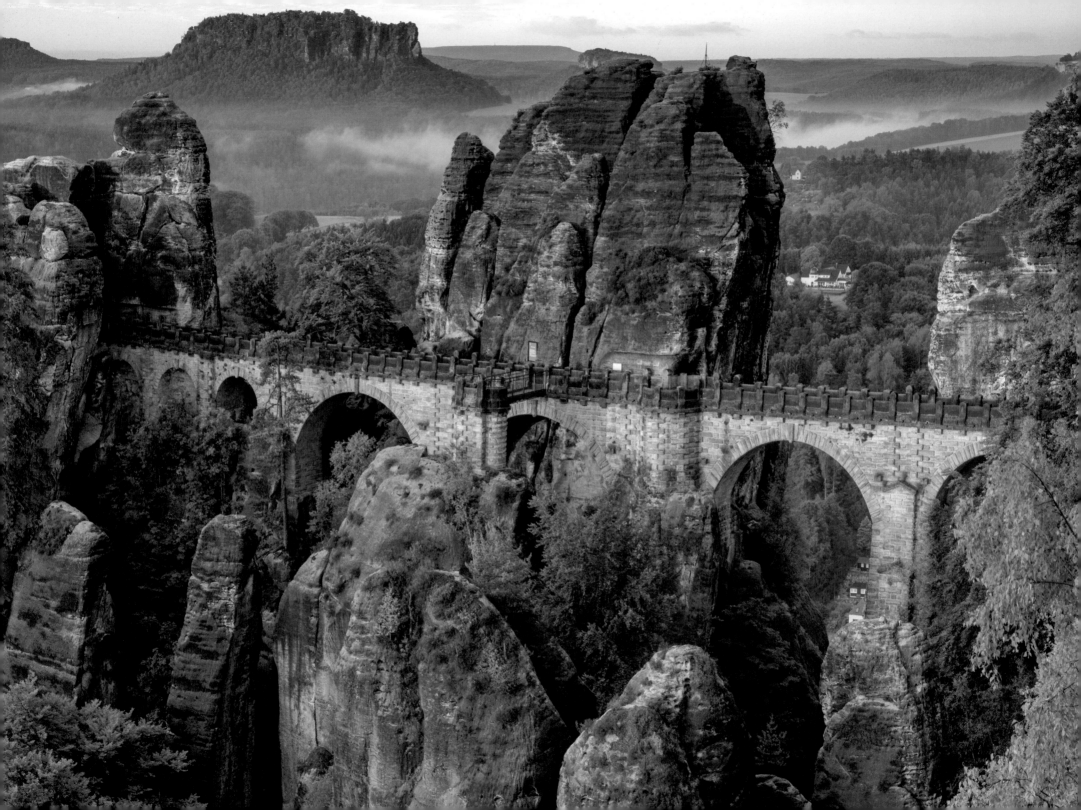

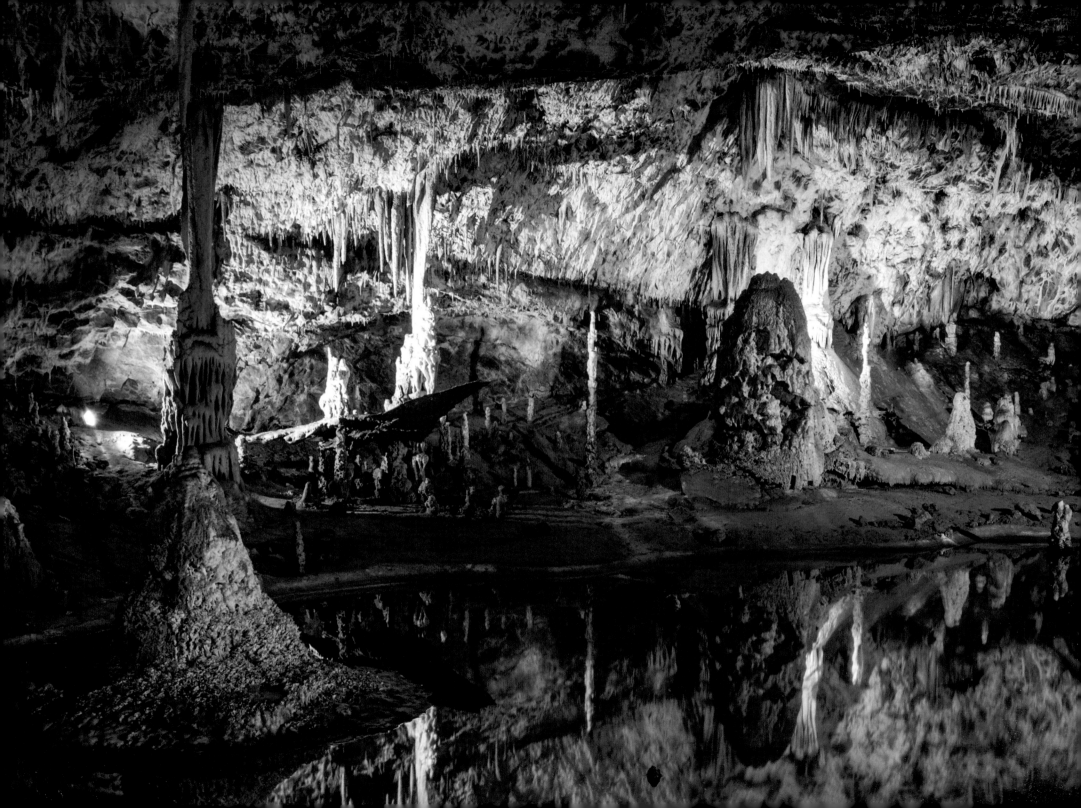

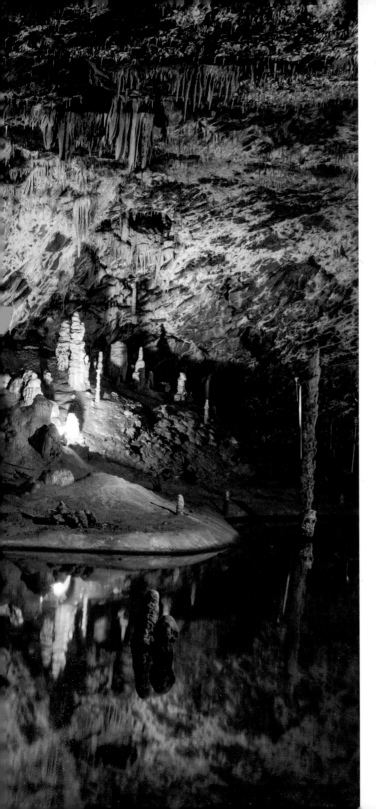

PUNKVA CAVES, CZECH REPUBLIC

The Punkva River flows through the Punkva Caves system in the Moravian Karst region. The river enters the caves at the Macocha Abyss, a sinkhole 138 m (453 ft) deep, made when a cave roof collapsed. Karst features, which form in areas of limestone and similar rocks, are a result of the acidity of rain and groundwater, after it has absorbed carbon dioxide from the air. Over thousands of years, water can dissolve the rock into caves, where stalactites grow from mineral-rich drips.

TATRA MOUNTAINS, POLAND

Close to the border with Slovakia, the Kasprowy Wierch peak is a popular destination for winter sports. The Tatras are the highest range, reaching 2,655 m (8,711 ft), in the wider Carpathian Mountains. On the tallest peaks, vegetation is sparse, consisting mostly of lichens. On the lower slopes are forests of mountain pine and spruce, home to the critically endangered Tatra chamois. Lower still is Carpathian beech forest, where red and roe deer can be found.

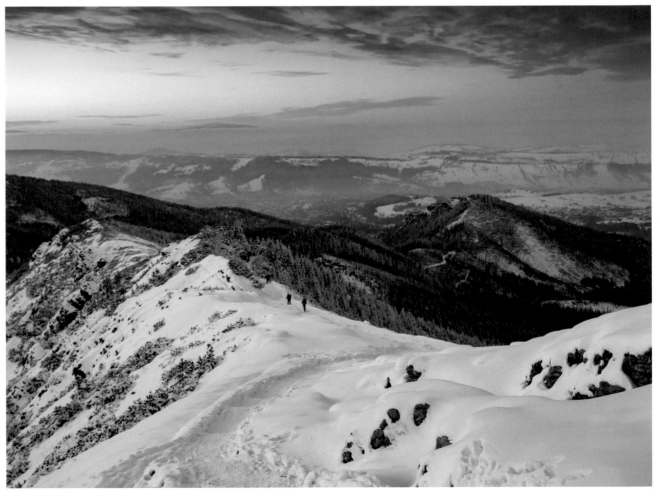

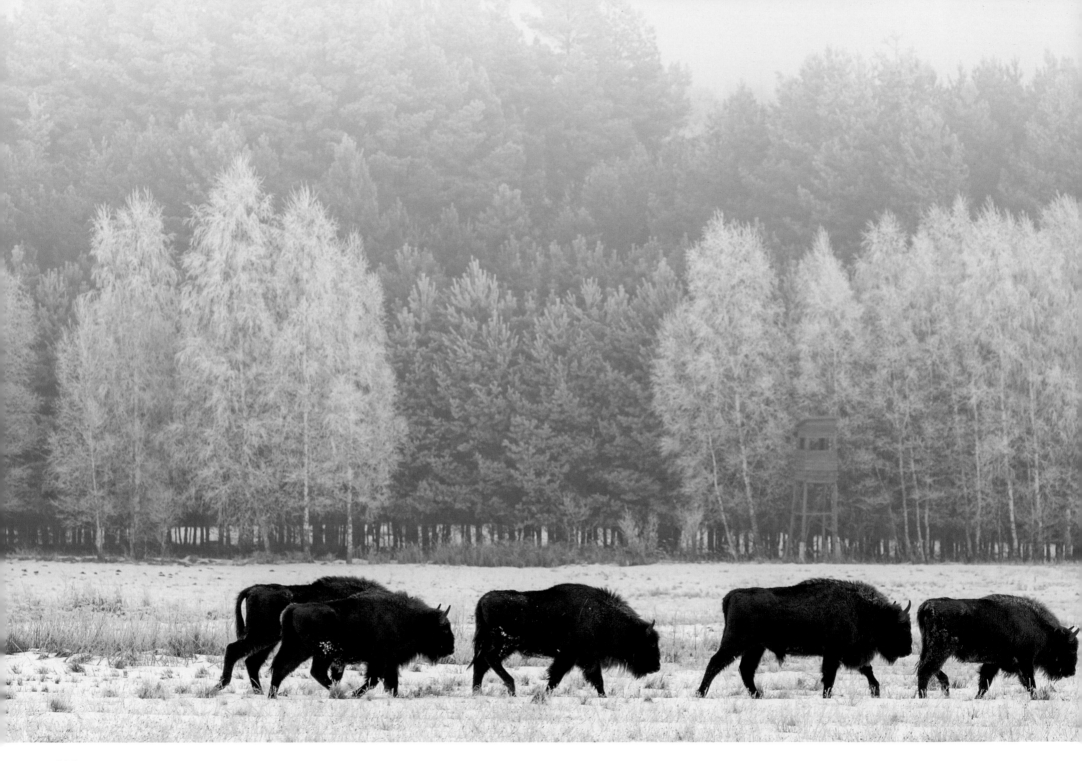

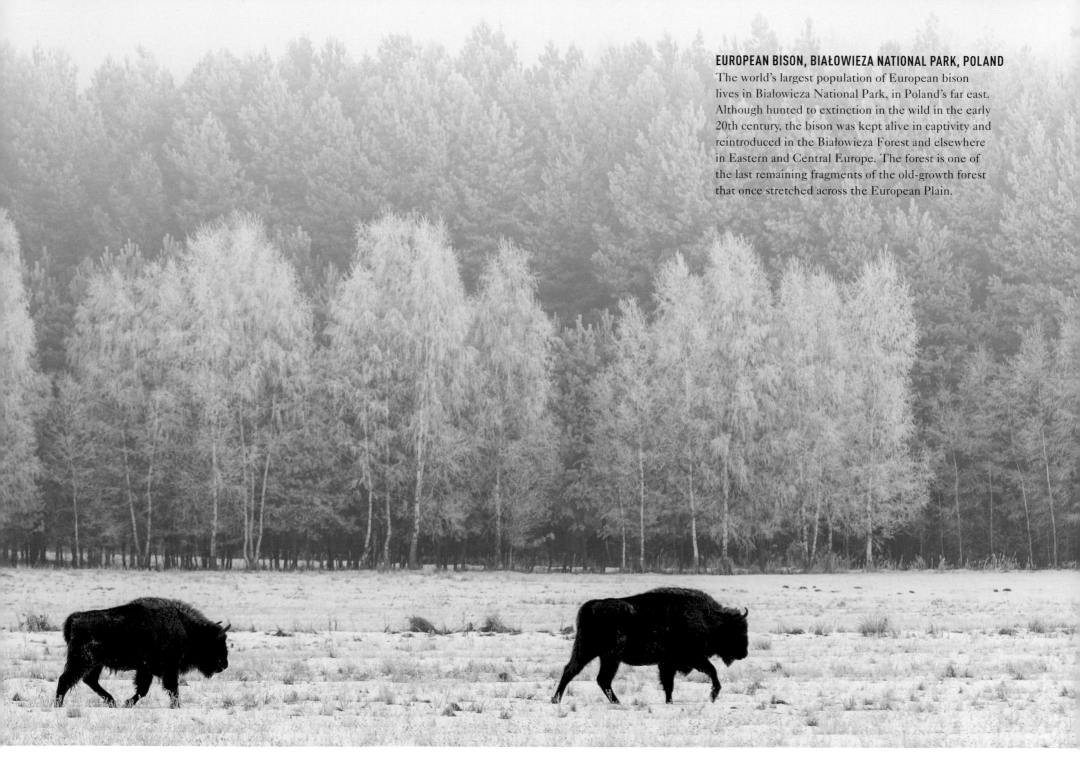

EUROPEAN BISON, BIAŁOWIEZA NATIONAL PARK, POLAND
The world's largest population of European bison lives in Białowieza National Park, in Poland's far east. Although hunted to extinction in the wild in the early 20th century, the bison was kept alive in captivity and reintroduced in the Białowieza Forest and elsewhere in Eastern and Central Europe. The forest is one of the last remaining fragments of the old-growth forest that once stretched across the European Plain.

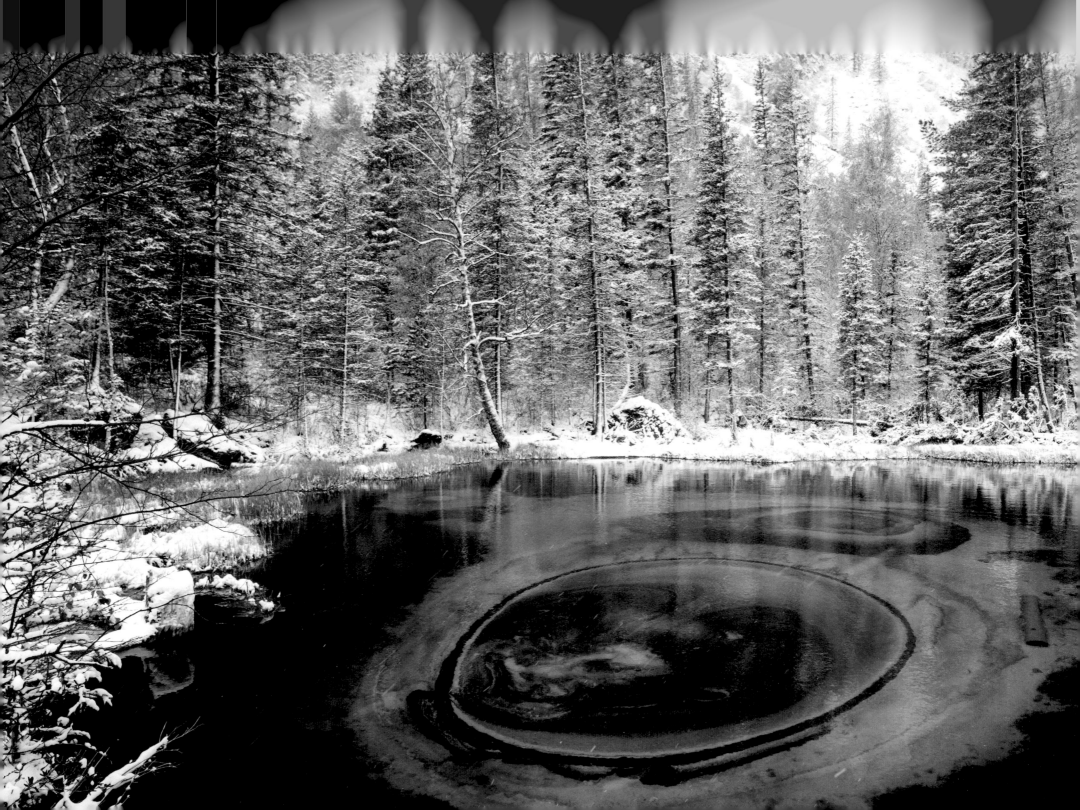

LEFT

GEYZERNOYE LAKE, ALTAI MOUNTAINS, RUSSIA

Not far from the village of Aktash, in Russia's Altai Republic, is this apparently luminous hot spring. Silt erupting from the bottom of the shallow lake refracts the light, forming turquoise concentric circles. The lake grew after an earthquake in 2003, caused by the constant collision of India and Asia. The Altai Mountains cross the borders of Russia, Mongolia, China and Kazakhstan, the region home to snow leopards, wild boar, grey wolves, Altai wapiti, moose and forest reindeer.

RIGHT

PETROGLYPHS, ALTAI MOUNTAINS, RUSSIA

Believed to have been created between 3000 BCE and the 3rd century CE, thousands of petroglyphs decorate the rocks of the Altai Mountains, many in the little visited Saldyar Valley, isolated from the rest of the world by the jagged peaks of the Saldyarskiy Pass. Animals carved into the rocks include deer, Siberian mountain goats, long-horned bulls and hunters with bows and arrows.

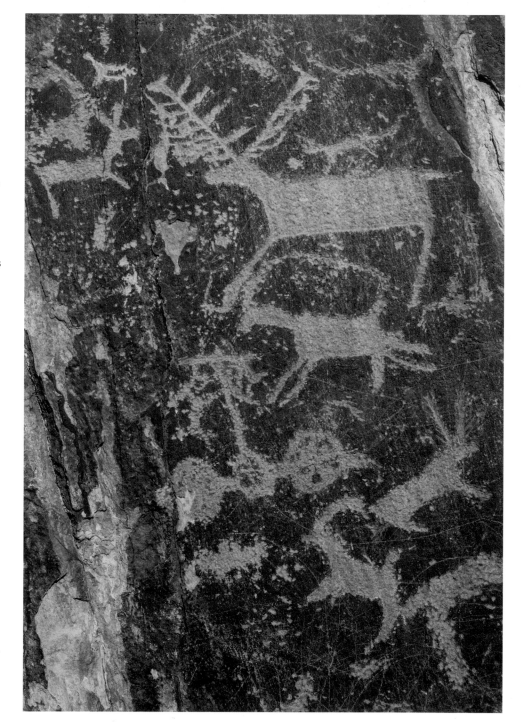

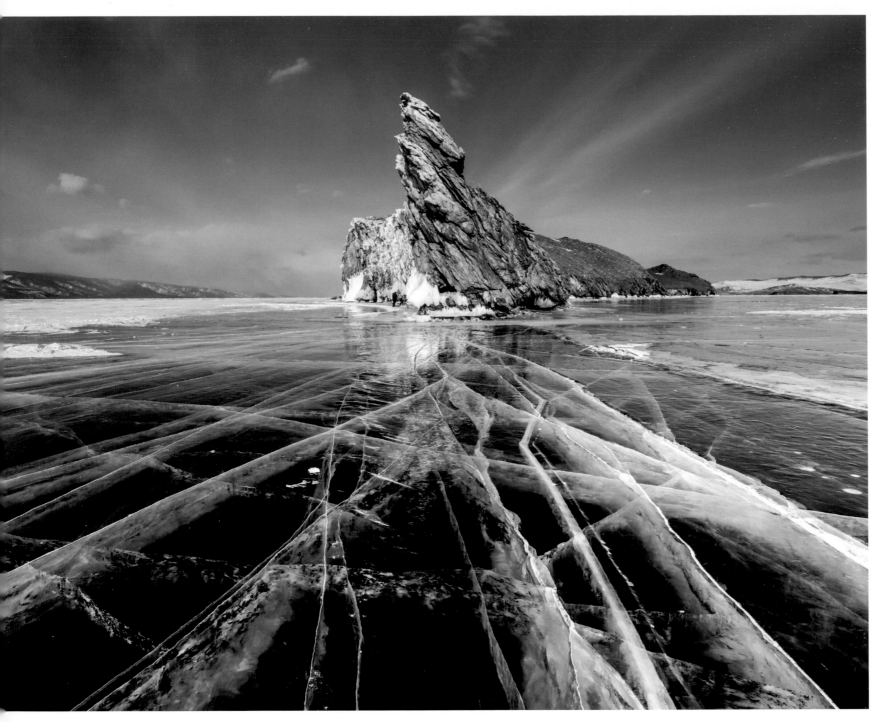

LAKE BAIKAL, RUSSIA

The world's largest freshwater lake, Baikal holds more water than all North America's Great Lakes combined: over 23,000 cu km (5,000 cu miles). Baikal is fed by 330 rivers. Perhaps the world's most ancient lake, it was formed 25 to 30 million years ago, as the Amurian plate slowly tore itself away from the Eurasian plate, creating a rift that is still widening. With winter air temperatures falling as low as -19°C (-2°F), Baikal freezes over for four months every year.

LAKE BLED, SLOVENIA

In the Julian Alps, with water just warm enough for dips at the height of summer, Lake Bled has one small island. Reached by a wooden, flat-bottomed boat, called a *pletna*, the island is home to the Church of the Assumption. Locally, it is considered good luck for grooms to carry their brides up the 99 steps of the 17th-century Baroque stairway to the church, then to ring the bell and make a wish inside. Another local tradition is making *kremna rezina*, a delicious cream pastry.

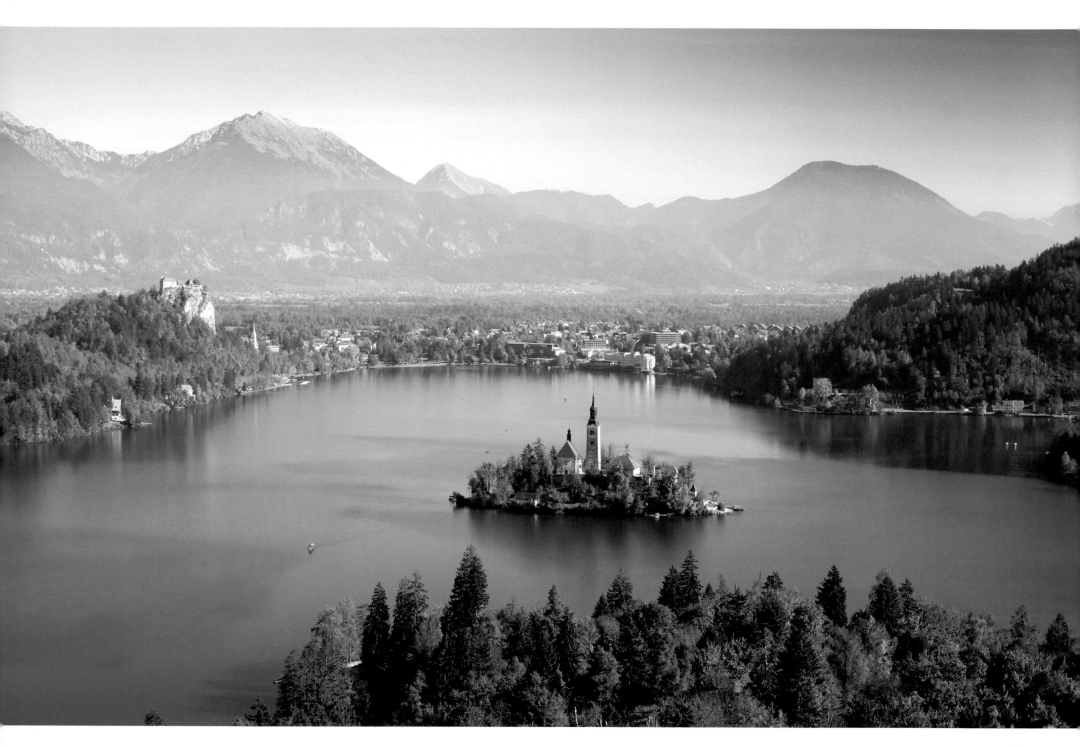

MOLDOVITA MONASTERY, ROMANIA

The frescoes on the external walls of this Romanian Orthodox monastery were painted by Toma of Suceava in 1537. Along with seven other Moldavian monasteries and churches with frescoes, Moldovita is listed as a UNESCO World Heritage Site. The plan to beautify the region's churches was hatched by Moldavian *voievod* (or ruler) Petru Rares. Scenes depicted here include the Last Judgment, the Siege of Constantinople and the Tree of Jesse, showing the ancestors of Christ.

BRAN CASTLE, ROMANIA

Linked forever in the popular imagination with Vlad III Dracula of Wallachia, also known as 'Vlad the Impaler' for his wartime cruelties, and with Bram Stoker's *Dracula* novel, this iconic castle unfortunately has no proven links with either. In fact, the castle's dramatic looks and location may simply have inspired a remarkable piece of marketing by the Romanian Communist government during the 1970s. The castle, built in the 14th century, has more than enough intriguing stories to justify a visit in its own right.

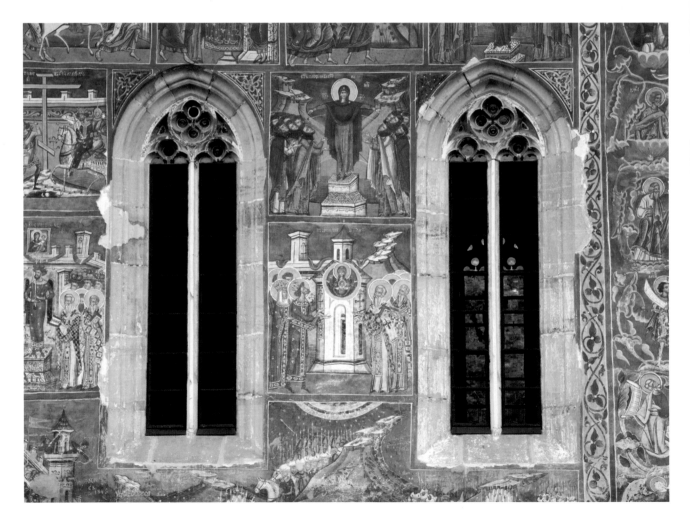

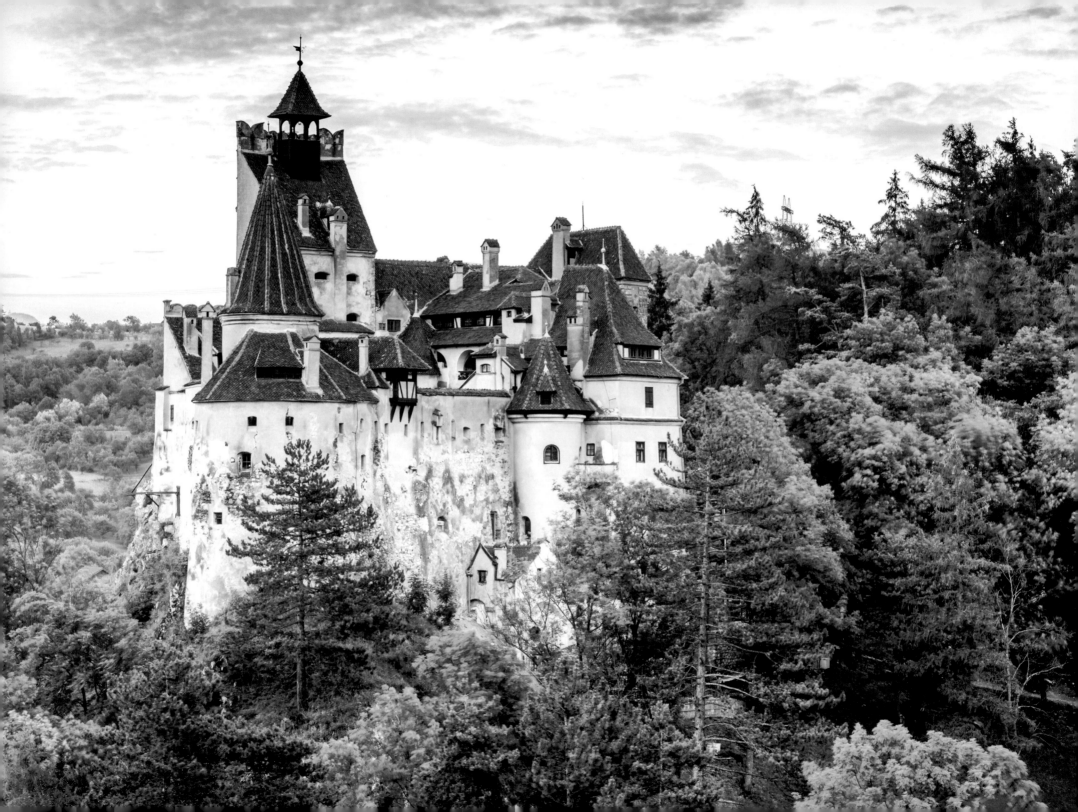

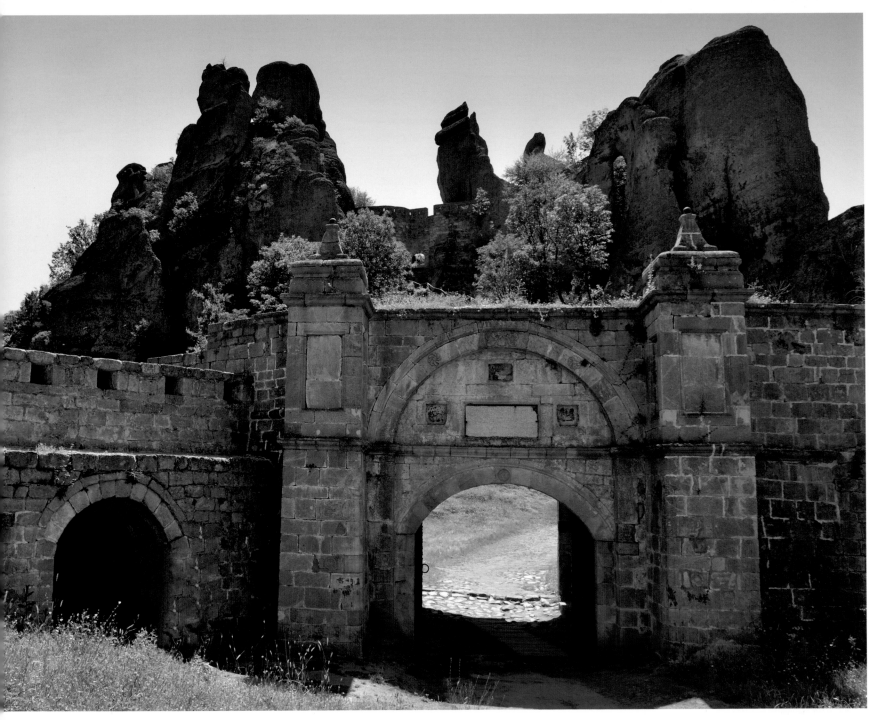

BELOGRADCHIK FORTRESS, BULGARIA

The first work on this fortress was carried out between the 1st and 3rd centuries CE, while the region was part of the Roman Empire. Few human-built walls were needed, as the sandstone and conglomerate rock formations, soaring up to 70 m (230 ft) high, offered natural protection on most sides. The walls were extended over the following centuries, with the current structure receiving the attention of Ottoman engineers during the 19th century.

PLITVICE LAKES NATIONAL PARK, CROATIA

At Plitvice National Park, 16 interconnected lakes flow through a karst canyon. The lakes are separated by natural dams of travertine, a limestone formed by the precipitation of carbonate minerals. As mats of moss, algae and bacteria accumulated, the travertine built up over many centuries to create waterfalls up to 70 m (230 ft) high. To protect the travertine, walkways have been constructed between the lakes.

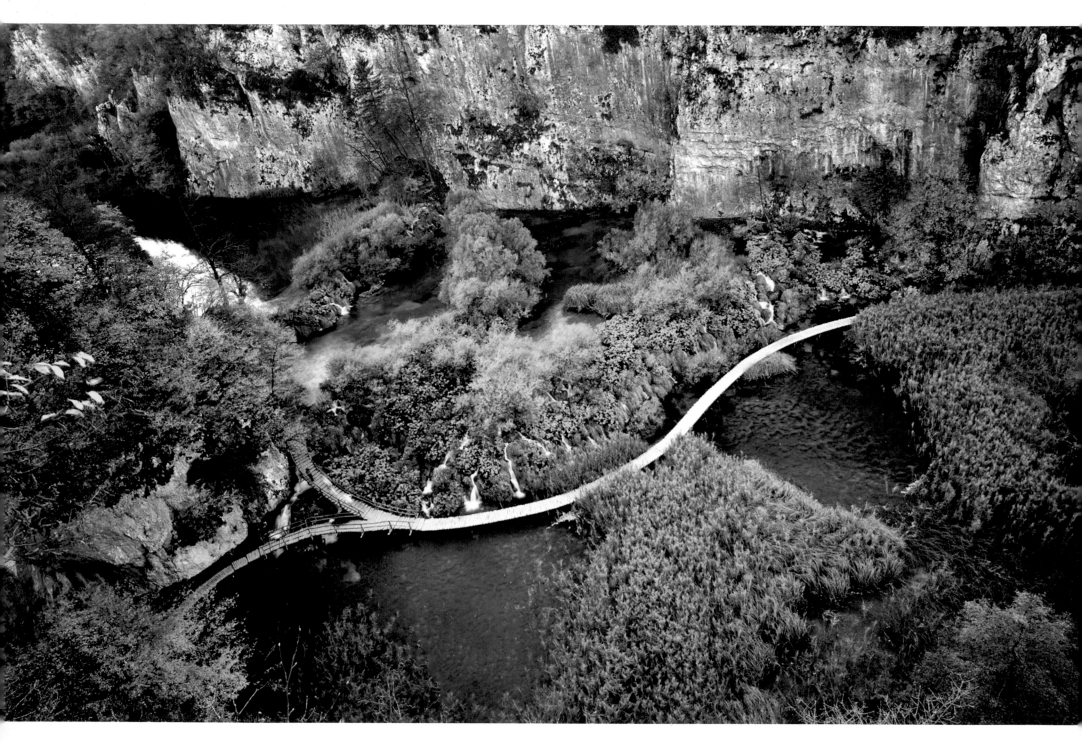

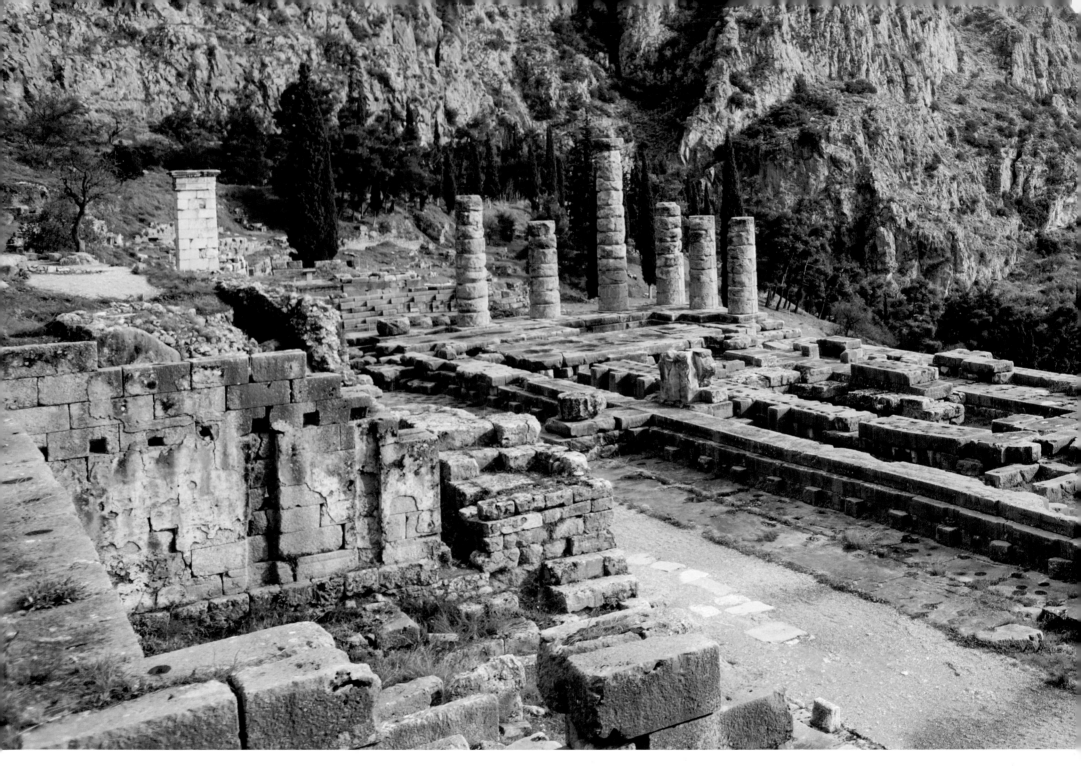

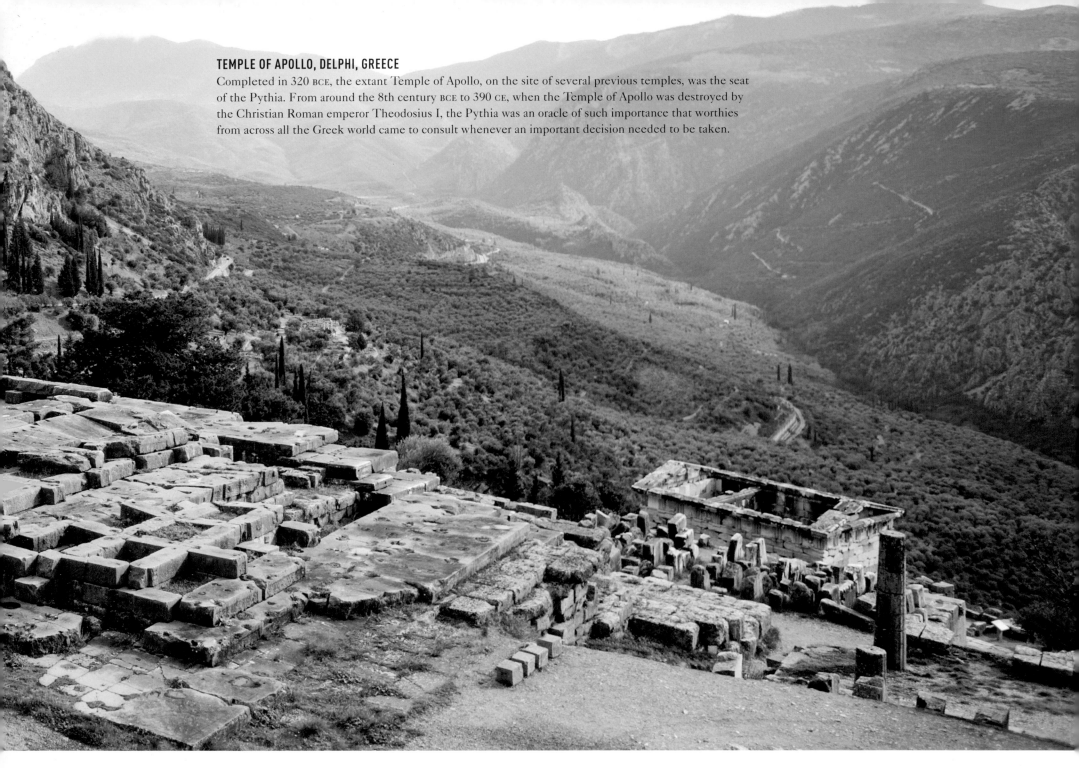

TEMPLE OF APOLLO, DELPHI, GREECE

Completed in 320 BCE, the extant Temple of Apollo, on the site of several previous temples, was the seat of the Pythia. From around the 8th century BCE to 390 CE, when the Temple of Apollo was destroyed by the Christian Roman emperor Theodosius I, the Pythia was an oracle of such importance that worthies from across all the Greek world came to consult whenever an important decision needed to be taken.

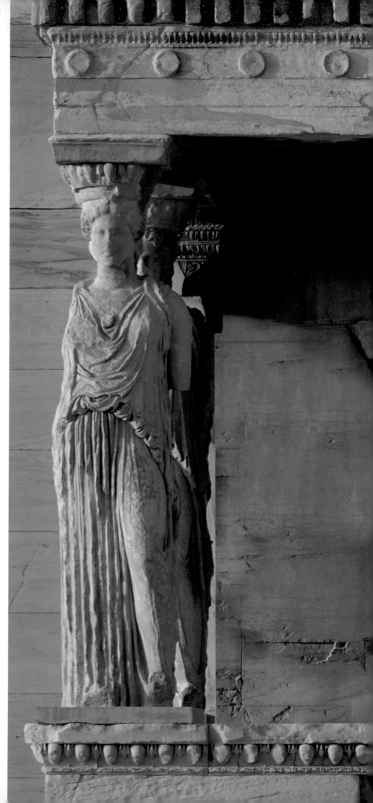

BELOW
ROUSSANOU MONASTERY, METEORA, GREECE

In the Plain of Thessaly, on the summits of soaring pillars of sandstone and conglomerate, perch six monasteries. These are the communities that remain of the original 24 monasteries, built from the 14th century to escape Ottoman attacks and allow a life of devoted prayer. Originally, access was only by ladder or winch. Roussanou has a lower elevation than the other monasteries, making it more accessible to visitors. It takes its name from the first hermit who probably settled on the rock.

RIGHT
PORCH OF THE CARYATIDS, ACROPOLIS, GREECE

The Porch of the Caryatids is part of the Erechtheion, a temple to Athena and Poseidon completed in 406 BCE. The Erechtheion stands beside the Parthenon, on the Acropolis. This 150-m (490-ft) high rock outcrop, in central Athens, was first inhabited in the 4th millennium BCE. It was under the rule of Pericles, leader of Athens from 447 BCE to 432 BCE, that an ambitious building programme on the Acropolis was begun. The caryatids on view are replicas, but five of the six originals are in the Acropolis Museum.

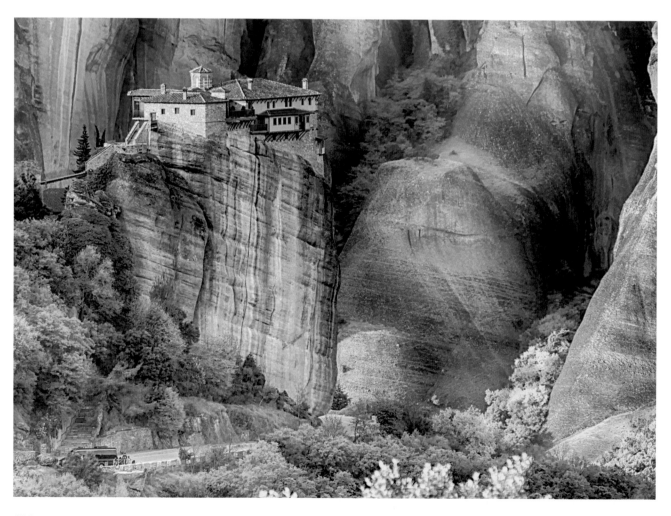

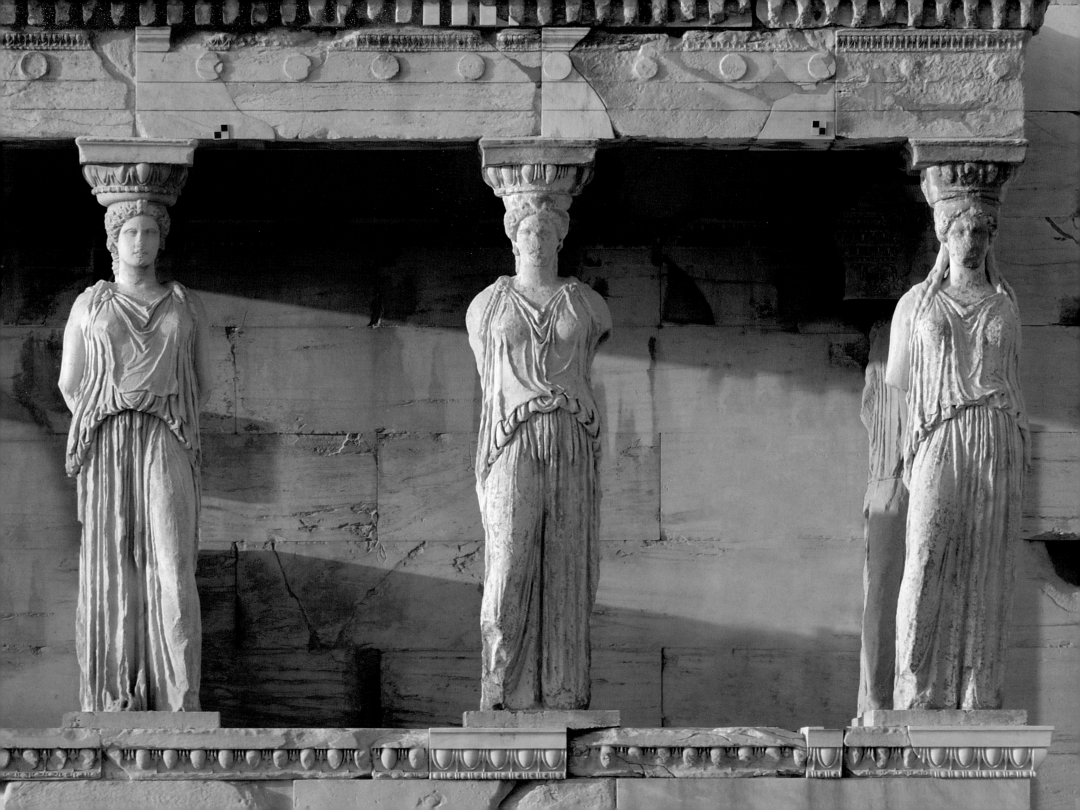

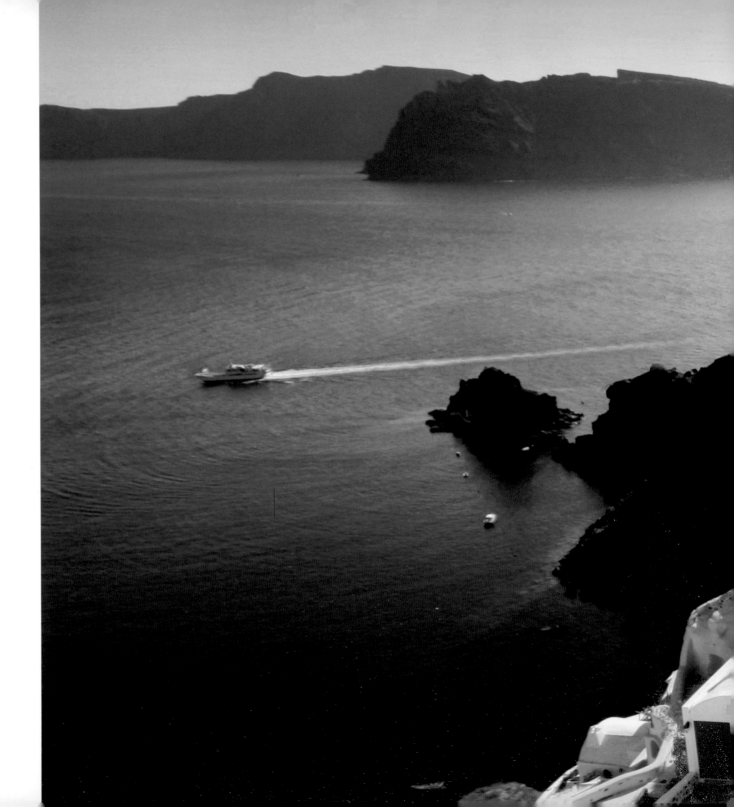

SANTORINI, GREECE

The village of Oia, on the Cycladic island of Santorini, perches on the edge of a flooded volcanic caldera. The eruption that resulted in the volcano's collapse, about 3,600 years ago, may have set off a tsunami that caused the decline of the Minoan civilization on Crete. Many of the village's white-painted houses and blue-domed churches are carved into the cliff face.

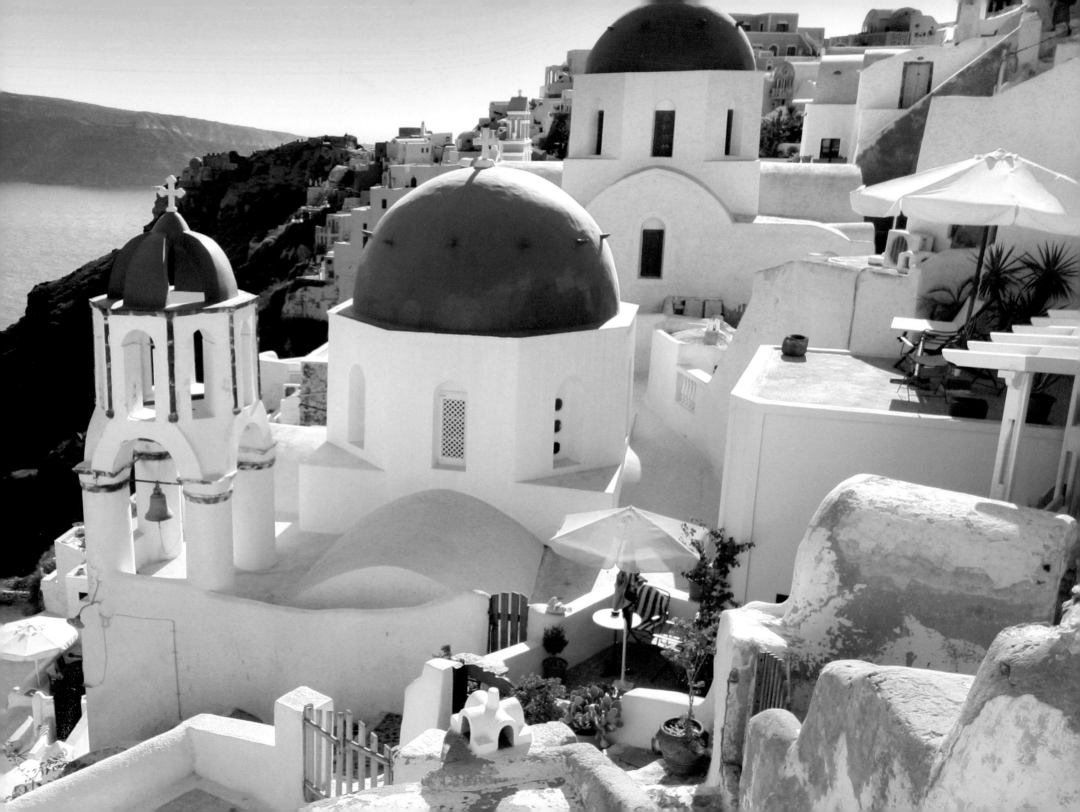

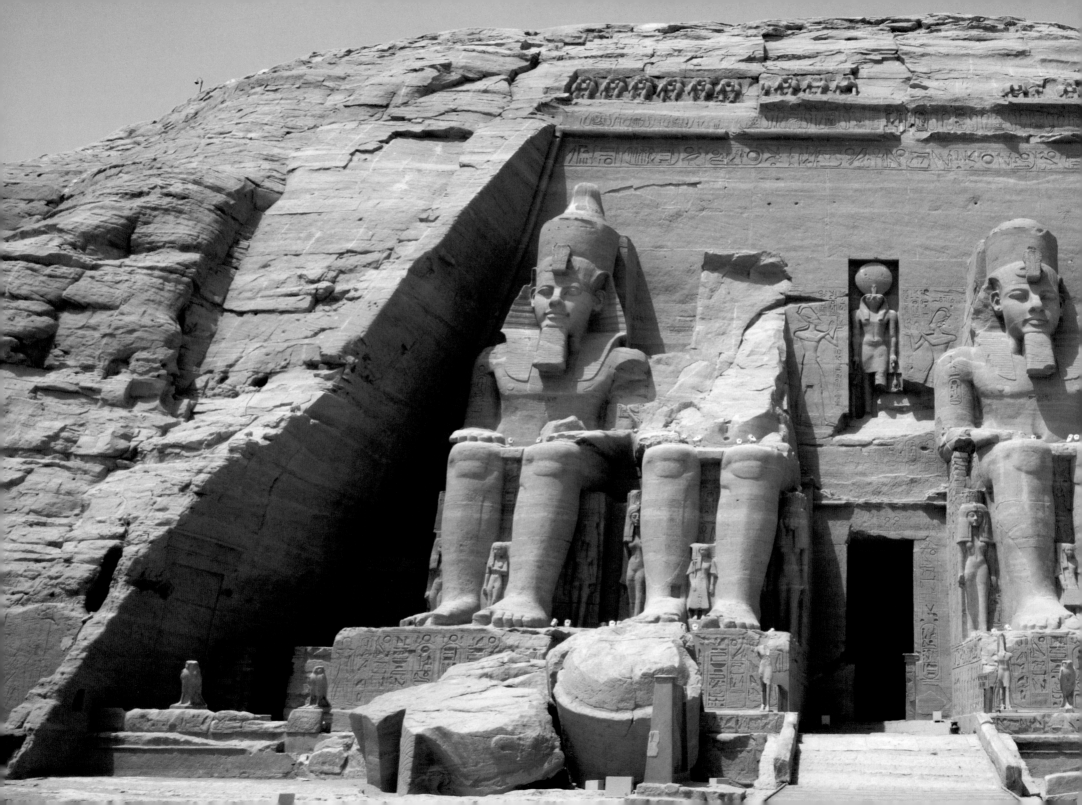

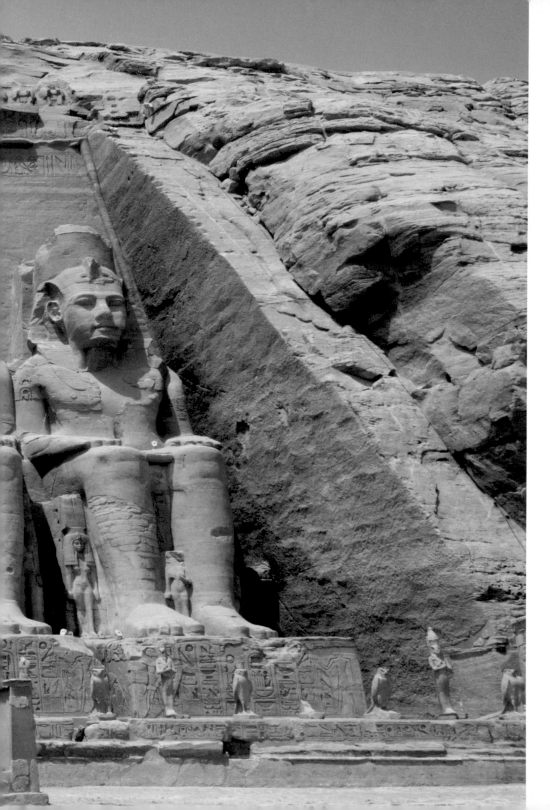

Africa and the Middle East

From the pyramids of Egypt's Fourth Dynasty to the rock-hewn mausoleums of the Arabian Peninsula's Nabataeans and the elaborate ceremonial capital of Persia's Achaemenids, this region boasts more than its fair share of the world's most magnificent ancient sites. Built to inspire awe, these monuments still leave visitors astonished by the unbounded ambition of their creators. In common with later feats of imagination and engineering, such as the churches of Ethiopia's Lalibela, these sites both mark and make use of the region's extraordinary landscapes.

These landscapes include the rippling sand seas of the world's largest hot desert, the Sahara, as well as the world's deepest hypersaline lake, the Dead Sea, where visitors love to bob and float. Lesser known natural marvels include the sharp *tsingy* formations of Madagascar and the underwater waterfall of Mauritius. The region's eternal draw is the sight of its extraordinary fauna, from migrating wildebeest to the flamingos of Lake Nakuru, as well as its often otherworldly flora, such as red-sapped dragon's blood trees and skyward-stretching baobabs.

ABU SIMBEL, EGYPT
The temples at Abu Simbel were carved from the mountainside to celebrate Pharaoh Ramesses II's defeat of the Hittites at the Battle of Kadesh in 1274 BCE. The entrance to the Great Temple is flanked by 20-m (66-ft) tall statues of the pharaoh.

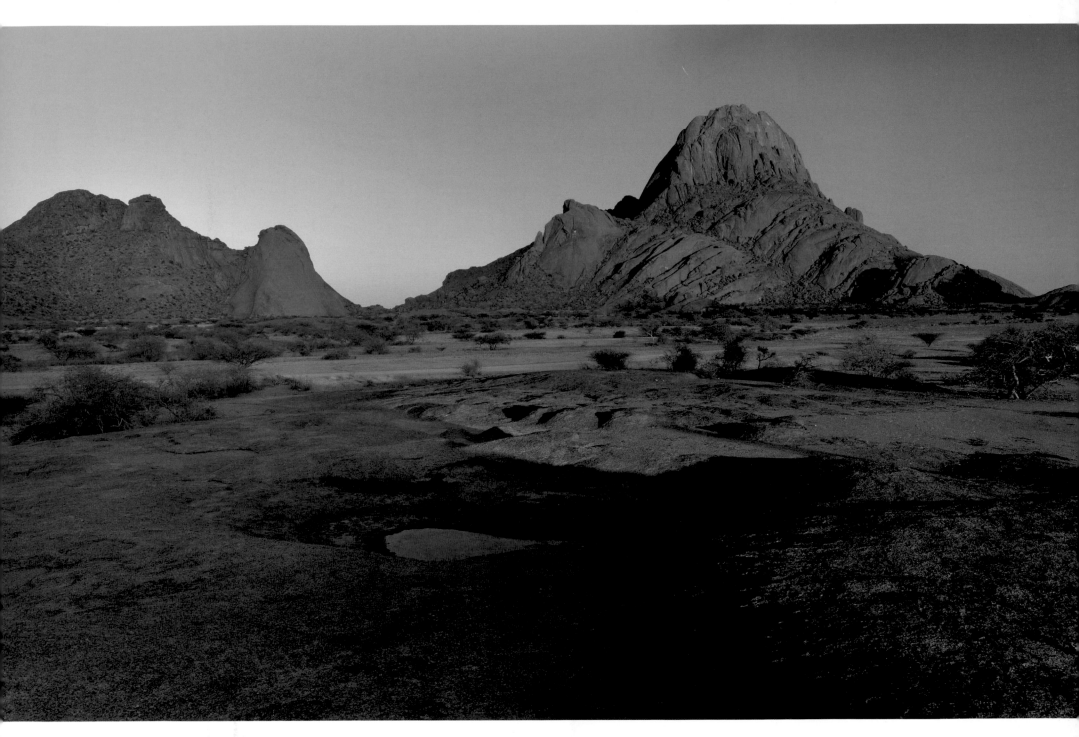

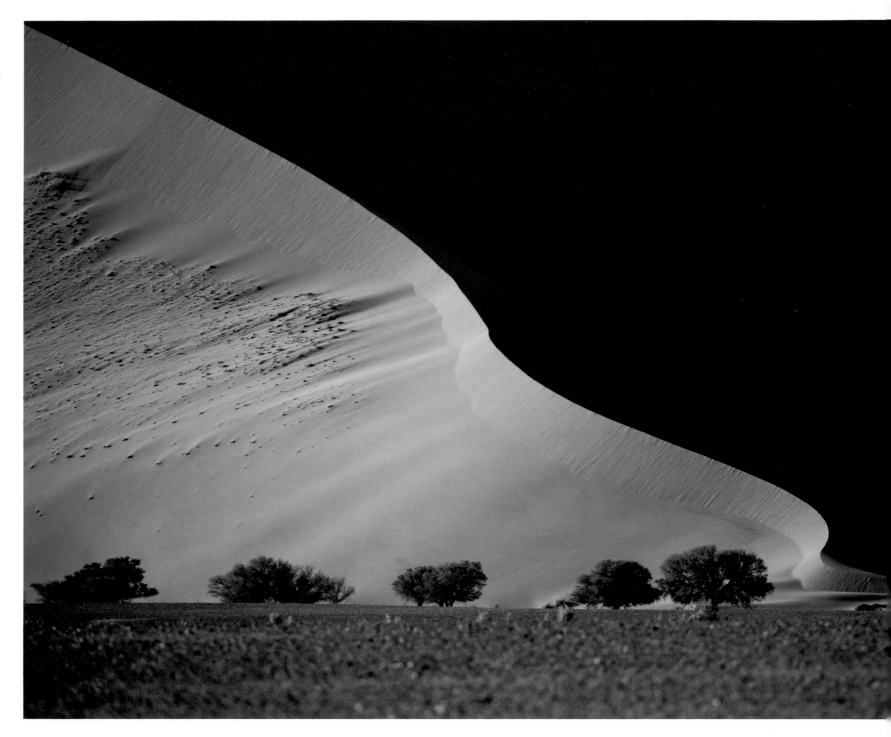

OPPOSITE

SPITZKOPPE, NAMIBIA

These isolated granite peaks, called inselbergs, rise abruptly from the Namib desert plain. The tallest peak is 1,728 m (5,669 ft). The inselbergs owe their continued existence to their tough granite, which is more resistant to erosion than the surrounding rock. Nearby are at least 37 examples of artwork created by Bushmen, many of them in the Bushman's Paradise cave. The paintings, believed to date back 2,000 to 4,000 years, feature zebras, rhinos, hunters and shamans.

RIGHT

SOSSUSVLEI, NAMIBIA

'Sossusvlei' comes from the Nama for 'dead end' (*sossus*) and the Afrikaans for 'marsh' (*vlei*). In the southern Namib Desert, this basin of salt and clay pans is surrounded by red sand dunes. One of the most photographed dunes is Dune 45, found 45 km (28 miles) past Sesriem Gate on the road to Sossusvlei. Over 170 m (560 ft) tall, it is a star dune, made by winds blowing from all directions, causing the sand to pile up in a star shape with multiple arms.

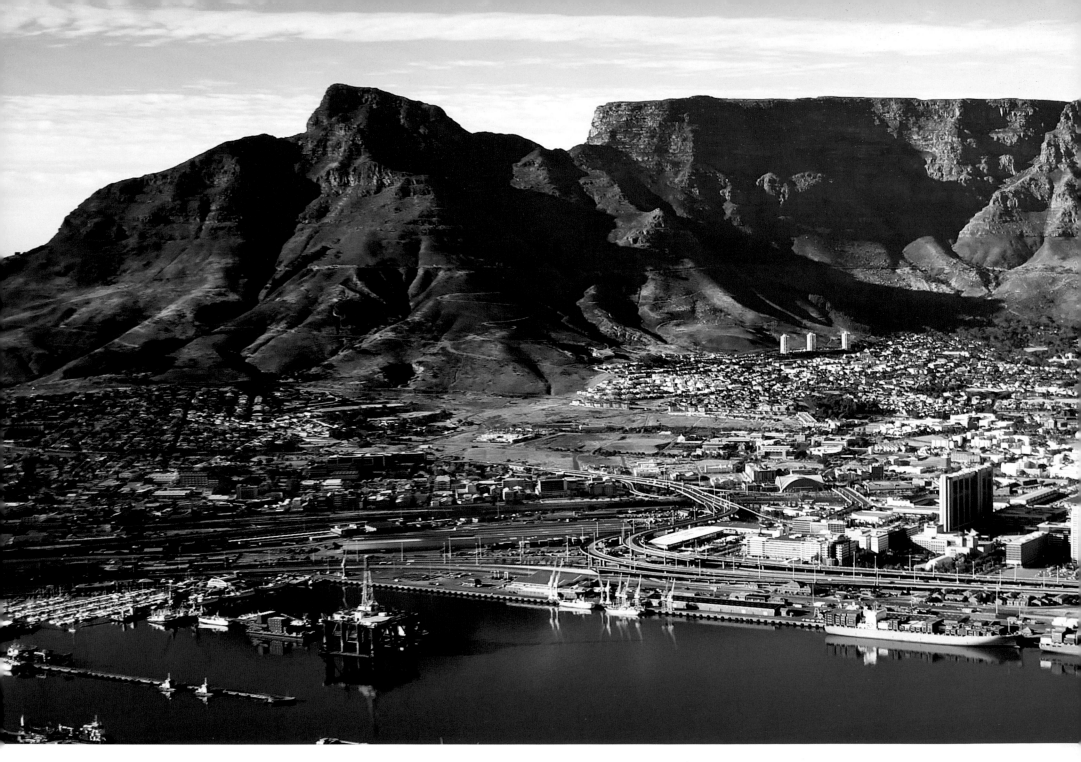

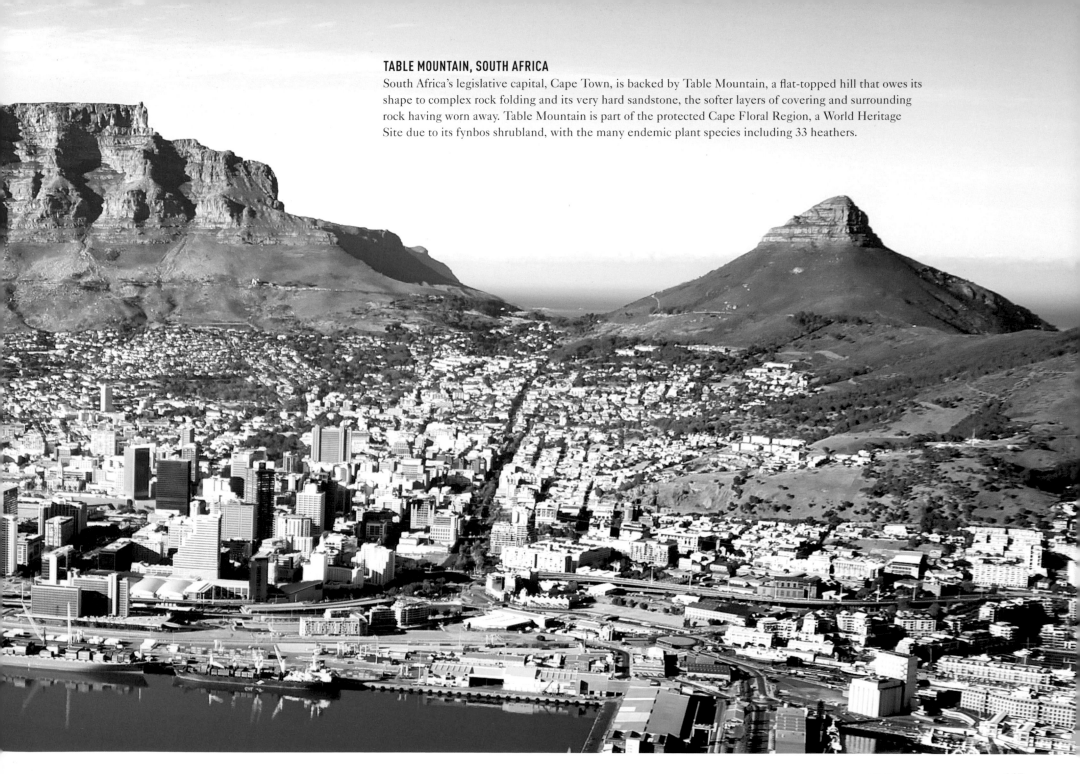

TABLE MOUNTAIN, SOUTH AFRICA
South Africa's legislative capital, Cape Town, is backed by Table Mountain, a flat-topped hill that owes its shape to complex rock folding and its very hard sandstone, the softer layers of covering and surrounding rock having worn away. Table Mountain is part of the protected Cape Floral Region, a World Heritage Site due to its fynbos shrubland, with the many endemic plant species including 33 heathers.

KRUGER NATIONAL PARK, SOUTH AFRICA

Along the border with Mozambique, South Africa's oldest national park encompasses areas of thorn trees, red bush-willow and shrubland. All of the Big Five are found here: lions, leopards, rhinoceroses, elephants and Cape buffalo. Southern giraffes and Burchell's zebras can be seen drinking at water holes. Packs of endangered African wild dogs also roam the park, hunting for mountain reedbuck and the ubiquitous impala, of which there are at least 130,000 in the park.

VICTORIA FALLS, ZIMBABWE–ZAMBIA

With a width of 1,708 m (5,604 ft) and height of 108 m (354 ft), Victoria Falls is one of the world's largest sheets of falling water. The falls, known in Lozi as Mosi-oa-Tunya ('The Smoke That Thunders'), are formed where the Zambezi River plummets into a transverse chasm that has been eroded by the water along a fracture zone in the basalt plateau. From this First Gorge, the river flows through a 110-m (360-ft) wide gap into the Second Gorge, which is crossed by the Victoria Falls Bridge.

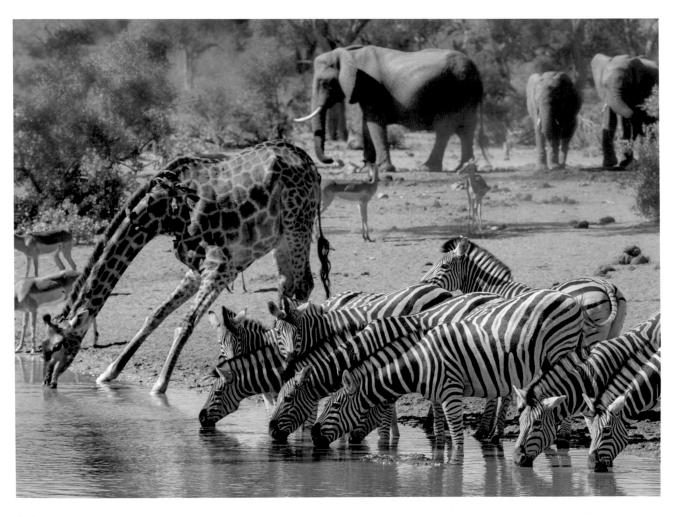

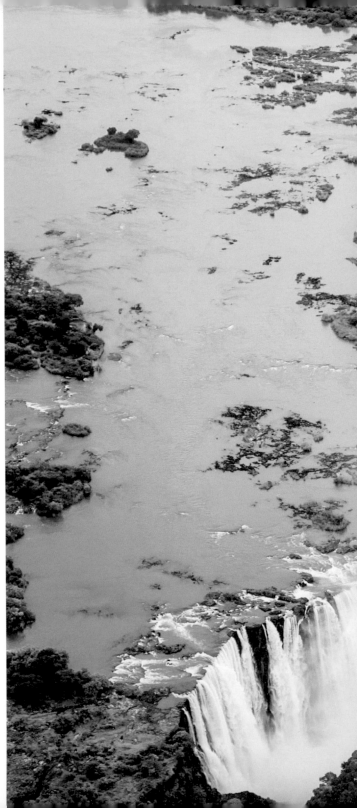

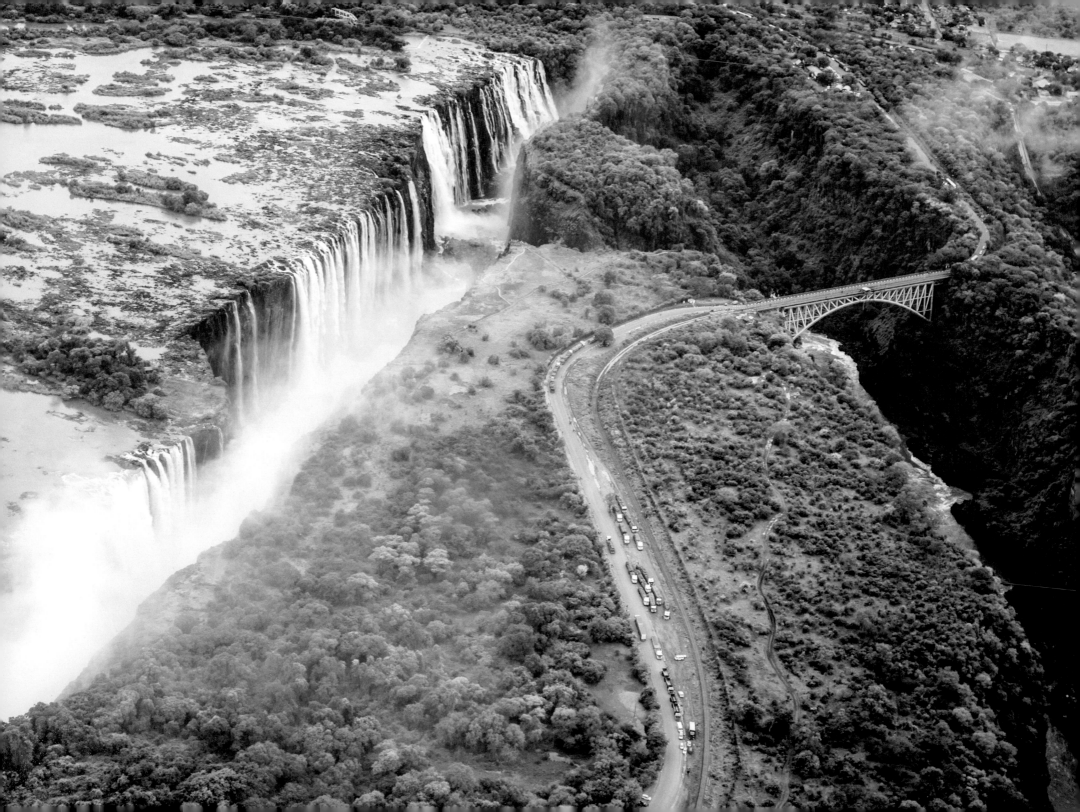

LAKE MALAWI, MALAWI

The southernmost of the African Great Lakes, Malawi
stretches for 560 km (350 miles) along the borders of
Malawi, Tanzania and Mozambique. The Great Lakes lie
in a 6,000-km (3,700-mile) rift, formed where the African
tectonic plate is splitting into two plates, the Somali and
Nubian, moving at 6–7 mm (0.24–0.28 in) per year.

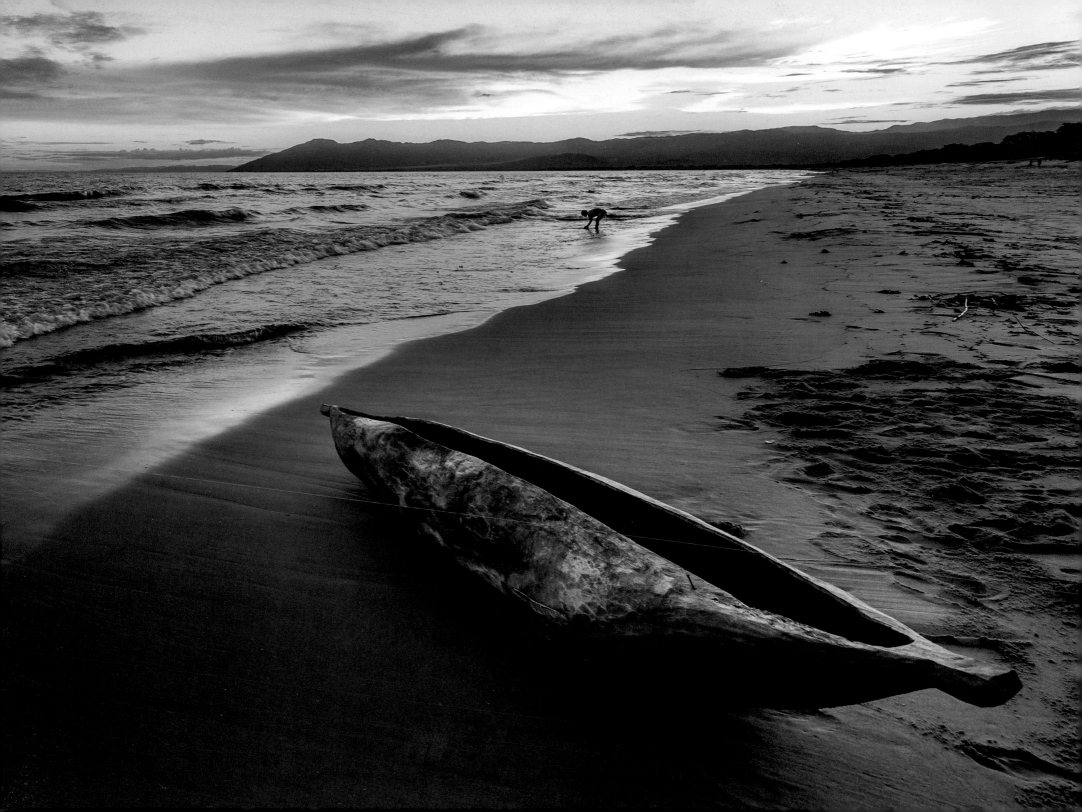

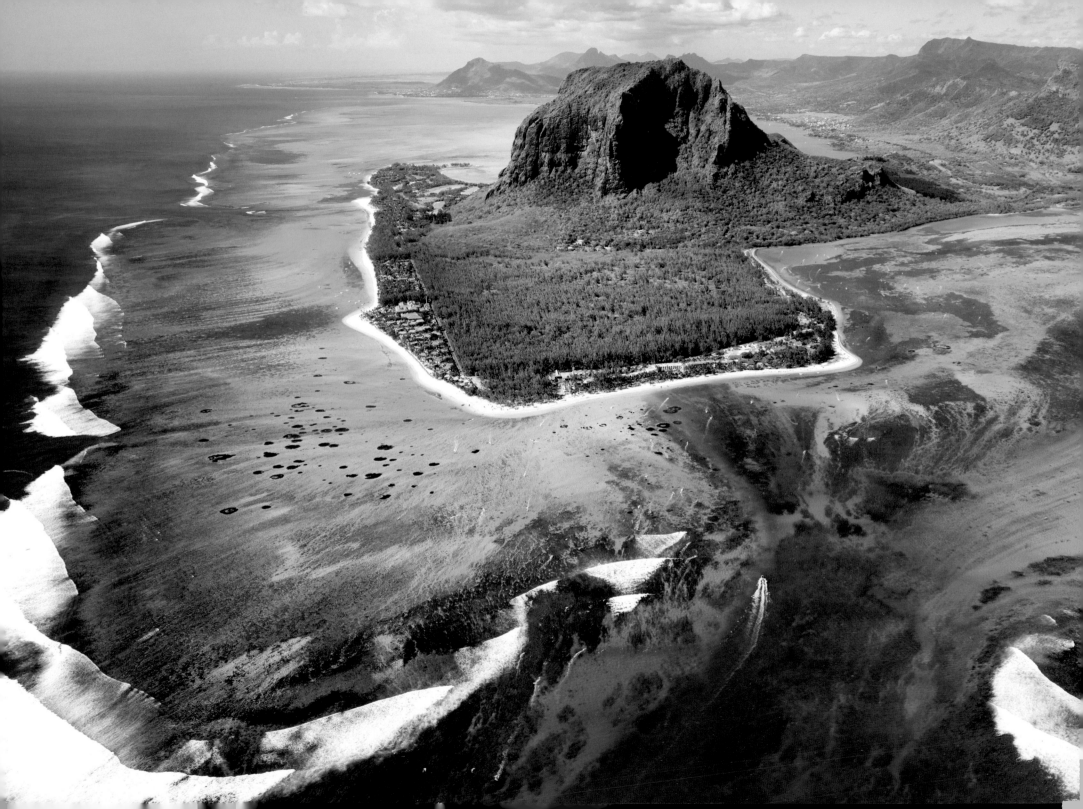

UNDERWATER WATERFALL, LE MORNE BRABANT, MAURITIUS

This apparent underwater waterfall, seen only from the air, is caused by sand being carried over the edge of the oceanic shelf on which the island of Mauritius rests. The nearby peninsula, Le Morne Brabant, is marked by a basalt monolith 556 m (1,824 ft) high. The peninsula is home to two rare plants, the pink-flowered, critically endangered mandrinette, and the boucle d'oreille, the national flower of Mauritius.

AVENUE OF THE BAOBABS, MADAGASCAR

Grandidier's baobabs line the road between Morondava and Belon'i Tsiribihina. These endangered trees, hundreds of years old, were once part of a forest that was cleared for farming. Grandidier's baobabs are the biggest of Madagascar's six baobab species, reaching up to 30 m (98 ft) tall. They flower from May to August, with the blooms opening at dusk for pollination by nocturnal fork-marked lemurs and hawk moths.

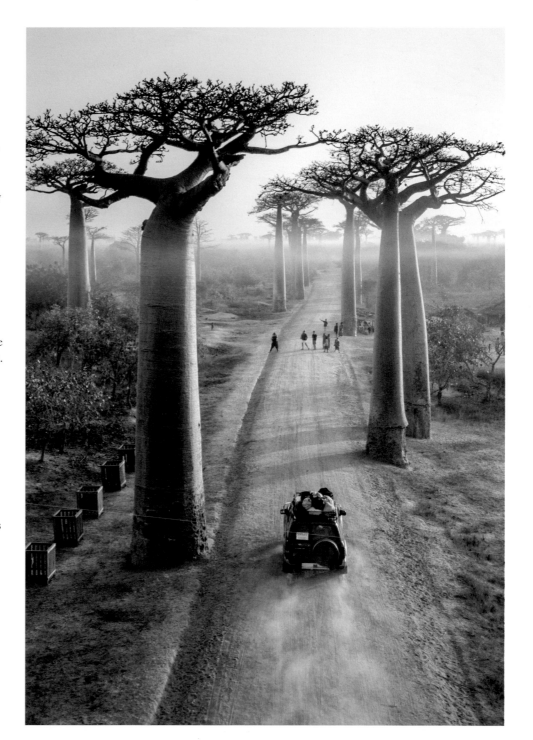

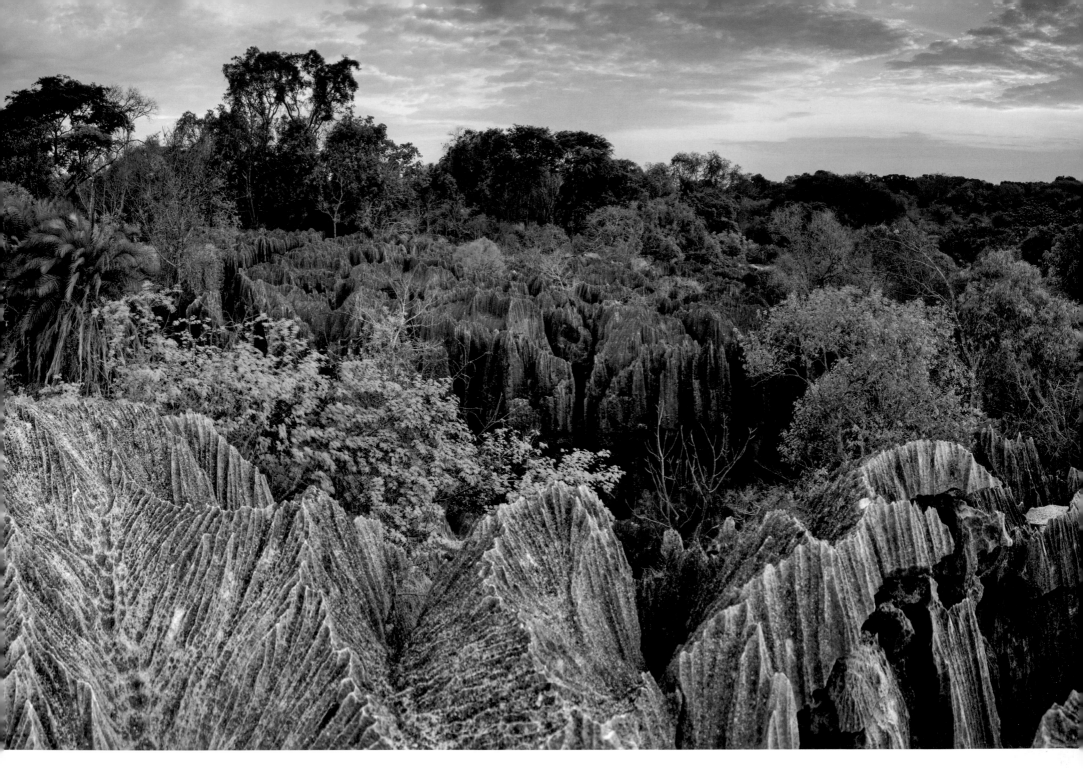

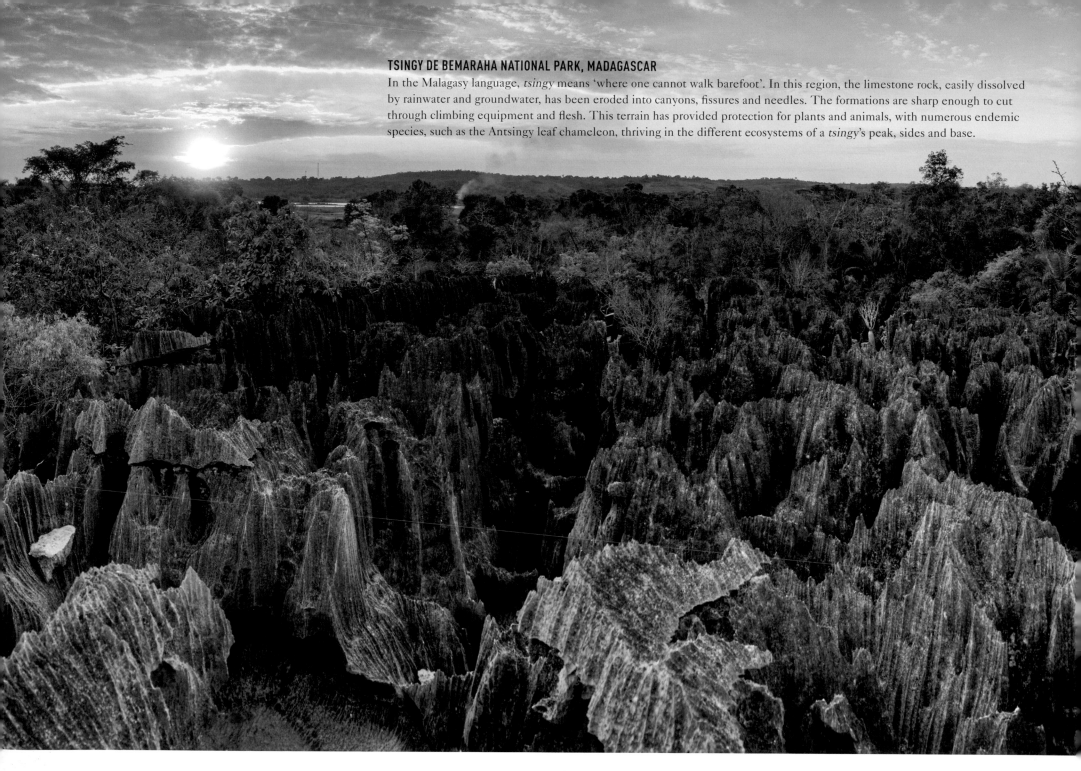

TSINGY DE BEMARAHA NATIONAL PARK, MADAGASCAR

In the Malagasy language, *tsingy* means 'where one cannot walk barefoot'. In this region, the limestone rock, easily dissolved by rainwater and groundwater, has been eroded into canyons, fissures and needles. The formations are sharp enough to cut through climbing equipment and flesh. This terrain has provided protection for plants and animals, with numerous endemic species, such as the Antsingy leaf chameleon, thriving in the different ecosystems of a *tsingy*'s peak, sides and base.

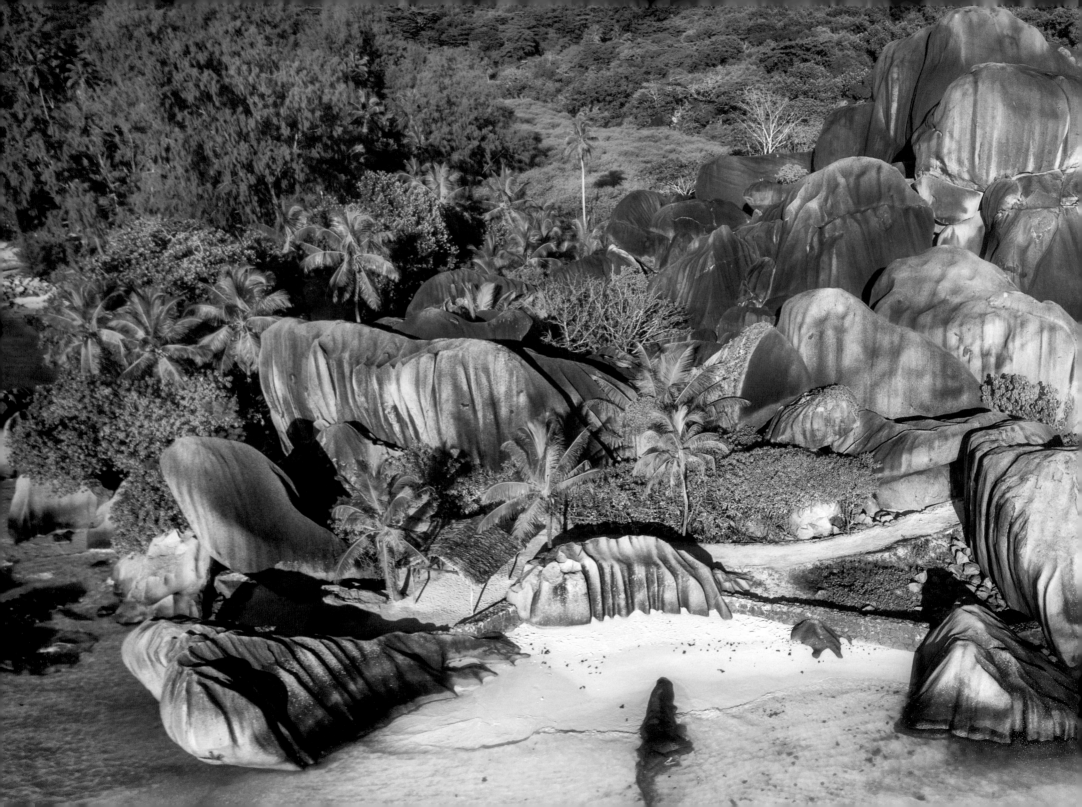

LEFT

ANSE SOURCE D'ARGENT, LA DIGUE ISLAND, SEYCHELLES

Unless visitors are unusually strong swimmers, they must pay a fee to cycle through L'Union Estate coconut plantation to reach this white-sand beach. The island of La Digue is known for its granite boulders, almost car-free lifestyle and its many endemic animals. One of these is the critically endangered paradise flycatcher, put at risk by habitat fragmentation and the arrival of invasive species such as rats, dogs and cats.

BELOW

TAKAMAKA, MAHÉ ISLAND, SEYCHELLES

The largest island in the Seychelles, Mahé is home to the capital city, Victoria, and nine out of ten Seychellois people. With only 94,000 total inhabitants, the Seychelles have the smallest population of any sovereign African country. Just a stroll from beaches shaded by coconut palms, Mahé's forests hide strange, endemic flora, including the jellyfish tree, named for the shape of its fruit, and the insect-eating Seychelles pitcher plant.

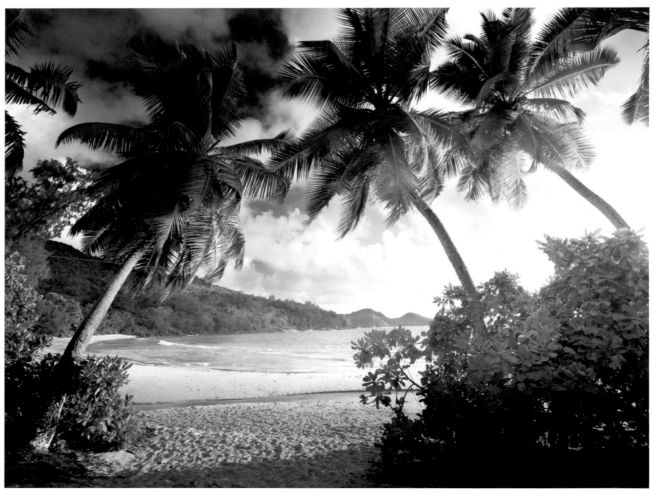

WATAMU MARINE NATIONAL PARK, KENYA

About 140 km (90 miles) north of Mombasa, Watamu Marine Park protects coral reefs, mangrove forests and white-sand beaches that are nesting sites for green, hawksbill and olive ridley turtles. In the warm shallows, more than 150 species of hard and soft corals provide shelter and food for 500 species of fish, including whale sharks, manta rays, angelfish, batfish and lionfish. While diving is forbidden in the park, it is possible in the surrounding marine reserve.

MAKGADIKGADI PANS NATIONAL PARK, BOTSWANA

Surrounded by the Kalahari Desert, Makgadikgadi is an inhospitably arid region of sandy desert dotted with vast salt pans, the remains of an ancient evaporated salt lake. During the dry season, very little flora or fauna can survive here, but after rain the region becomes an important habitat for migrating animals such as elephants, wildebeest, buffalo and zebra, along with the lions and cheetahs that prey on them.

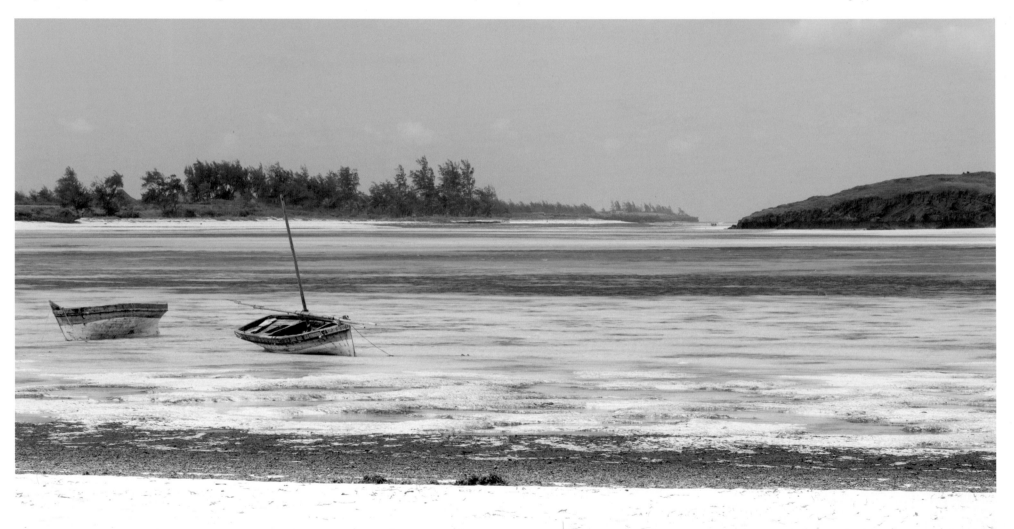

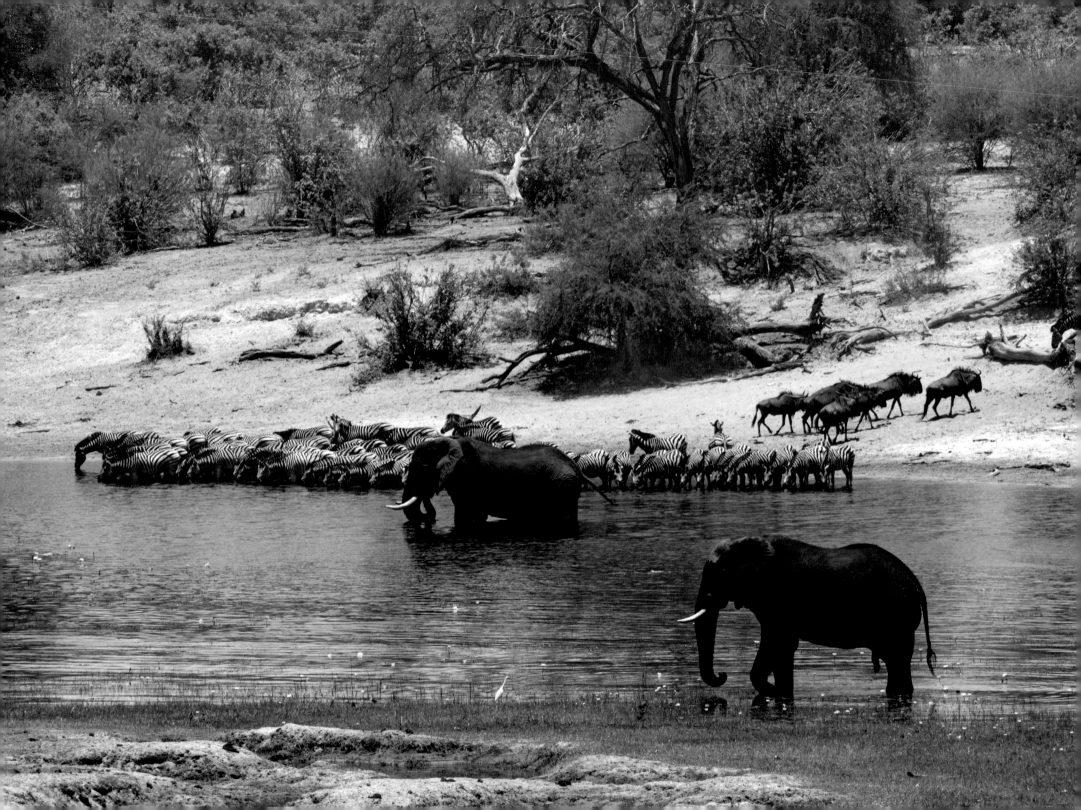

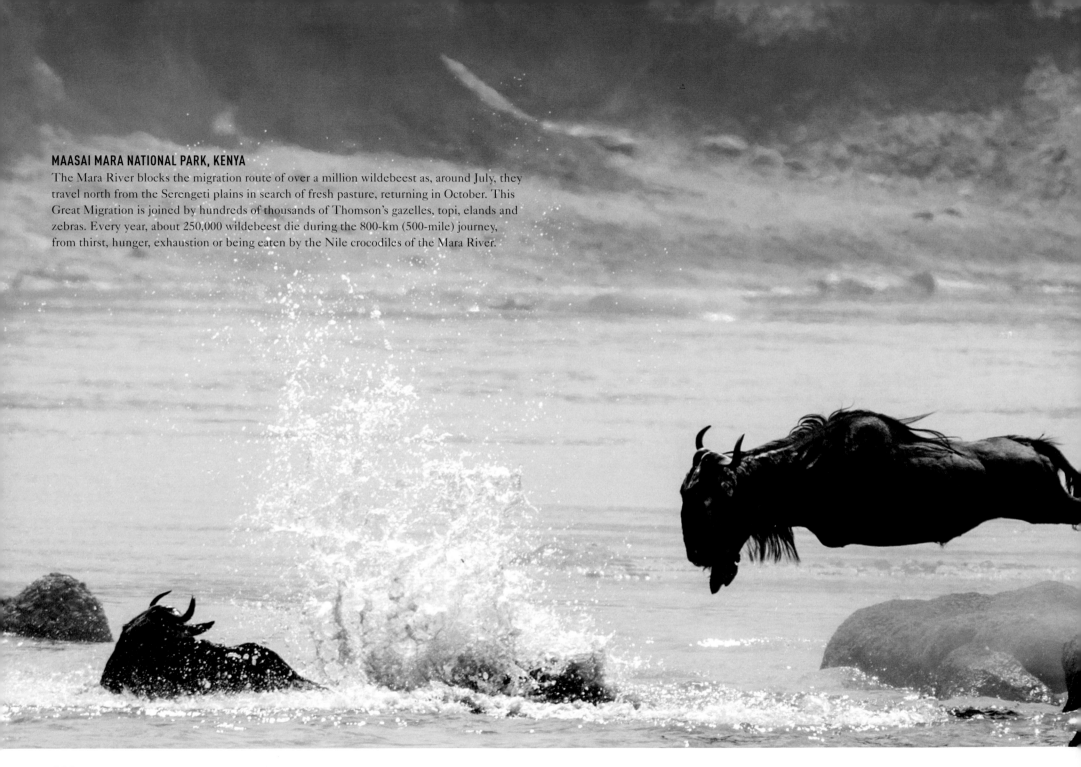

MAASAI MARA NATIONAL PARK, KENYA

The Mara River blocks the migration route of over a million wildebeest as, around July, they travel north from the Serengeti plains in search of fresh pasture, returning in October. This Great Migration is joined by hundreds of thousands of Thomson's gazelles, topi, elands and zebras. Every year, about 250,000 wildebeest die during the 800-km (500-mile) journey, from thirst, hunger, exhaustion or being eaten by the Nile crocodiles of the Mara River.

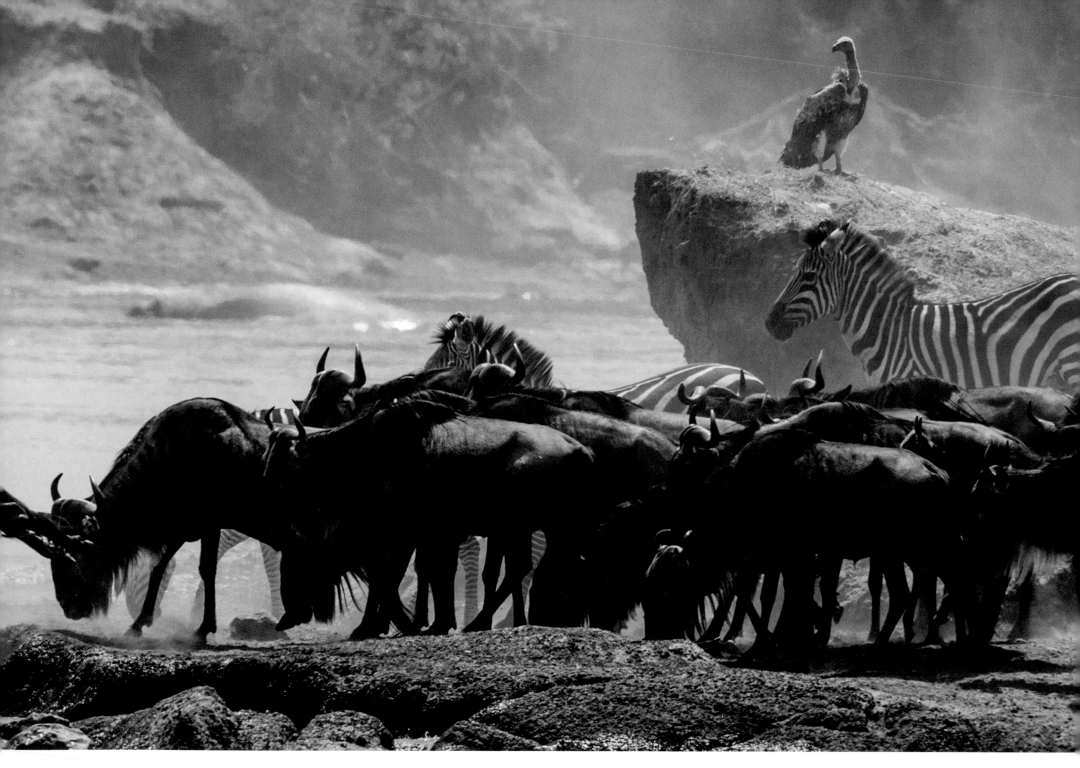

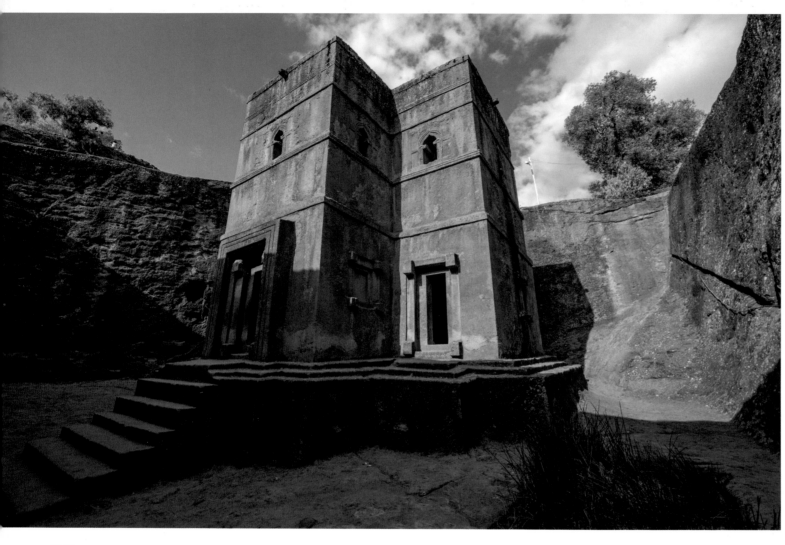

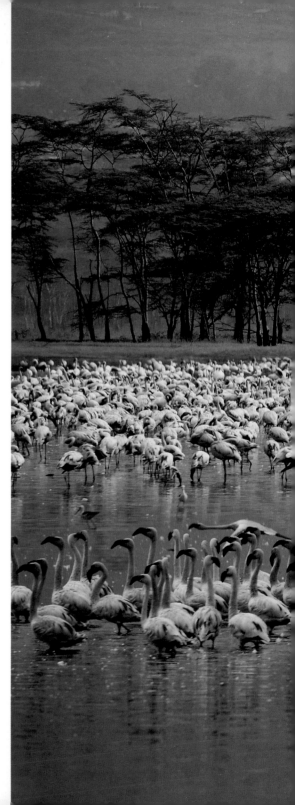

CHURCH OF ST GEORGE, LALIBELA, ETHIOPIA

Along with 10 other churches in Lalibela, cross-shaped St George's was carved from the ground on the orders of the Emperor of Ethiopia, Gebre Mesqel Lalibela (1162–1221), who is a saint of the Ethiopian Orthodox Tewahedo Church. Lalibela's plan was to re-create Jerusalem, positioning his churches in two groups, one representing the earthly city and the other the heavenly. Between them is a trench representing the River Jordan.

LAKE NAKURU NATIONAL PARK, KENYA

Lake Nakuru is an alkaline 'soda lake', with a high concentration of sodium carbonate and other salts. High levels of dissolved carbon dioxide make the water an extremely productive environment for algae, attracting thousands or millions of greater and lesser flamingos to feed. The national park also protects southern white rhinos, endangered Rothschild's giraffes and critically endangered eastern black rhinos.

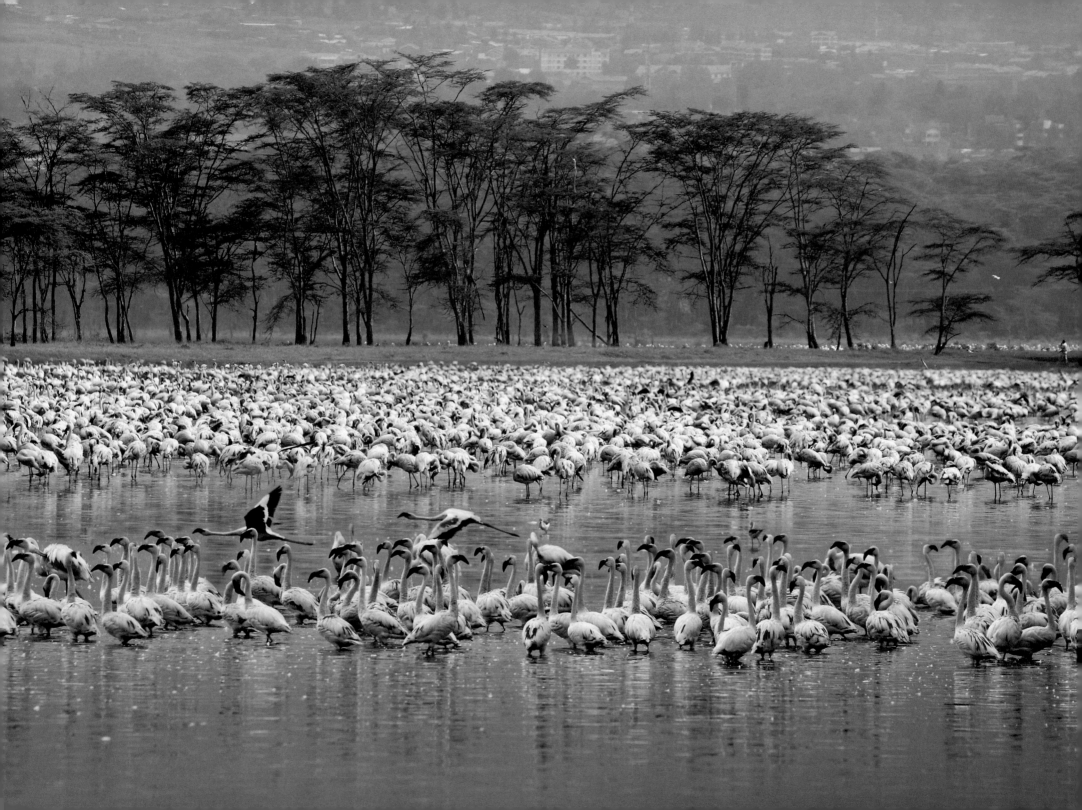

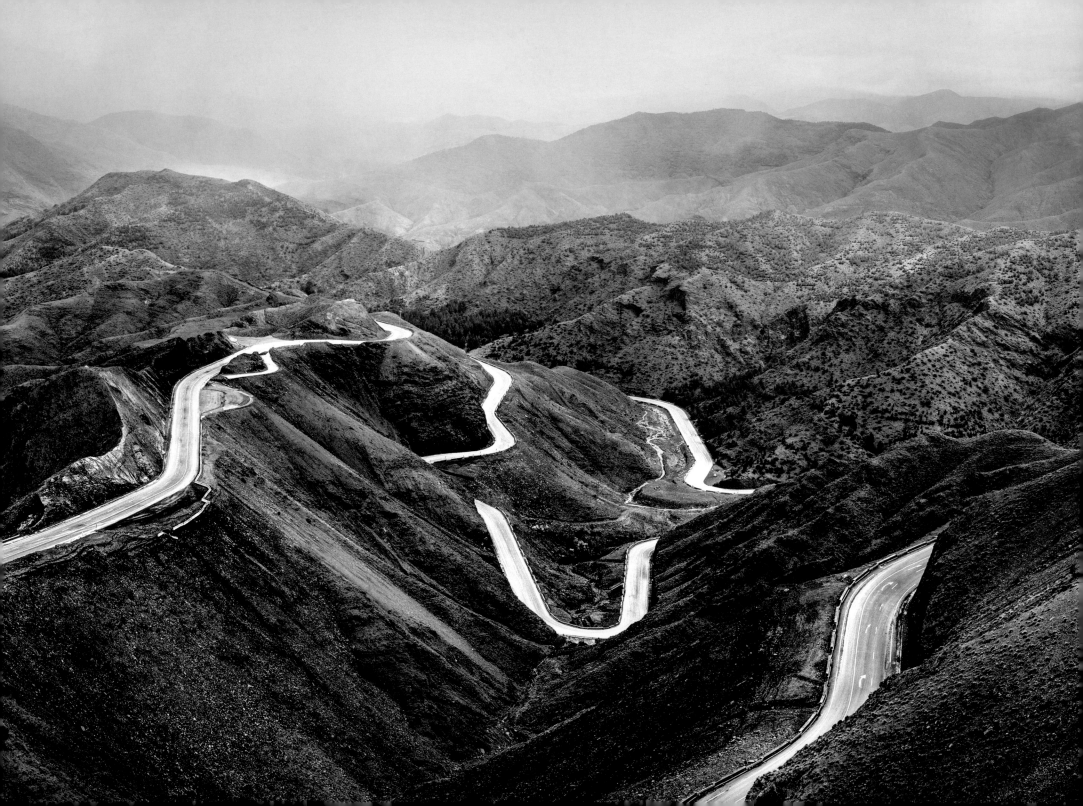

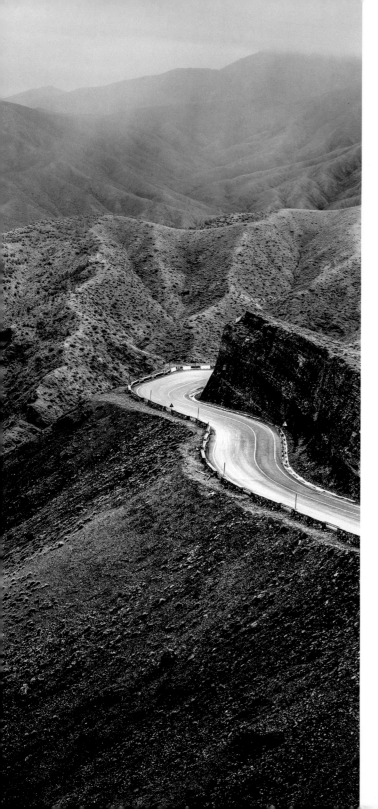

LEFT
ATLAS MOUNTAINS, MOROCCO

The Atlas Mountains of Morocco, Algeria and Tunisia reach their highest point, 4,167 m (13,671 ft), at Toubkal, in southwestern Morocco. Most people in the region are Berber, a group with a history dating back at least 12,000 years. Traditionally, the Berber are semi-nomadic, moving with their livestock between grazing areas and water sources. Berber craftswomen weave kilims, often striped and with the addition of sequins or fringes.

BELOW
ERG CHEBBI, MOROCCO

Lying in the Pre-Saharan Steppes, this sea of wind-blown sand is around 28 km (17 miles) long and 6 km (3.7 miles) wide. The tallest dunes are 150 m (492 ft) high. Surrounding the dunes is hamada, or rock desert. From the town of Merzouga, camel treks lasting a day or two can be taken into the dunes. During summer, Moroccans suffering from rheumatism come to be buried neck deep in the hot sand for a few minutes.

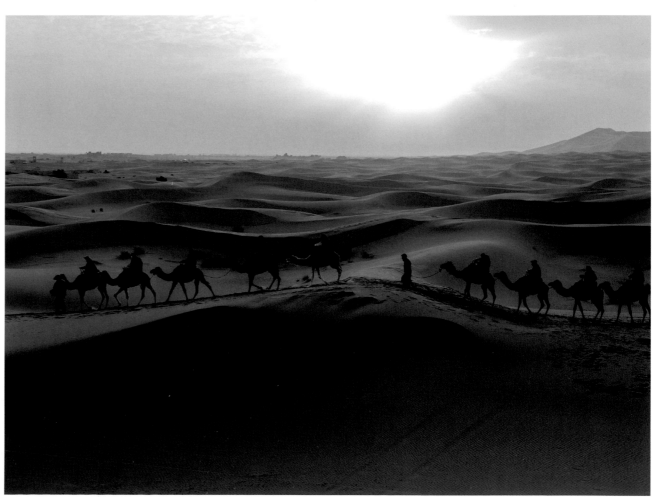

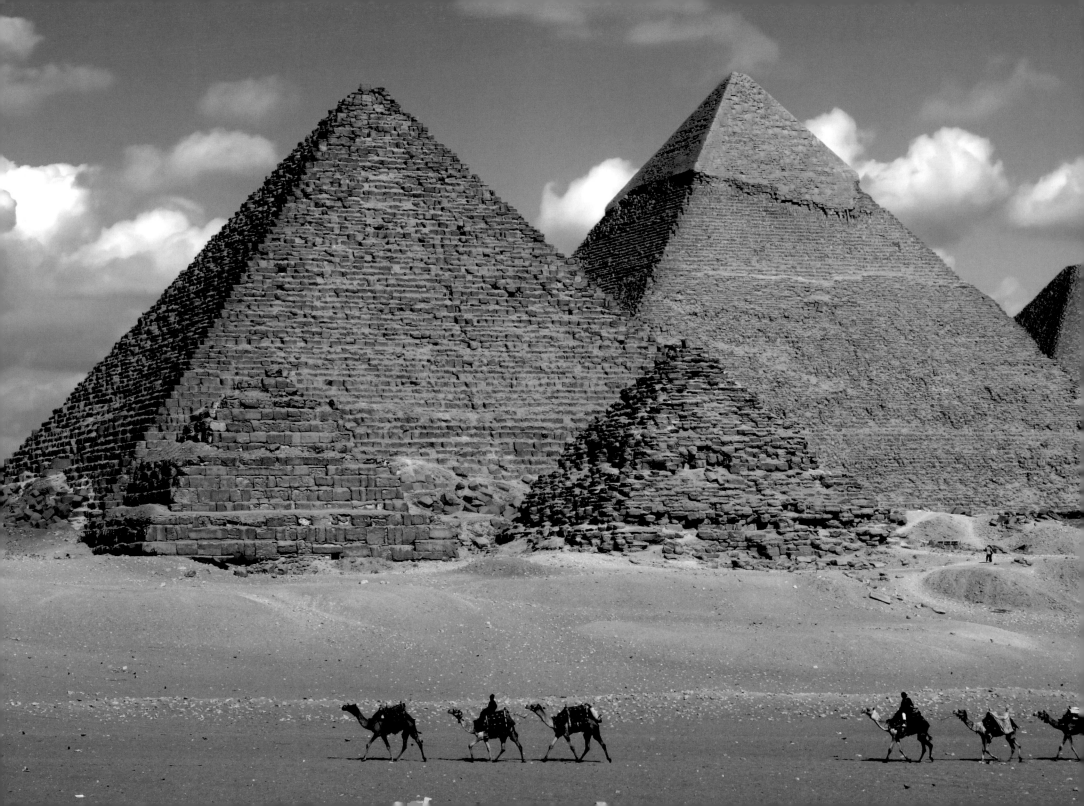

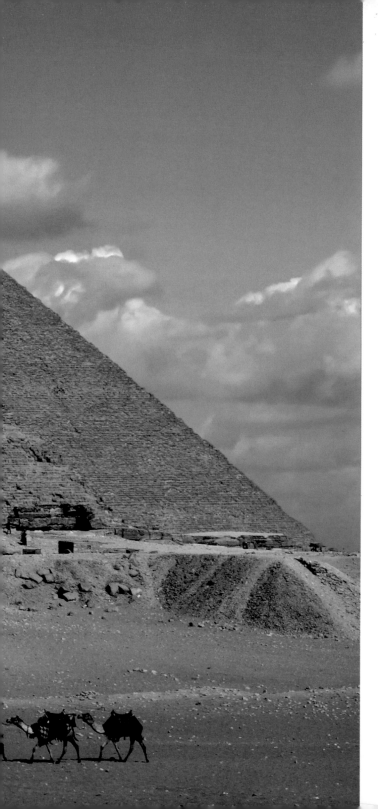

PYRAMIDS OF GIZA, EGYPT

From around 2630 to 1550 BCE, pharaohs' tombs were in great stone pyramids, the largest of all the Pyramid of Khufu at Giza (far right), which reached 146.5 m (481 ft) tall. Completed around 2560 BCE, it was constructed from 2.3 million blocks of limestone and granite. Khufu's pyramid stands close to those of his son Khafre (middle), and grandson Menkaure (left). Three subsidiary pyramids, known as queens' pyramids, stand beside Menkaure's.

GREAT SPHINX OF GIZA, EGYPT

Constructed during the reign of Khafre (c.2558–2532 BCE), this limestone statue has the head of a human, believed to be Khafre himself, and the body of a lion, suggesting kinship with the solar deity Sekhmet, a lioness. Sphinxes were symbols of royal strength and power. Standing just southeast of the pyramids, the Great Sphinx measures 73 m (240 ft) from tip of paw to tail. The nose was deliberately chiselled off some time between the 3rd and 10th centuries CE.

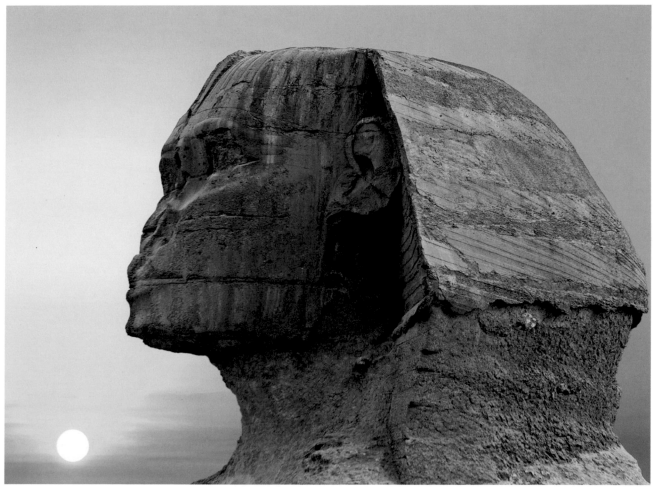

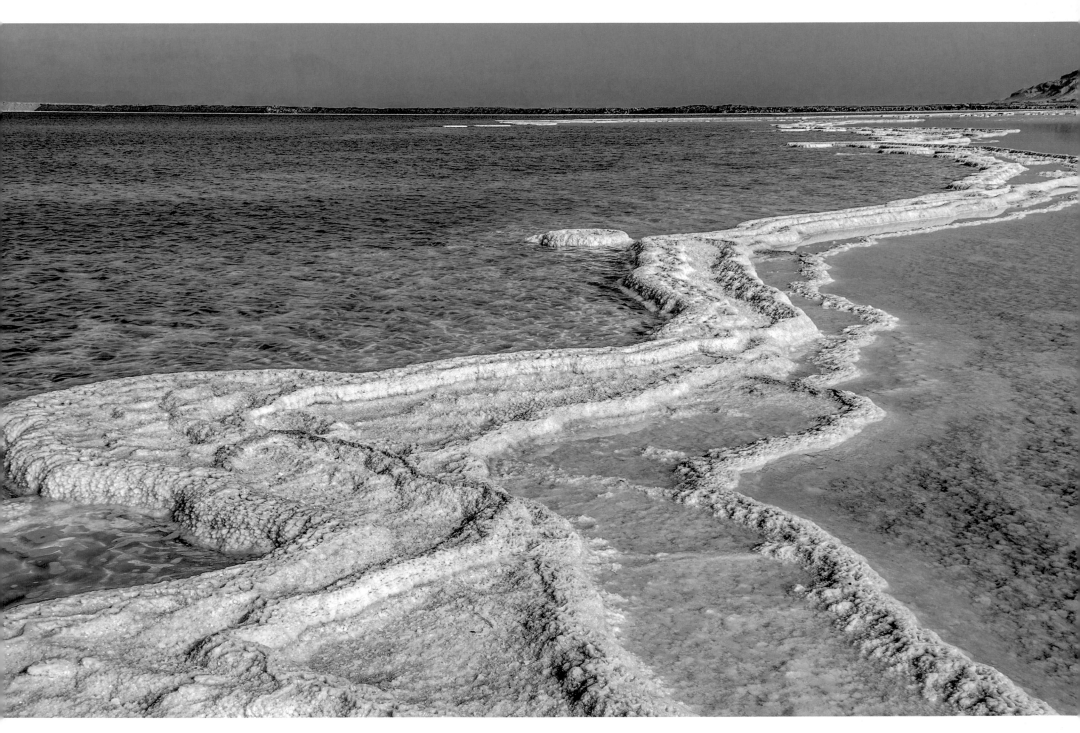

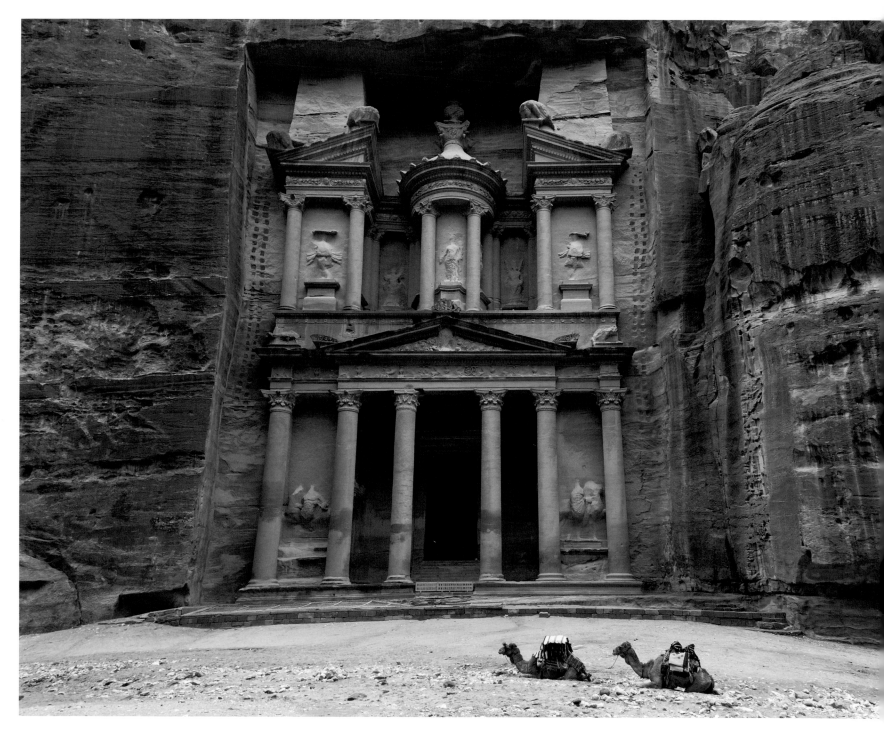

DEAD SEA, ISRAEL, PALESTINE AND JORDAN

With a depth of 304 m (997 ft), the Dead Sea is the world's deepest hypersaline lake, more than nine times saltier than the ocean. Since the dissolved salts make the lake considerably denser than the human body, it is very easy for swimmers to float. The salinity creates a hostile environment for fish and aquatic plants, resulting in the lake's name, although some bacteria and microbial fungi do survive here. The lake's surface is 430.5 m (1,412 ft) below sea level, making this the lowest point on Earth's land.

AL-KHAZNEH, PETRA, JORDAN

Petra had become the capital and trading hub of the Nabataeans by around the 2nd century BCE. Al-Khazneh ('The Treasury') was built in the 1st century CE as a mausoleum for their King Aretas IV. Like the city's other major structures, it was carved from the pink sandstone rock face. The Nabataeans controlled this desert area's dangerous flash floods with dams, cisterns and conduits, storing the water for periods of drought.

BELOW
JEITA GROTTO, LEBANON

At Jeita, two interconnected limestone caves were worn away by groundwater, made slightly acidic by dissolved carbon dioxide. The Lower Cave, through which an underground river courses, can be visited only by boat, while the Upper Cave houses the world's longest known stalactite, reaching 8.2 m (27 ft) long. The Upper Cave also features stalagmites, columns, mushrooms, curtains and draperies, some pure white calcite and others red from small quantities of iron oxide.

RIGHT
SALALAH, OMAN

Although the landscape around the sociable city of Salalah is dry and brown for much of the year, it comes alive with sparkling waterfalls and bright leaves during the *khareef*, the monsoon season of July and August. This is when moisture from the Indian Ocean brings fog and often a continual misty drizzle. Visitors should overcome the great temptation to swim in any of the natural pools in Wadi Darbat or Ayn Khor, as they are known for their lurking, bilharzia-carrying snails.

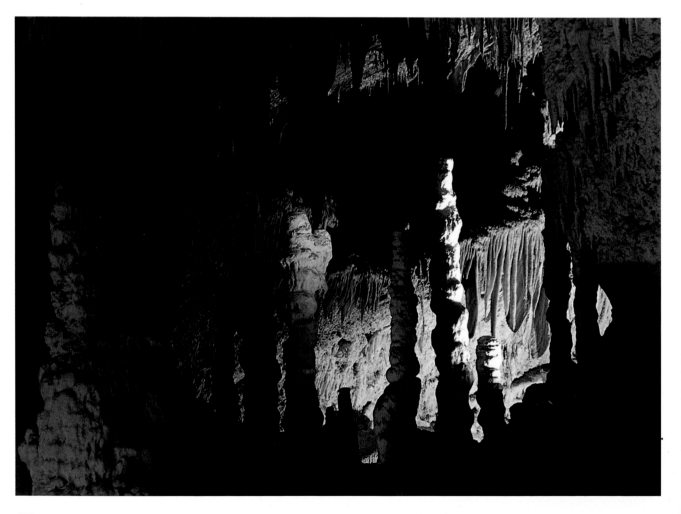

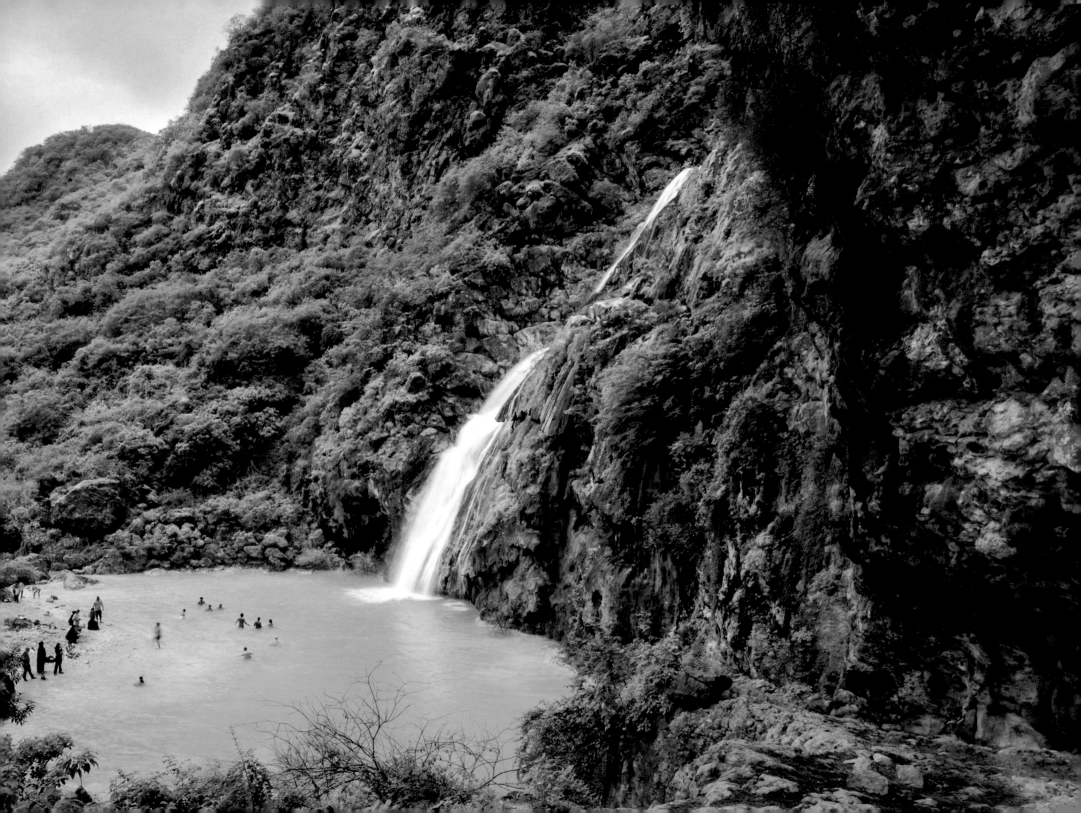

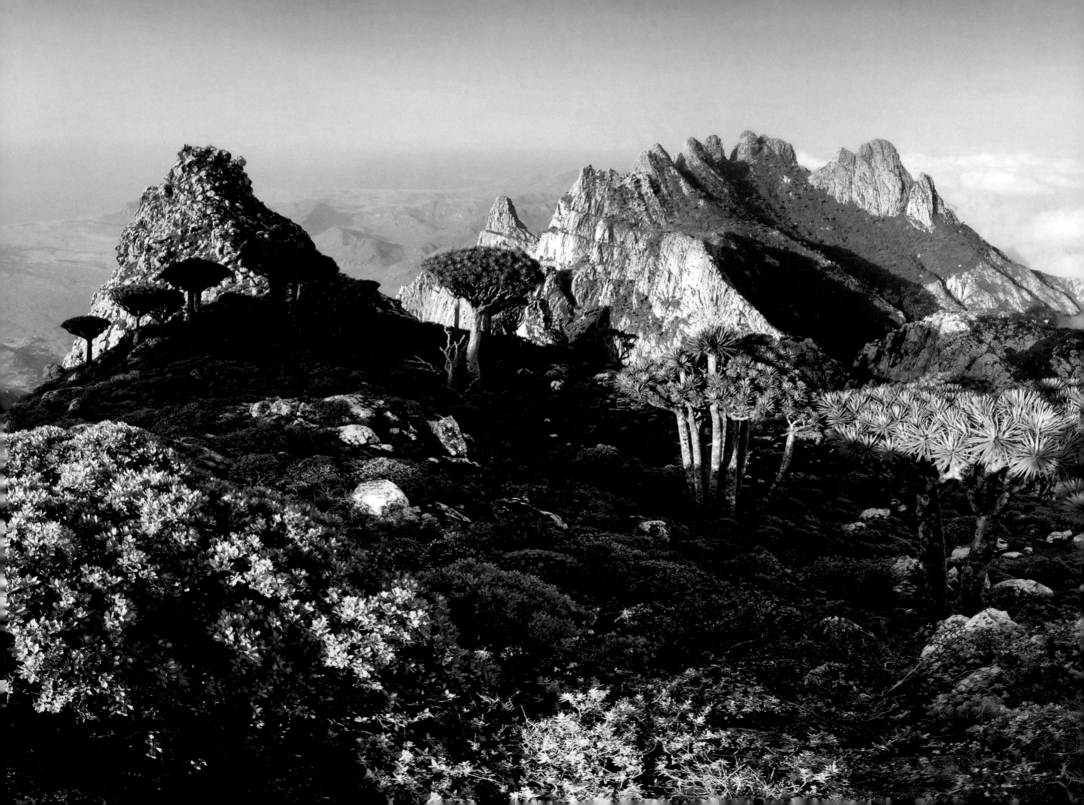

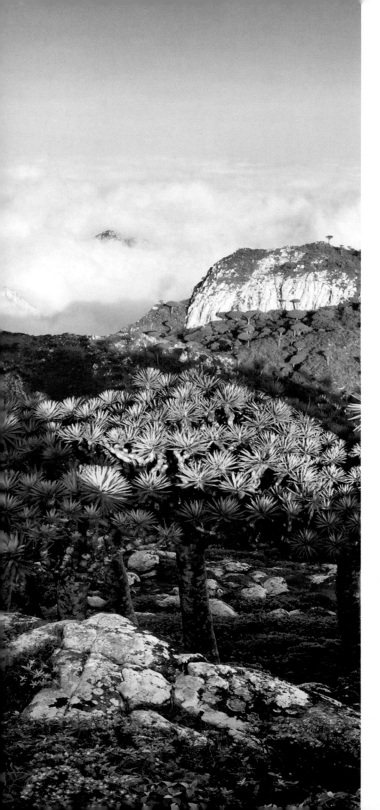

SOCOTRA, YEMEN

This isolated island, 380 km (240 miles) south of the Arabian Peninsula, is home to a vast number of endemic species, including one-third of its plants. One of the many strange-looking plants is the dragon's blood tree (*Dracaena cinnabari*; pictured on the left), shaped like an umbrella and with red sap once thought to be dragon's blood. The Socotran desert rose (*Adenium obesum socotranum*; pictured below) grows on the island's rocky slopes, holding its showy pink flowers above its stout caudex.

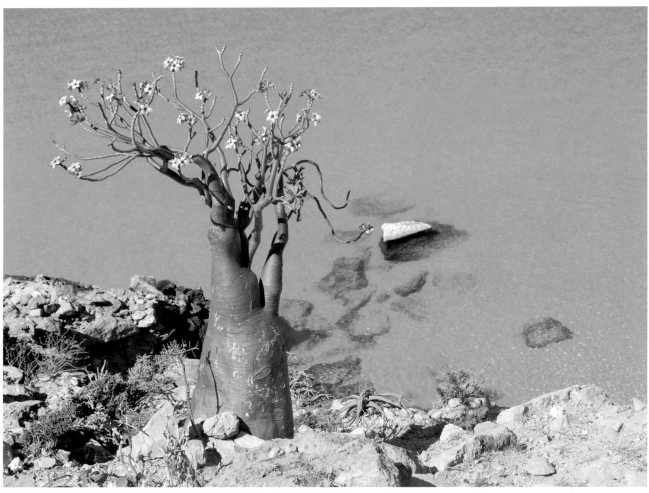

MADA'IN SALEH, SAUDI ARABIA

Mada'in Saleh, possibly then known as Hegra, was the Nabataeans' second largest city, after Petra in modern-day Jordan. Unlike in Petra, which is thronged with tourists and in danger of decay, visitors may have this site to themselves. Much of the city is still to be excavated, but more than 130 huge tombs, most dating from the 1st century CE, have already been unearthed. Their elaborately ornamented facades, while distinctly Nabataean in style, show the influence of Greece, Rome and Babylon.

PAMUKKALE, TURKEY

The glistening white terraces at Pamukkale (from the Turkish for 'cotton castle') are made of travertine, deposited by hot spring water that is supersaturated with calcium carbonate. As the water drips down the mountainside, it collects in pools on the terraces, then spills over the rims, creating stalactites as it drips to the pools below. At the top of the mountain is the ancient Greek site of Hierapolis, built as a thermal spa and healing centre in the early 2nd century BCE.

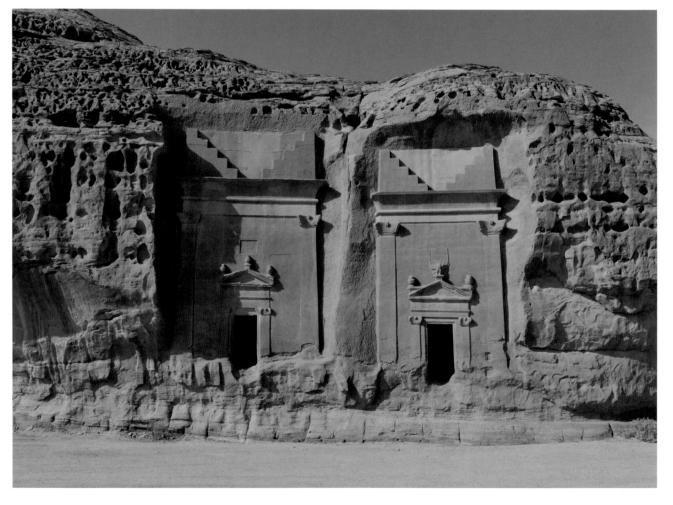

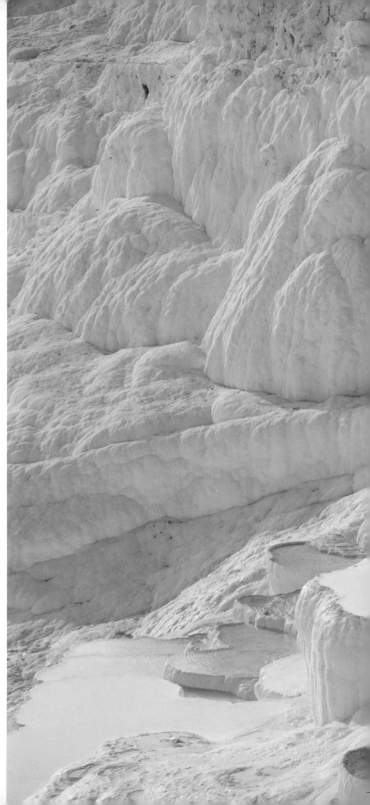

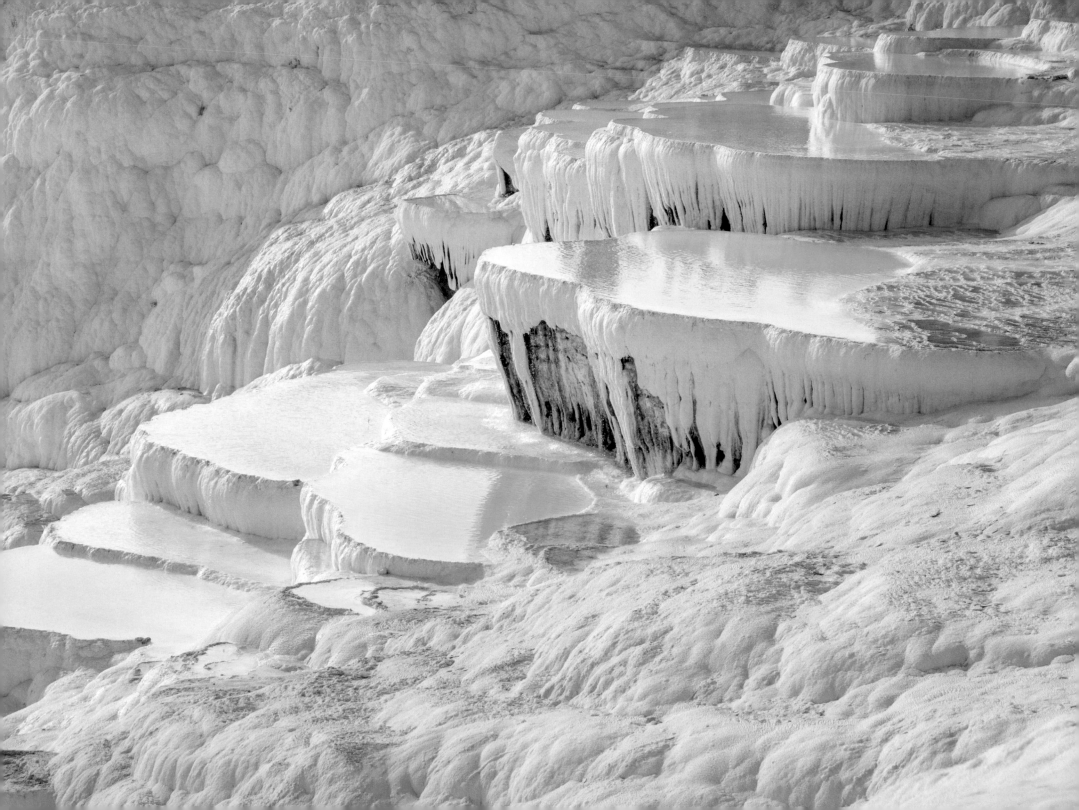

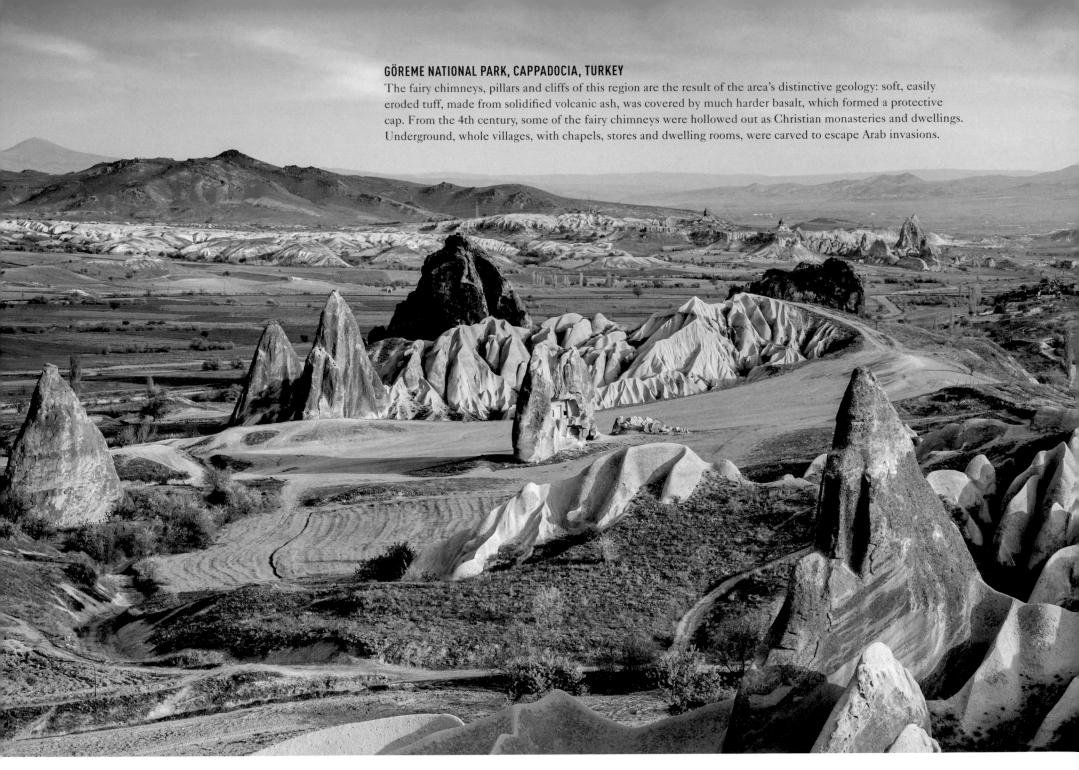

GÖREME NATIONAL PARK, CAPPADOCIA, TURKEY

The fairy chimneys, pillars and cliffs of this region are the result of the area's distinctive geology: soft, easily eroded tuff, made from solidified volcanic ash, was covered by much harder basalt, which formed a protective cap. From the 4th century, some of the fairy chimneys were hollowed out as Christian monasteries and dwellings. Underground, whole villages, with chapels, stores and dwelling rooms, were carved to escape Arab invasions.

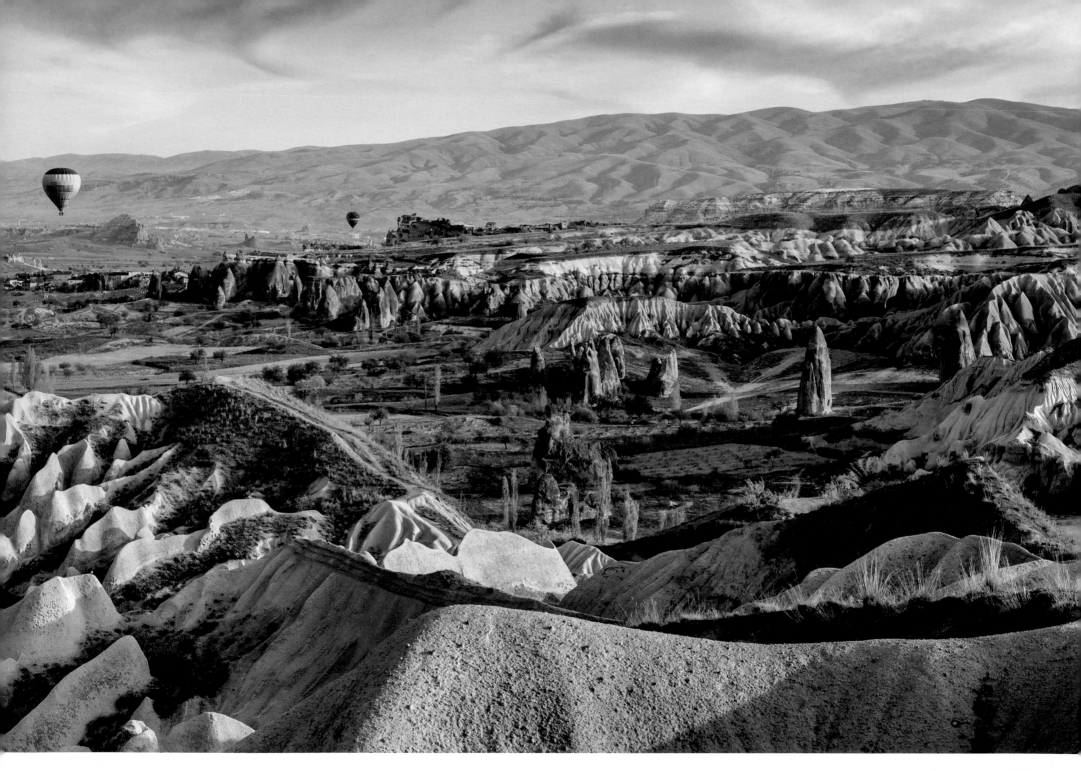

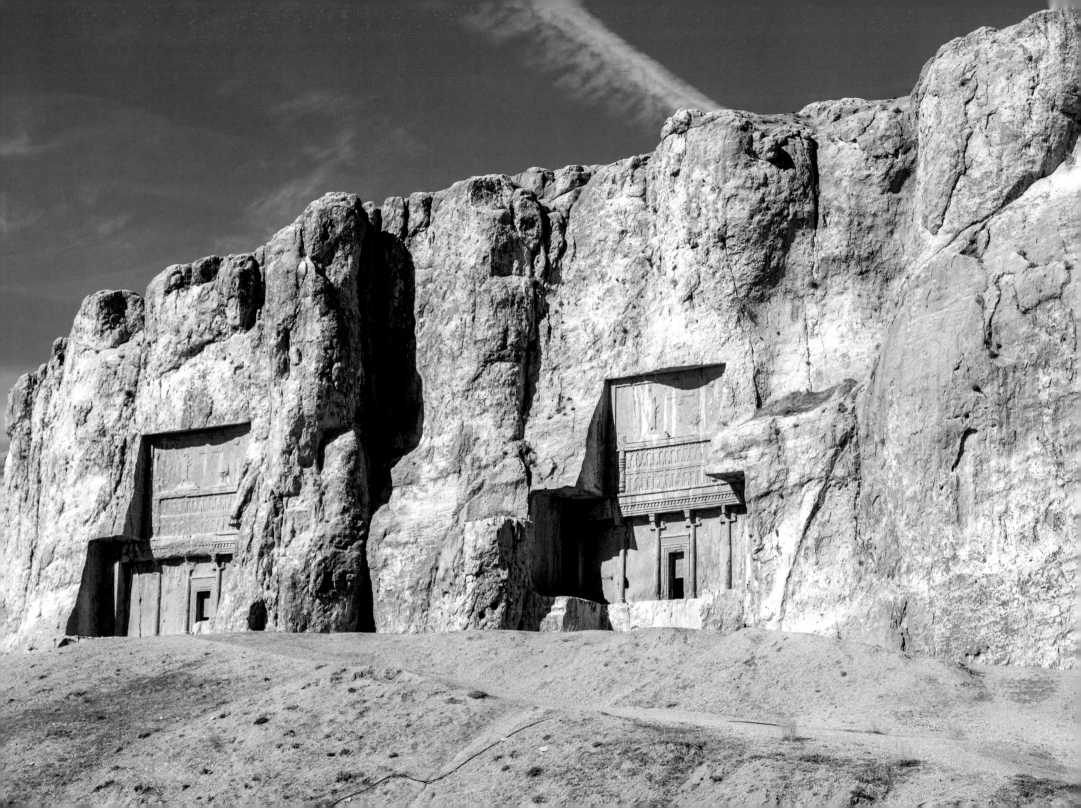

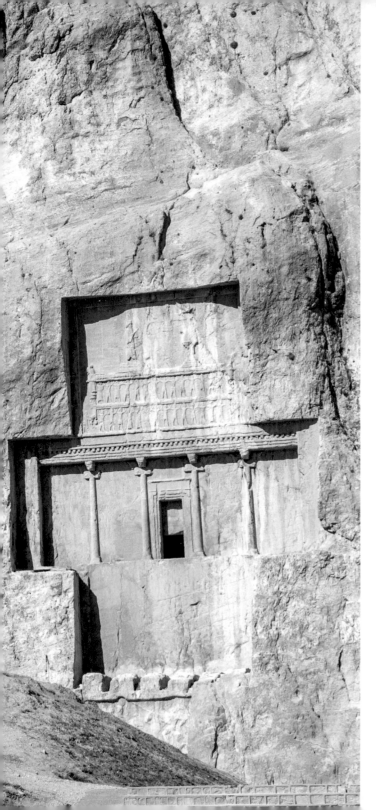

LEFT
NAQSH-E ROSTAM, IRAN

This was the necropolis of the Achaemenid dynasty of Persia (c.550–330 BCE). Four tombs are cut into the cliff face, believed to belong to Darius I, Xerxes I, Artaxerxes I and Darius II. A lengthy inscription by Darius I, carved around 490 BCE, is on the facade of his tomb, reading in part: 'I am Darius the great king, king of kings, king of countries containing all kinds of men, king in this great earth far and wide, son of Hystaspes, an Achaemenid, a Persian, son of a Persian, an Aryan, having Aryan lineage.'

BELOW
PERSEPOLIS, IRAN

This exquisitely designed and wrought city was the ceremonial capital of the Achaemenid Empire, from its construction in 515 BCE until it was conquered and burned by Alexander the Great in 330 BCE. Buildings include royal accommodation and reception halls, a treasury, military facilities and stables. Bas-reliefs depict processions of ambassadors, tribute-bearers, soldiers and animals from every corner of the empire, suggesting both the subjugation and celebration of the empire's myriad peoples.

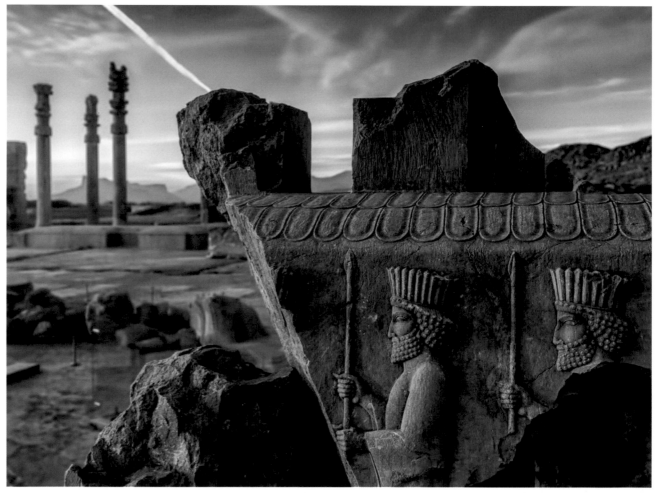

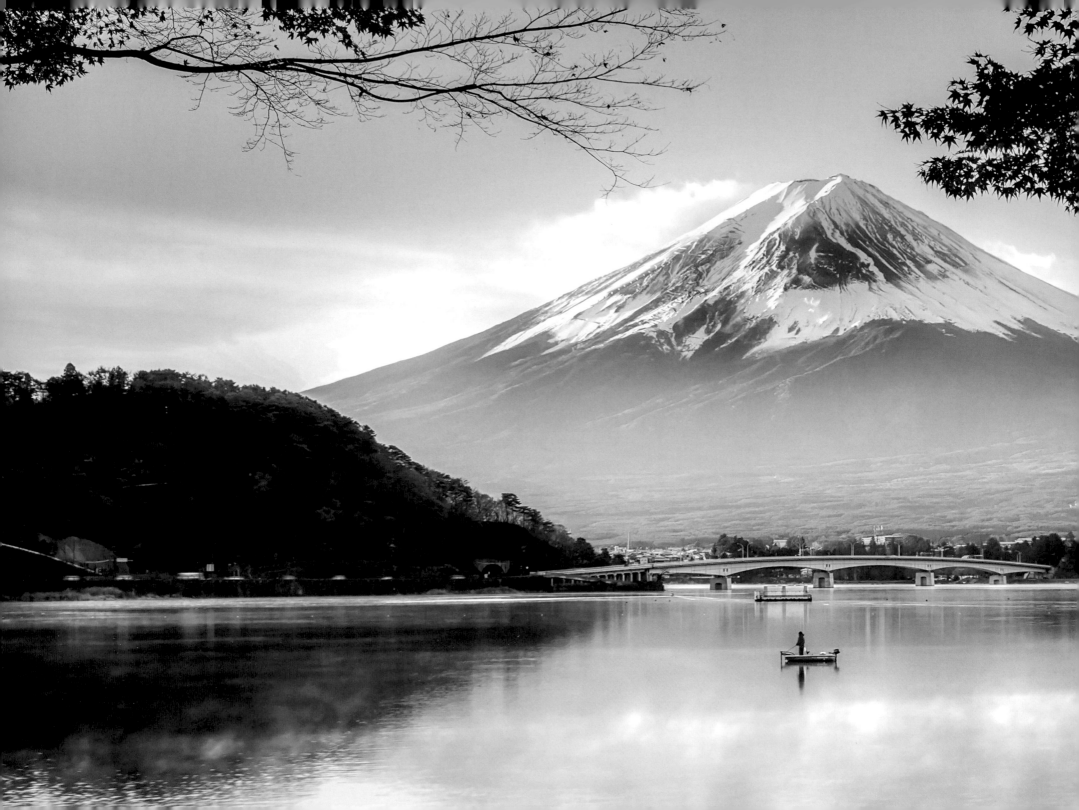

Asia and the Pacific

Asia's landscapes range from the vast, empty steppes of Mongolia to the densely populated islands of Japan, where busy towns and cities cluster even on the slopes of unpredictable volcanoes. In Oceania, Australia is the greatest landmass, its red desert rich with myth and hidden life, its coast fringed by the world's most extraordinary coral garden. The islands of Oceania, scattered widely across the Pacific Ocean, offer unmissable lessons in the myriad ways that life can develop when isolated, not only in their flora and fauna but also in the unique art and traditions of their human inhabitants.

South Asia was the birthplace of two world religions, Hinduism and Buddhism, which spread across the region and beyond, leaving their mark not just on human lives but in some of the world's most breathtaking places of worship, from the gopurams of southern India to the pagodas of Myanmar's Bagan. In Asia and the Pacific, it is also humankind's entirely earthbound desire to dominate both other people and the land that has the power to awe. In China, it is the overarchingly ambitious Great Wall, forever a monument to imperial control. In the Philippines, it is the centuries-old rice terraces that farmers painstakingly carved into the hillsides to master the rain and soil.

MT FUJI AND LAKE KAWAGUCHI, JAPAN
One of the Fuji Five Lakes, Kawaguchi was formed when an ancient eruption of Mt Fuji dammed the local rivers with lava. At 3,776 m (12,389 ft), Fuji is the highest volcano in Japan. It last erupted during the winter of 1707–8.

BELOW
MUD VOLCANOES, GOBUSTAN, AZERBAIJAN

Azerbaijan has more mud volcanoes than any other country, around 350, many of them in the Gobustan State Reserve. Mud volcanoes, often found around oil and gas fields, are formed by the eruption of mud, water and gas. Groundwater is heated in the crust, mixing with earth and minerals, then pressure imbalances force it to the surface through a fissure. Gobustan also has 6,000 rock carvings, dating back over 5,000 years, depicting dancers, battles, animals and boats.

RIGHT
VARDZIA, GEORGIA

The cave monastery at Vardzia, stretching for 500 m (1,640 ft) and in 19 tiers, was largely constructed in the 12th century. The site was almost abandoned in the 16th century, after domination by the Ottomans, but a handful of monks still live here today, ringing the bell in the archway every day at 7 a.m. Celebrated wall paintings in the Church of the Dormition show Byzantine and local folk influences in their depictions of Georgian royalty and the life of Christ.

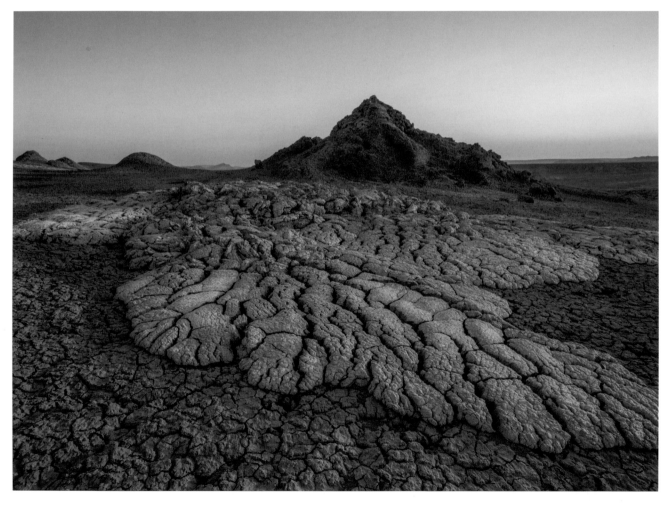

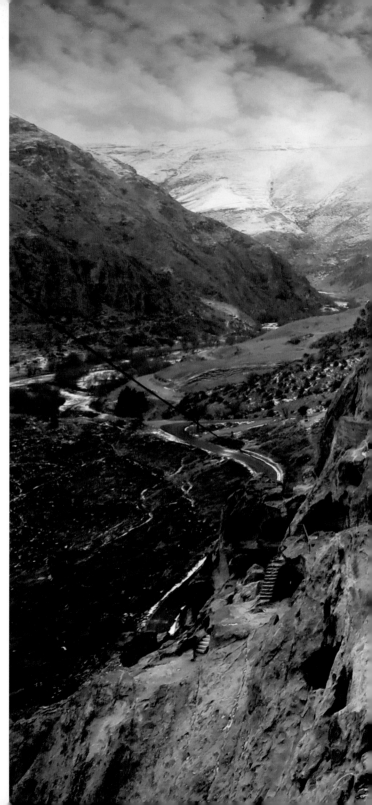

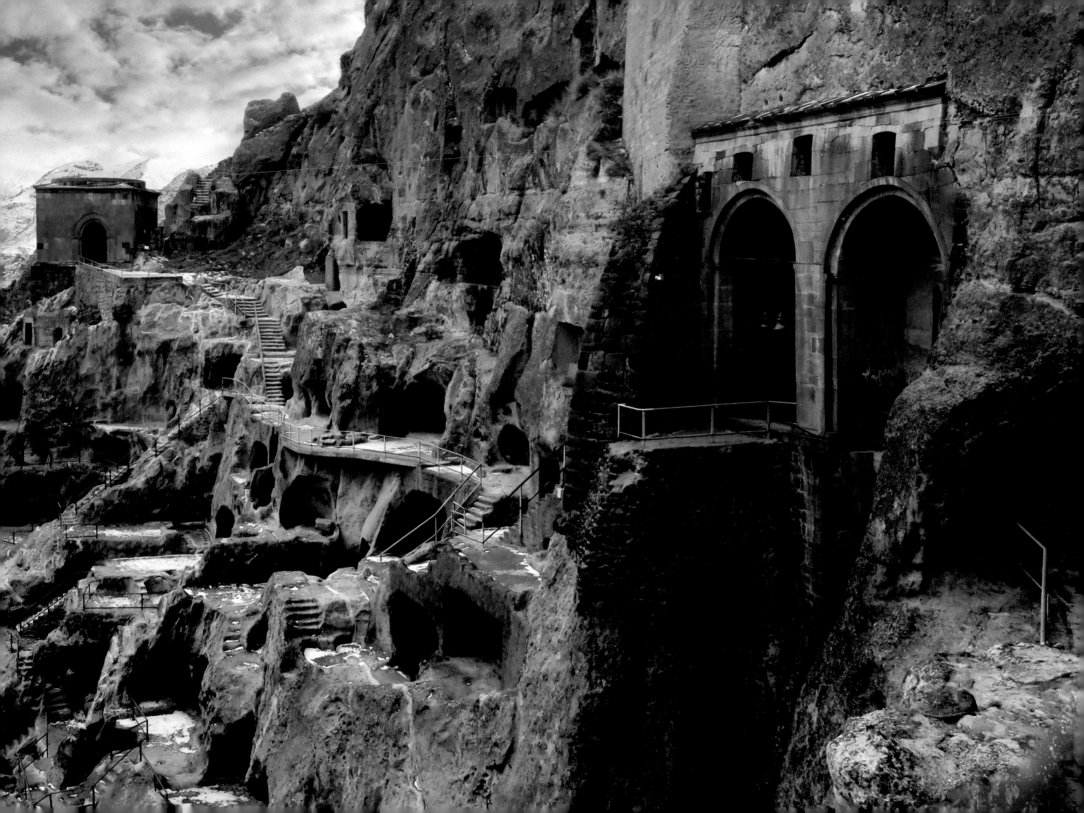

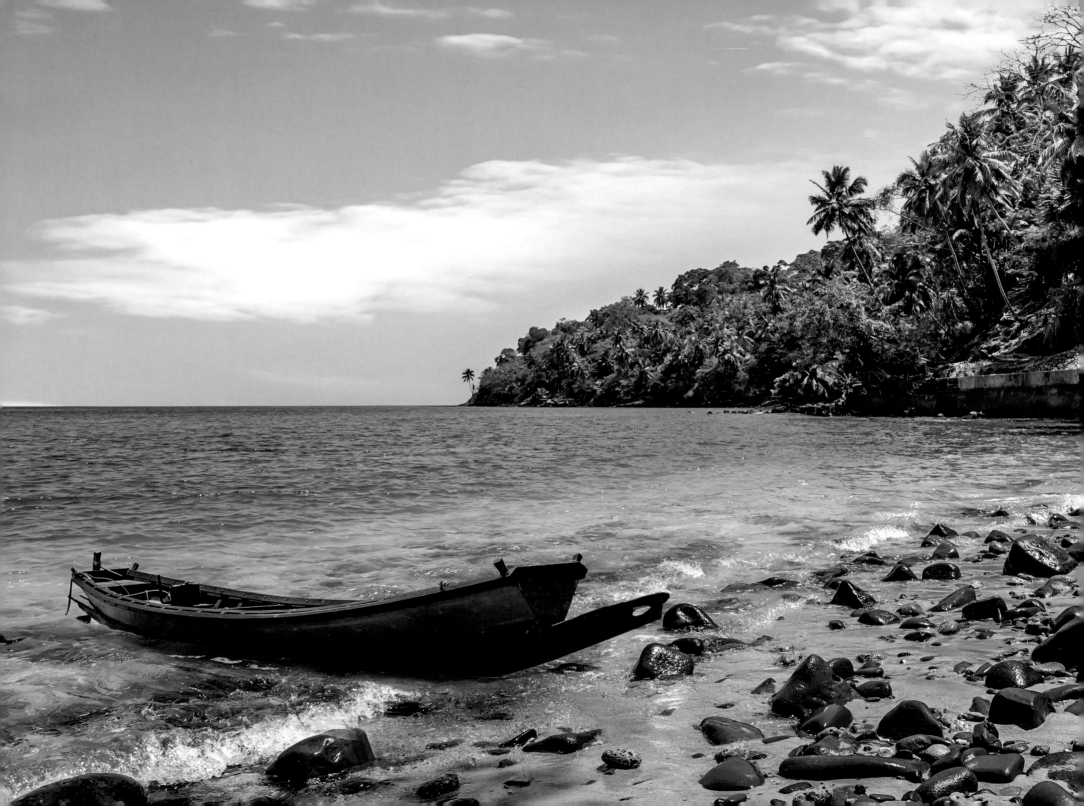

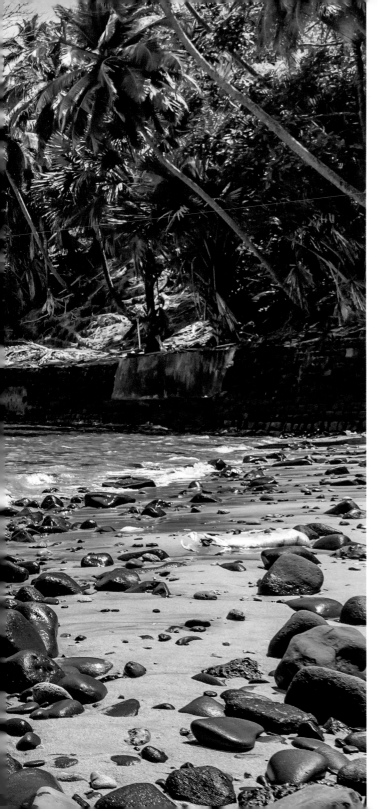

NETAJI SUBHASH CHANDRA BOSE ISLAND, ANDAMAN ISLANDS, INDIA

This thickly forested island, home to peacocks and spotted deer, has no civilian settlements, but a museum and colonial buildings in various states of ruin memorialize the days when this was the seat of British power on the Andaman Islands. Back then, the island, known as Ross Island, was often called the 'Paris of the East'. In 2018, the island was renamed in honour of the eponymous Indian nationalist, who controversially worked to rid India of British rule with the help of Nazi Germany and Imperial Japan.

HAMPI, INDIA

Excavations of the ancient city of Hampi have revealed artefacts dating back to the 2nd century CE. In the 14th century, the city became the capital of the Vijayanagara Empire, holding sway over southern India until conquered and destroyed by the armies of Muslim sultanates in 1565. Here still stands the Virupaksha Hindu temple, with its 50-m (160-ft) high *gopuram*, or entrance tower.

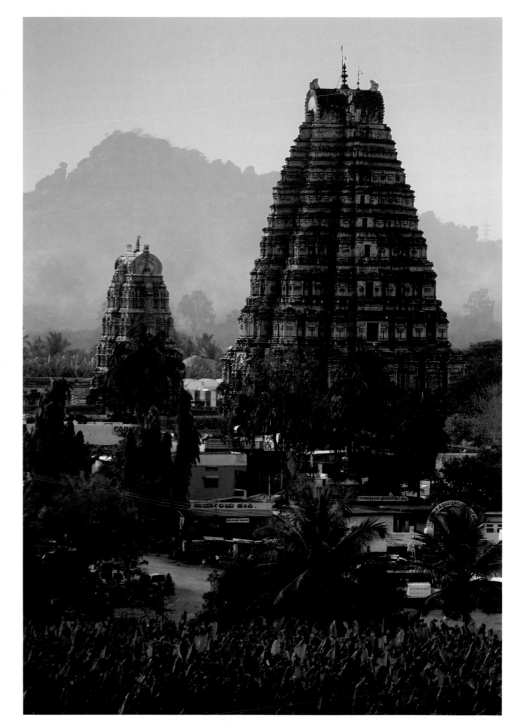

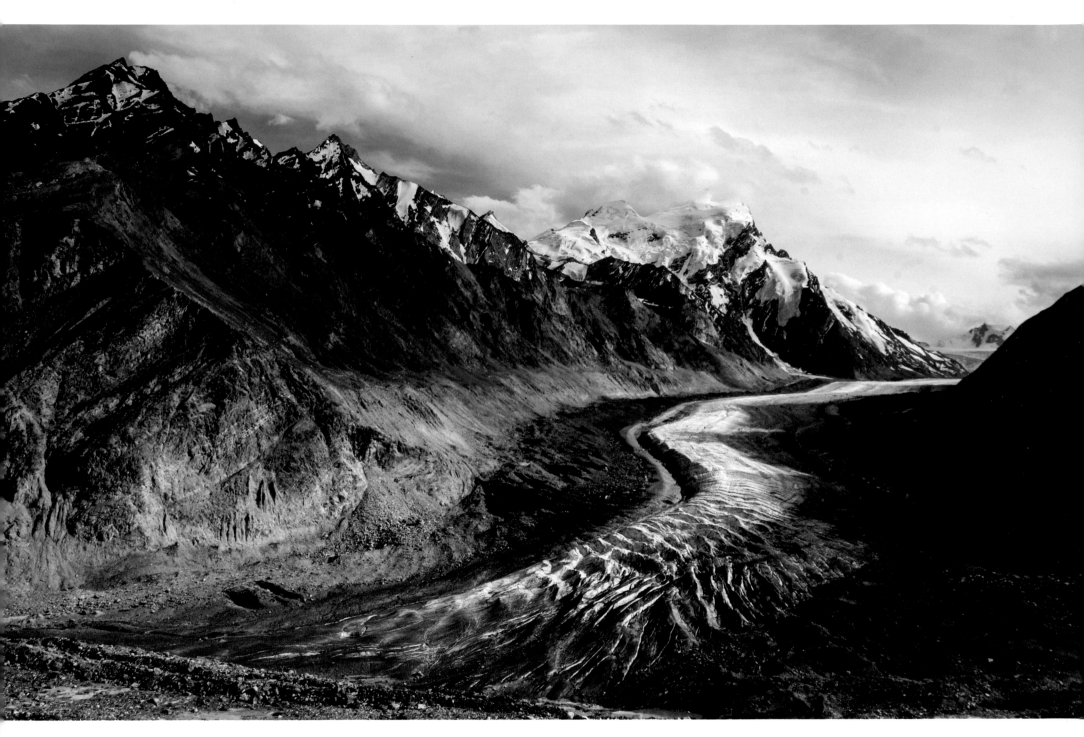

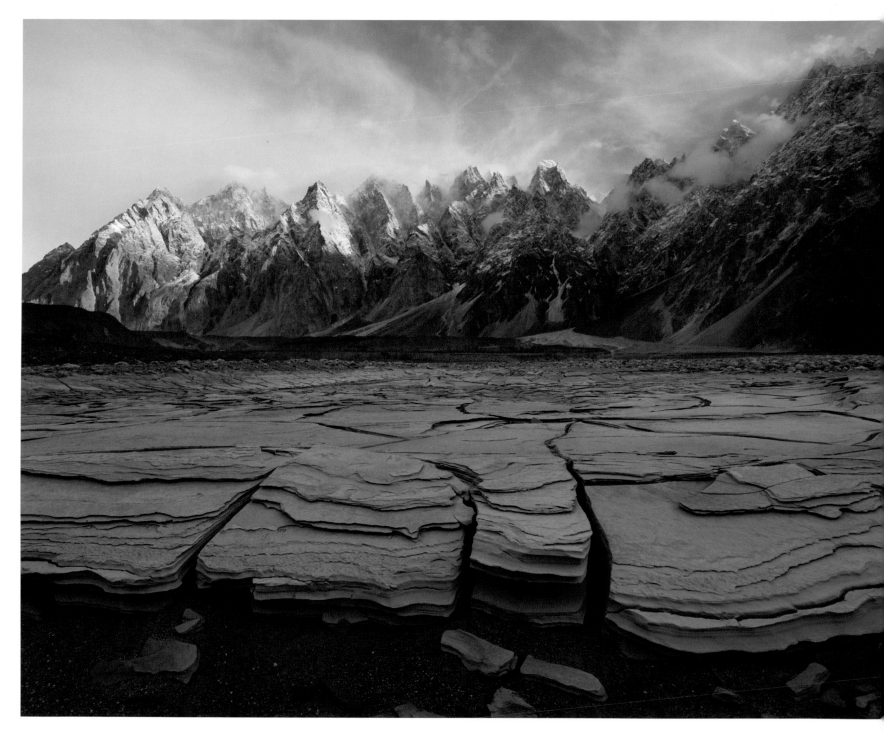

DRANG-DRUNG
GLACIER, INDIA

In the Kashmiri region
of Ladakh, high in the
Zanskar Range of the
Himalayas, is this 23-km
(14-mile) long glacier.
Glacier meltwater creates
the Doda River, which
eventually feeds into the
Indus and reaches the
Arabian Sea. The glacier,
reached by a two-day,
spectacular drive from
Srinagar, is best visited
during summer, when
mountain passes are not
closed by snow. The head
of the glacier is a day's
trek only for the fittest.

PASSU CONES, PAKISTAN

Jutting beside the
Karakoram Highway are
the Passu Cones, serrated
peaks up to 6,106 m
(20,033 ft) tall. Perhaps the
world's most demanding
and beautiful road trip, the
Karakoram Highway passes
through the Karakoram
Range on its way from the
Punjab province of Pakistan
to China's Xinjiang Uyghur
Autonomous Region.
The road crosses the
border at the Khunjerab
Pass, the world's highest
surfaced international
border crossing.

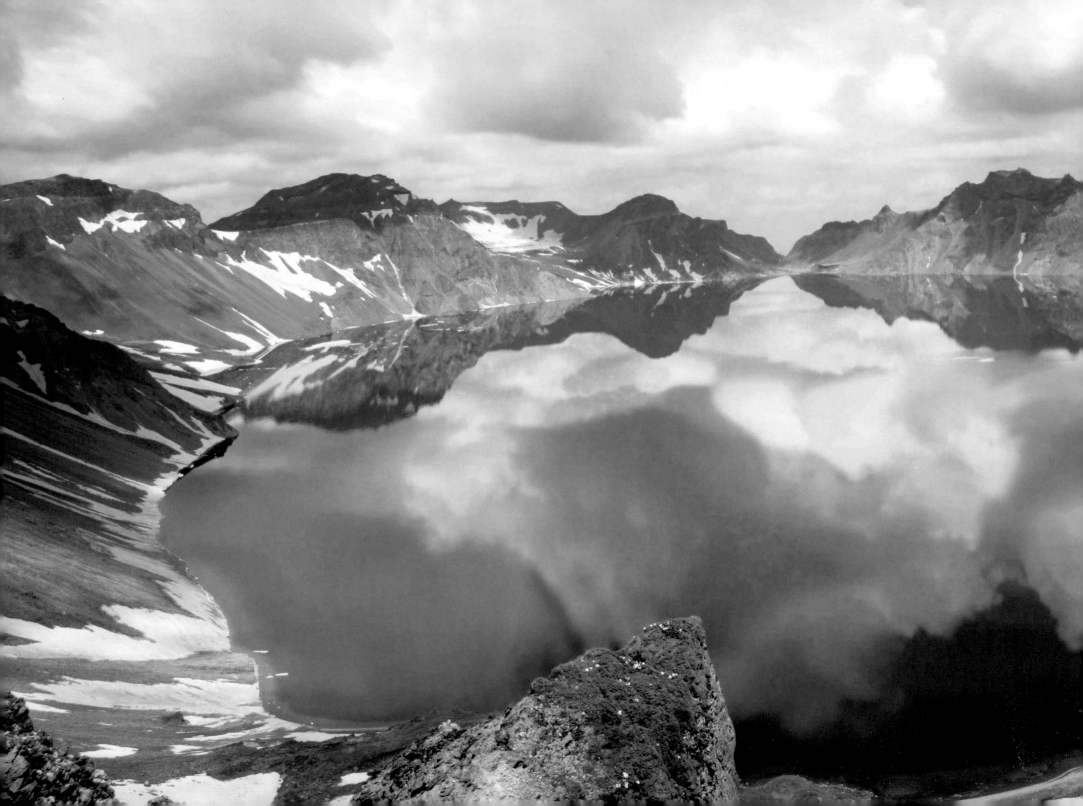

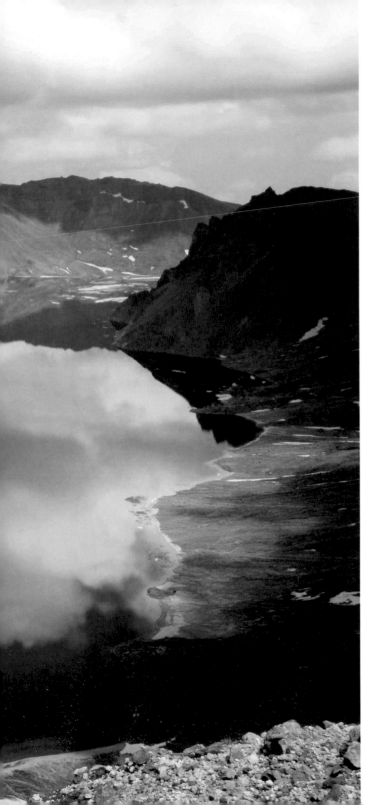

LEFT
HEAVEN LAKE, CHINA
On the border between China and North Korea is this flooded caldera, at the top of Changbai Mountain, an active stratovolcano. The caldera was formed by the volcano's 946 eruption, an event so enormous that it also ejected 100–120 cubic km (24–29 cu miles) of material, blocking sunlight and causing climate change across the region. This was one of the largest volcanic eruptions in recorded history. The lake is alleged to be the home of Loch Ness-type monsters, which take numerous forms, depending on the observer.

BELOW
ZHANGJIAJIE GLASS BRIDGE, CHINA
Designed by Israeli architect Haim Dotan, this 430-m (1,410-ft) long, vertiginously glass-floored bridge (which has faced closures due to safety fears) spans a canyon in Zhangjiajie National Forest Park. The region is known for its countless limestone pillars, eroded by ice, streams and the roots of thickly growing plants. The formations are a hallmark of depictions of the Chinese landscape, from the days of ink-painted silk scrolls to the action movies of today.

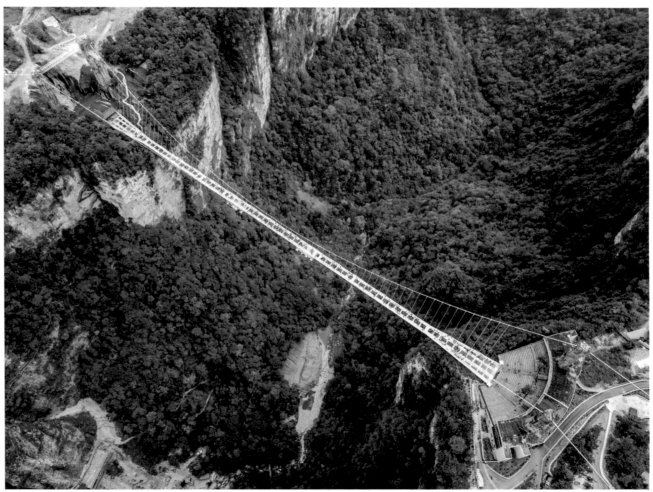

BELOW

BENXI WATER CAVES, CHINA

Around 2.8 km (1.7 miles) of this 5.8-km (3.6-mile) cave system is open to the public, much of it reached by boat. Thickets of centuries-old stalactites and stalagmites are brightly lit and often imaginatively named as 'lotus lamp', 'crocodile's head', 'corn tower', 'elephant' and 'snow mountain'. Visitors should bring warm clothing, rubber-soled shoes and a change of trousers, as insurance against drips, splashes and wet seats.

RIGHT

GHENGIS KHAN STATUE COMPLEX, MONGOLIA

Near the Tuul River, about an hour's drive east of Ulaanbaatar, is a 40-m (131-ft) tall equestrian statue of Genghis Khan (c.1162–1227), on the spot where legend has it he found a golden whip. Genghis Khan united the nomadic tribes of the Mongol homeland and launched horse-borne invasions that conquered most of Eurasia. Visitors can climb to the horse's head, from where there are wide views over the steppe.

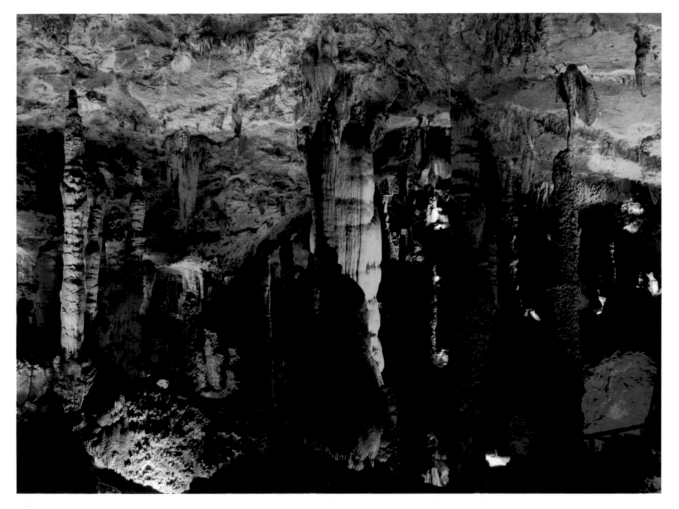

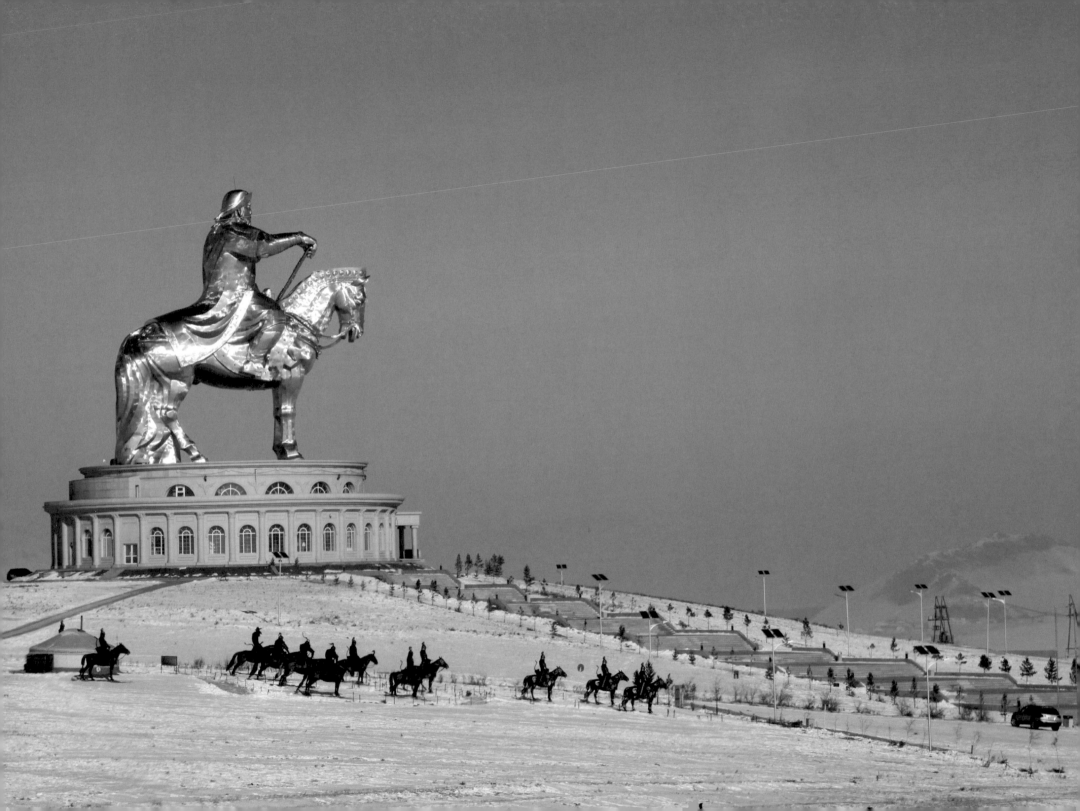

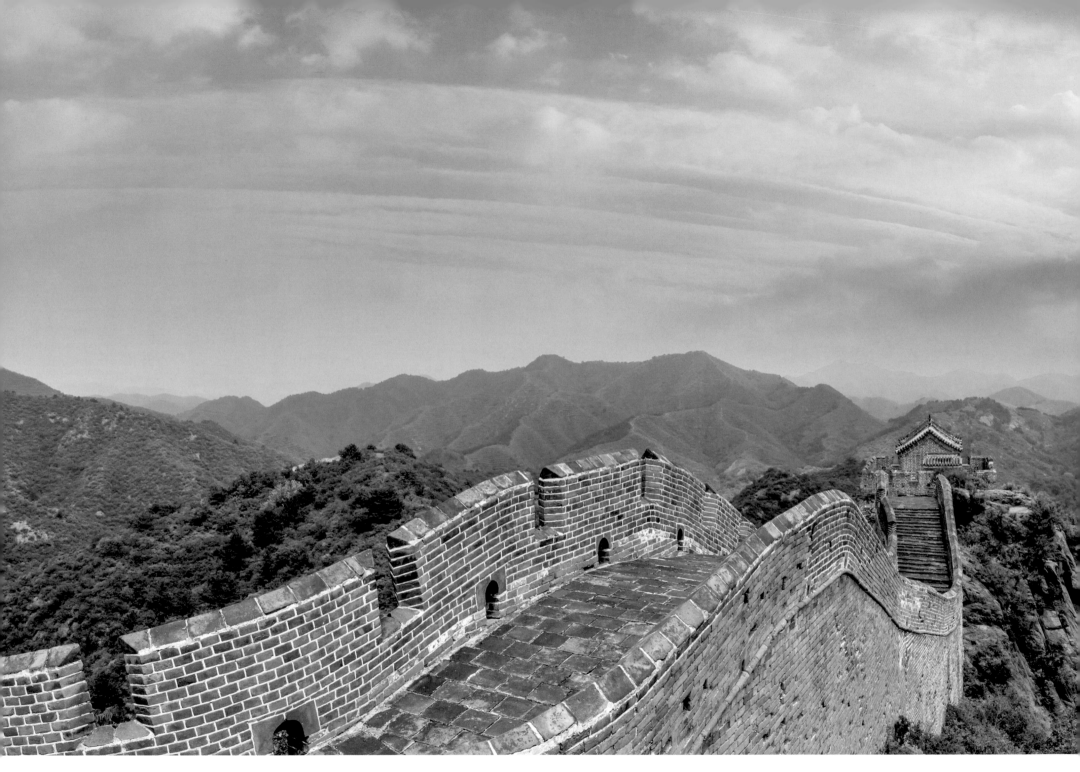

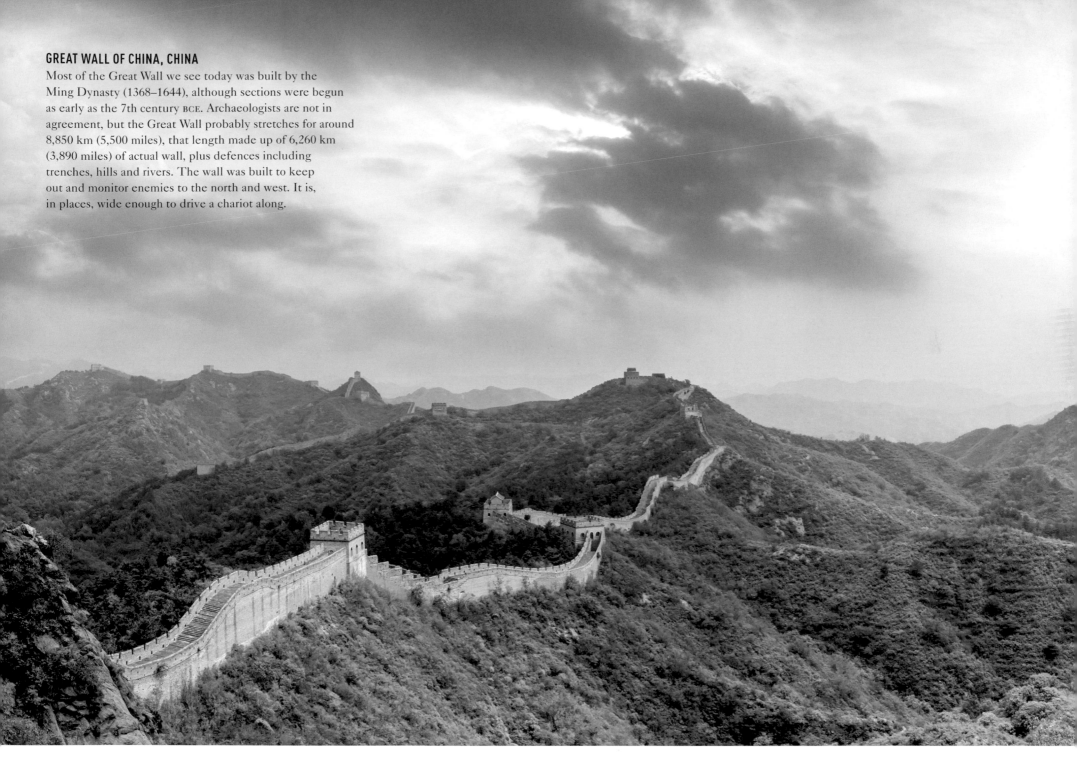

GREAT WALL OF CHINA, CHINA

Most of the Great Wall we see today was built by the
Ming Dynasty (1368–1644), although sections were begun
as early as the 7th century BCE. Archaeologists are not in
agreement, but the Great Wall probably stretches for around
8,850 km (5,500 miles), that length made up of 6,260 km
(3,890 miles) of actual wall, plus defences including
trenches, hills and rivers. The wall was built to keep
out and monitor enemies to the north and west. It is,
in places, wide enough to drive a chariot along.

SEONGSAN ILCHULBONG, JEJU ISLAND, SOUTH KOREA

Known in English as Sunrise Peak, a 180-m (590-ft) high tuff cone lies on the east coast of Jeju Island. The cone was formed during an underwater eruption around 5,000 years ago, as lava mixed with seawater. Jeju Island, itself made by an eruption around 2 million years ago, is also known for its lava tubes. These caves formed as surface lava cooled and hardened, while hot lava continued to flow through natural conduits beneath.

WORYEONGGYO BRIDGE, ANDONG, SOUTH KOREA

This 387-m (1,270-ft) bridge across the Nakdong River, the longest pedestrian-only bridge in South Korea, carries visitors to the Andong Folk Village. The village houses many traditional buildings, from farmhouses to courtyard-centred mansions, that were moved here during the construction of the Andong Dam in 1976. Every year, Andong hosts its renowned Mask Dance Festival, during which wooden-mask wearing performers dance ancient rituals and tales.

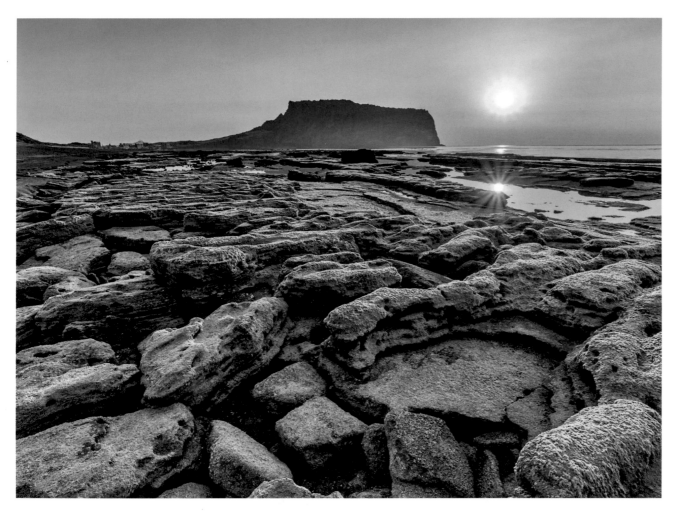

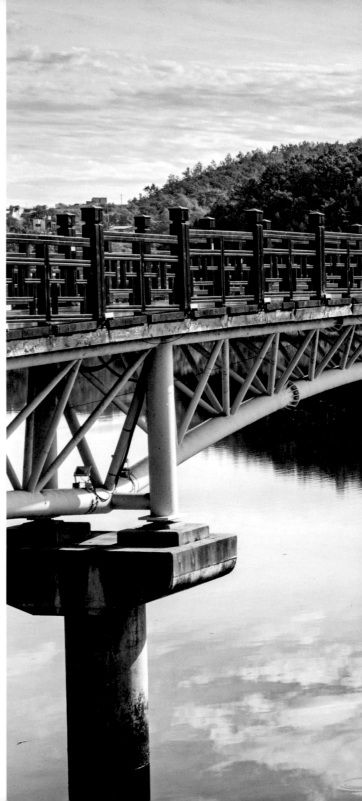

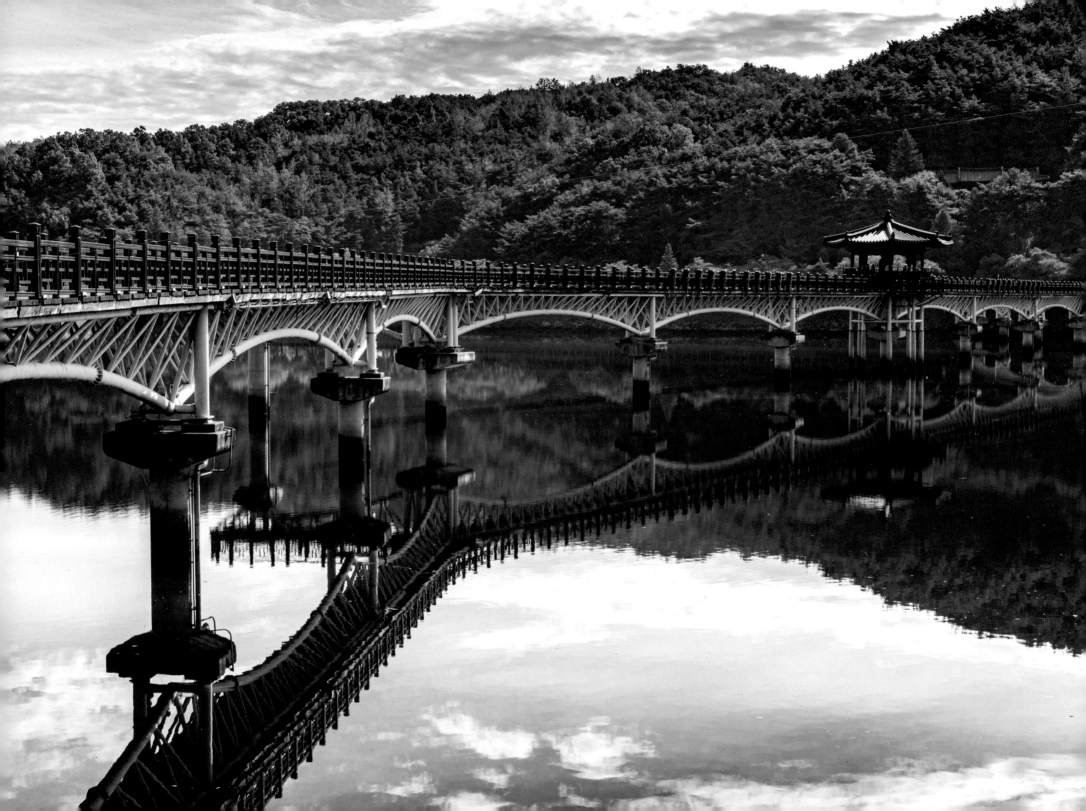

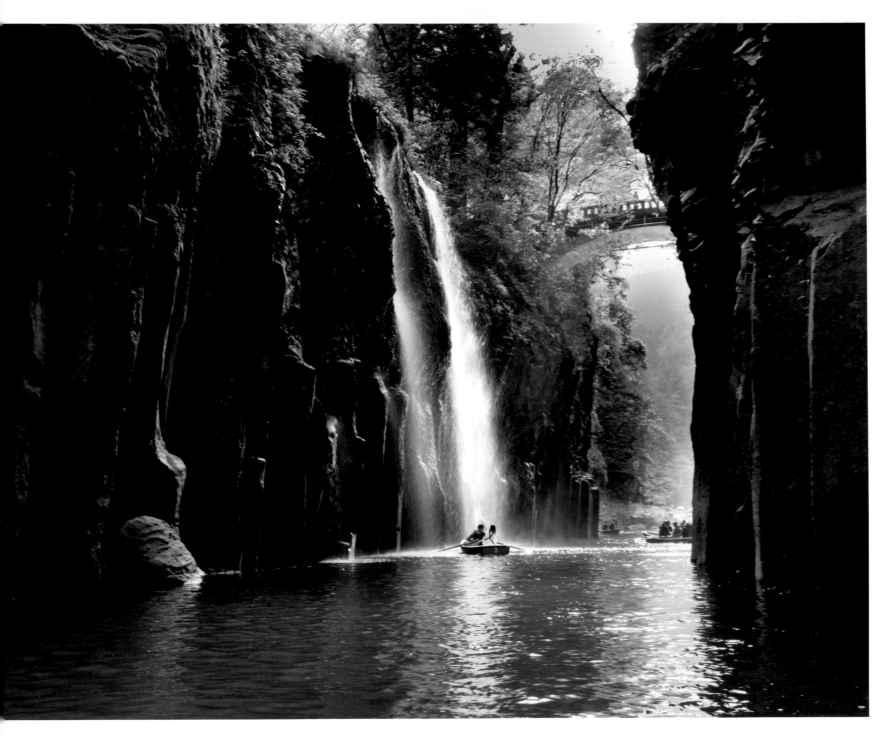

TAKACHIHO GORGE, JAPAN

This gorge was the work of the Gokase River, which cut its way through the basalt layer left by an eruption of Mt Aso. The apparent rippling of the chasm walls was created by columnar jointing in the basalt. In the narrowest section of the gorge, the 17-m (56-ft) Manai Falls shower the many renters of rowing boats. The surrounding area is well featured in tales of Amaterasu Omikami, the sun goddess, and her brother Susano'o, the storm god, as told in the 8th-century *Kojiki* chronicle.

TOTTORI SAND DUNES, JAPAN

Japan's only large dune system, these shifting mountains of sand consist of sediment from the Chugoku Mountains, carried to the Sea of Japan by the Sendai River. The dunes have been here for 100,000 years, but have been shrinking in recent decades due to reforestation and the erection of concrete anti-tsunami barriers. The surrounding San'in Kaigan Geopark also encompasses caves and *onsens* (hot springs).

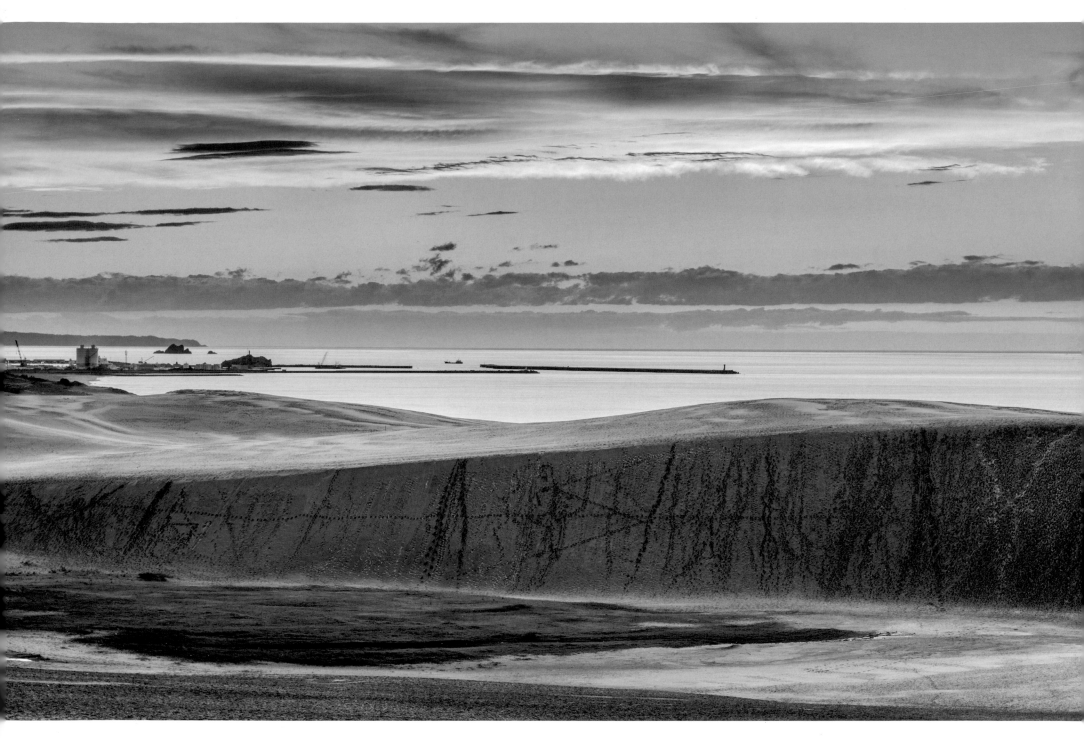

HA LONG BAY, VIETNAM

With a name meaning 'Descending Dragon', this coastal bay in northeastern Vietnam is dotted with limestone karst islands, many with such deeply eroded caves that they are almost hollow. Story has it that a family of dragons once helped the Vietnamese to defend their country from sea-borne invaders. The dragons spat out jewels, which turned into the bay's many islands, forming a barricade to the invaders.

BATAD RICE TERRACES, BANAUE, PHILIPPINES

Today a World Heritage Site, these terraces were first carved from the hillside up to a thousand years ago, when they were used for cultivating taro rather than rice-growing, which began here in the 17th century. On the higher slopes of the mountains is a fringe of dense forest, which serves as a natural filter for the rainwater that trickles to the terraces below. This culturally and economically important landscape is threatened by deforestation and climate change.

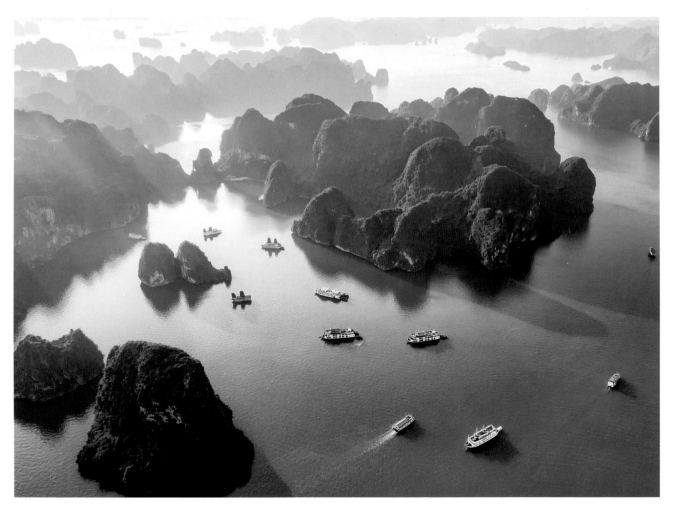

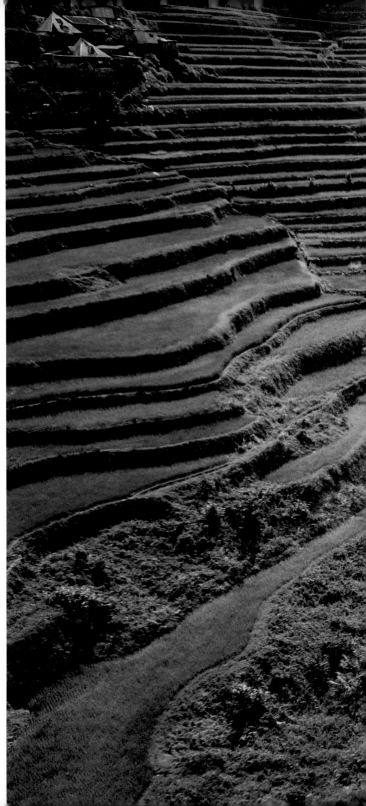

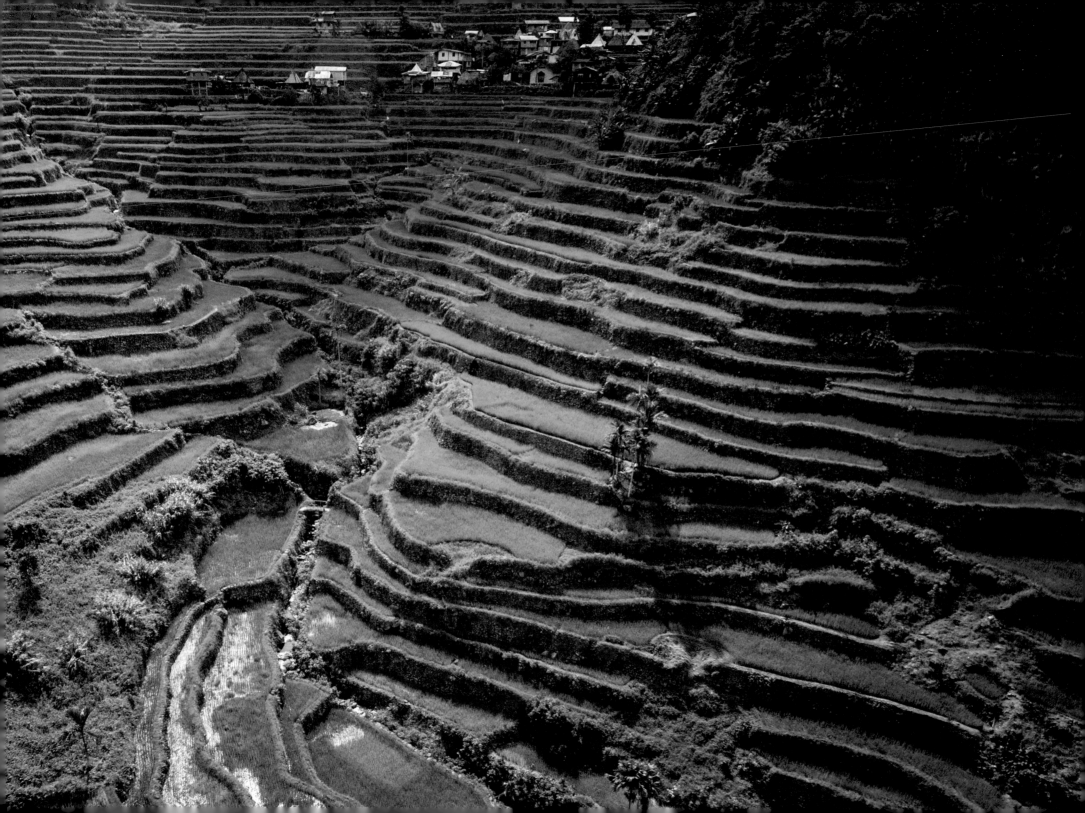

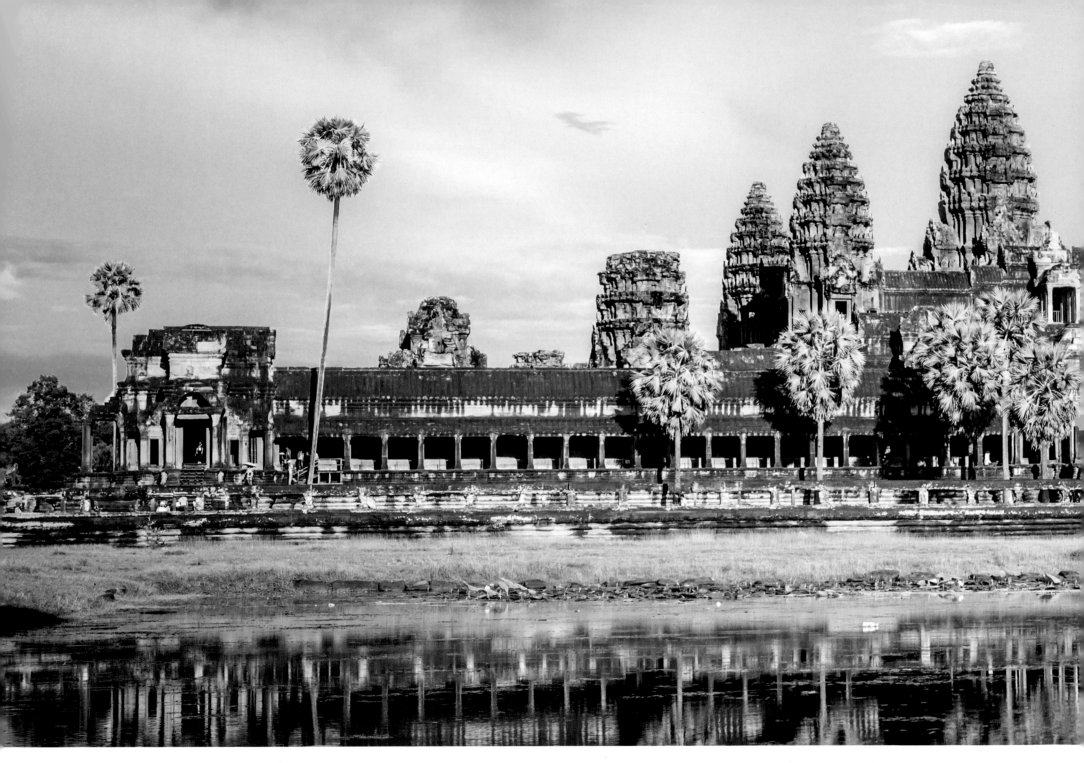

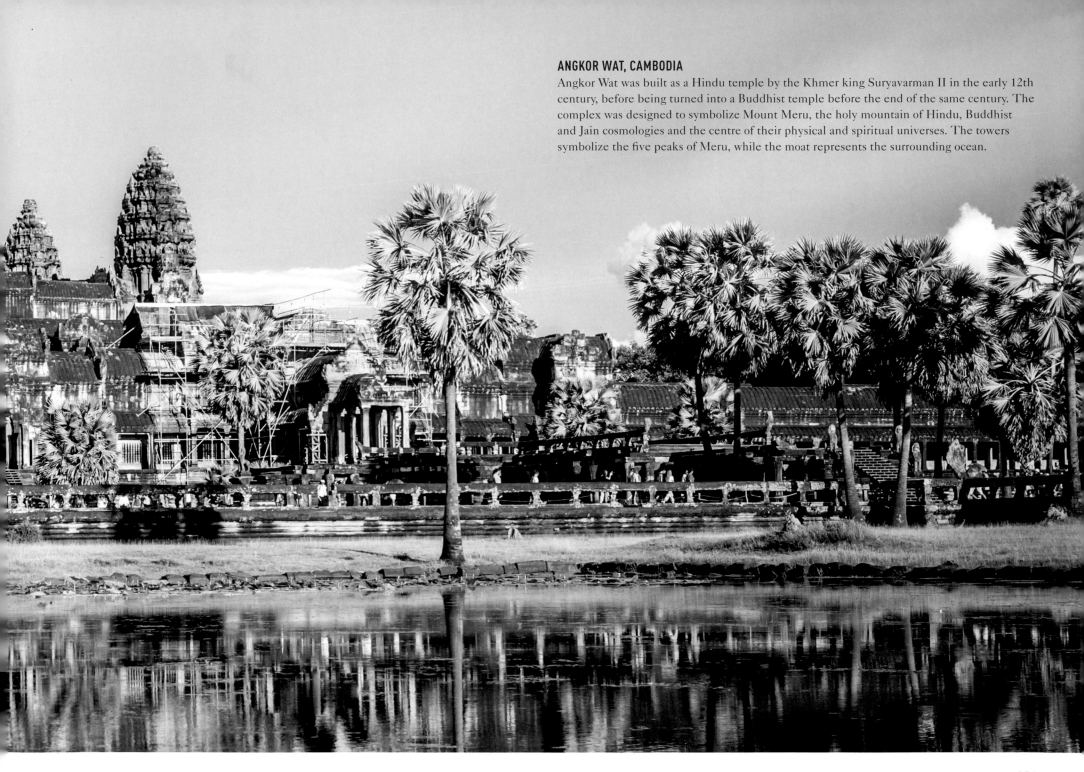

ANGKOR WAT, CAMBODIA

Angkor Wat was built as a Hindu temple by the Khmer king Suryavarman II in the early 12th century, before being turned into a Buddhist temple before the end of the same century. The complex was designed to symbolize Mount Meru, the holy mountain of Hindu, Buddhist and Jain cosmologies and the centre of their physical and spiritual universes. The towers symbolize the five peaks of Meru, while the moat represents the surrounding ocean.

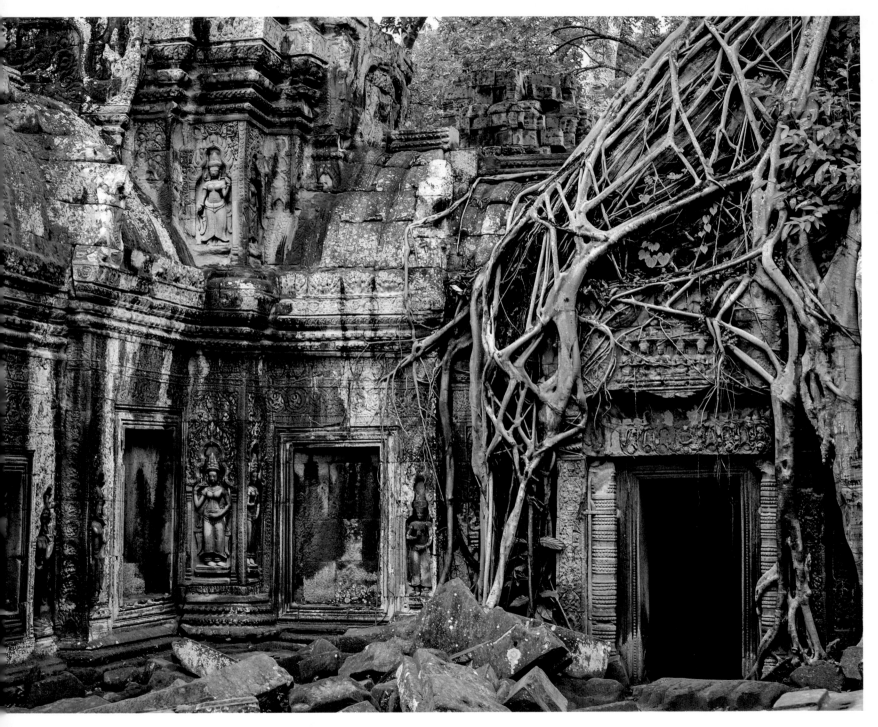

PREAH KHAN TEMPLE, ANGKOR, CAMBODIA

A strangler fig has been allowed to wrap the masonry of the Preah Khan temple, which was built in 1191 by Khmer king Jayavarman VII in honour of his father. The king constructed Preah Khan to the north of Angkor Wat and his own monumental walled citadel, called Angor Thom, which was the last and longest-lasting capital of the Khmer Empire. The outer wall of Preah Khan measures 800 by 700 m (2,625 by 2,300 ft), its courtyards and buildings designed to house 100,000 officials and servants.

OPPOSITE
BAGAN, MYANMAR

From the 9th to 13th centuries, Bagan was the capital of the Pagan Kingdom, which ruled the region of modern Myanmar. Of the old city's countless Buddhist temples and pagodas, 3,822 survive today. The often bell-like shape of the pagodas, also called stupas, is modelled on Mount Meru, thus representing the Buddhist cosmos. Hot-air balloon is a popular way to view the cityscape.

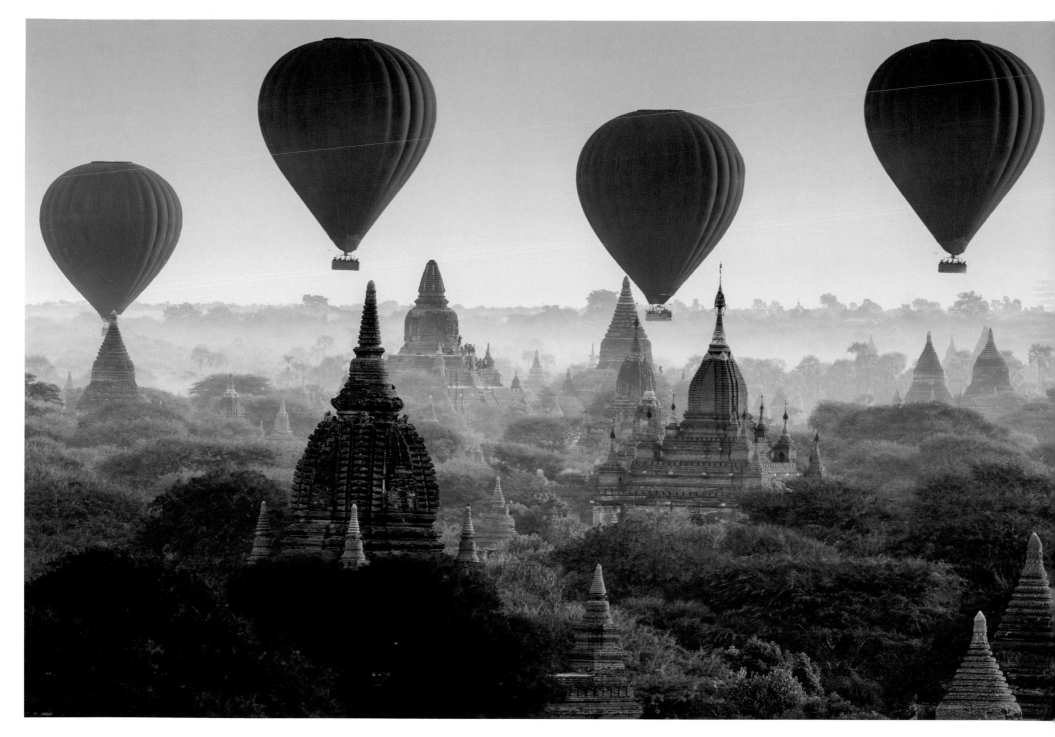

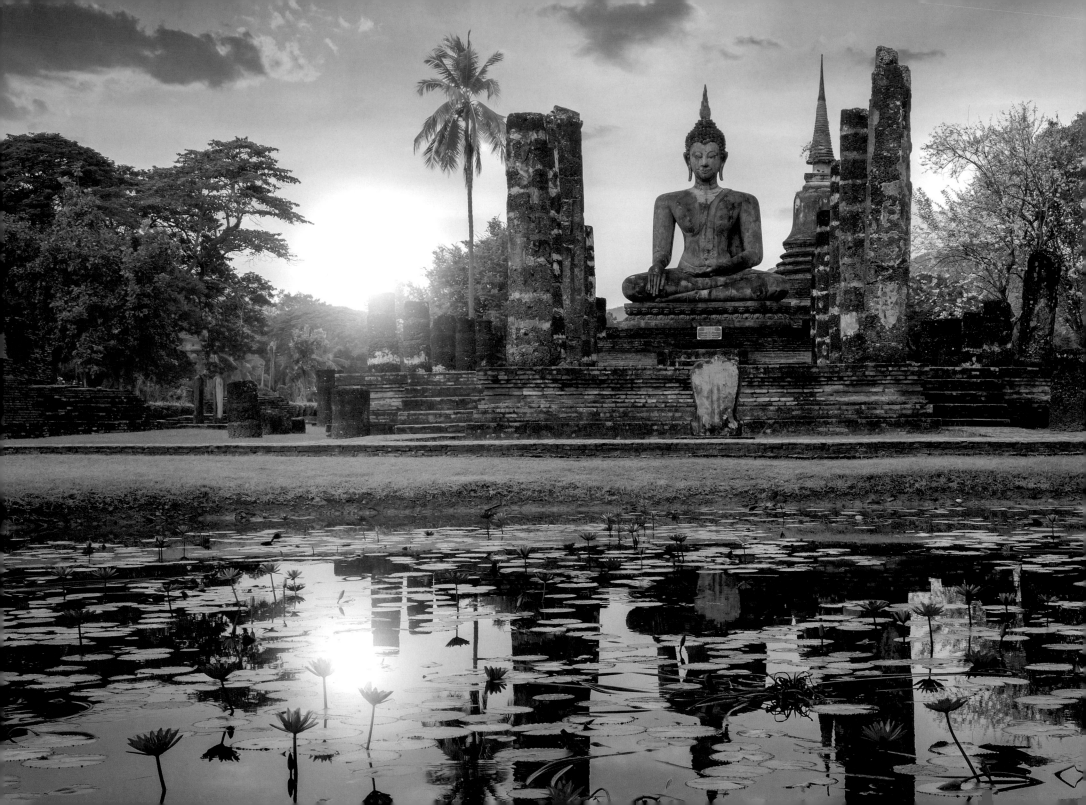

LEFT
WAT MAHATHAT, SUKHOTHAI, THAILAND

Founded in 1238, Sukhothai (meaning 'Dawn of Happiness') was the capital of the Thai Empire for around 140 years. Today, more than 190 temples have been excavated on the site. Many of the temples, including Wat Mahathat ('Temple of the Great Relic'), have stupas, here called *chedi*, in the typically Sukhothai form of a lotus-bud, topped with a conical spire and on a three-tiered base. Statues of the Buddha, both immense and delicate, are standing, walking or reclining.

BELOW
WAT MAHATHAT, AYUTTHAYA, THAILAND

The city of Ayutthaya was founded by King Ramathibodi I in 1351, remaining the capital of the Ayutthaya Kingdom, with a couple of hiatuses, until 1767. Today, the ruins of the great temple of Wat Mahathat stand at the centre of the old city. Here a carved head of the Buddha, entwined with the roots of a strangler fig, has become one of the most photographed relics in the country. Built in 1374 by King Borommarachathirat I, the kingdom's third king, this temple was once the most important in the realm.

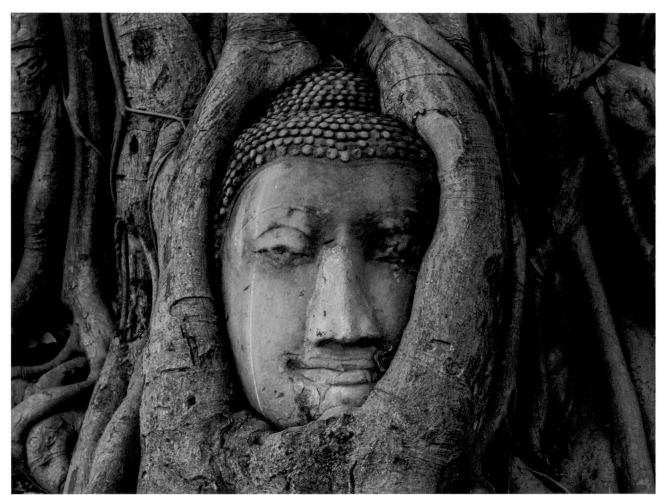

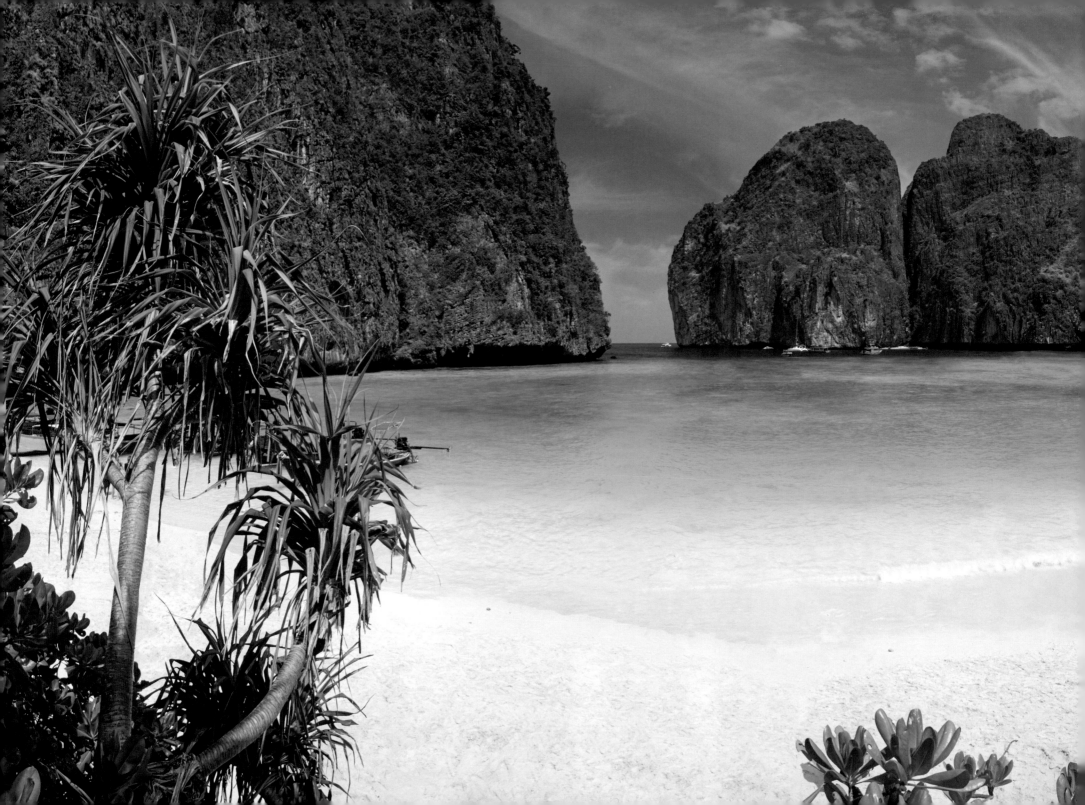

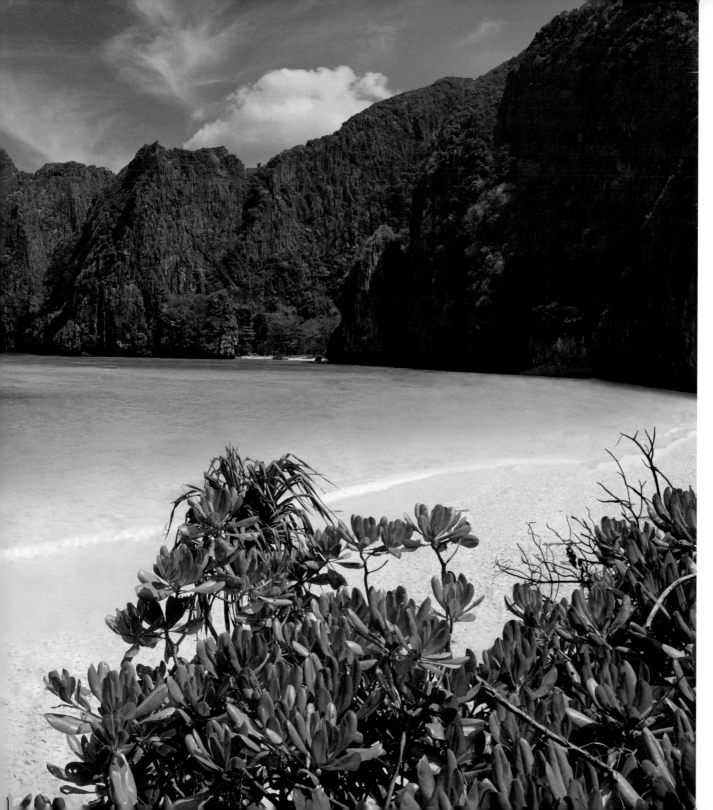

MAYA BAY, KO PHI PHI LE, THAILAND

On the second largest of the Phi Phi Islands, Maya Bay is almost completely surrounded by steep limestone cliffs. It is accessible only by longtail boat or speedboat, but at low tide it cannot be reached directly due to its coral reefs, so visitors must disembark in a neighbouring bay and scramble through the jungle. Maya Bay was made famous by the 2000 film *The Beach*, the spot's popularity creating a delicate balancing act between conservation and tourism.

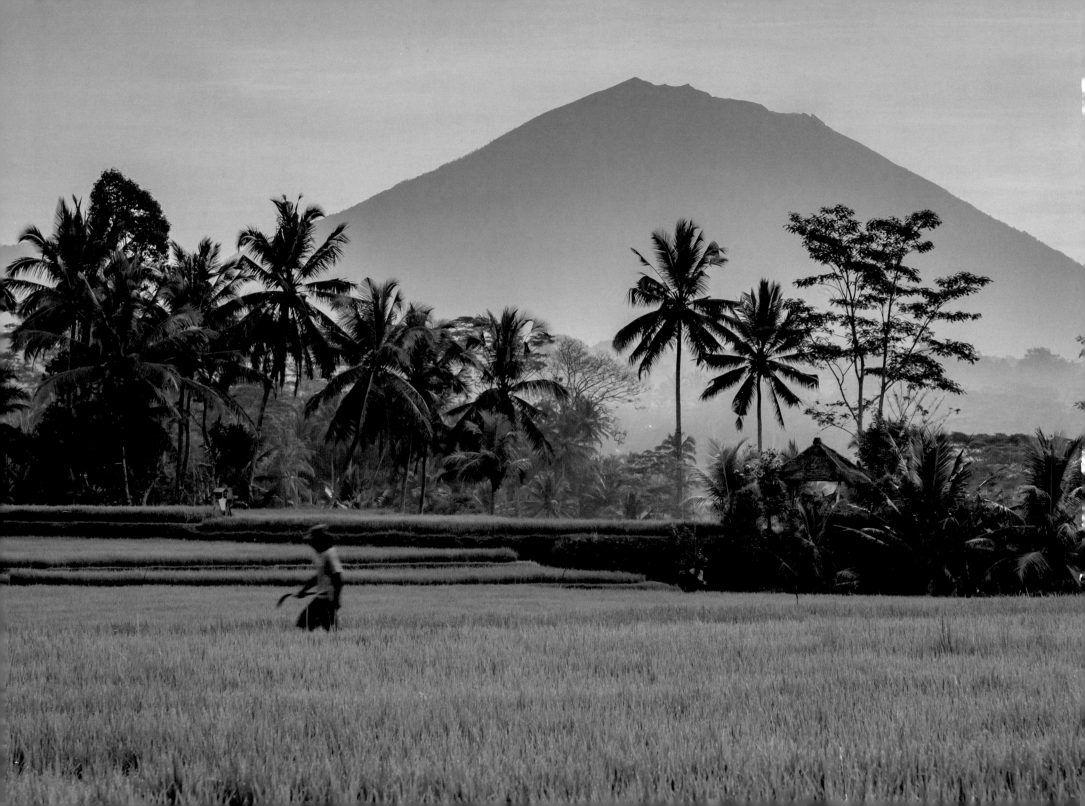

MOUNT AGUNG, BALI, INDONESIA

The highest point on the island of Bali, Mount Agung is 3,031 metres (9,944 ft) tall. This stratovolcano is one of Indonesia's 130 active volcanoes. Most of these volcanoes are on the 3,000-km (1,860-mile) long Sunda volcanic arc, part of the Pacific Ring of Fire, where the Indo-Australian Plate and the Pacific Plate are sinking under the Eurasian Plate. Ash from Bali's volcanoes has resulted in fertile soil, in which rice, chili peppers, tapioca and coffee are grown. Even some of the beaches are made of volcanic ash.

MOUNT KINABALU, SABAH, MALAYSIA

Kinabalu National Park protects the 4,095-m (13,435-ft) peak of Mount Kinabalu. Travellers can apply for a permit to make the spectacular climb, which edges step by step above the clouds, to the jagged, barren summit. Although the hike is demanding, no experience or special equipment are needed to make the two-day, guided round trip. The national park encompasses rainforest; montane forest, home to the carnivorous pitcher plant *Nepenthes rajah*; and alpine meadows.

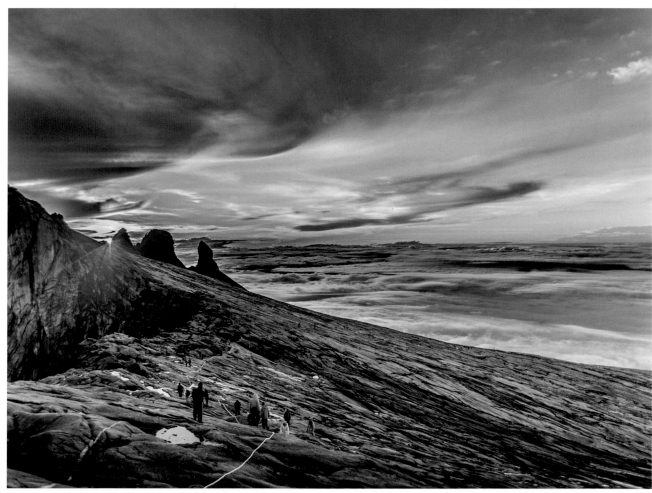

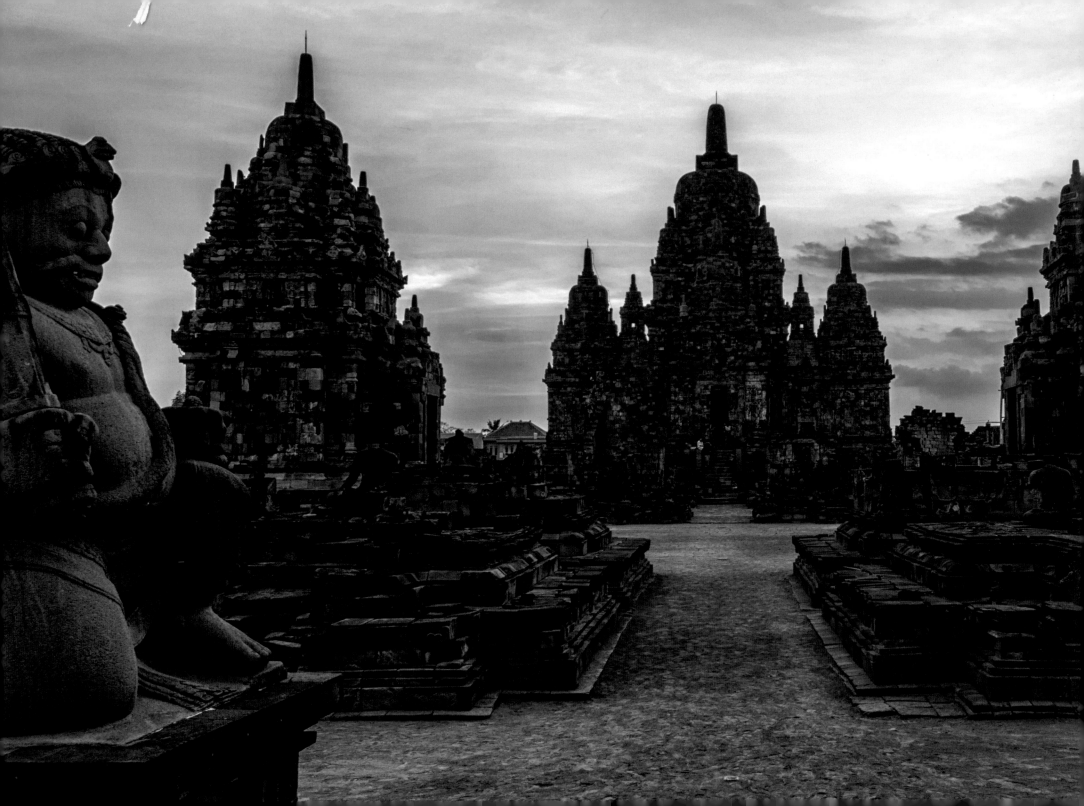

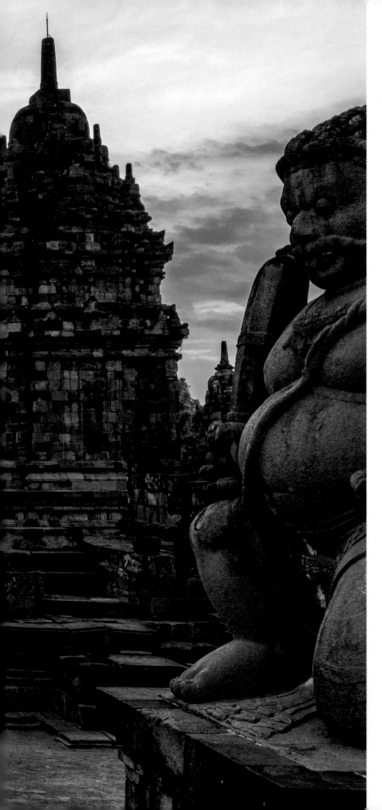

LEFT
SEWU TEMPLE, JAVA, INDONESIA
Built in the late 8th century, this Mahayana Buddhist temple was constructed on the orders of Rakai Panangkaran (746–780), king of the Medang Empire of central Java. The complex's 249 buildings are arranged in a mandala around the main hall, this geometric configuration expressing the Mahayana Buddhist view of the universe as infinite and interconnected. For many years, the complex lay partly buried under volcanic debris from the nearby Mt Merapi.

BELOW
RAJA AMPAT ARCHIPELAGO, WEST PAPUA, INDONESIA
Raja Ampat (meaning 'Four Kings') is an archipelago of more than 1,500 small islands, cays and shoals around the four main islands of Batanta, Misool, Salawati and Waigeo. The name comes from a local myth about a woman who finds seven eggs. Four of the seven hatch into kings, who live on the four main islands, while the other three become a ghost, a woman and a stone. Part of the Coral Triangle, the archipelago boasts extraordinary marine biodiversity, including 1,508 species of fish and 537 of coral.

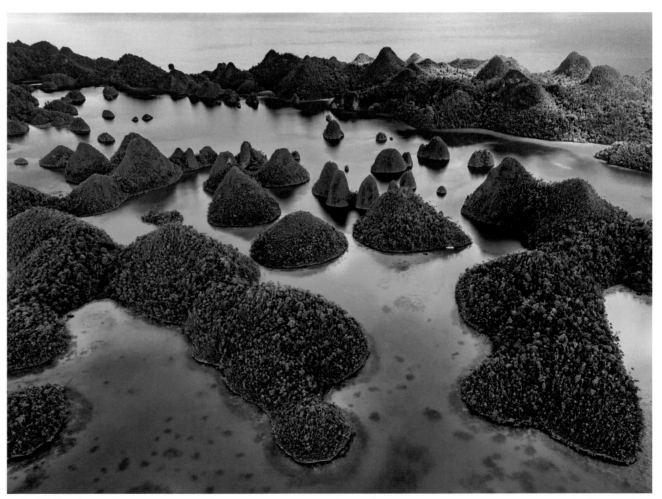

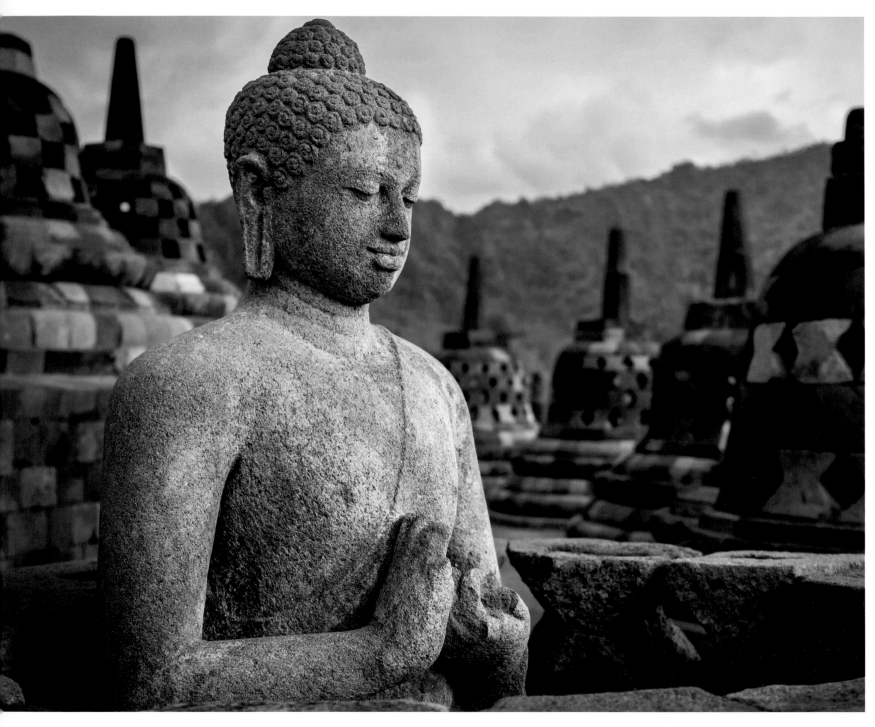

BOROBUDUR, JAVA, INDONESIA

The world's largest Buddhist temple, Borobudur was built in the 9th century by the Sailendra Dynasty. The temple consists of nine tiers, the bottom six square and the top three circular. The entire design represents the quest for Nirvana. Pilgrims and other visitors walk a climbing path through the tiers, which represent three worlds: the lowest, Kamadhatu (the world of desire), Rupadhatu (the world of forms) and Arupadhatu (the world of formlessness). The story of the search for enlightenment is told through 2,672 relief panels and 504 statues of the Buddha. On the top tier, the cross-legged statues are seated in a lotus position and have their hands in the *dharmachakra mudra* position, suggesting turning of the wheel of *dharma*.

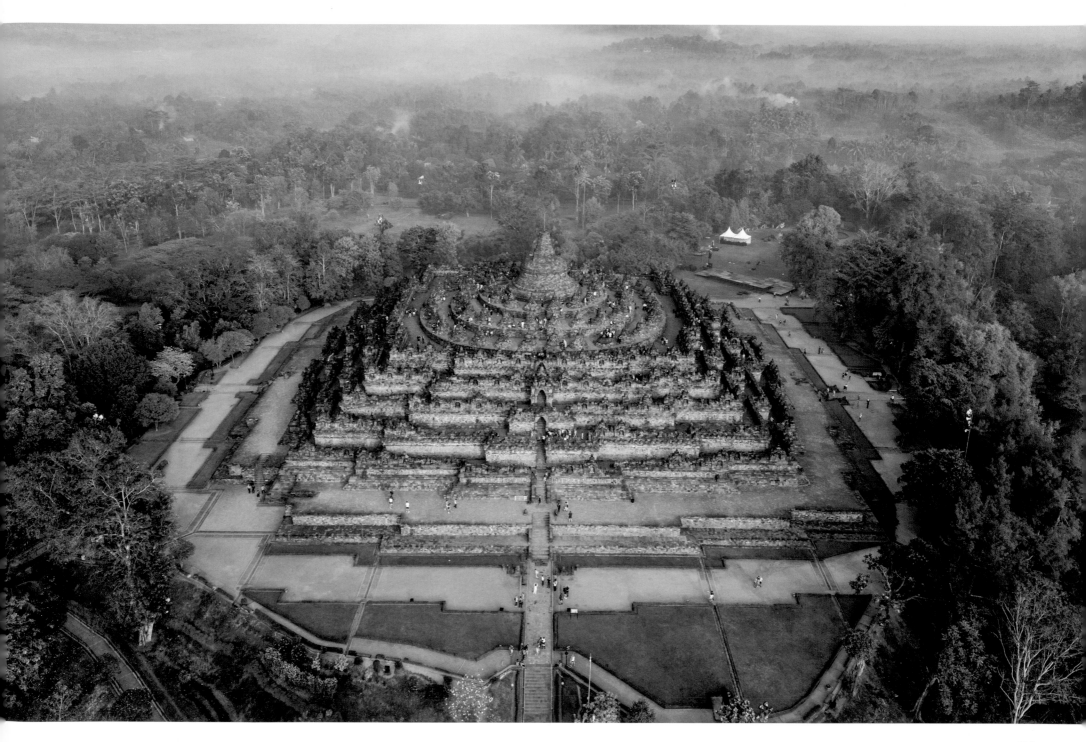

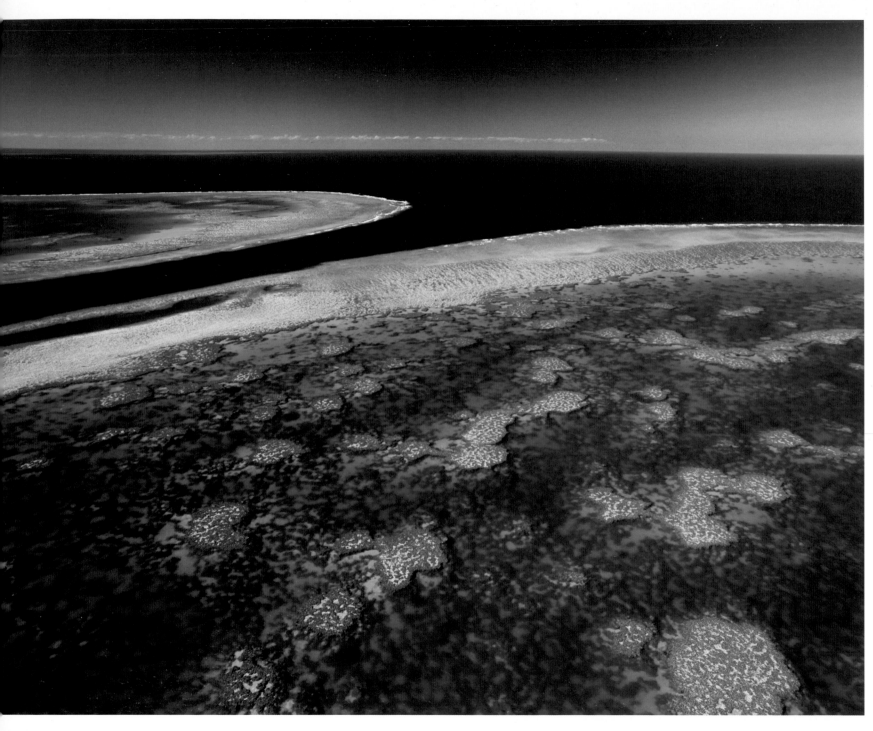

GREAT BARRIER REEF, AUSTRALIA

The world's largest coral reef system, the Great Barrier Reef stretches for 2,300 km (1,400 miles) off the northeastern coast of Australia and consists of over 2,900 individual reefs. Reefs are made of the skeletons of millions of coral polyps. Like all reefs, the Great Barrier Reef is at risk from rising sea temperatures, which causes the polyps to expel the algae that live inside their tissues and from which they take much of their food. This disastrous event leaves the coral at risk of starvation and looking paler, a phenomenon known as bleaching. The Great Barrier Reef is home to 1,600 species of fish and more than 600 corals, 3,000 molluscs and 2,000 sponges.

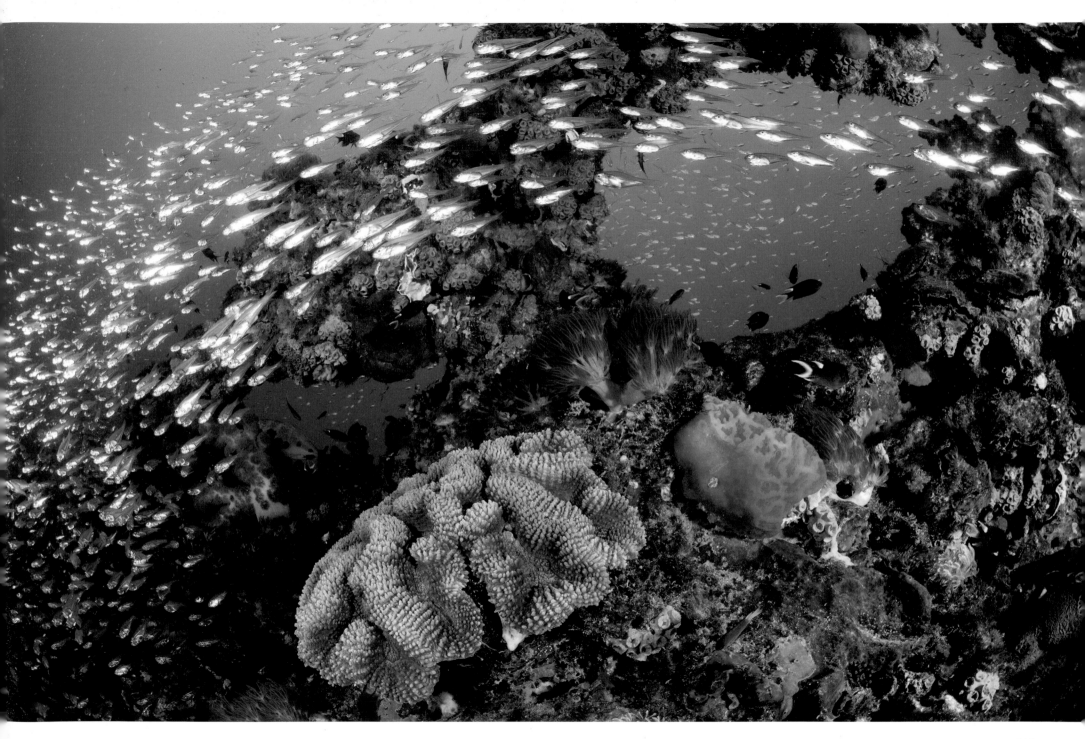

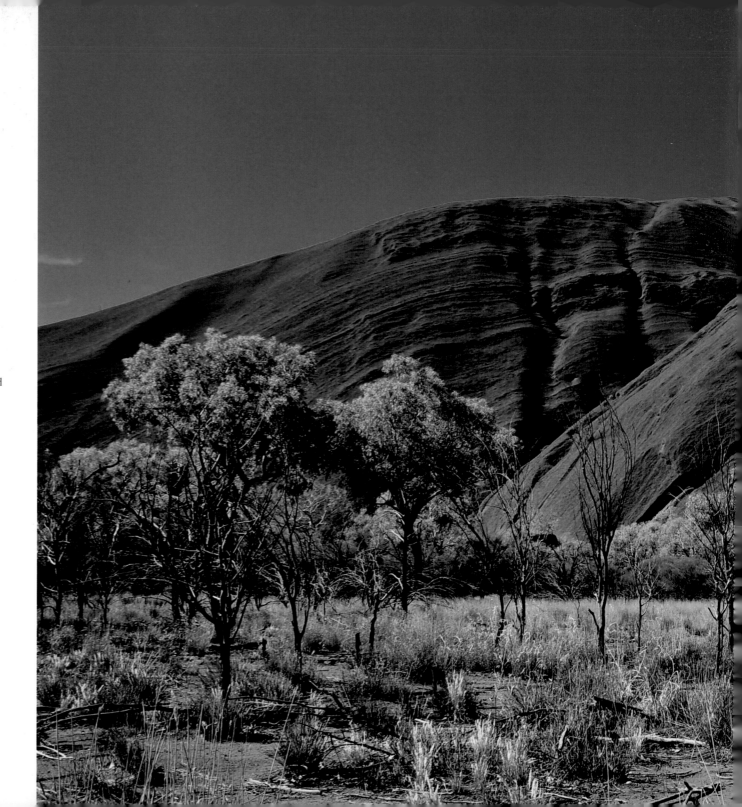

ULURU, AUSTRALIA

Uluru is a vast block of sandstone, 348 m (1,142 ft) high and 9.4 km (5.8 miles) around its base. Thanks to its lack of jointing, the inselberg remained standing while the surrounding softer rock was worn away. Uluru is sacred to the Anangu Aboriginal people, who request that certain sections not be photographed, while climbing was finally forbidden in 2019.

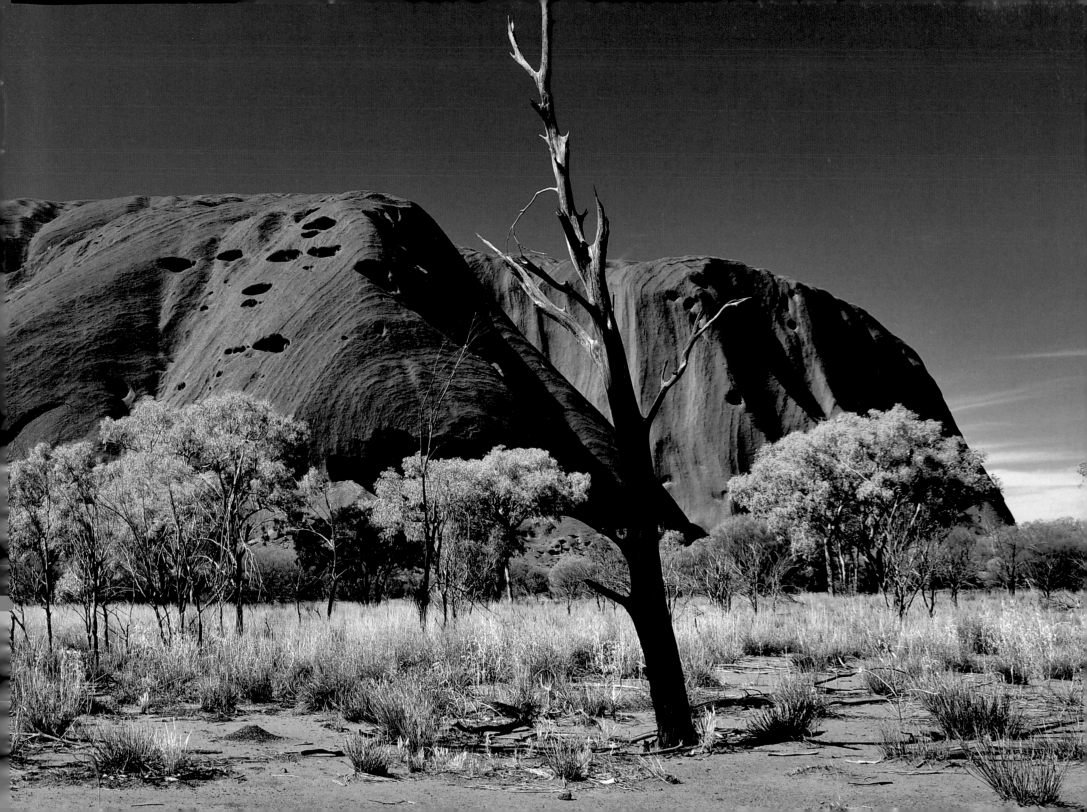

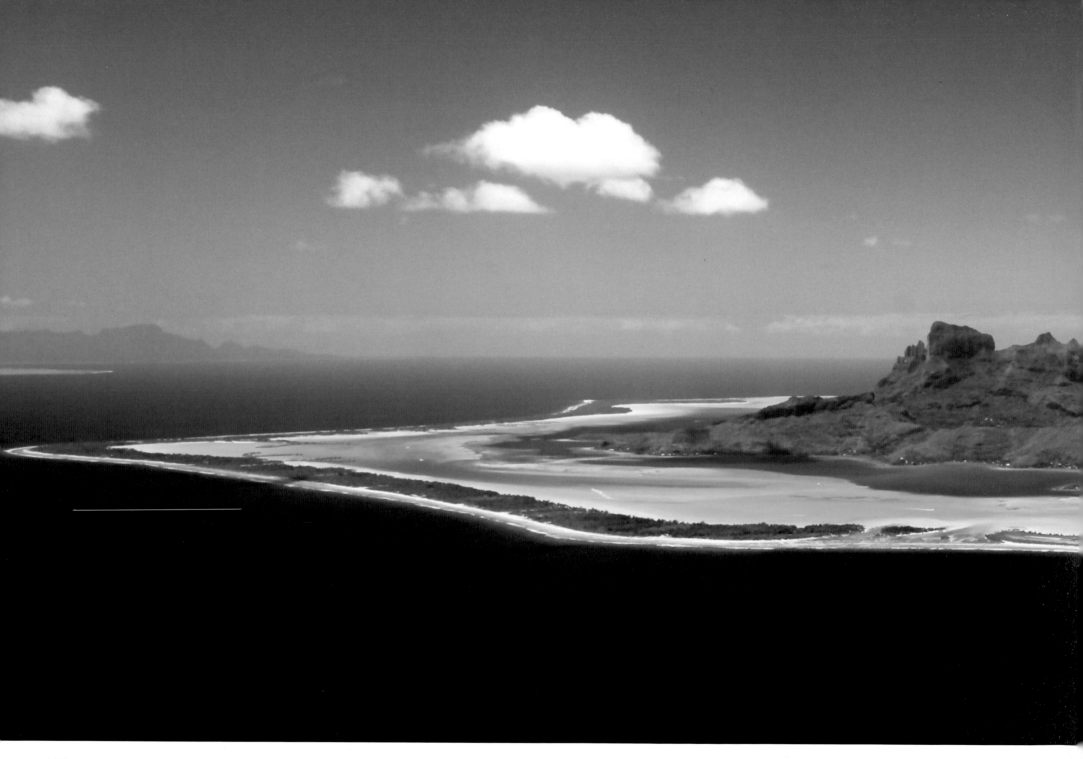

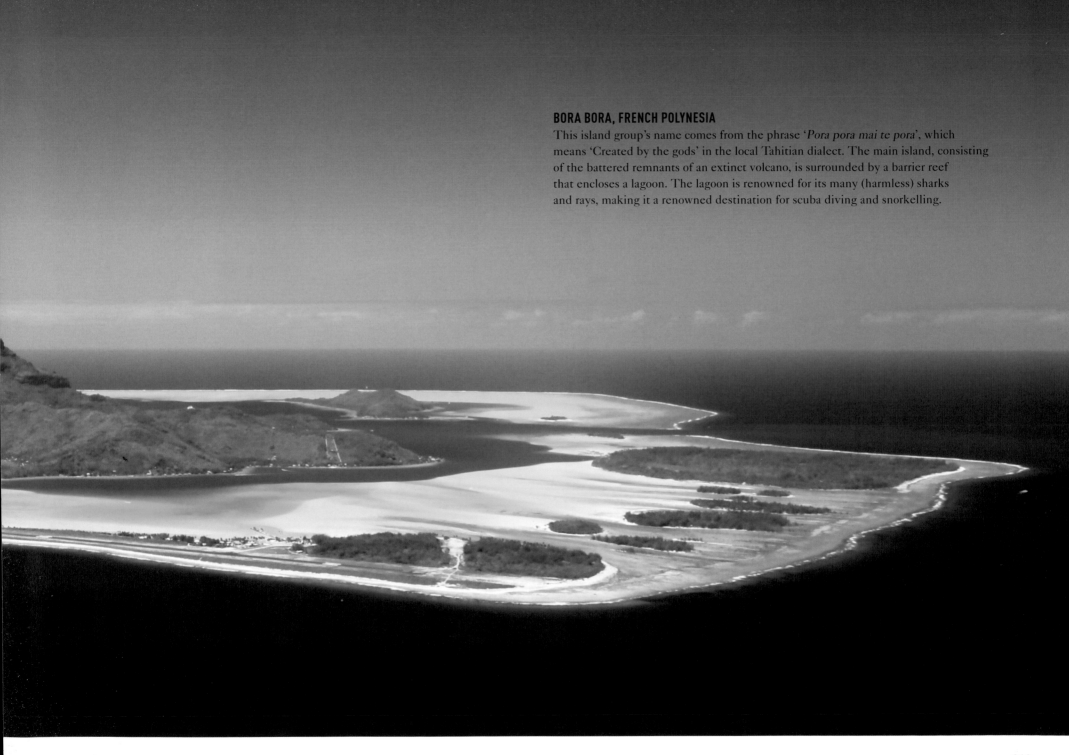

BORA BORA, FRENCH POLYNESIA

This island group's name comes from the phrase '*Pora pora mai te pora*', which means 'Created by the gods' in the local Tahitian dialect. The main island, consisting of the battered remnants of an extinct volcano, is surrounded by a barrier reef that encloses a lagoon. The lagoon is renowned for its many (harmless) sharks and rays, making it a renowned destination for scuba diving and snorkelling.

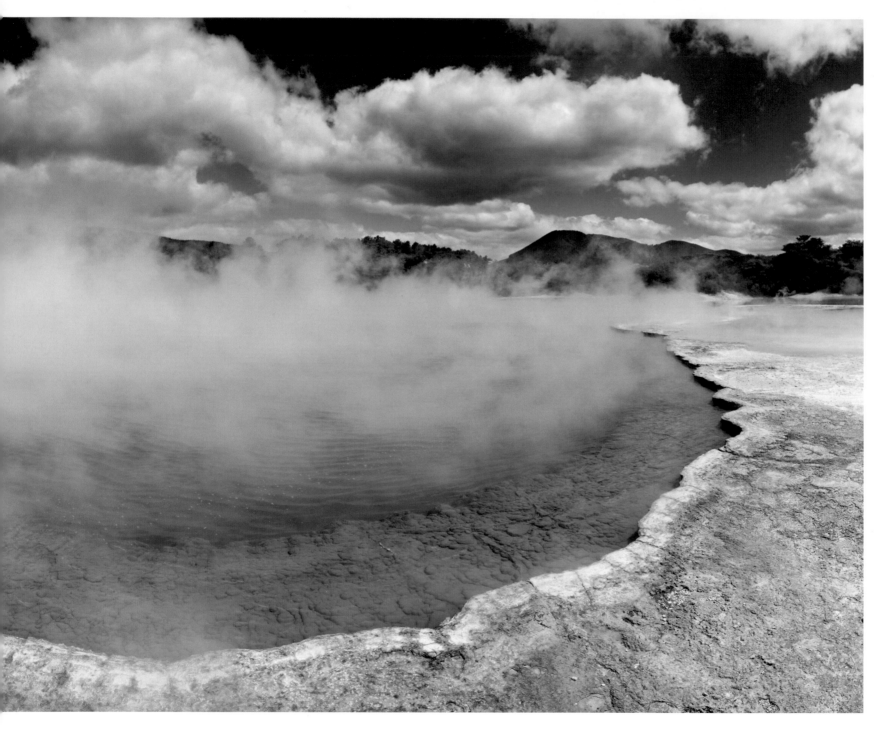

CHAMPAGNE POOL, WAIOTAPU, NEW ZEALAND

Part of the vast Taupo Volcanic Zone, the Champagne Pool is named for its rising bubbles of carbon dioxide. The hot spring was formed around 900 years ago by a hydrothermal eruption. The pool's water, which maintains a steady 73°C (163°F), is supersaturated with orpiment and stibnite, which form orange crystals around the edges. The Waiotapu geothermal area is also home to the spectacular Lady Knox Geyser, with its 20-m (66-ft) high jet, and numerous mud pots.

OPPOSITE

THE CAITLINS, SOUTH ISLAND, NEW ZEALAND

A pocket of temperate rainforest lies in the southeast corner of South Island, its heavy rainfall a gift of the Pacific Ocean. Dominant here are podocarps, a family of southern hemisphere conifers, including the rimu, totara, matai and kahikatea. The Caitlins is also home to one of New Zealand's only two native non-marine mammals, the long-tailed bat (the other is the short-tailed bat).

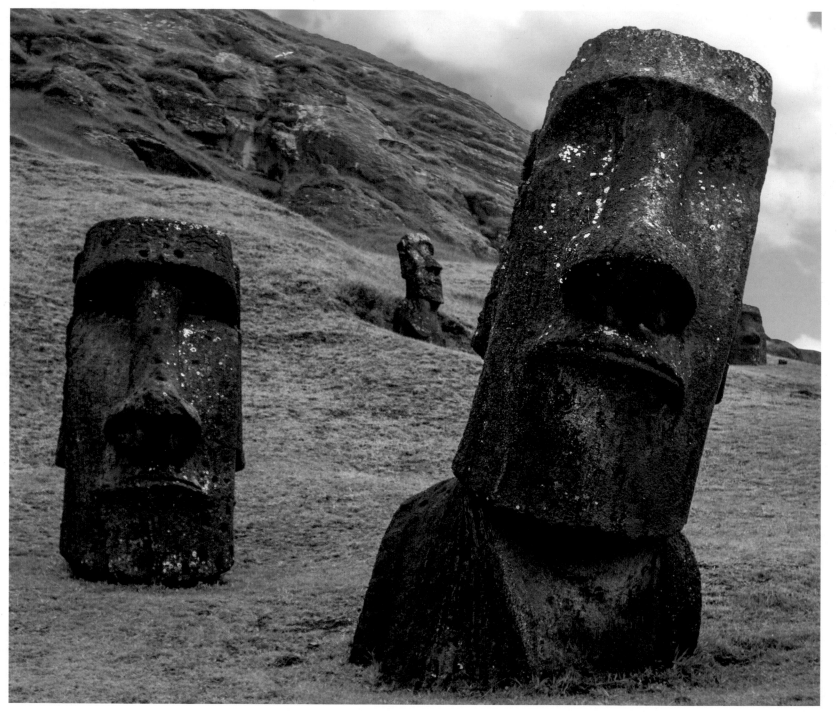

EASTER ISLAND, CHILE

Easter Island, or Rapa Nui, is one of the world's most remote inhabited islands, with the nearest inhabited land 2,075 km (1,289 miles) away at Pitcairn Island. Between 1100 and 1680, the Rapa Nui people carved more than 880 statues, called *moai*. The statues represent the islanders' ancestors, positioned to watch over their land and people. The *moai* average around 4 m (13 ft) tall and were carved in a quarry from relatively lightweight tuff, then possibly 'walked' to their sites by being tugged and rocked on ropes.

OPPOSITE
MILFORD SOUND, NEW ZEALAND

The aptly named Mitre Peak, its sharp summit rising to 1,683 m (5,522 ft), is reflected in the waters of Milford Sound. The sound is a fjord, carved by glaciers over thousands of years. Milford's Maori name is Piopiotahi, after the thrush-like South Island piopio, which was driven to extinction some time in the 20th century due to predation by introduced cats and rats.

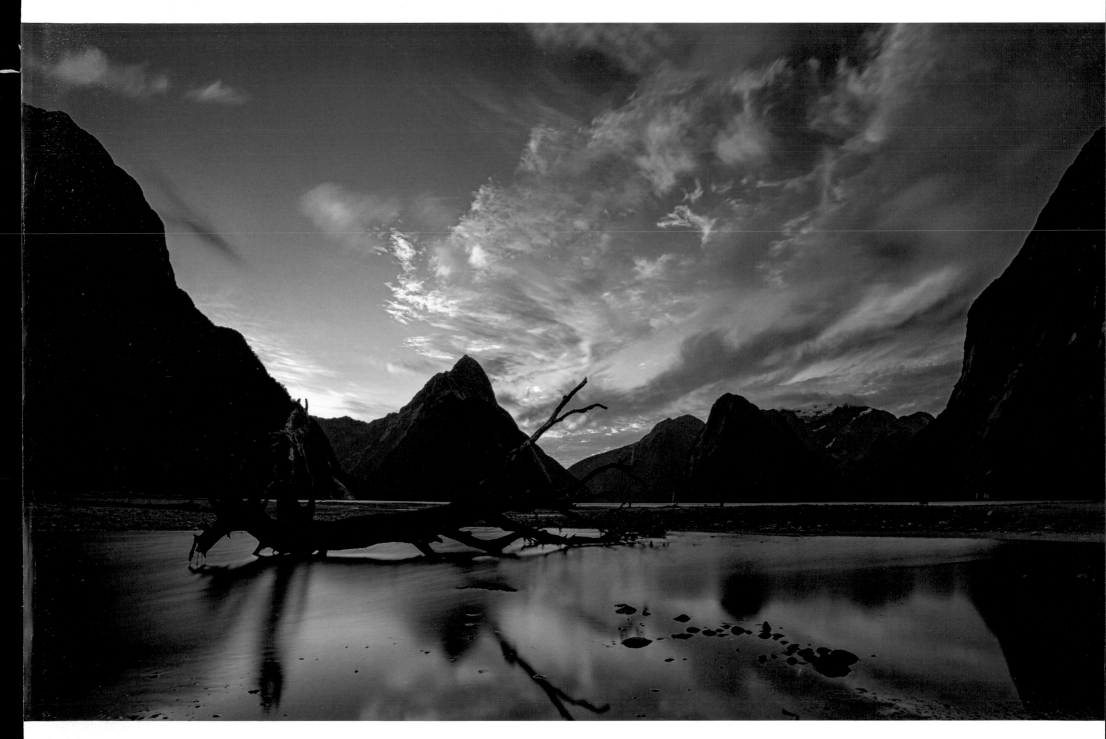

Picture Credits